vice

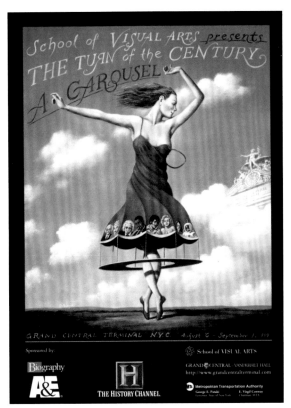

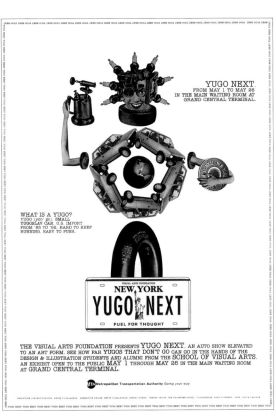

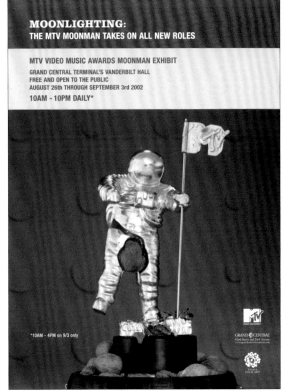

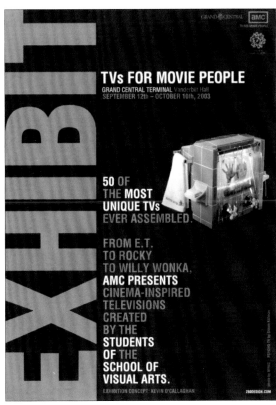

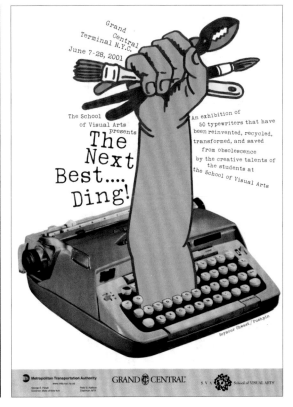

ENTAL

THE
REIMAGINED
WORLD OF
**KEVIN
O'CALLAGHAN**

DEBORAH HUSSEY
FOREWORD BY
STEVEN HELLER

ABRAMS, NEW YORK

Designer: Mike Joyce, Stereotype Design
Production Manager: Anet Sirna-Bruder
Editorial consultants: Dan Hanson, Louis Phillips, Monica Weiss

Page 1 (clockwise from top left): The Turn of the Century: A Carousel: *Rafal Olbinski*; Yugo Next: *The Valentine Group, illustrator: David Plunkert*; Moonlighting: *Thomas Berger*; The Next Best … Ding!: *Seymour Chwast, Pushpin*; TVs for Movie People: *Basia Grocholski, Olga Krigman*; MTV Video Music Awards: *Jeffrey Keyton*

Library of Congress Cataloging-in-Publication Data

Hussey, Deborah.
Monumental: The Reimagined World of Kevin O'Callaghan / Deborah Hussey; foreword by Steven Heller.
 p. cm.
 Includes index.
 ISBN 978-0-8109-8953-5 (alk. paper)
1. O'Callaghan, Kevin—Criticism and interpretation. 2. School of Visual Arts (New York, N.Y.) —Students. 3. Design—United States—History—20th century. 4. Design—United States—History—21st century. 5. Salvage (Waste, etc.) —United States. I. O'Callaghan, Kevin. II. Title. III. Title: Reimagined World of Kevin O'Callaghan.
 NK1412.O29H87 2010
 745.2092—dc22
 2010014038

ABRAMS
THE ART OF BOOKS SINCE 1949
115 West 18th Street
New York, NY 10011
www.abramsbooks.com

ACKNOWLEDGMENTS

This book has been more than fifty years in the making. It begins with the enduring love that I received from my mother Mary, who taught me not to be afraid to stand out in the crowd. An understanding of how things work and thinking "big" came from my father Timothy. I love you both. In the early years of my craft, my stepfather Richard bestowed upon me his work ethic and his support of my art, which were vital to my later practice. Love you. I am thankful to my sister Patricia Filasky for her strength and perseverance, and to my brother Donald O'Callaghan, who taught me about leadership and tolerance. I love you both. To my sister-in-law Patricia Bernhard, thank you for your inspiration and talent. To Jacqueline Hendershott for your love and all the great meals you cooked, and to Joseph Hendershott, who taught me about the beauty of the written word. Love you. I am grateful to my uncle and aunt, William and Barbara Lambert, and to my entire family for the support, encouragement, understanding, and love that I have been given.

I want this book to be a document of all the hard work and the obstacles that were overcome to achieve these exhibitions and projects. What comes to mind is the heart and soul that the students all give to make them happen. There are hundreds of faces of my students that come to mind when I look at the artwork. Every chrome has a story and a face, and a kid who slept in the back of a truck or on a loading dock … oh my God, the camaraderie. What makes my class special is that the students leave with an education about the real world: if you work hard, you can make it spectacular. My students aren't afraid to try anything: They know what it takes and what the reality is. They know what is possible.

The first time I walked into the School of Visual Arts, I knew I had found a home. For more than thirty years, I have been profoundly blessed by the generosity and support of several members of its community. I am indebted to the Silas H. Rhodes, SVA's chairman of the board, who was an instrumental figure in my life and my career, and to David Rhodes, president, for believing in the importance of what my students learn from my class. I am grateful for the continued support of Anthony P. Rhodes, SVA's executive vice president.

My mentor Richard Wilde is a constant source of inspiration and encouragement. Richard and Judith Wilde are my dearest friends; thank you Judith for your kindness and creative support. Thank you to Brandon and Trilby Wilde for your presence in my life. I want to thank Milton Glaser, whose work has always been my creative yardstick. To Steven Heller, who had the faith to see this book to fruition, it is a dream come true, thank you.

I would also like to thank my colleagues at SVA who have given of their time and of themselves, not only to my students, but also to the larger mission of educating all of our students: Marshall Arisman, Ed Benguiat, Francis Di Tommaso, Jacqueline "Pif" Hoffner, Dee Ito, Carolyn Hinkson-Jenkins, Arlyn Lebron, Sam Modenstein, Paula Paylor, Gary Shillet, Carla Tscherny, and Tommy Tucker.

A big thank you goes to my assistant of many years, Adria Ingegneri, whose creativity and devotion to the students and many of the projects in this book helped to make them successful. The other individuals that are part of my team have also given generously of their time and effort: André "Pirate" Araujo, Shaun Killman, Joseph Pastor, and Kaori Sakai. I am thankful to the graduates of my class who continue the effort and invest in teaching the skills they learned to current students: Richard Awad, Mark Cadicamo, Ben Kim, Wei Lieh Lee, Sofia Limpantoudi, Ann Marie Mattioli, Laurie Mosco, Sarah Nguyen, and Lee Yaniv.

I wish to thank the wealth of creative professionals who have collaborated on my student exhibitions as well as my professional endeavors, in particular: Dawn Banket, Al Braunreuther, Marc Cadicamo, Floyd Chivvis, Seymour Chwast, Myrna Davis, Cubie Dawson, Jay Jay French, Andy Fuzesi, Todd Goings, Genevieve Gorder, Olga Grisaitis, Basia Grocholski, Ken Gubblman, Robert Hawse, Sarah Horowitz, Paul Kassner, Patrick Kaler, Jeffrey Keyton, Jimmy Korpai, Olga Krigman, Edna and Warren Lang, Dale Mallie, Jeanne Moos, Catherine Moran, Rafal Olbinski, Jerid O'Connell, Dimitri Papadakos, Geoffrey Parnass, Stewart Pastor, MYKO Photography, RED Design, Paula Scher, Matt Targon, and Rob Tringali, as well as the people at the Art Directors Club.

Lastly, I would like to express my thanks to Eric Himmel, editor-in-chief at Abrams, for his guidance and endless patience. To Deborah Hussey, who achieved the impossible task of conveying what it took to create the projects in this book so eloquently, thank you. Thanks to Mike Joyce, who designed a book that is both beautiful and respectful of the artworks.

No artworks in this book have been retouched or digitally altered.

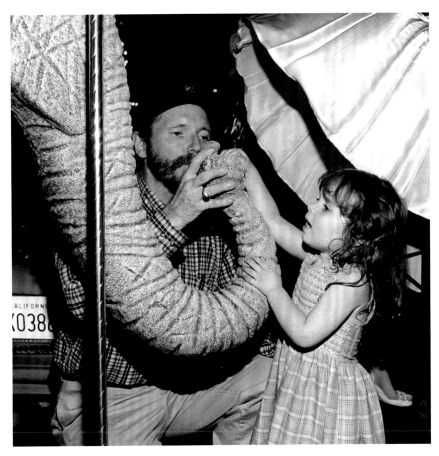

FOR MY WIFE SUSAN AND MY DAUGHTER CAROLINE
OUR LIFE AND LOVE ARE MONUMENTAL

Caroline, your light shines on all that I do.

CONTENTS

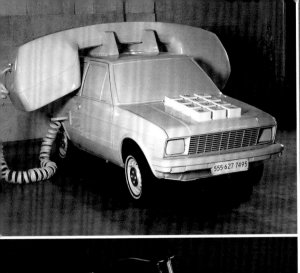

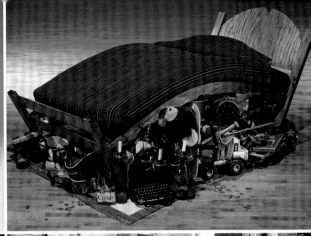
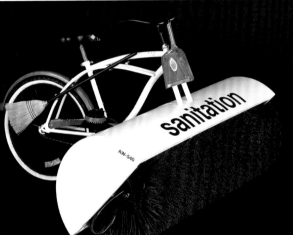
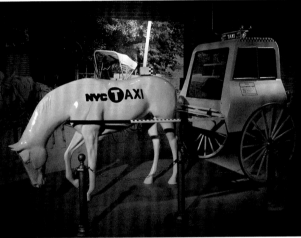
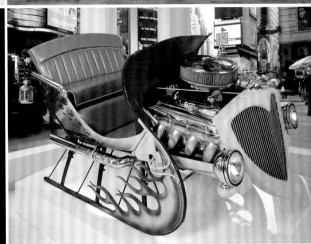
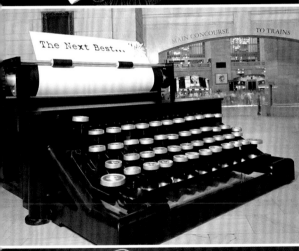
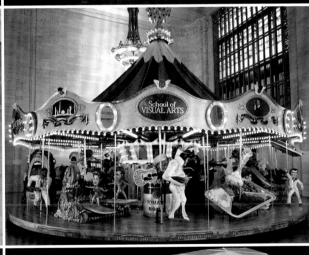
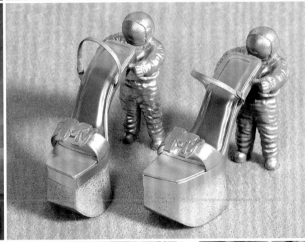
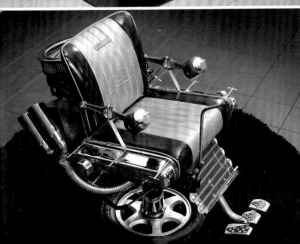
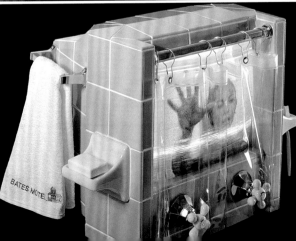

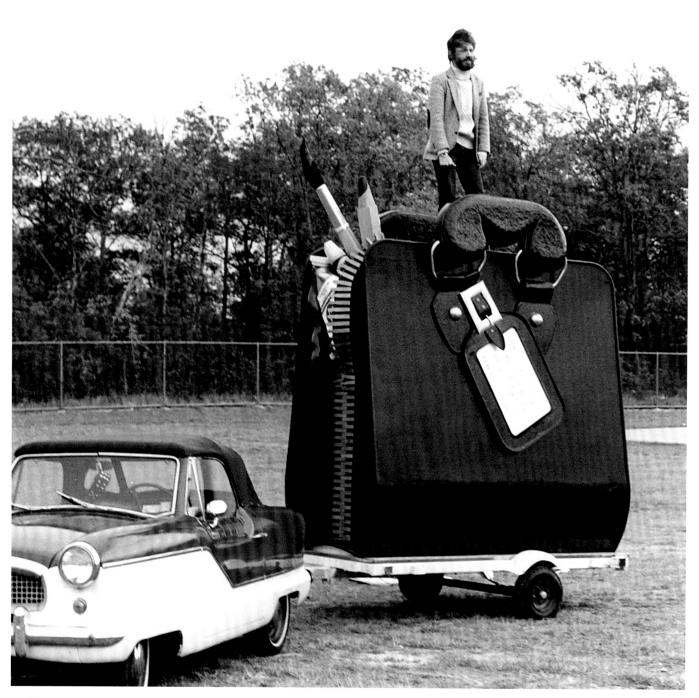

A 1982 family snapshot of Kevin O'Callaghan with his giant portfolio. The portfolio was built with wood, fiberglass, found objects, and hardware store items: Paint-mixing sticks were interwoven to form the enormous zipper, and a large plastic ball was sprayed with gold paint to form the rivets of the handle. Textured linoleum flooring was painted black to replicate the grain of a portfolio case and an upturned flowerpot became the point of a crayon. A starched wig was formed into the bristles of the paintbrush.

THE REAL O'C

BY STEVEN HELLER

Y ou are an art student who has never made anything larger than what fits neatly into an average-size portfolio case. Suddenly, you are thrown headlong into a class with the unassuming title "Three-Dimensional Design and Illustration." You think, "Maybe I'll be making three-dimensional images that can only be seen with those funny glasses." Instead, you find yourself hammering, welding, vacu-forming, soldering, and performing countless other technical feats that transform old Yugo compact cars, vintage typewriters, televisions, gas masks, beds, birdhouses, skeletons, bicycles, subway cars, pushcarts, and even a real antique carnival carousel into functional, albeit monumental spectaculars. You conceive of ideas and fabricate objects that would have been impossible to imagine, no less do, only a few weeks earlier. You become fearless about working with your hands and other appendages. As though by some transforming transcendental force, your work is good enough to stand alongside other unique assemblages in such exhibition venues as the Vanderbilt Hall at New York's Grand Central Terminal, the lobby of Washington's Union Station, the Whitney Museum of American Art, and prestigious gallery spaces around the country. You wonder, "Is this some out-of-body experience?"

No. In fact, this is what happens in every class that Kevin O'Callaghan teaches in his department at the School of Visual Arts. Through the drive of a drill sergeant, he has whipped you into creative frenzy. And you will never be the same, ever again.

Kevin O'C (as I call him) is something of a madman—yet, an incredibly generous, nurturing madman. What else but a touch of insanity could account for his indefatigable drive? If all madness was like his, however, the asylums would be creative hothouses and the inmates all geniuses. O'C may appear to be delusional about how much he can make his students achieve in a short time frame, but he succeeds in ways that boggle what's left of his students' minds. He begins by imparting knowledge and a little theory, but the key is convincing all class members that they can do anything they set their sights on. It is about orchestrating and conducting, and O'C is the Leonard Bernstein of the 3-D symphony.

Case in point: For the Beaux Arts Ball in New York City, sponsored by the New York Arts Club, Lita Talarico, cochair of the School of Visual Arts' MFA design program, did not have to beg O'C to create the elaborate float that would compete against those of five other area art schools. He panted at the opportunity. The thrill of competition was enough motivation. Never mind that he should never have accepted the Beaux Arts assignment, given a previous commitment to produce three other exhibitions during the semester, as well as his commercial work for MTV. To O'C's personal detriment,

he never says never! Instead, he allowed his class a week and a half to conceive and build the float, which resembled a circus train with its own lighting and sound system, and choreographed a costumed performance piece, with his team dancing the cancan. No detail was left to chance: Every component, from mechanics to decoration, was perfectly designed. And guess what? O'C's creation won, beating out floats that took months to produce.

With his strawberry blond, though speedily graying moustache, intense bright-blue Irish eyes, and toothy smile, O'C looks like a

"I WAS A LITTLE LATE, BECAUSE MY PORTFOLIO

man possessed. He speaks in a breathless, nasal-twangy Long Island cadence. Sentences are frequently punctuated by a nervously lilting "you know, you know"; he sounds more like a teamster than a creative maestro. He recognizes certain obsessive and compulsive traits in himself, but not in the clinical sense.

Despite his infectious zeal and stress-filled schedule, O'C is a practical teacher, unflappable in the face of impossible deadlines. In 2003, for example, he was allotted only four weeks to produce an exhibition sponsored by the American Movie Channel, destined for Grand Central's 12,000-square-foot Vanderbilt Hall, entitled "TVs for Movie People." Each student had to illustrate or symbolize a film from the AMC library through an environmental sculpture with a centerpiece TV playing an iconic clip. *Singin' in the Rain* was represented by a real lamppost with the TV screen set in a polyurethane puddle on an ersatz sidewalk. A replica of a suburban pink bathroom with the TV imbedded in the sink evoked *The Incredible Shrinking Woman*. The statue for *King Kong* was a gigantic model of the Empire State Building, with small screens cut into the towering facade.

The complex pieces were assembled in breakneck speed. But with only twenty-four hours before the grand opening, the New York City

fire marshal closed the show, charging that the proximity of the show's electrical wiring to the walls constituted a fire hazard. Most curators would have been instantly hysterical. Not O'C! An hour later, he had designed an alternative plan for the wiring and the show opened on schedule. Then the post-traumatic stress set in. But for O'C, stress is a combustible fuel.

O'Callaghan began what he calls the "monster" object phase of his career back in the early 1980s when he was an advertising major at the School of Visual Arts. Upon graduating he showed his work to Milton Glaser. Rather than carry a standard portfolio up the two flights to Glaser's Thirty-second Street Manhattan studio, O'C decided to build a two-story portfolio case. "I was a little late," O'C recalled, "because my portfolio case got stuck in the Midtown Tunnel." In fact, it was wedged against the roof, and O'C had to let some air out of the tires of his trailer to free it. Showing up tardy, O'C met the slightly annoyed Glaser, who stated he didn't have much time, and asked, "Where is the portfolio, anyway?" O'C answered, "Look out the window." The portfolio was level with the second floor. O'C continues, "So he got on his intercom to tell everyone 'go to the windows,' and just as he did that a reporter from *People* magazine, who heard about the Midtown Tunnel incident, came to write a story that appeared on two pages in the magazine." After this, O'C started getting an enormous amount of work.

Work is more than his bread and butter; it is his mythic source of strength. O'C thrives on challenges, even those he could do without, and he impresses this ethic on his students. There should be no limits to their thinking and making. He commands them to work with their hands, yet not to confuse hands-on with a resistance to technology. He is far from being a Luddite, but when the computer became the standard design tool, he attracted students who wanted to build real

things. They were, he once told me, "The same kids who on Christmas morning played with the boxes and not the toys."

O'Callaghan's design classes are highly unusual in that they often result in massive public exhibitions. O'C has always craved the interactivity exhibitions can provide, and his are not just hangings on the wall. They are monumental extravaganzas, architectural entertainments—part display, part playground, part dreamscape. We see this in "New York Housing for the Birds," one of his first shows. He always prefers giving a starting point, because then everybody

CASE GOT STUCK IN THE MIDTOWN TUNNEL."

has a shared context for viewing the exhibit. For his birdhouses, O'C settled on functional architectural follies as that point. His students did not disappoint: One birdhouse might have a million locks, another the look of a takeout food container, and another might be a mailbox stuffed with fliers and menus. These ideas made his mind soar.

Many of his shows derive from personal concerns. Rather than undergo psychoanalysis, O'C makes his fears and phobias into monu-MENTAL therapies. His motto is, "If you're going to do an exhibition, do it based on something you personally love" (or, I presume, want to exorcise). "If you have an interest, there is more adrenaline," says the man whose name could be a stand-in for the word *adrenaline*. A psychoanalytical case in point: O'C once confided to me that he has problems sleeping at night, so he devised methods to put himself to sleep, which he calls bedtime rituals. Bingo, it became a class project that challenged students to design full-size beds illustrating their own rituals.

What does he get in return for all this effort? O'C craves the feeling he gets from the grandeur of the work and the enormity of the response to it. So he ensures that the press (CNN is especially loyal) beats a path to his galleries to cover the wonderment.

The biggest of the big spectaculars was "Yugo Next." Here was a challenge, one of those serendipitous opportunities that mortal men would shrug away as a nice, unfeasible idea. A show fell out from New York's Grand Central Terminal, and the events coordinator asked O'C to fill Vanderbilt Hall. Our 3-D impresario had to think bigger than he had in the past. Cars are one of the loves of his life, so combining art and autos was a no-brainer. He was also interested in the curious plight of the little Yugo car, the Yugoslavian compact that tried to make it big in the United States but, unlike the Little Engine That Could, failed to capture the market. O'C didn't know in what direction he would go with this idea until he turned up a dead-end street one day, and he saw a Yugo being used by a group of kids as a baseball backstop: The pitcher was throwing directly at the car—a brand-new one now covered with round little dents. One of the kids' fathers had offered it up as a piece of junk that should be good for something.

Score! O'C would do the same thing—give the Yugo other existences. He bought thirty-nine cars for an average of forty dollars a piece; thirty-two students received these much-maligned compacts, and not one of them said no. The rest is history.

The intention of this book is to chart O'C's monumental manifestations and to delve into his monomaniacal brain. This is the first time the work of O'C and his students has been collected between covers. One question: Can one book do justice to the extraordinary effort? Maybe. Maybe not. It is as difficult to re-create his larger-than-life environments—even using the best photographs—as it is to capture how speedily his mental spark plugs fire. But we will try. Kevin O'C is a force of nature. While this book cannot be as gargantuan as his work, think of it as a genie's lamp—rub it and watch the inspirational energy fly out and take shape.

INTRODUCTION

Working small or LARGE SCALE, O'Callaghan always THINKS BIG.

When Alexander Calder's miniature circus was exhibited at the Whitney Museum in the early 1970s, the public was captivated. For fourteen-year-old Kevin O'Callaghan, the effects of seeing it were seismic. The circus characters were made from found objects and offered an amusing do-it-yourself quality, which Calder orchestrated through whimsical performances using his three-dimensional constructions. These creations were, in fact, intricately detailed and crafted with precision. Though small in size, Calder's *Circus* and its ringmaster served as principal influences for O'Callaghan's artistic evolution. Working small or large scale, O'Callaghan always thinks big, weaving together visual narratives that offer new perspectives through the juxtaposition of the ordinary with the spectacular.

O'Callaghan's mother, Mary "Buddi" Steller, embraced the elaborate and the humorous, and had a flair for the theatrical—traits that were endowed upon her son. She met Kevin's father at the 1939 World's Fair, where Timothy O'Callaghan, a well-known architect, had designed several pavilions. In one of them, Steller, a showgirl for Billy Rose, was hired to strike and maintain a pose within a big golden frame. (Sixty-five years after the '39 World's Fair, O'Callaghan would create a gold-leaf frame to surround a mammoth television monitor that projects eclectic entertainment to its audience in the heart of Times Square.)

The attraction to the monumental coupled with an innate artistic talent are his father's legacy. In his architectural practice, which included contributions to the design of the Mets' Shea Stadium, the senior O'Callaghan strove to emphasize a fine-art aesthetic. Timothy O'Callaghan also created stage sets for producer Mike Todd, whose adaptation of *Around the World in 80 Days* is an apt metaphor for Kevin's tenacity and success in uncharted territory.

OUT OF THE CLASSROOM

Completing his studies at the School of Visual Arts (SVA) in New York, O'Callaghan began searching for a career in advertising, his collegiate major and intended profession. Feeling disheartened by the perfunctory agency review process, in 1982 O'Callaghan created a colossal 3-D portfolio case that he drove around New York City, which gained him a two-page spread in *People* magazine and several job offers.

O'Callaghan's blossoming talent was cultivated at Dale Mallie's design studio, which specialized in making props for TV commercials. Up against an impossible deadline, Mallie, whose work O'Callaghan had always admired, was looking for someone who could work all night to finish a job. Their conversation ended with a suggestion that O'Callaghan bring a toothbrush, since they would be working until dawn. In O'Callaghan's orbit, synchronicity is commonplace. He had

Photo booth picture of Kevin O'Callaghan, circa 1961: the beginning of a lifelong adoration for cowboys.

just finished making a ten-foot toothbrush for a toothpaste ad and brought it along. He stayed well past sunrise, finishing the job, and then he worked at the studio for two months creating special effects for commercials and expanding his artistic skills. Achieving these effects in a predigital environment meant constructing them. O'Callaghan became known as the guy who could make huge objects and deliver them overnight. His ability to produce at warp speed is unparalleled. During a five-week period he created a carousel for MTV, worked on the ninetieth anniversary exhibition for Grand Central Terminal, and designed the AMC "TVs for Movie People" extravaganza.

During the early 1980s, O'Callaghan enjoyed a successful and lucrative career, first on the East Coast and then in Los Angeles, where he designed props and sets for the film industry, including a giant faucet in Rodney Dangerfield's *Easy Money* and the iconic scooter that become the centerpiece of Garry Marshall's 1984 hit, *The Flamingo Kid*. Living in LA did not sever his connection to his alma mater. Throughout O'Callaghan's early career, Silas H. Rhodes, SVA's founder and chairman of the board, offered advice and counsel. An advocate of experimentation in the arts, Rhodes later supported and encouraged the educational initiatives that O'Callaghan embarked upon with his students.

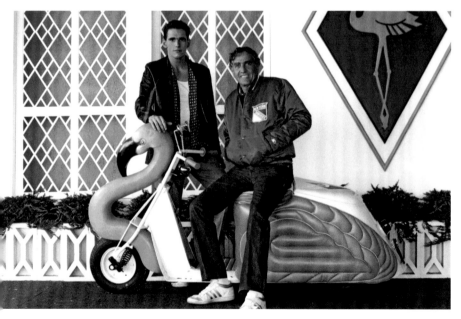

Matt Dillon and director Garry Marshall with scooter from The Flamingo Kid, *1984.*

BACK TO SCHOOL

Southern California was not a good fit for O'Callaghan, and he returned to New York in the mid-1980s. Shortly thereafter, he went to visit his mentor, Richard Wilde, chair of the undergraduate advertising and graphic design programs at the School of Visual Arts. Over lunch, he proudly updated Wilde on his professional accomplishments, many of which had been achieved while working at Dale Mallie's studio. He spoke of his first job as a window design specialist for Hammacher Schlemmer, a short-lived venture that ended when he was contacted by Dale Mallie to work on a Bonjour Jeans TV commercial. The resulting ad was a surreal compilation of fast-paced, unconnected, nonsensical images. It was ultramodern for its era. The telephone busy signal during the opening sequence is quintessential O'Callaghan; he liked the sound and convinced the art director to include it. O'Callaghan laughed as he recalled an ad campaign for L'eggs pantyhose. It was a multistory inflatable egg that the Radio City Rockettes danced around. The prop was accompanied by a major hitch: The paint applied to its exterior would cause the enormous oval to explode if the egg started to deflate. Throughout the eighteen-hour work session, O'Callaghan's vigilant eye was glued to the air gauge. The shoot completed, he left Rockefeller Center in the midst of an artificial blizzard, as specks of white paint fluttered down onto the stage.

Brought up-to-date on his former student's achievements, Wilde remarked, "So, why are you so unhappy?" And O'Callaghan started to tremble, aware that something important was absent in his life, but oblivious as to what that something might be. Wilde instinctively knew what O'Callaghan needed and took him straight from lunch to an afternoon class in visual literacy, where O'Callaghan gave a guest lecture on his activities. Afterward, he was besieged by students hungering for more. This teaching experience, like seeing Calder's *Circus*, would have a profound impact on O'Callaghan's future. Instructing and mentoring students were the missing components, the balance needed to complement his work. Reciprocally, professional projects inform his endeavors in the classroom, and he has successfully shifted between the roles of teacher and designer for more than a quarter century.

Wilde asked him to develop a class of his own, and O'Callaghan's teaching career began with an elective course, offering an approach to problem solving in three dimensions. Students from various disciplines who were intrigued with experimenting in 3-D registered for the class, and it quickly became an incubator for those with imagination. O'Callaghan teaches his students to think as large and wild as they can, and then find a solution to make the concept a reality. As they do this, students acquire whatever skills are needed along the way. By mastering craft and solving problems in unfamiliar ways, many discover their future professions. One student learned faux finish during a project because it was the only technique that worked effectively for her intended goal. It was a new skill for her, and quite unexpectedly, she found an unknown talent and her creative calling.

students' craft. They see how well someone is doing something and then pick up the pace in their own projects. Typically, O'Callaghan sees the real learning experience in the final days before an opening: If students don't work together, rushing as a team to complete the final exhibition tasks, the show may be a failure, and they know it. His students leave his course understanding how to get a job done. "Shoot for the stars and then work within your constraints" is an O'Callaghan dictum; at the same time, he emphasizes the importance of continuously reevaluating those constraints and finding ways to navigate around them. Often, this calls for enlisting outside assistance: For example, one of the students on the "Yugo Next" project wanted to transform his car into a copper submarine, but copper is expensive. He had tried using tin, but it looked like a tank. O'Callaghan

"IT'S A KIND OF GENIUS THAT GOES BEYOND YOUR EXPECTATION OF HUMAN CAPABILITY."
—MILTON GLASER

Former students often return to collaborate on projects, and they do so because they are revitalized by O'Callaghan's creativity and enthusiasm. His "calls for entries" are intended for the exuberant and hardworking only—all others need not apply. These alumni come back twenty years on, graduates with fantastic jobs, but nothing they have created is truly their own. They return to rediscover a time when they were the proprietors of their creative ventures.

In 1999, O'Callaghan founded the undergraduate 3-D design program at the School of Visual Arts, which he currently chairs. Addressing his educational initiatives, SVA president David Rhodes reflects, "There is nothing like it anywhere in the world, as far as I can see. There's a certain kind of playfulness about a lot of Kevin's students' work that just isn't there anywhere else, as well as his ability to get students to work extraordinary hours in compressed amounts of time to bring together an exhibition. Some of those things go on elsewhere, but nothing like what he does." O'Callaghan conducts his classes in a large, open workspace filled with "let yourself go" energy and believes this is the best environment to foster creativity. While students work on projects individually, each is influenced by other

suggested taking the sketches of the sub to copper-supply companies. A manufacturer of thin copper sheets loved the sketches and donated all of the needed metal. Not only for the initial project: The company also shipped a roll of copper sheets to each venue where the sub was on exhibit, just in case some repairs were needed after transit.

As an educator, O'Callaghan possesses a rare combination of indomitable fortitude and immeasurable tenderness. He is a demanding teacher who gives his students all that he can, and expects them to work at least as hard as he does in helping them to achieve their visions. The wisdom of everything in moderation eludes O'Callaghan; his is a realm based upon the paradoxical, encompassing Foucault's "thinking the unthinkable" and Voltaire's reasoning that "the superfluous is a very necessary thing." He's been known to have a quick fuse under pressure and to react with verve, often accompanied by audible projection and a face as red as his hair.

By now, though, O'Callaghan has mellowed with age, and he can laugh a bit when something goes awry. Where teaching gave perspective to his professional life, his marriage to Susan Hendershott and the

birth of their daughter, Caroline, bestowed a personal happiness through which he has rediscovered playfulness and gained patience. In short, he has found the stability and contentment that was sorely missing from his life. His wife has also given him the ability to believe in his dreams; through all of their years together, she has never said, "Don't try that," and O'Callaghan relies on her unwavering confidence in striving for the monumental in all of his endeavors. As his daughter gets older and her artistic abilities have begun to flower, O'Callaghan finds strength in her talent and creativity, and often turns to her for creative input. When he speaks of Caroline, his face radiates with the joy of her presence in the world.

MAKING STUFF

O'Callaghan's remarkable success rests on a foundation of craftsmanship and resourcefulness. He will scour the globe for whatever technique, technology, or specialist can deliver the goods. When he worked on a television series about the Kennedy family, O'Callaghan went to the Hyannisport estate and met with members of the clan. Through this project, O'Callaghan developed an attention to historical accuracy and authenticity in his work. His research led him to the manufacturer of the fabric used for the sofa in the Oval Office, and he was able to find another roll of it. O'Callaghan loyally re-created the mementos that had adorned the presidential desk, including the famous coconut shell with an inscribed message and a brass plaque from Kennedy's PT-109 ordeal.

His interest in craft was kindled at a young age, from watching his stepfather, Dr. Richard Sherman, make dental molds for his patients. He instilled in O'Callaghan an unwavering devotion to working hard and loving what you do, demonstrating this by working until the age of eighty-seven. As an apprentice set designer in high school, O'Callaghan's first project required the replication of a thatched-roof Irish cottage for a Sean O'Casey play. Since then, he has made it a practice to build intricate models for all of his projects, and often constructs full-scale facsimiles to help guide the final outcome, by working through potential problems and variations prior to fabricating the actual piece. Some projects have additional motives: O'Callaghan created one such life-size model for an eighteen-foot kinetic outdoor sculpture, which rotates in two directions and revolves every hour on the hour. Designed by Milton Glaser for the SVA Theatre, a full-scale rendition was paramount in determining viewer sightlines from various distances and approaches. It would have been much easier and less time-consuming to stick a few long poles together with large bits of cardboard in order to calculate the many perspectives, but easier and less time-consuming are not part of the O'Callaghan vocabulary. Addressing O'Callaghan's talents, Glaser states, "I don't know anybody like him. With *really* extraordinary practitioners, you can't figure out what it is that they do…. Somebody does it like this instead of like this, and all of a sudden it's transformative … it's a kind of genius that goes beyond your expectation of human capability."

Peculiarly conjoined with his technical abilities, O'Callaghan relishes serendipity and is at ease in working without a predetermined finish. Nearing completion of *3rd Rail*—a mock subway car for the "Yugo Next" exhibition—sculptor James Korpai found his artwork covered with graffiti tags. He immediately contacted his teacher and informed him of the disaster. But embracing the unexpected, O'Callaghan replied, "Wait a minute, is it any good?" It is this comfort of allowing the undefined to unfold that causes every project to go down to the wire. It's also a primary component in what makes something spectacular.

A hum of relentless cogitation accompanies him wherever he goes. He finds comfort and inspiration in visually cluttered places like salvage yards and flea markets. Curiously, it is in these saturated environments that O'Callaghan's thoughts slow to a contemplative state of inattention while his ideas roam unabatedly. He doesn't attempt to lasso them into structured thought; these moments of distraction support his monumental vision. In O'Callaghan's universe the fodder is limitless—you can take a ride in Einstein's brain, transform your car into a diner, or turn a typewriter into a fish tank.

Part cultural anthropologist and part creative whiz kid, O'Callaghan possesses a mature artistic vision that coexists with that cusp of life where the tooth fairy is alive and well, seductively inviting the fanciful to flourish. Yet for all the razzmatazz and grandeur that

contribute to his creative ingenuity, he is a dignified and humble man, thoughtful and deliberate in his communication. When he shares an exploit, he becomes fully submerged in the moment, as though reliving the experience—the smells, colors, sights, and sounds. Ultimately, O'Callaghan symphonies are composed of textured dialogues through which disparate elements are repurposed and interwoven: a moonman makes orange juice and discarded cell phones are transformed into an Earth Day tree. A master of the visual subtext, he summons audiences by constructing environments that invite individual interpretation of the artworks and their stories. Above all else is O'Callaghan's inextinguishable resolve to awaken the creative in each of us.

While many of his projects and commissions bring forth the whimsical, O'Callaghan also engages in social and political commentary. Each undertaking is supported by the idea of taking obsolete objects and giving them new uses through creative reinvention. The 2009 "Off-Roading" project took a fuel-indulgent truck off the highway and gave it new life by converting its parts into household furnishings, including working lamps, chairs, tables, a couch, and a chaise longue. "Off-Roading" did not offer a solution to the problems of consumption and waste that plague contemporary culture, but it was a vehicle, literal and otherwise, for contemplation of these pressing matters.

Sounding a call to arms that embrace, O'Callaghan mounted the acclaimed "Disarm" exhibition in 2006, which repurposed M16 assault rifles into icons of a nonviolent society: the sanctity of a white picket fence, the sounds of a violin, and the security of a teddy bear. O'Callaghan's humanitarian beliefs are expressed in *Art is … Healing*, a poster he created in response to the World Trade Center devastation of September 11, 2001. The poster is part of the permanent collection of the Library of Congress in Washington, D.C.

The narrative accompaniment to the images on these pages offers a background to the brilliant mosaic that is O'Callaghan. The anecdotes have been gleaned from the artist as well as from the shared experiences of his collaborators and colleagues. Their reflections speak to a career that has spanned three decades and continues to surprise and delight.

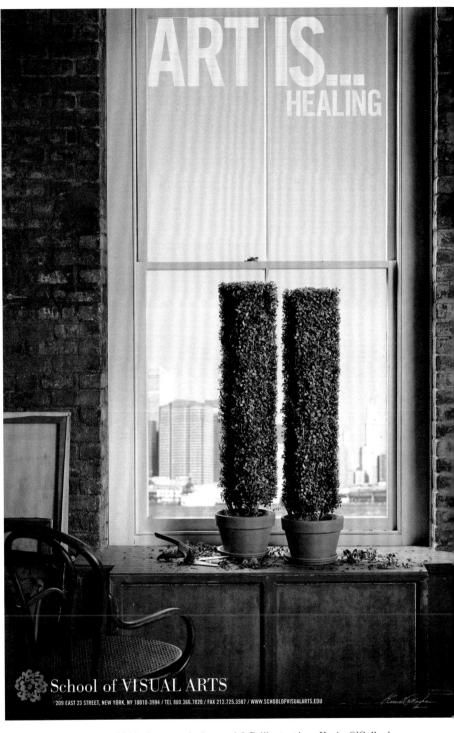

Art is … Healing *poster, 2002. Concept, design and 3-D illustration: Kevin O'Callaghan; art direction: Mike Joyce; photography: Hugh Kretschmer*

YUGO NEXT

CHALLENGE: TAKE A YUGO, THE FAILED YUGOSLAVIAN COMPACT CAR, AND GIVE IT A NEW LIFE OTHER THAN
THE ONE IT WAS INTENDED TO HAVE.

STARTING POINT: 29 YUGO AUTOMOBILES

ARTISTS: 32

WEEKS: 6

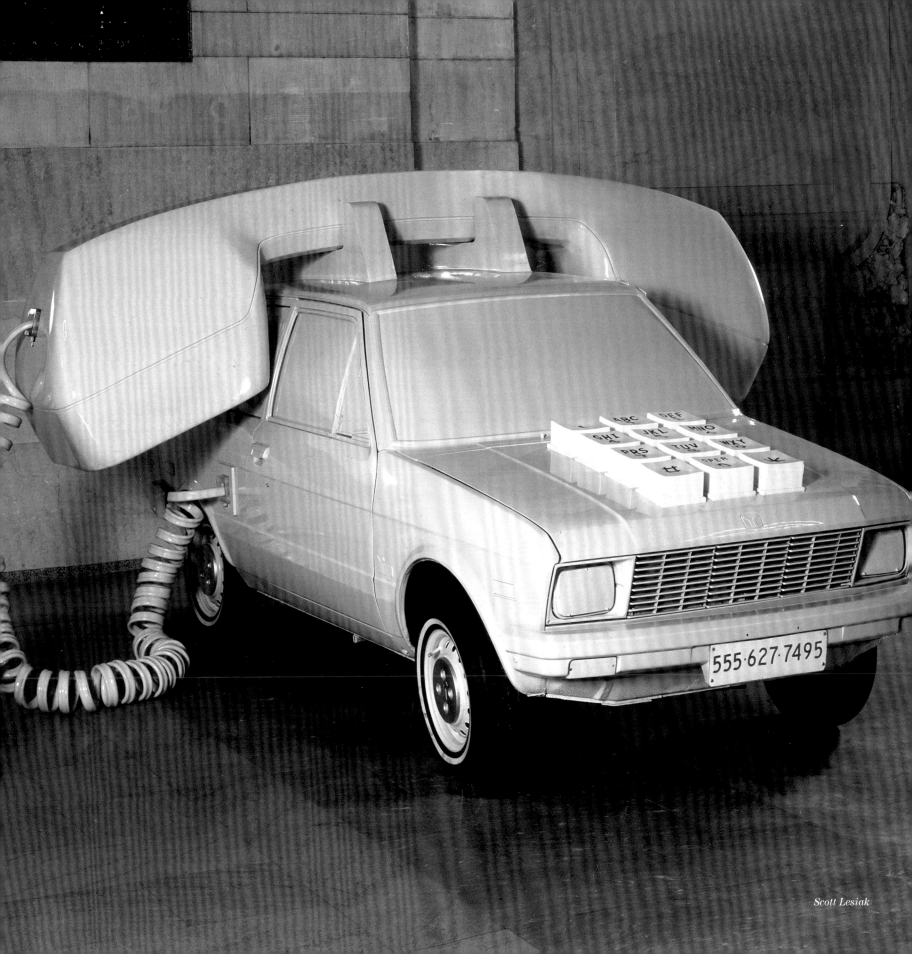

Scott Lesiak

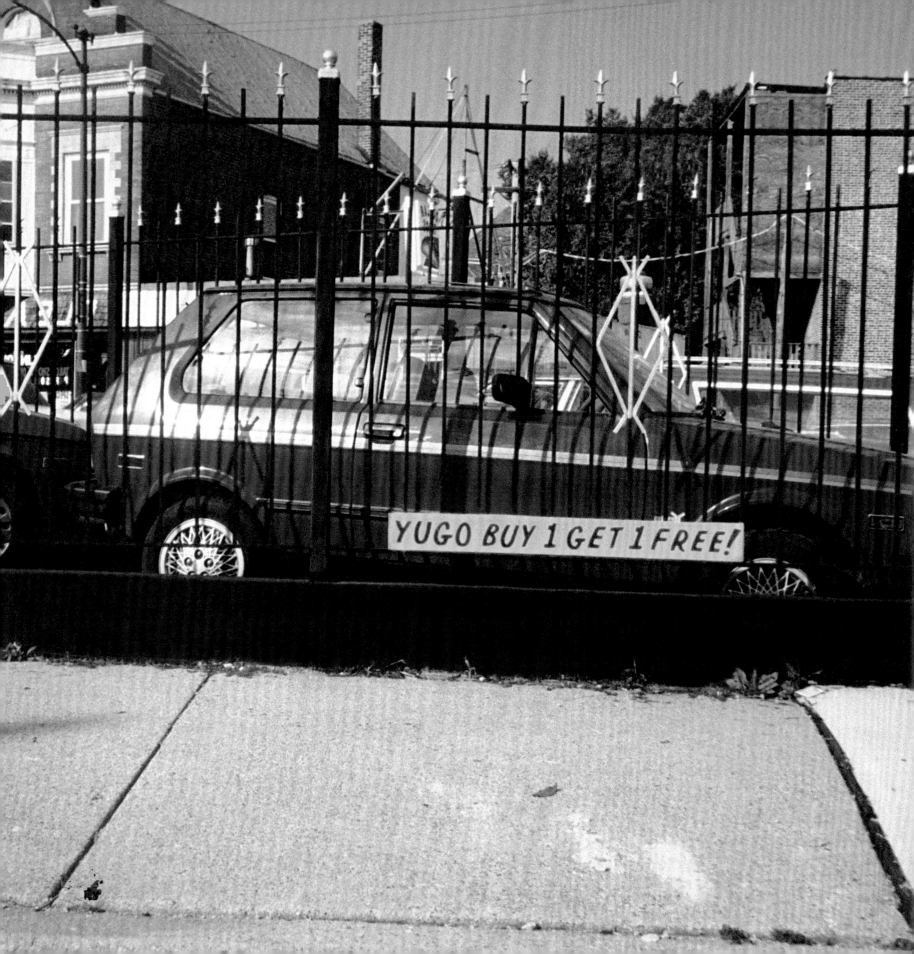

One owner DONATED his, asking only for a ride home— in ANYTHING except a YUGO.

R eady for another weekend on the road, O'Callaghan waves good-bye to his wife Susan and hits the highway. There is a lot of ground to cover: from the Pine Barrens of southern New Jersey to the steel mills in western Pennsylvania, then north toward the Adirondacks and the final stretch home through Connecticut. The itinerary includes thirty "must-see" destinations in forty-eight hours. It isn't the latest episode of *The Amazing Race* or *Survivor*—it's the second official Yugo Tour, one of five such journeys that O'Callaghan will take in as many weeks, winding his way through four states, three mountain ranges, and countless below-average drivers. His pit stops are determined by one common element: wherever his students are working to transform automobiles into … whatever.

The class assignment was conceived after O'Callaghan received a call from an events coordinator who had just learned that an upcoming show at Vanderbilt Hall in Grand Central Terminal had been cancelled, and she needed to find a replacement quickly. The space is 12,000 square feet, large by any measure, and O'Callaghan became weak when he saw the vast, vaulting room. All of his previous class projects had been human-size or smaller. What the heck, he'd figure out something, and so he did.

O'Callaghan's life has been blessed with a chorus of ingenuity angels that often guide him, albeit in bizarre ways, to what he might need in a jam. On the occasion of the Yugo, the creative cherubs altered his internal GPS and he ended up taking a wrong turn onto a street where some kids were playing stickball and using a car for the backstop. Horrified, O'Callaghan asked why they would do such a thing; the answer was just what he was looking for, although he didn't know it when he had started out: "It's a Yugo; it doesn't run and can't be fixed." He began to think about what a car could be if it didn't work as a car, and came up with the concept to give it a second life.

An inexpensive subcompact vehicle built in the former Yugoslavia by Zastava Motor Works, the Yugo entered the American market in the mid-1980s. More than 140,000 were sold in the United States, though many owners will never disclose that they actually bought one. Based on the mechanics of the Fiat 128, Yugo reliability was sketchy at best. Add to this a civil war that halted the availability of replacement parts, and making one into a backstop didn't seem so wrong; making one into a work of art would be even better. Get enough of them and they can fill a really big hall. O'Callaghan placed an ad for "Yugos Wanted: Dead or Alive" which harvested thirty-nine lemons that were purchased and delivered for under 4,000 dollars in total. One owner donated his, asking only for a ride home—in anything except a Yugo.

O'C: (Page 19) Scott Lesiak transformed this Yugo into a functional phone. After dialing, you could have a conversation by running from one side of the giant receiver to the other.

Snapshot taken outside a Yugo dealership, circa 1989

The union of art and automobile has a rich history. From John Chamberlain's love affair with bumpers to the Kustom Kulture of George Barris and Ed "Big Daddy" Roth, axel and acrylic have intermingled in many ways. But to take a car and transform it into another object—that is groundbreaking.

O'Callaghan's students are always given a starting point. In this instance, they were each given a set of car keys with a registration card, and instructed to take an engineering disaster masquerading as a car and give it a new and viable identity. O'Callaghan made pint-size, cut-and-fold Yugos for his charges to take home and work with to develop their ideas. Each of his thirty-two students was required

No one knew that this was only the beginning of a much longer expedition and that O'Callaghan would spend another one hundred Sundays taking Yugo road trips during the two and a half year exhibition tour. "Yugo Next" traveled to cities across the United States and to Canada, followed by a trail of newsprint that generated hundreds of articles in North America; the show was also featured in publications throughout Europe and Asia. The former cars were a source of interest to diverse communities, from the readers of *Ranger Rick* to *The New Yorker* to *AutoWeek* and *Life* magazine. Andy Fuzesi, owner of the Los Angeles Auto Show, read about the exhibition and flew to New York to see it for himself before booking an engagement for the art cars to travel west. Editorials on the

THE CLASSIFIED AD IN THE PAPER READ, "YUGOS WANTED: DEAD OR ALIVE"

to submit sketches for five concepts from which their teacher hoped three dozen could be realized. Expecting 160, he was inundated with more than 2,000 drawings. The artists had six weeks from approved sketch to final project, and worked frantically in the cold of winter wherever they found a place to garage their vehicles. Jude Dominique, who created the shower Yugo, parked his near a mason who had agreed to teach him about concave tiling, a necessary skill for the work at hand. (Actually, the mason was only a part-time tile man who was otherwise employed as a clown with Ringling Bros. O'Callaghan's band had been given some angels of its own.)

JALOPY OVERHAULS IN OVERDRIVE
In 1995, webcams and streaming video were tools of the future, and O'Callaghan was obliged to make on-site visits to check the projects' progress and offer in-person advice. He would have rejected the lens-based alternative anyway, as virtual reality doesn't fit comfortably in his 3-D galaxy. O'Callaghan enjoyed the trips, especially seeing the artworks' newest details and meeting his collaborators' pit crews. During this time, Susan O'Callaghan was coordinating how to transport the artworks and offering support to weary students, who fondly gave her the name "Mama Yugo."

artworks and their creators were published in the *Washington Post*, *Los Angeles Times*, and *Houston Chronicle*, as well as in local papers from Maine to Hawaii. The *New York Times* editorial summed it all up with "Wow." Globally, more than two hundred broadcast markets chronicled "Yugo Next," from the Greek island of Thásos to Tahiti, by way of Tokyo Bay. CNN's Jeanne Moos covered the show, and would later say of O'Callaghan, "With him, you can't miss."

"Yugo Next" embraced the essence of the O'Callaghan doctrine: All are invited to collaborate. Movers who hand-carried the pieces alongside the artists, loading them with care and concern, often appeared at the opening receptions. Former Yugo owners saw their regretted purchases reworked into magnificent objects. Suppliers and craftspeople who donated their materials, time, and expertise became ad hoc design-team members. Animated audiences would enthusiastically offer their ideas and opinions. In Montreal, where "Yugo Next" had an extended stay at the Musée Juste Pour Rire (Just for Laughs Museum), the artists arrived at the opening in gowns and tails, awaiting the prime minister of Canada, who cut the ribbon—in this case, a seat belt. There were even Canadian actors portraying various roles, such as a cigarette girl next to the giant Yugo lighter. And the exhibition outsold the fabulously popular Renoir to Picasso show that was concurrently on view in Montreal that summer.

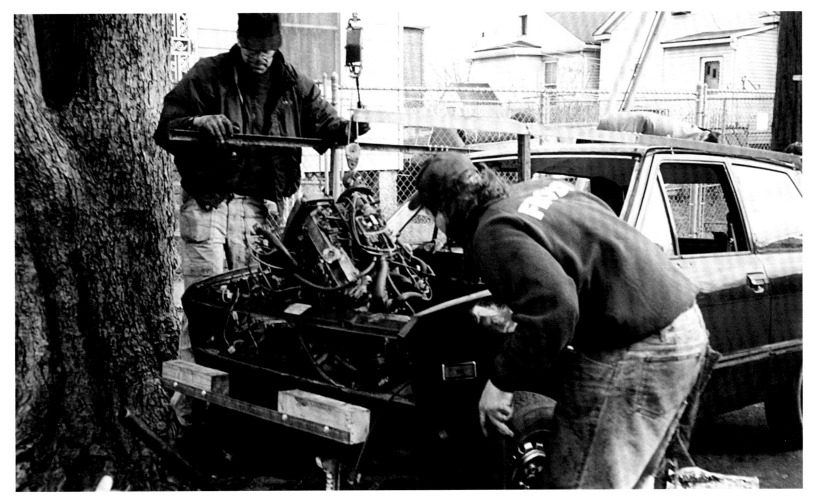

Candid shot of students removing the engine from a Yugo, with the help of a nearby tree.

This collaborative energy didn't always take hold. During one of the massive initiatives to load the artworks for departure to the next venue, the Yugo telephone was pushed into a cul-de-sac and accidentally left behind. O'Callaghan needed to garage the car until he could reunite the show. No parking attendants would accept it, even when offered payment for two spots: one for the phone and another for its receiver. O'Callaghan and some of his students endured a chilly night entertained by the surprised expressions of passersby who wondered if they might have had one too many.

Among the "Yugo Next" anecdotes, one gives keen insight into O'Callaghan's pedagogical methods. Four weeks out from opening night, O'Callaghan received a call from a student who hadn't begun the project. With his sketch approved and materials purchased, the stalled designer should have been more than halfway done by now.

Their conversation revealed the problem: The Yugo was his first set of wheels, and he just couldn't transcend the desire to preserve its pristine state (though this is somewhat of an oxymoron—it's a *Yugo*). He just really, really wanted to drive it, prepared to relegate his artistic ambition to the backseat. O'Callaghan emphasized that this particular car was only deadweight that couldn't get around the block, but then recognized that he might as well be trying to convince the asphalt on which the clunker was parked. So he headed out on a Yugo detour. Finding the car and its student owner, O'Callaghan threw a rock through the windshield and declared the automobile stone dead. But desire can be stubborn; the young artist challenged the forensic evidence, citing the engine as still viable. O'Callaghan went to his truck, retrieved a sledgehammer, opened the Yugo's hood, and shattered the engine with one blow.

Art was back in the driver's seat.

O'C: One fear I had with "Yugo Next" was that it might look like a big parking garage when the art pieces were all in one room. To eliminate that possibility, I decided to create large-scale picturesque backdrops (I used this exhibition design element for many shows thereafter). So that each car was contained in an individual environment, we added huge curved photographs, eight feet tall by fourteen feet long, to the exhibition space. For the Yugo toaster, the image was a 1950s American kitchen. The idea came from the dioramas I had seen at the Museum of Natural History, where the artifacts were placed in their natural habitat.

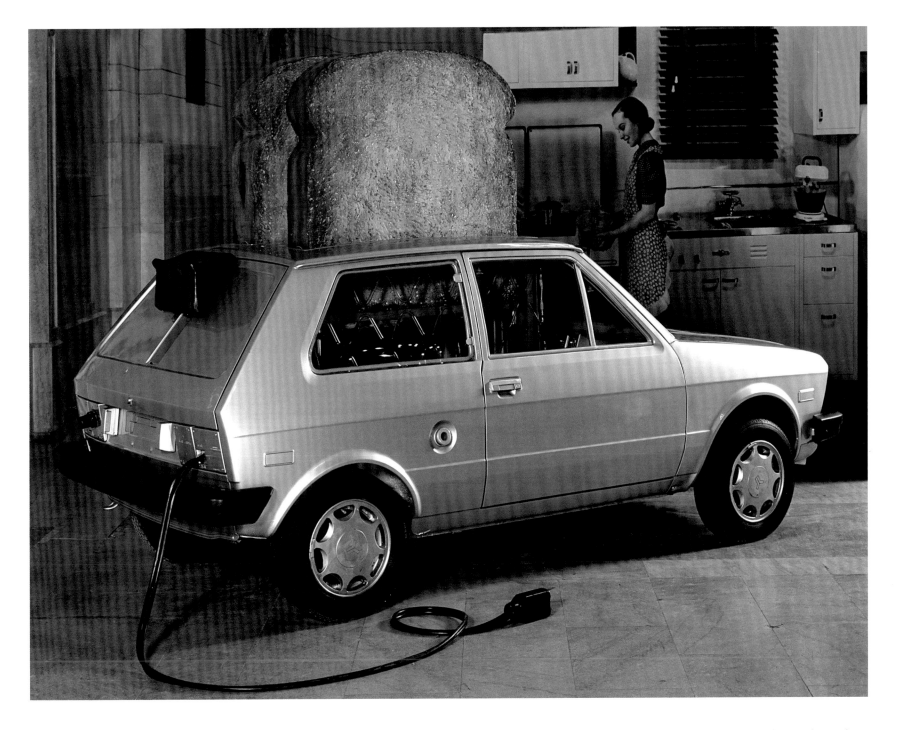

O'C: The bread slices went up and down more than three hundred times a day, and ran flawlessly for the two and a half years the exhibition toured. When the bread went into the toaster, the red neon coils began to light up, and the toaster began to smoke until the bread popped up again. Piera Digiulo used a smoke machine hidden inside the car.

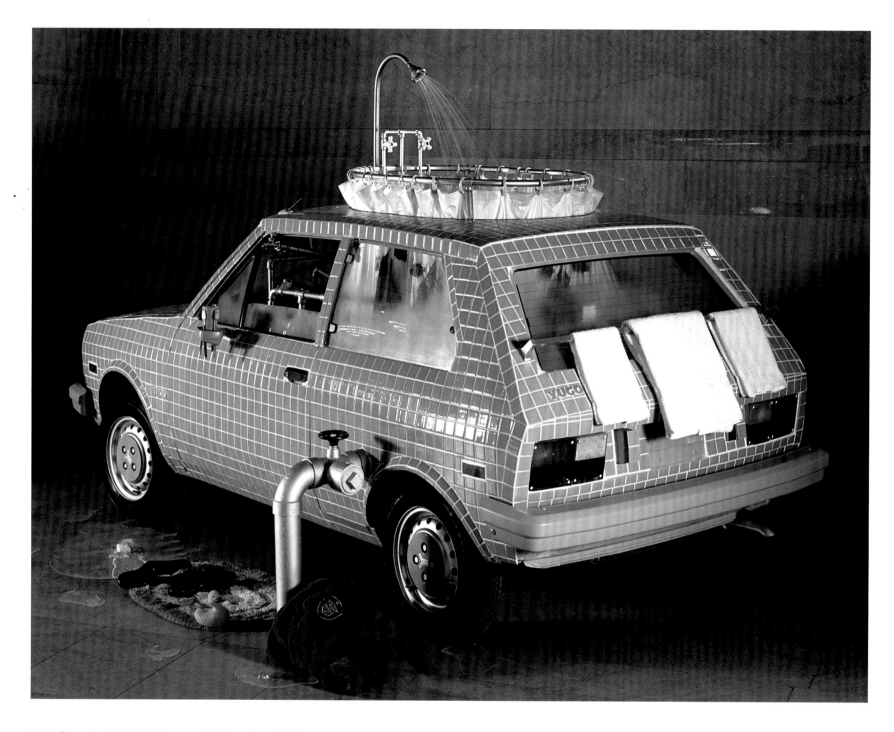

O'C: Every day, Jude Dominique would take a shower in his car, and soon he became a Yugo celebrity. We had a sign that read "Jude will shower at 8:30 a.m." and people would come and talk with him about the car as he washed. I particularly like the way the side mirror was flipped to become a toothbrush holder.

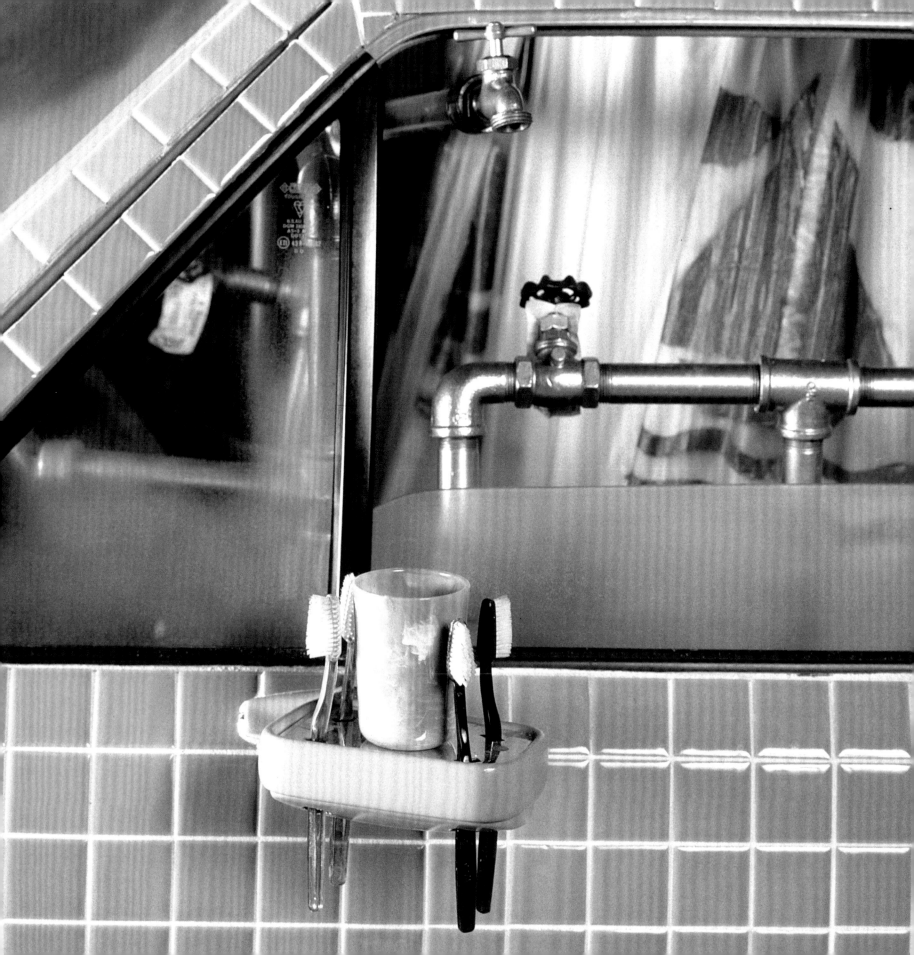

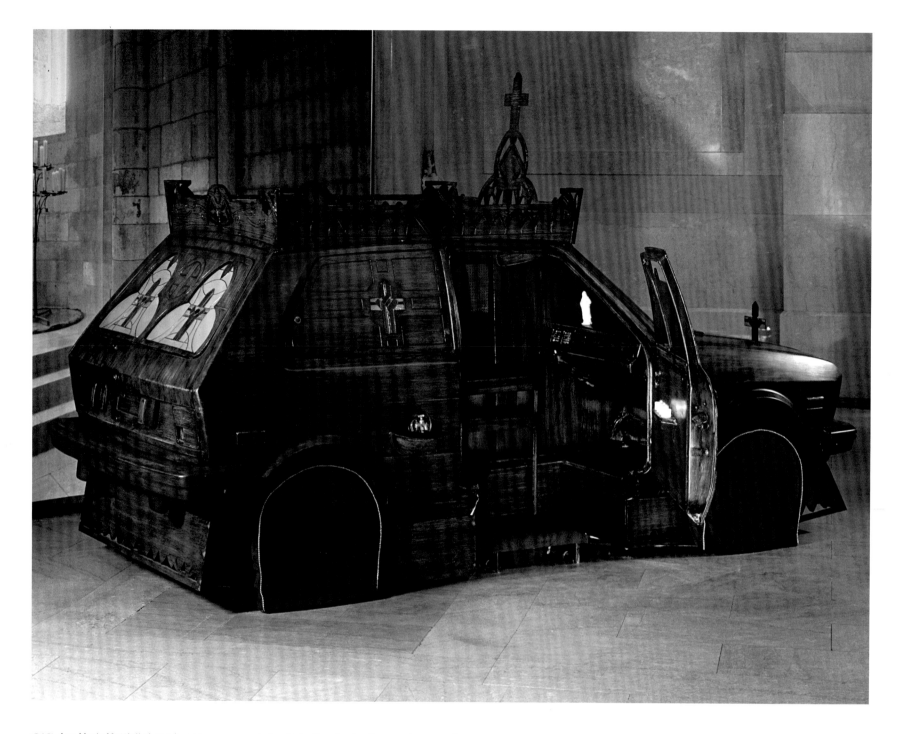

O'C: Ann Marie Mattioli showed up at every venue in her Catholic school uniform and answered questions about her confessional, aptly titled *UgoFirst*. Mattioli would kneel on the passenger side; the driver's side was reserved for priests. The subject matter was based on her thirteen years in parochial school. The faux finish showed exceptional craft, as did the details, including the red velvet tire covers, the Yugo symbol in the stained glass, and converting the gas cap into a basin of holy water.

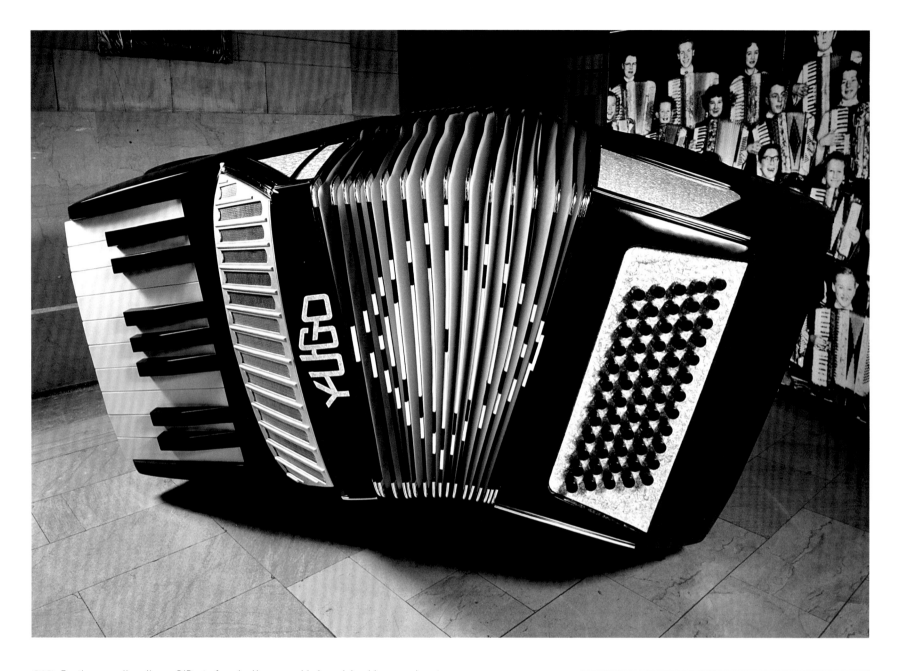

O'C: For the accordion, Jimmy DiResta found a Yugo near his Long Island home and sent me a photograph of it, and I sent him a check to buy it. I was intrigued by the car, noting it had special wheel covers added, and various other embellishments. After DiResta cut the car in half, we found out that it was one of only two cars produced by the Yugoslavian government for the Yugo racing team. The other was in a museum. The car was so cheaply made that it could be cut with scissors. When the accordion was pushed back and forth on the little rollers underneath the car, it played three notes. It sounded better than the Yugo's engine ever had.

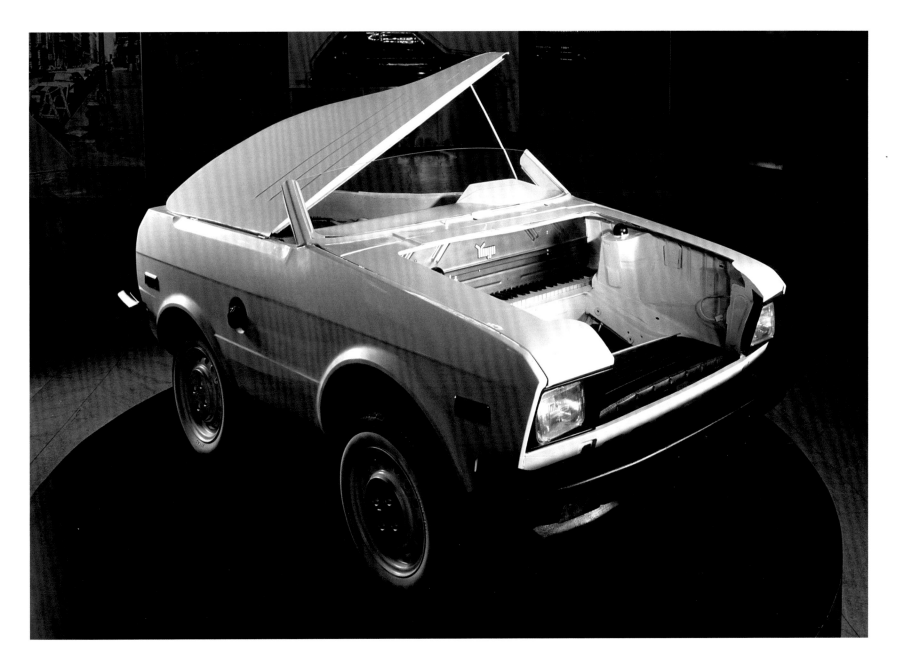

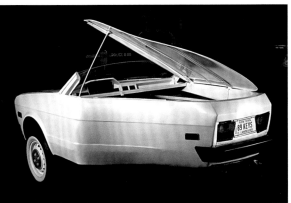

O'C: The piano Yugo by Celia Landegger was the centerpiece of the show. It was a tribute to her grandmother, who had been a concert pianist. The car was bent into the shape of a baby grand, and the seat was where the grill had been. The piano keys were on the firewall in the engine compartment. She titled the car *89 Keys*: eighty-eight on the keyboard and one in the ignition. Imagine *bending* a car—WOW!

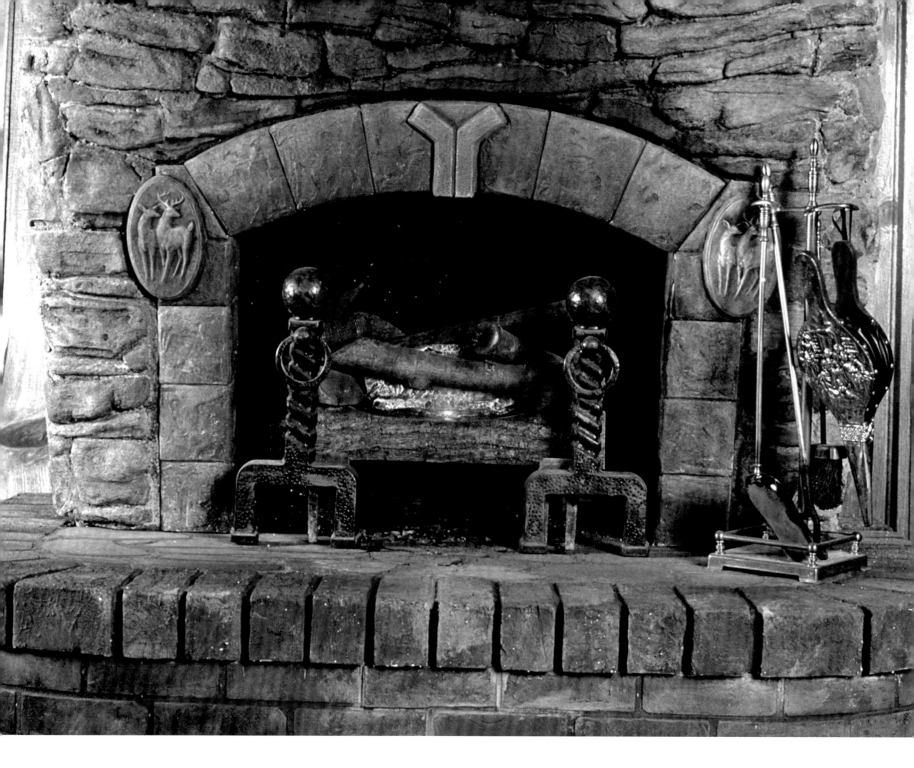

O'C: The Yugo fireplace was created by David Hughes, a former student of my 3-D class who had moved to California. He really wanted to be in the exhibition, so I sent him the money to buy a Yugo on the West Coast. When he opened the envelope, he called me and asked, "How can I buy a Yugo with forty dollars?" I said, "Trust me," and he ended up with eight offers. He towed it across the U.S., arriving a few hours before the opening. It was covered with cups, straws, and all of the things you would see on something that was towed cross-country, and didn't look anything like the progress images that I had seen during its construction, but then we put it up on its nose and what he created was truly magical.

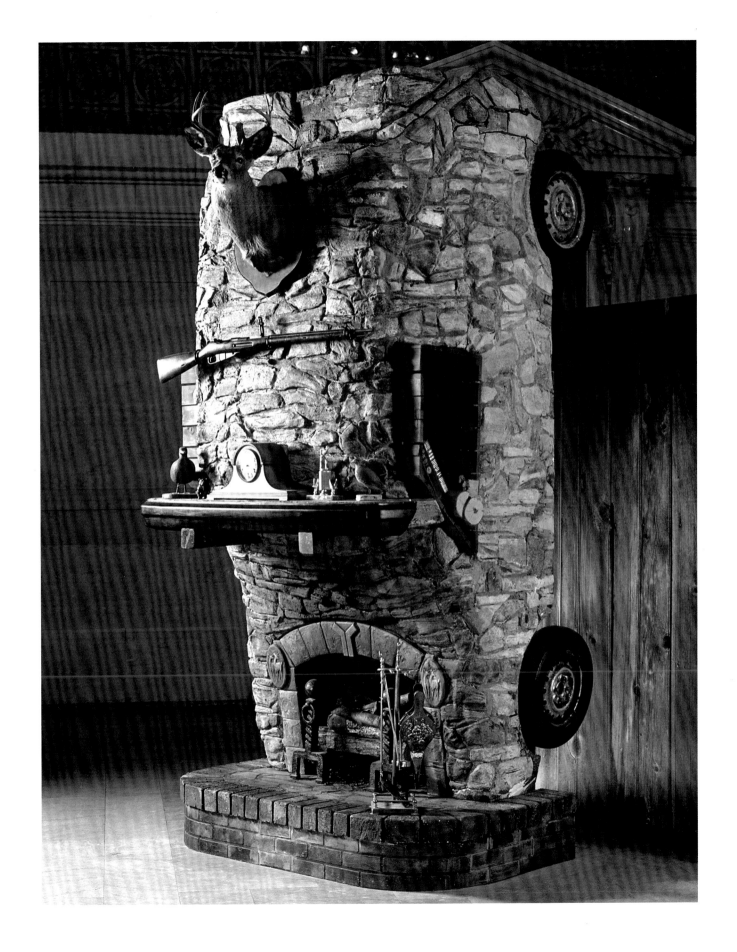

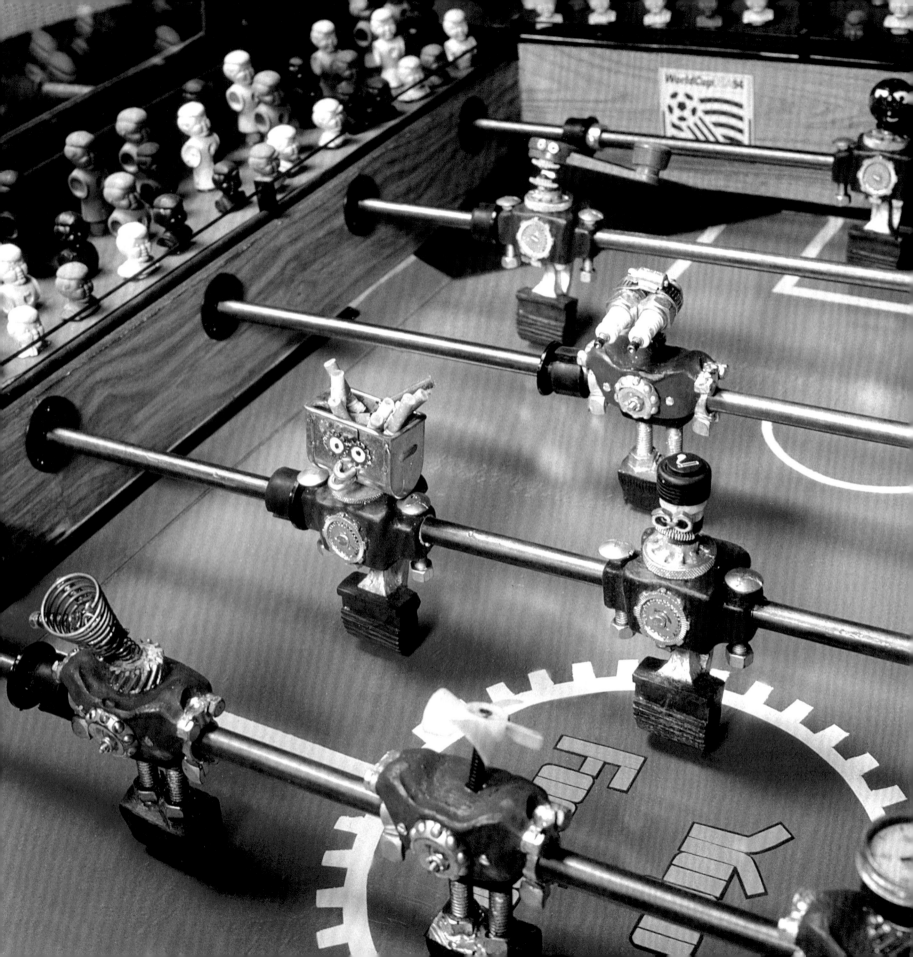

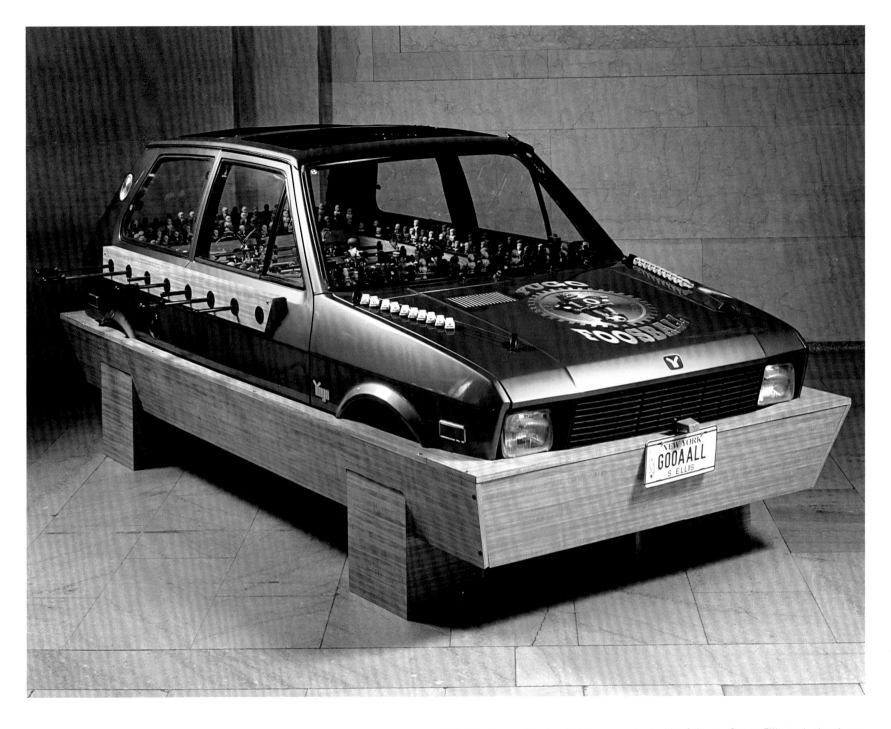

O'C: The magic of the foosball Yugo was the inside of the car. Steven Ellis made the players from both engine and interior parts. For the "cigarette" player, he glued together the smokes that were left in the ashtray by the car's previous owner. He took the plastic players from the original foosball set, cast several more, and turned them into spectators. When we were in Montreal, the Canadian national foosball team came to the exhibition dressed in their uniforms and played it, stating that it worked just like a professional foosball table.

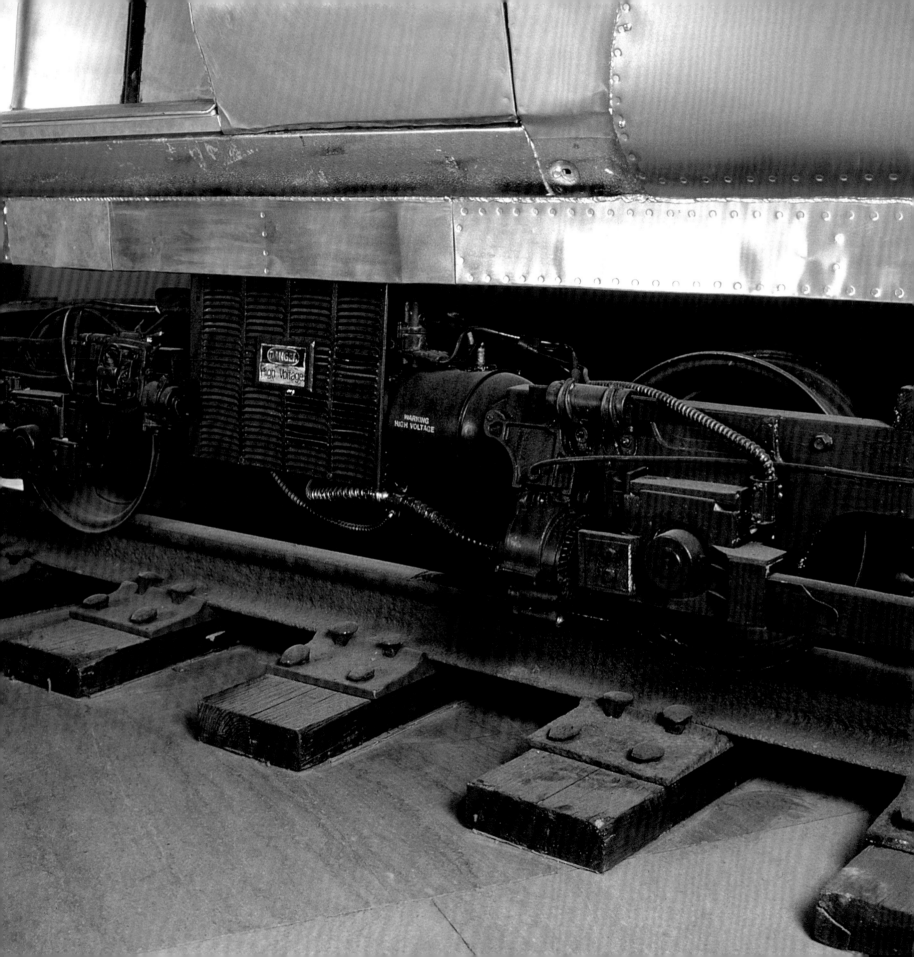

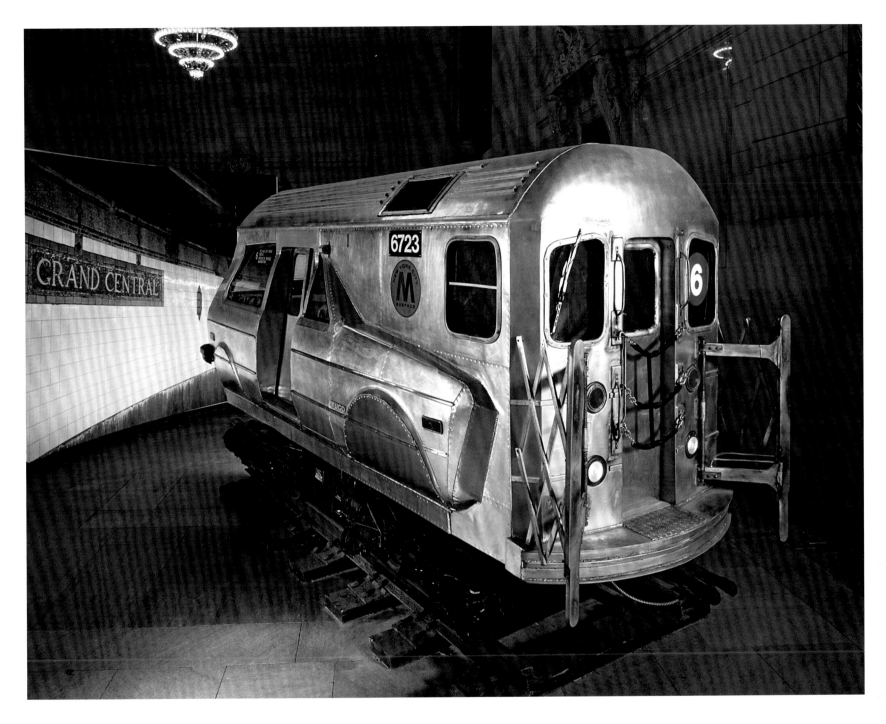

O'C: James Korpai's subway Yugo was covered with thin sheets of tin and riveted together; the interior was from a real subway car that the MTA donated. A composite of engine parts from the Yugo was used for the underside of the car. The close-up shows the master brake cylinder, power steering unit, and parts of the air-conditioning unit that were collaged together and blanketed with a rust-colored patina so it resembled the mysterious mass of mechanics on the bottom of a train. The tires were removed and the rims attached to the subway track. Shortly after we installed the exhibition at Grand Central Terminal, I heard a news report that mentioned a Queens train had derailed because of a missing piece of track. I thought, "Oh, no, was that the piece under Jimmy's Yugo?" He also saw the news clip and called to assure me that it wasn't the same piece of track!

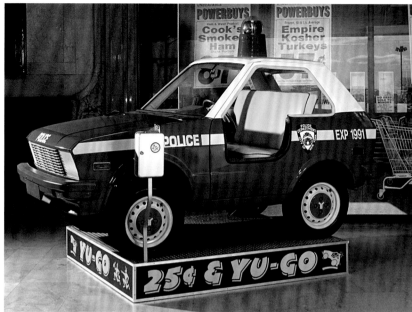

O'C: The shooting gallery was the only car in the show to make a statement about the violent conflict in the former Yugoslavia. In addition to the traditional ducks, Robert Hawse introduced soldiers, tanks, missiles, and jet fighters as targets, and painted the car a military khaki.

O'C: Robert Johnston cut three feet in length from his Yugo to match the dimensions of those kiddy rides found outside of supermarkets. It went up and down, and he added the sounds of a siren and a policeman yelling at a robber—very Keystone Kops. The car was on a timer, so you didn't need money for it to work; we put tape over the coin slot, but people kept inserting quarters. We finally gave up, and used the weekly collections for pizza parties.

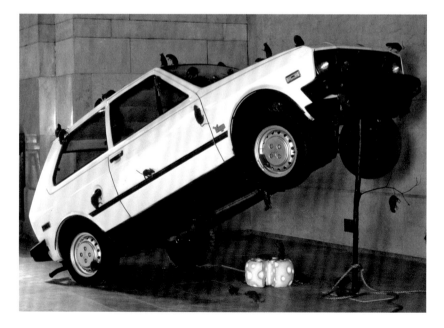

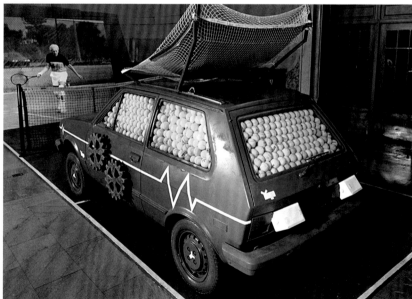

O'C: The mousetrap was a clean, simple solution. By putting the car on a stick and then pulling the string, the Yugo would trap the mice underneath it. Hilary Carlson created more than three hundred little furry mice that inundated the car inside and out. People were amazed, and frightened, when they saw that the car was balancing on a stick.

O'C: Wilson Sporting Goods Co. supplied thousands of tennis balls to Wendy Halliday for her piece. The car was rigged to volley a ball onto a giant image of a tennis player. We angled the image so that the player appeared to hit the ball back, and it then dropped into the net on top of the car.

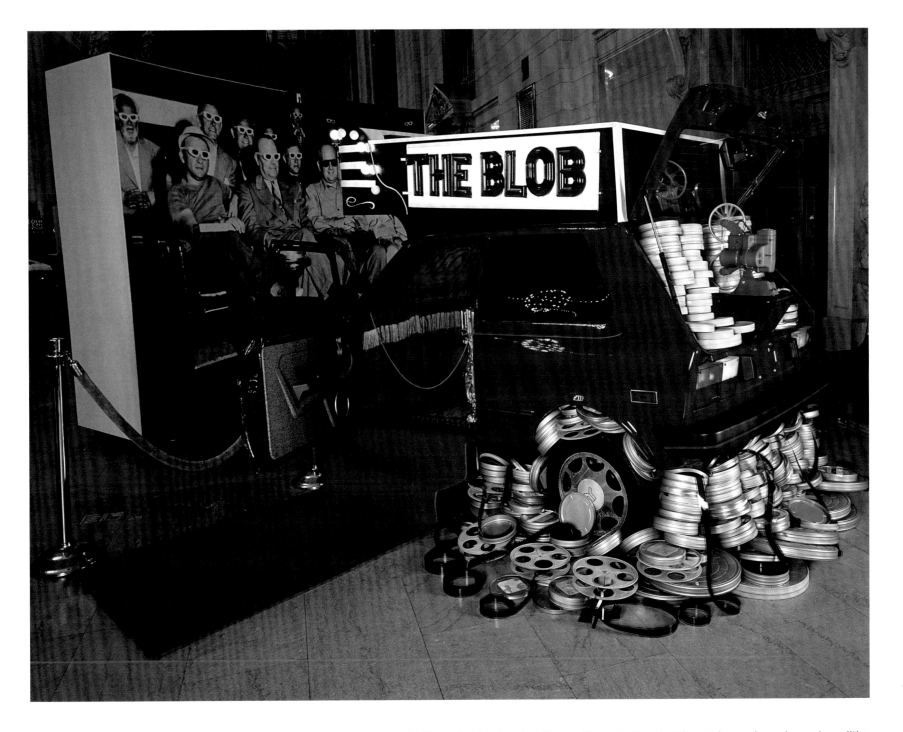

O'C: The engine didn't work on Brendan Kennedy's Yugo, but the exterior was in good enough condition that he didn't need to repaint it. The car had movie theater seats with the 1950s movie classic *The Blob* projected on the windshield. People would come at lunchtime and sit in the car and on the floor to catch the movie. My students decided to cash in on this and sold popcorn in Yugo-shaped containers that they created while at the Musée Juste Pour Rire in Montreal.

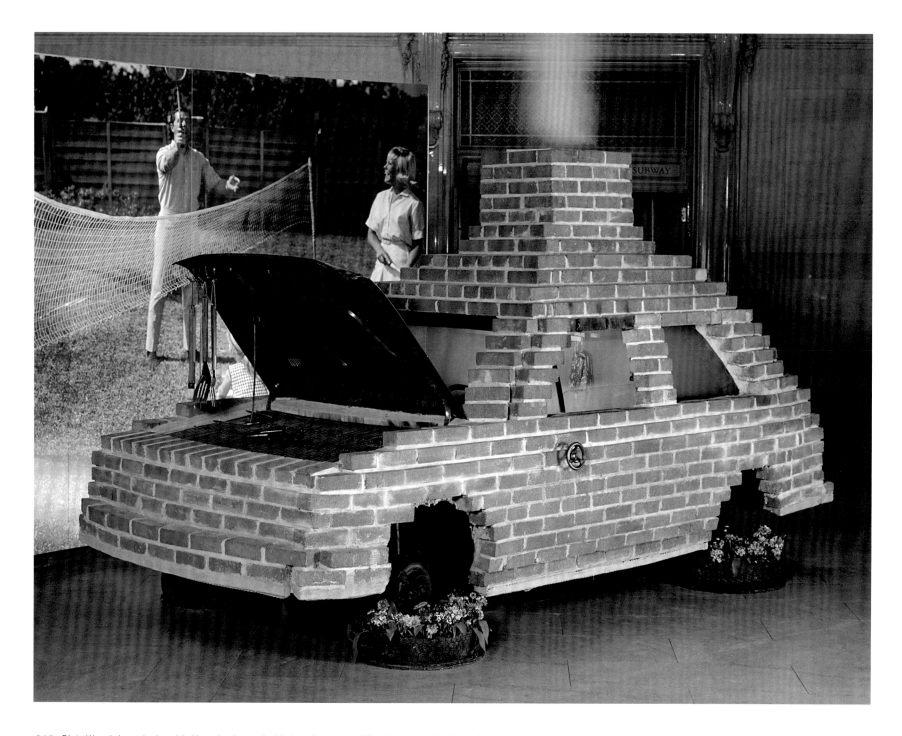

O'C: Piotr Wozniak worked on his Yugo barbecue in his boss's garage. When I went to check the final project, I asked if he had measured the exit, because I realized that the eight hundred bricks he added made it too wide to get out of the garage. He had to remove the rear wall of the garage to get the car out, and he was then out of a job. It took twelve men to push the car into place because of the weight of the bricks. The close-up shows hotdogs "cooking" over the simulated hot engine, and inside the car was an imitation smokehouse with curing meats. The tire planters are the finishing touch.

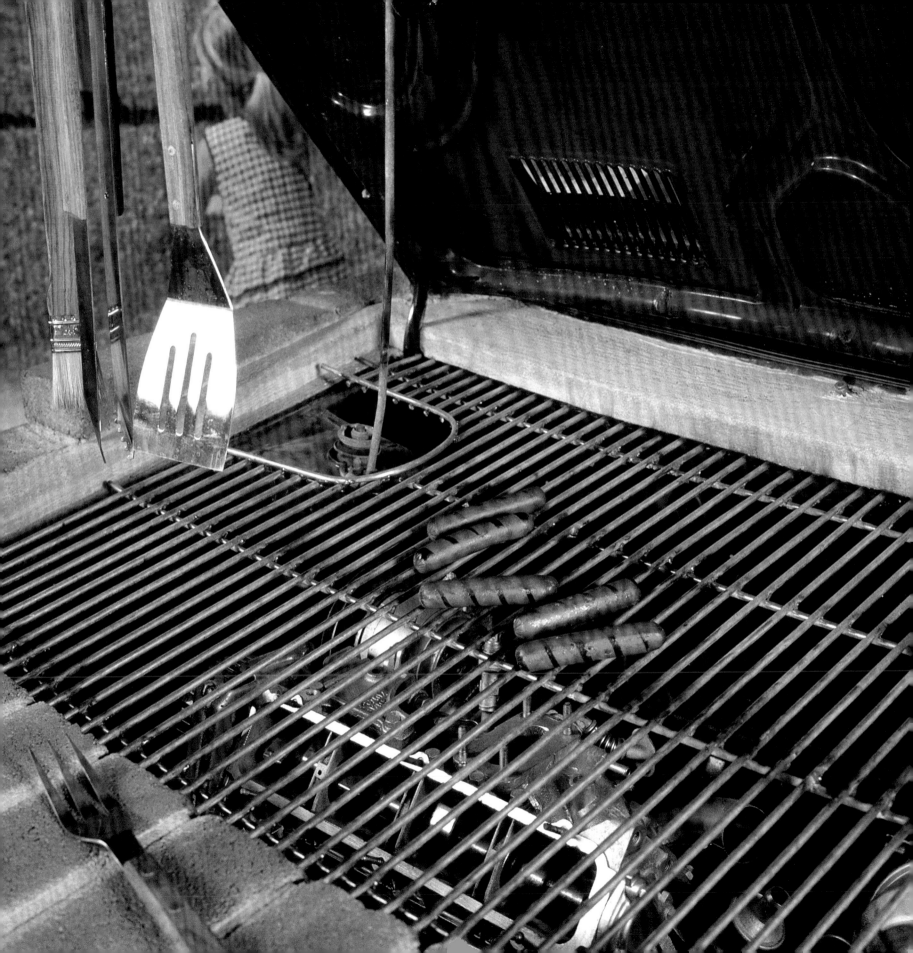

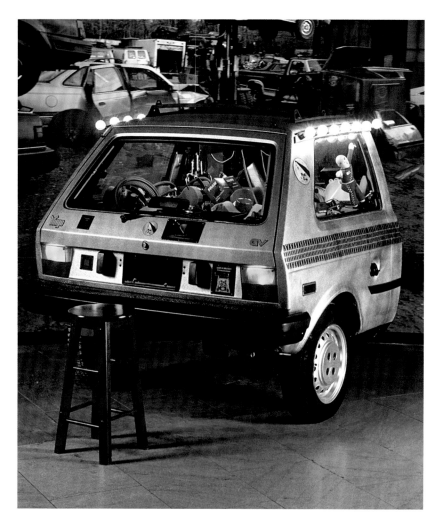

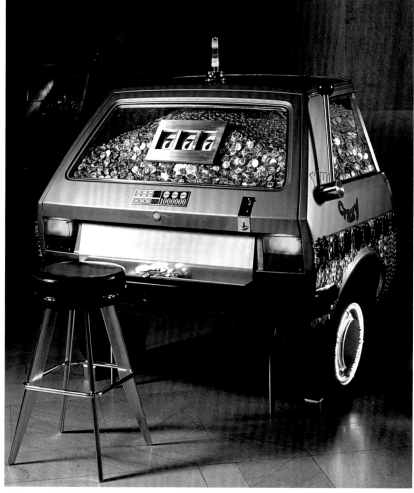

O'C: Bought from a junkyard, this Yugo was the most dilapidated we found. When Tracy Vetter went to get it at the salvage site, the huge crane that picked up and moved cars around became her inspiration. She decided to create a children's claw machine and make the prizes from parts of the car itself. I really enjoyed watching businessmen get excited about winning a pink spark plug or a purple carburetor.

O'C: Plastic coins spilled out from Cynthia Nagy's slot machine Yugo when someone hit the jackpot—three lemons in a row. Members of the New York State Gaming Commission came to see the show in Grand Central Terminal and insisted we turn the machine off, citing that was it a form of gambling.

O'C: The front of Karrie Hovey's Yugo was in such bad shape that she chose to use the back half only. The postal mailbox looked so real that people dropped their letters and bill payments in the slot. This happened a lot at Union Station in Washington, D.C., especially with tourists. I didn't understand it because the "mailbox" was in the middle of the exhibition. A local postal worker told me that the car had to be removed, which I refused to do. The conflict ended up in the news and resulted in the postal service making me an unofficial mail carrier, little bag and all. I had permission to remove the mail every day at four o'clock and bring it to the post office.

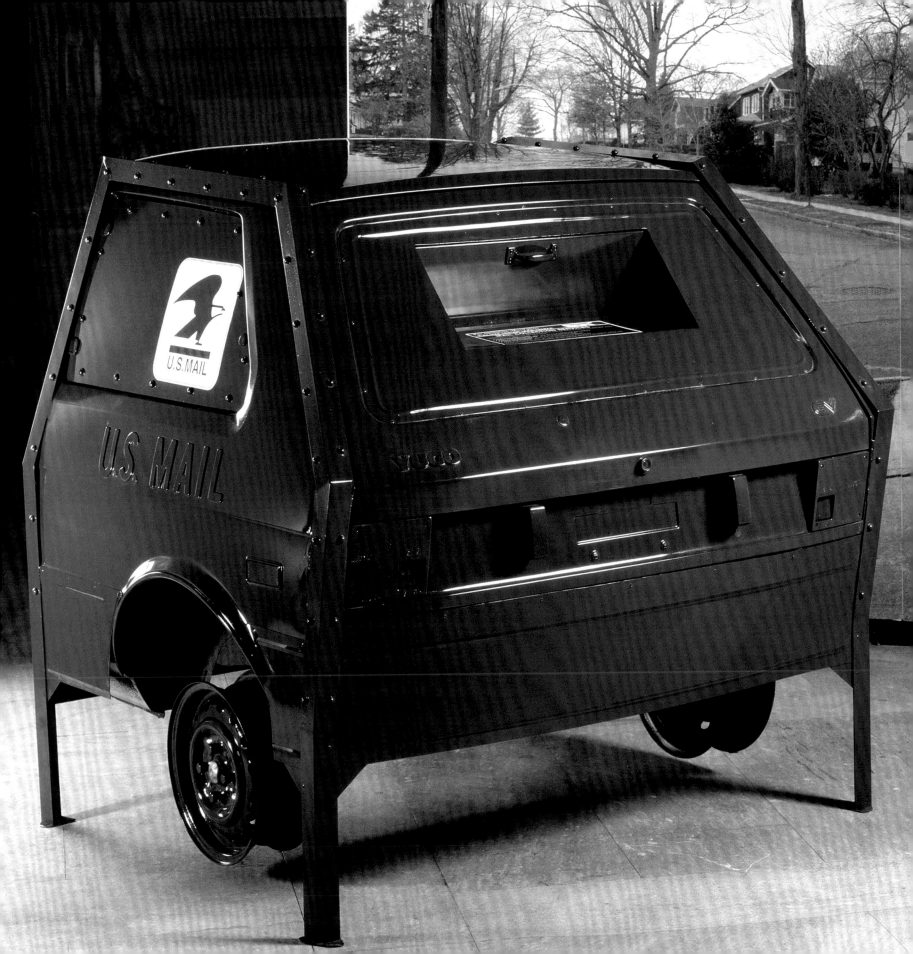

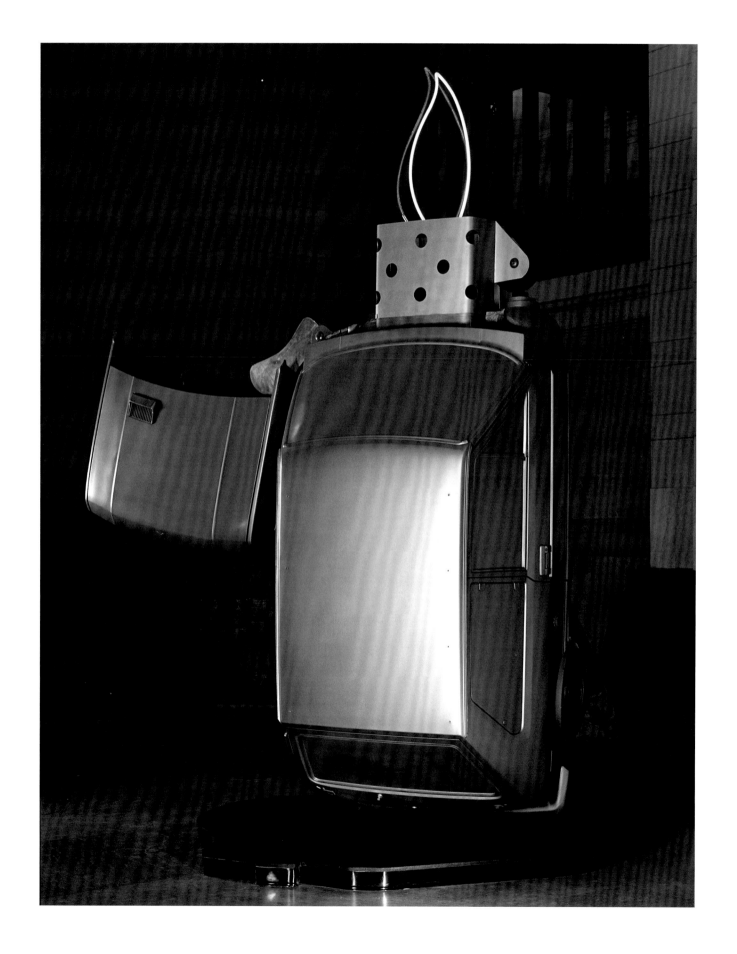

O'C: For the assignment, I asked my students to submit five initial sketches. Matthew Targon could only come up with four; frustrated, he jokingly drew a lighter that was sitting on a table, but I liked the idea. He took the fact that everything had to function to heart, and he put a propane torch on the top of the piece. When I walked into his workshop, which was a barn, he had flames shooting out of the top of this twelve-feet-high Zippo. I ran out thinking we were all going to die. He had to compromise and use neon instead of fire for the exhibition. A finishing touch was an enormous Oldenburg-like sculpted cigarette.

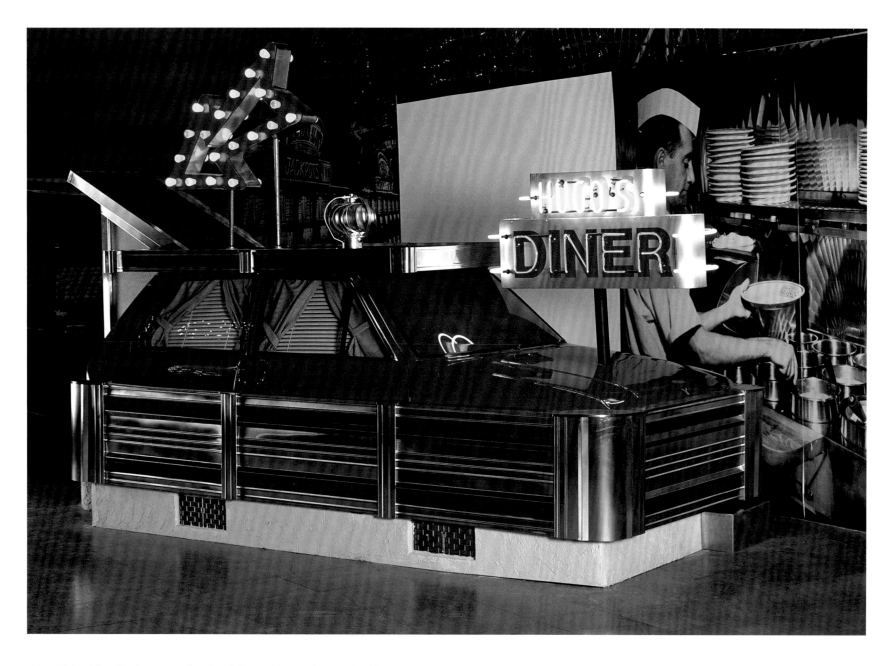

O'C: Richard Awad's piece was a functional diner with room for two. The *H* and the *S* on the neon sign were designed to flash, so that it read *UGO* some of the time. At the show's first reception, a fellow came running into Grand Central Terminal announcing that he collected cars and diners. He bought the car on opening night. I asked, "How do you collect diners?" He explained that he bought fifties-style abandoned diners and stored them. Everywhere we toured he would show up, sometimes with his family, and stand next to the car and tell everyone that he owned it. Imagine what he thought when he walked into Grand Central and saw a diner and car all in one.

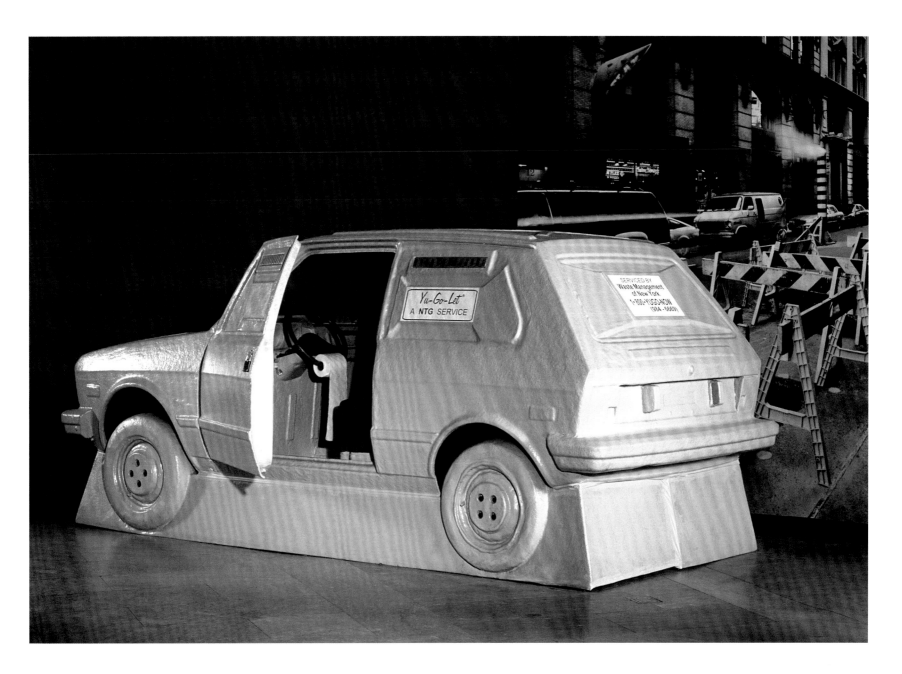

O'C: For *Got2Go*, Harlan Silverstein went to the source: a portable toilet company that helped him create the piece. They equipped the Yugo with the plumbing and inner workings and fiberglass finish by loading the car onto the assembly line with real port-o-johns. This was a perfect solution that summed up the show, because the Yugo was in fact a piece of crap. The car looked so realistic that a few people mistakenly used it, and we had to call in a sanitation crew.

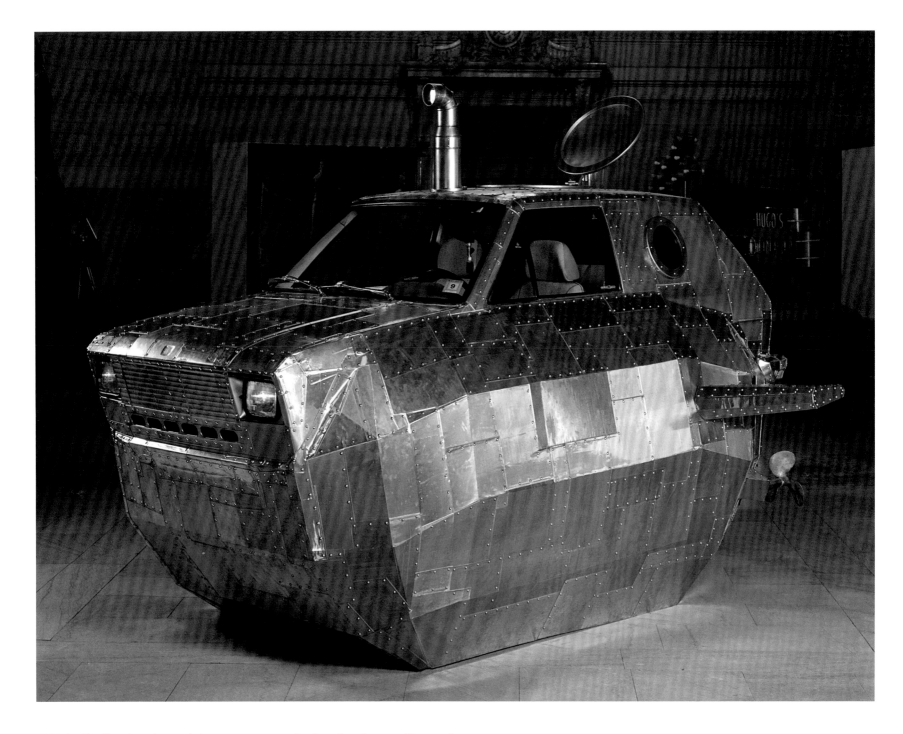

O'C: Joe Verni's submarine needed some new copper sheeting at each venue. The supplier who had donated the expensive copper for the original project was so generous that he sent extra sheets wherever we toured in case we needed to repair any copper pieces that were damaged in transport. He sent so much that at some of the venues we even used a bit of the extra as paper for writing notes.

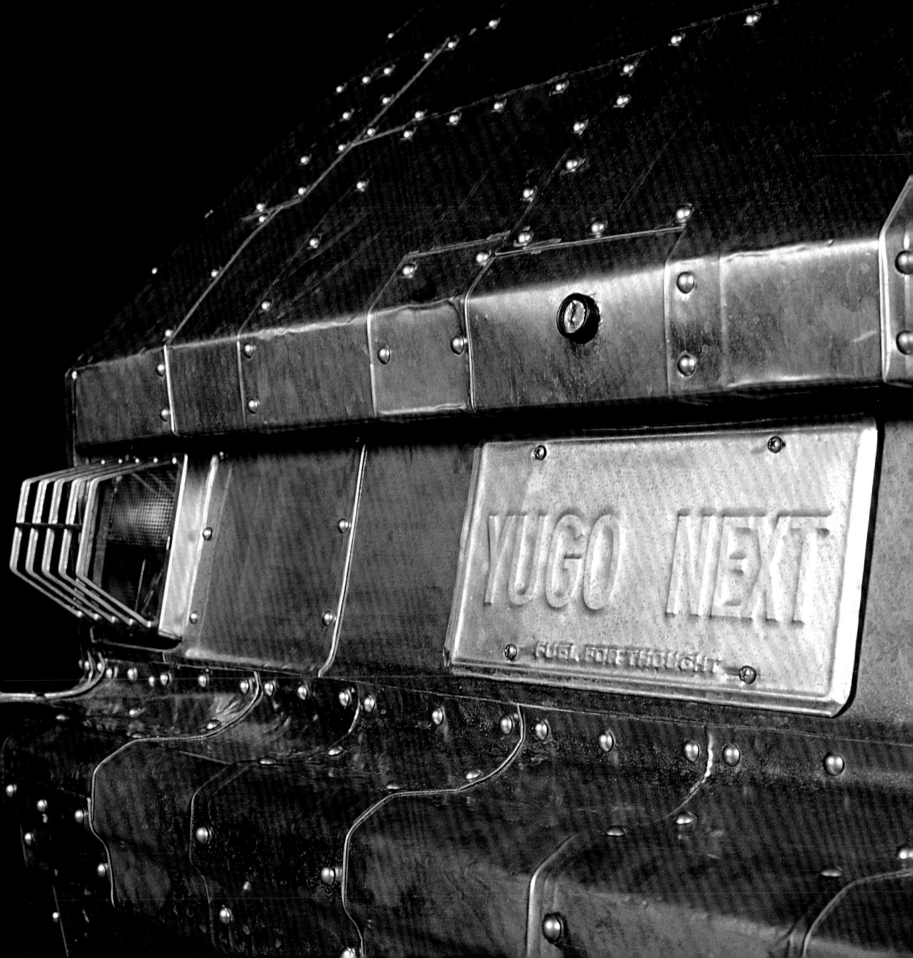

THE NEXT BEST ... DING!

CHALLENGE: PAY HOMAGE TO THE MECHANICAL TYPEWRITER THAT HAS BEEN RENDERED OBSOLETE BY DIGITAL TECHNOLOGY, AND CHANGE ITS PURPOSE INTO ANOTHER PRODUCT.

STARTING POINT: 75 TYPEWRITERS

ARTISTS: 40

WEEKS: 3

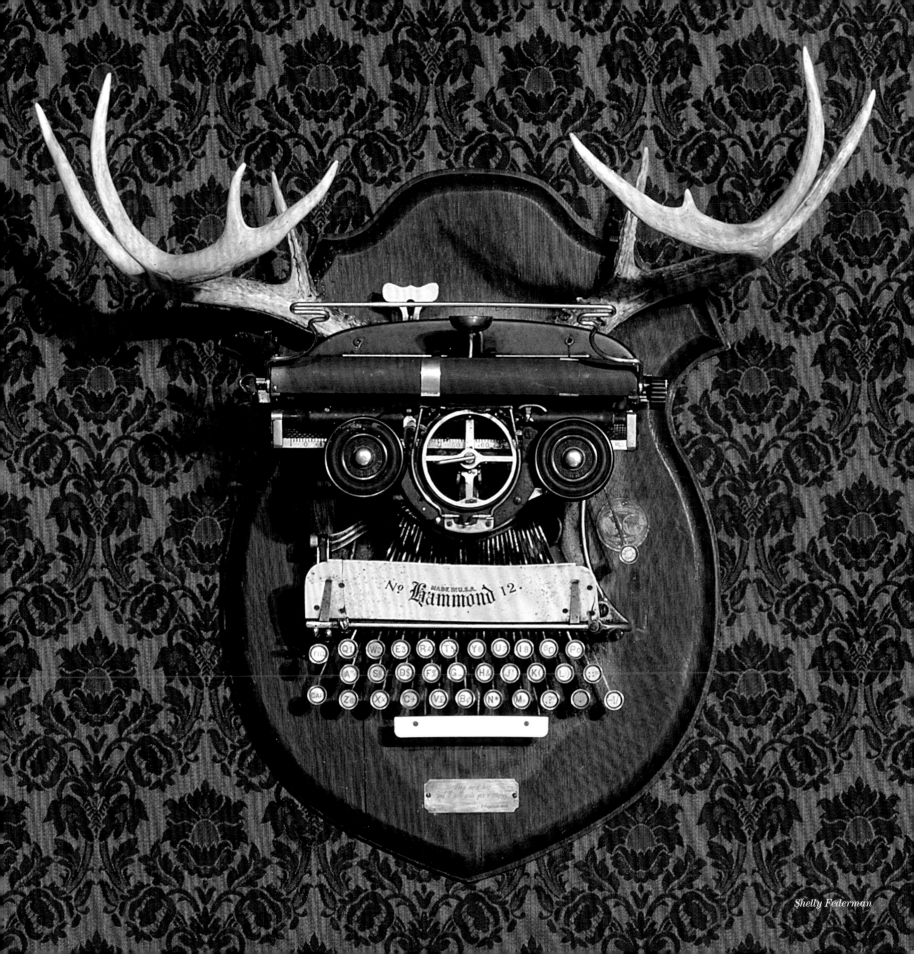

No Hammond 12

Shelly Federman

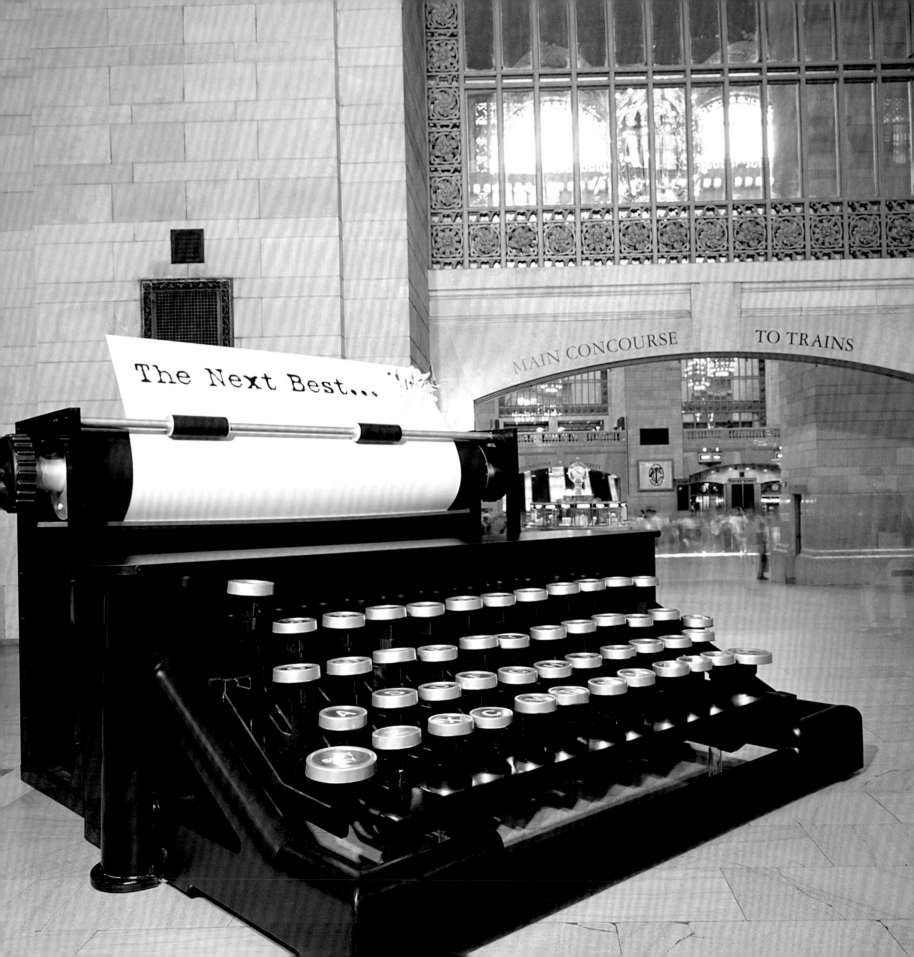

"I could get another TRANSMISSION, but I could never get those TYPEWRITERS AGAIN."

Cruising along in his Jeep Grand Cherokee on Long Island's Southern State Parkway, Kevin O'Callaghan is deep in thought about his next class assignment. The muffler has been hitting the asphalt, but he ignores the clanking, choosing instead to crank up the radio and blast David Bowie (he's a Ziggy Stardust man) to match his euphoric mood. Only when the transmission grinds out heavy metal does O'Callaghan turn his attention to the jeep. He pulls to the side of the road, along with the highway patrol officer who has been following him, wondering why the Grand Cherokee has become a lowrider. The trooper sees the cause at a glance: a sea of metal in the backseat. More accurately, there's about a ton and a half of nonfunctional typewriters—O'Callaghan's most recent find. Elated by his discovery, O'Callaghan hadn't considered the weight-to-wheels ratio when he loaded it. He recalls, "I felt like an idiot, but I was still ecstatic. I could get another transmission, but I could never get those typewriters again."

On vacation in rural Pennsylvania, O'Callaghan had digested that day's local newspaper, focusing on an article about a typewriter repair shop that was doomed for closure. He began to think about the future of this industry, wondering if typewriter restoration was still a viable business. His research of other repair shops suggested not. After a century of churning out the history of the world, the typewriter had been placed on technology's endangered species list. This slide to extinction had begun in the 1980s with the invention of IBM's Displaywriter and Apple's Macintosh. The era of cut-and-paste had marked the death of Olivetti.

O'Callaghan began his quest to salvage some of these mechanical treasures. In December 2000, he discovered the Long Island Typewriter Company and acquired his reserve. After more than eighty years, this family-owned shop was on the brink of closure. Many such businesses had integrated computer repair into their offerings; for others that hadn't, like this one, the outcome was catastrophic. The Long Island Typewriter Company's client base had dwindled from two thousand to twenty. In the front room of the shop, only a handful of the obsolete machines were visible, but the owner escorted O'Callaghan to the basement, where mounds of typewriters covered the floor and concealed the lower steps. O'Callaghan was told he could take them all, and he spent the next six hours in the August sun lugging IBM Selectrics and a clan of Royals into his jeep.

DING! That triumphant sound—proclaiming another line of type completed and beckoning for the next to begin—was unfamiliar

O'C: The giant typewriter at the entrance of the exhibition space was fifteen feet by ten feet and served as our concession and information stand. When you pushed several of the keys, they moved, though it never operated as a typewriter. It stressed the surreal aspect of the show.

exhibition design: Kevin O'Callaghan; exhibition construction: Scott Lesiak (typewriter)

to O'Callaghan's students. He discovered that only five of the forty had experienced this aural exhilaration. When the students took the machines apart, they saw the typewriter for the masterpiece it was and is, and they learned about its sacrosanct partnership with writers and journalists. They then transformed these once-prolific machines into incongruous objects that were beautifully designed and surprisingly practical. The Smith Corona waffle iron held literal and visual nourishment, the R.C. Allen hand dryer provided towel and hot-air options, and a fish circled in the retrofitted Underwood. Each metamorphosis, including a place setting, a wall-mounted telephone, and a multimedia puppet theater, was meticulously crafted.

One piece, Shelly Federman's *Guillotine*, emphasized the typewriter's weight and its crushing downfall. (Ironically, concurrent with the typewriter's demise, the French government had outlawed the

the dusk-rose two-slice toaster—Dimino's creative transformation of a '50s Olivetti emphasized the complementary nature of objects from a specific era.

What had begun as a three-week class assignment became an exhibition at Vanderbilt Hall in Grand Central Terminal that traveled cross-country to the Los Angeles Convention Center. Cubie Dawson Jr., an expert in mixed-use transit facilities for commercial real estate at Jones Lang LaSalle, brought the show to Union Station in Washington, D.C., where it was enthusiastically received. Dawson recalls, "You felt like you were not only giving something back to the community, but also saw these forgotten objects take on a whole new meaning." Within the Beltway's hub of news agencies, where the typewriter had been a ubiquitous partner, people returned to the exhibition to donate their portables. "You'll do more with this than I

THIS WAS O'CALLAGHAN'S WISTFUL EULOGY TO THE TYPEWRITER.

guillotine in 1981.) Federman was determined to create a historic facsimile. Unsatisfied with her attempts to reproduce the look of aged wood, she researched historic wood-restoration firms and sent them preliminary sketches of the concept. Her effort was rewarded when a contractor who had just razed a three-hundred-year-old barn in Vermont offered her some of the discarded beams.

In juxtaposition, designer Tom Takigayama opted to keep a level head and created a Zen fountain. His project underscored the changed nature of the typewriter from being a workhorse, like the computer is today, to residing in retirement as a contemplative observer. The typewriter given to Takigayama was one of the most pristine—no scratches, no dents, alas, no dings—and he immediately distressed it. O'Callaghan was thrilled, aware of the courage it took to do this. The result was exquisite. The show's concept was well reflected in the vacuum cleaner crafted by graphic designer Christopher Dimino. With a nod to the vogue of matching appliances from the 1950s—the starmist-blue refrigerator, the willow-green oven, and

will. Please take care of her," read a note taped to a Remington. These writing machines had been very personal objects, which added to the show's charm and success.

O'Callaghan realized that anyone born after the moonwalk of 1969 might not comprehend the emotion that a typewriter could evoke; to them it was simply detritus of the century past. This understanding motivated him to build an educational wall that illustrated the machine's history and profound importance. He also supplied the exhibition venues with a dozen functioning typewriters (along with correction tape), enticing the uninitiated to commemorate the *DING!*

This was O'Callaghan's wistful eulogy to the typewriter.

O'C: In Grand Central Terminal, I decided to surround the hall with black curtains that offset the photographic images. There was an educational wall that made a statement about the history of the typewriter with clips of famous film scenes where a typewriter played a prominent role, including Rob Reiner's *Misery*.

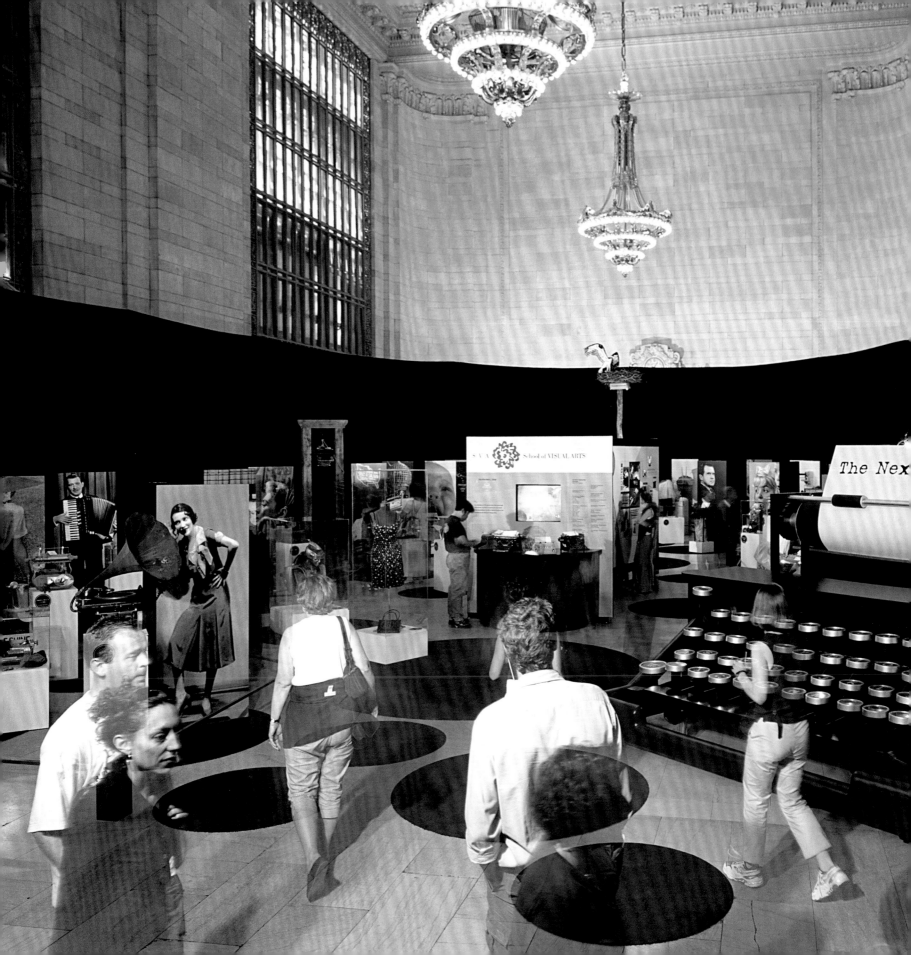

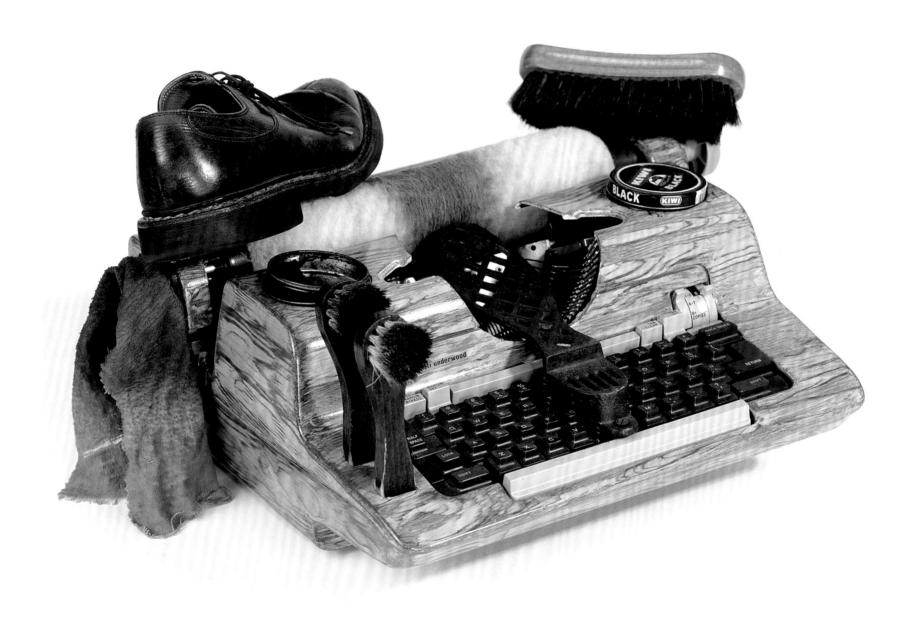

O'C: Vincent Perrella chose to work with the electrical dimension of his Underwood in making this shoeshine machine. The roller could be set to spin fast enough to actually produce a well-buffed shine. The polish sat where the ribbon cartridges had been.

O'C: This black evening dress by Roswitha Rodrigues included hundreds of typewriter keys. She transcribed the last paragraph from Dashiell Hammett's *The Maltese Falcon*, which could be read by starting at the top of the dress and reading in circles.

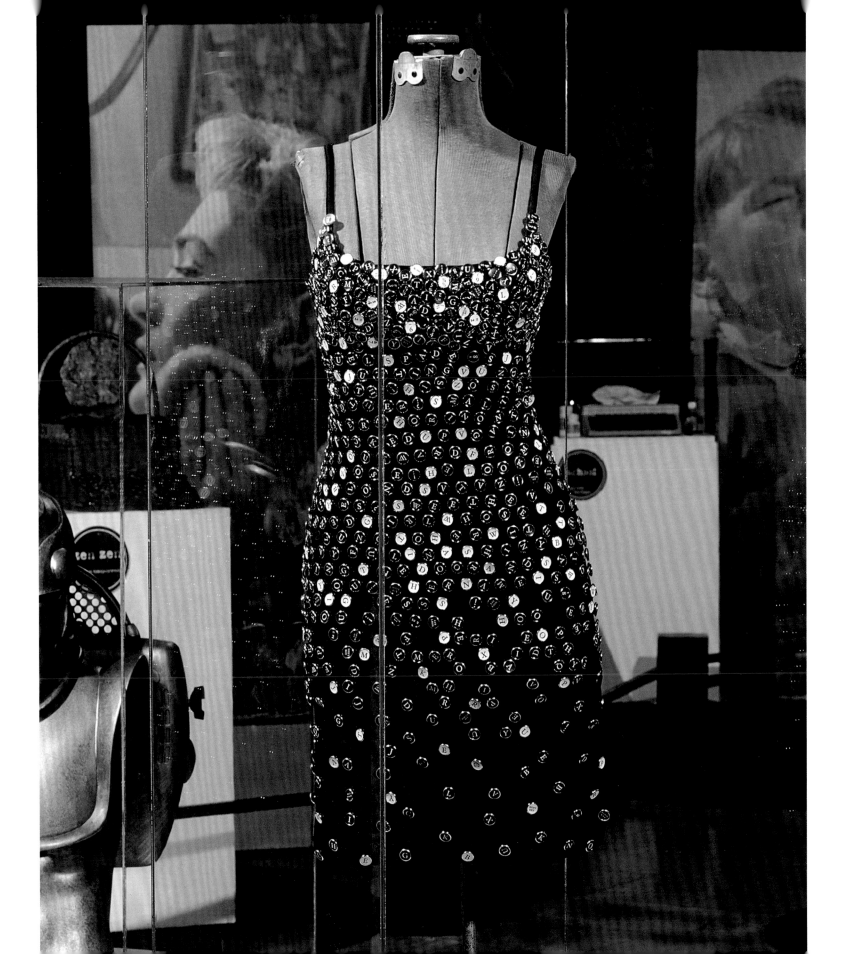

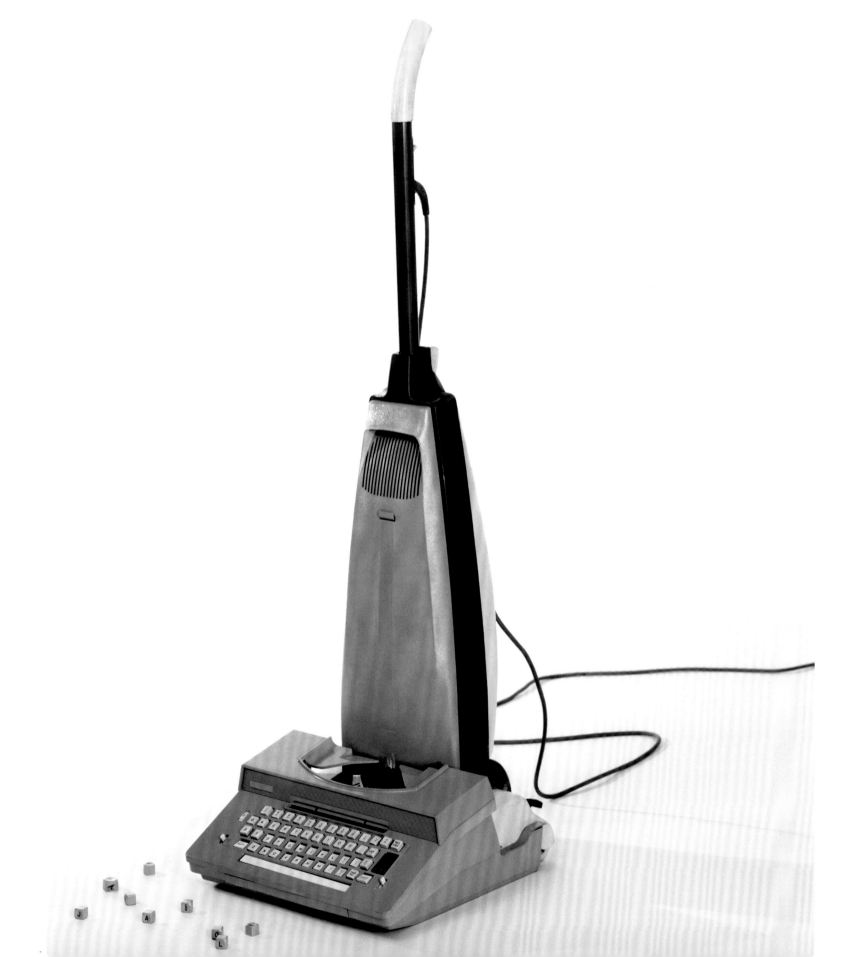

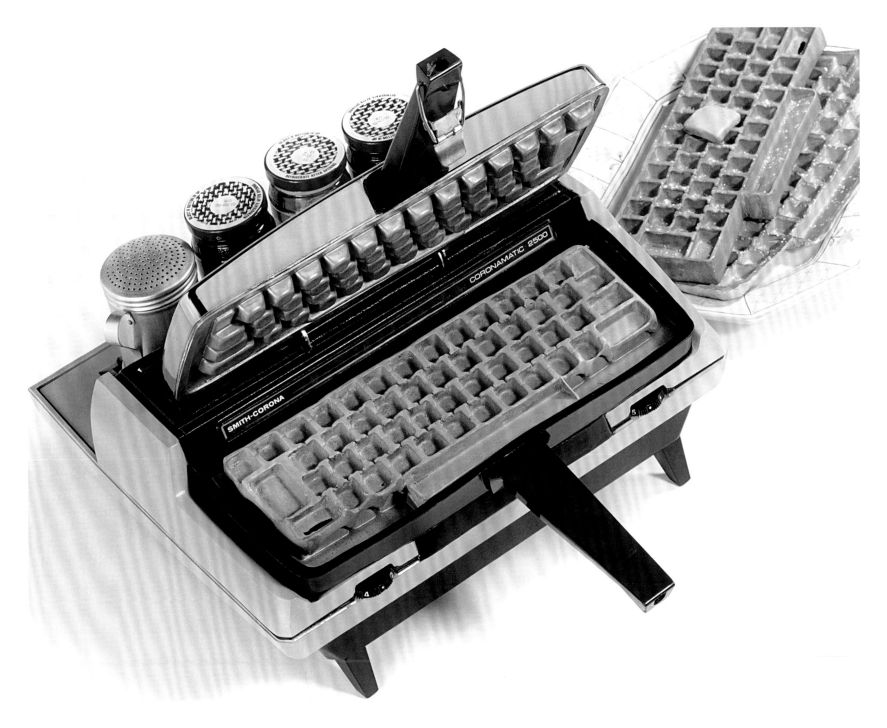

O'C: Christopher Dimino made five pieces for this show. His vacuum cleaner design was a perfect marriage of machines because he took into consideration the design of appliances from the same time. At the show he demonstrated that it functioned by vacuuming up old keys from other typewriters. The powder-blue color was chosen to imitate household appliances from the 1950s.

O'C: The waffle iron was also made by Christopher Dimino. This Smith Corona imprinted the keyboard onto the waffles, and he created the iron part from a mold, complete with imitation waffles.

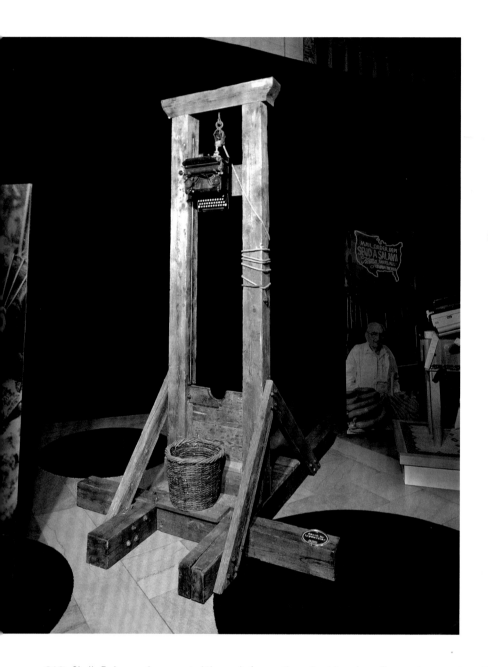

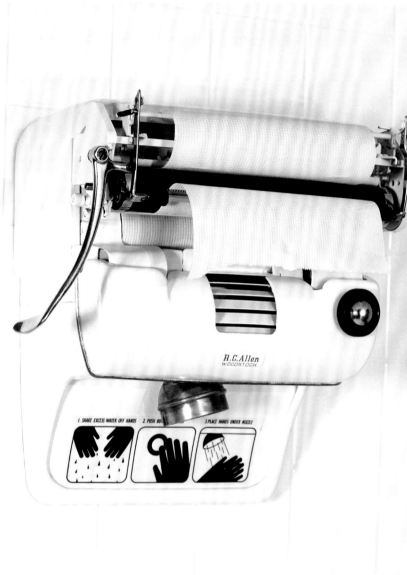

O'C: Shelly Federman incorporated the goal of reuse throughout her piece. The wood was from a centuries-old barn in New England that had been demolished. The wooden structure was very realistic looking, and very eerie.

O'C: The industrial look of this typewriter and hand dryers from the same period was taken into consideration in this work by Tom Takigayama. Moving the carriage return lever dispensed the paper towels. This R.C. Allen included an air-dry option by pushing the knob on the right.

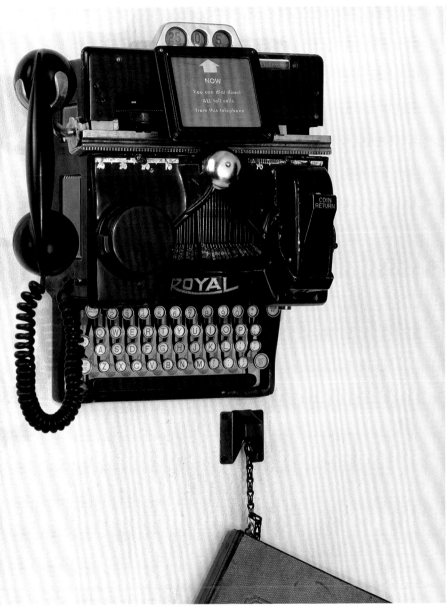

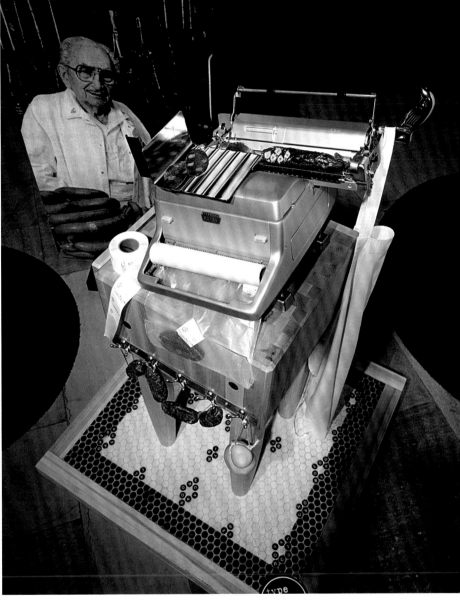

O'C: This was a 1920s Royal. It is interesting how typewriters, being industrial products, resembled other things of the time. Carolyn Mueller realized that by hanging the machine on the wall, it became a pay phone, and she transformed it from one medium of communication into another. It was the only piece in the exhibition that could still sound the "ding!"

O'C: The tiled floor of the delicatessen included keys from the typewriter in this piece by Ann Marie Mattioli. The sliding carriage went back and forth to cut the meats. She also created imitation slices of prepared meat in which she integrated shadows of the typewriter keys to resemble the mysterious sections of a deli "surprise loaf."

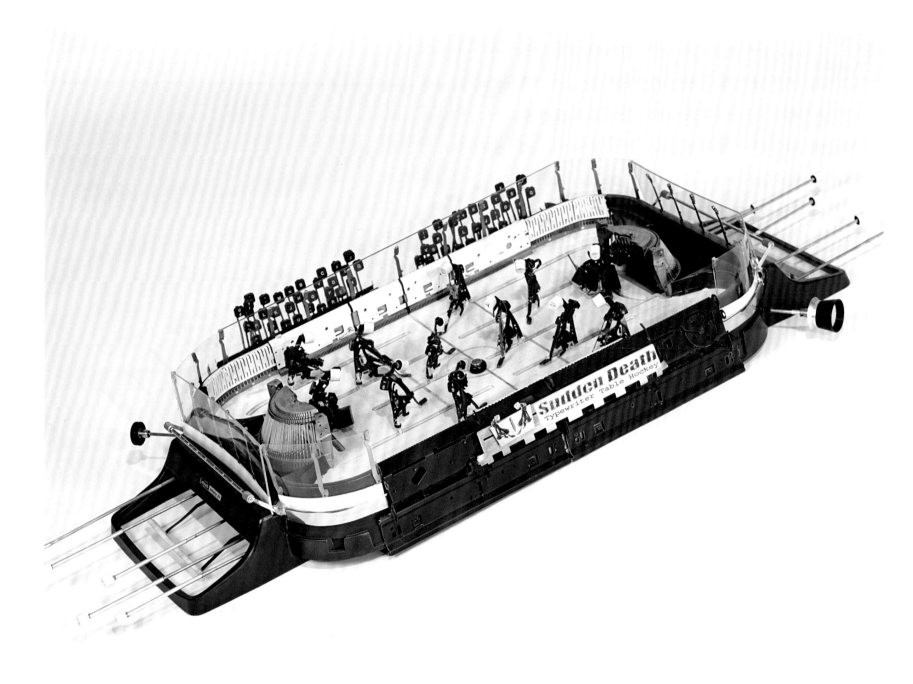

O'C: The hockey rink by Christopher Dimino used all of the parts of two typewriters to which he added a plywood floor and a protective clear plastic shield that surrounded the playing area. What made this piece brilliant was that he turned the characters of the keys into facial expressions of the hockey players, and they seemed to come to life. The spectators were made from the remaining typewriter keys.

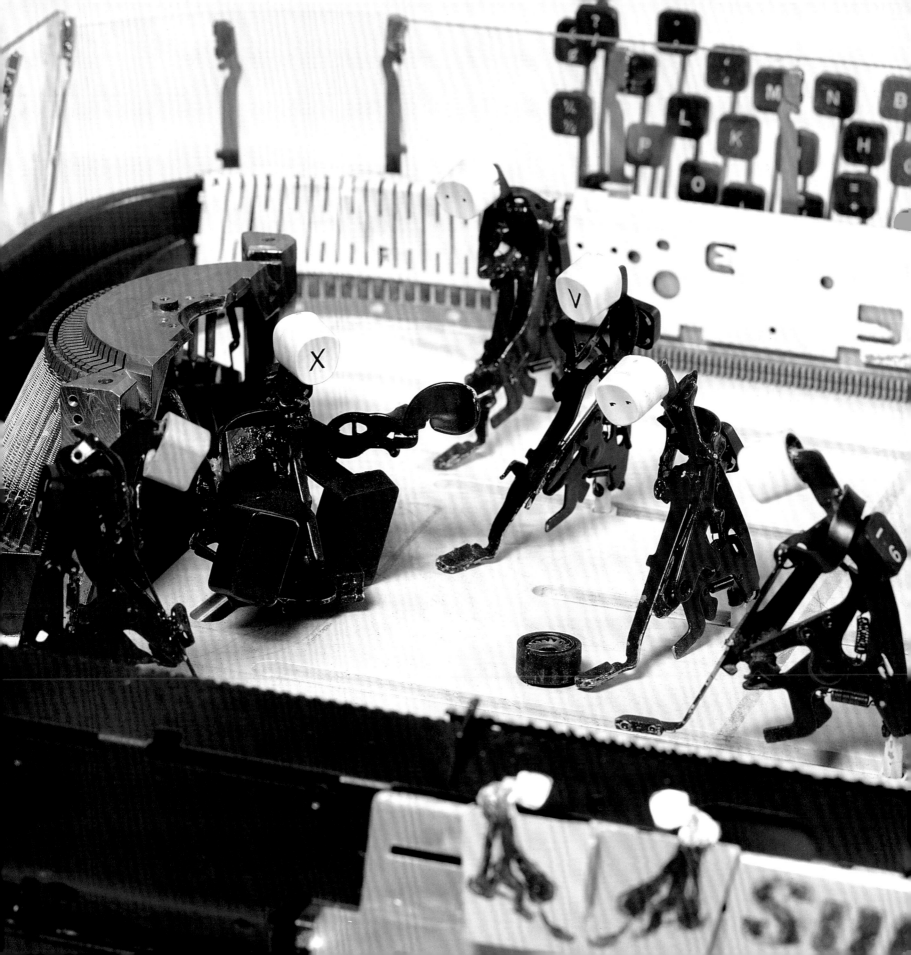

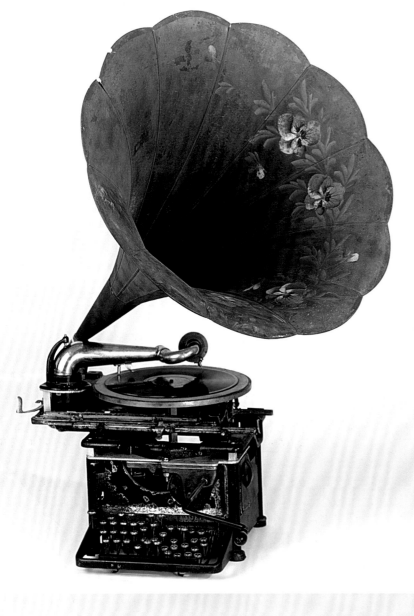

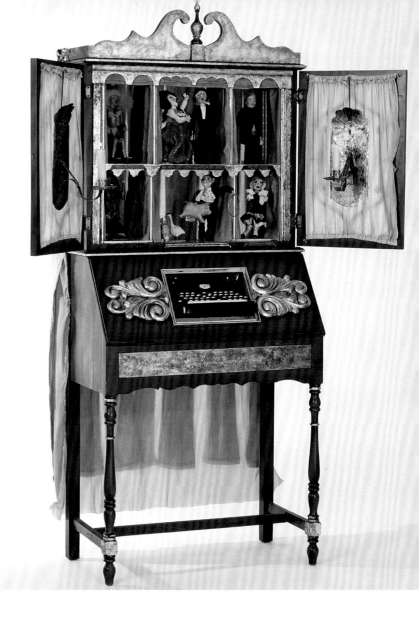

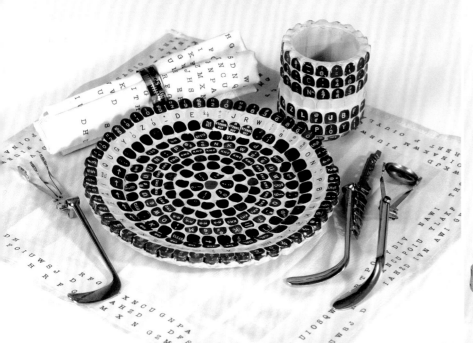

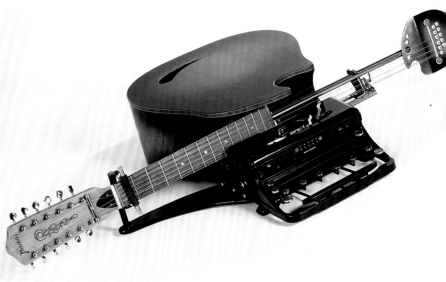

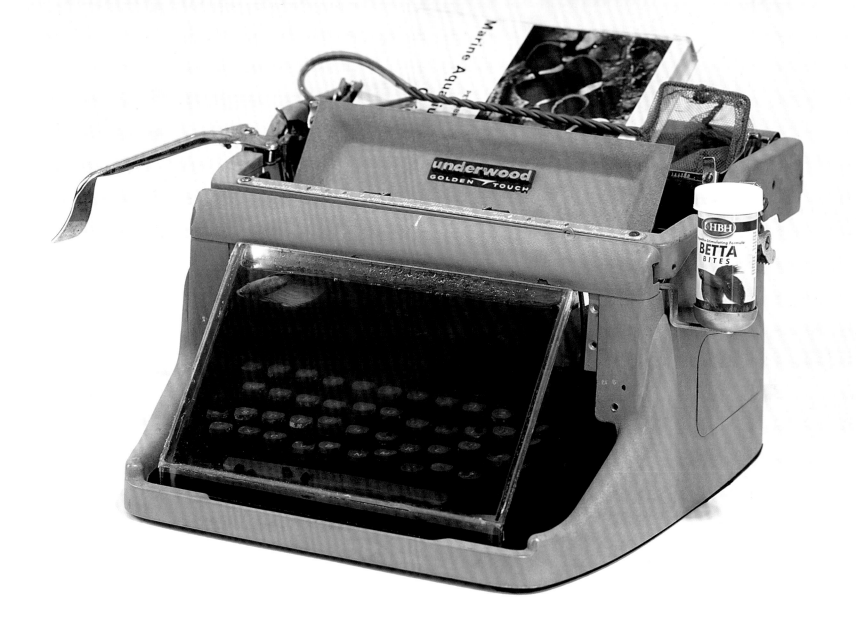

O'C: A 1920s typewriter was left over after the students had made their pieces, and I used it to created a phonograph from that era, incorporating components from an antique windup phonograph to build the mechanisms inside the typewriter. The typewriter roller pulled the needle across the record to play a song.

O'C: For the puppet theater, Lee Yaniv attached string to the typewriter levers, and the keys activated the Victorian-type puppets. The theater itself was made from an upright desk found on the street and embellished with decorative elements that were originally intended for the carousel that I created for the School of Visual Arts' fiftieth anniversary.

O'C: This place setting by Laurie Mosco focused on the keys instead of the machine. The colors of the keys are those common to typewriters from the 1940s and early 1950s. She designed the border of the place mat and the napkin with type.

O'C: The slide guitar by David Hughes was a real beauty. I liked how he made use of carriage return mechanism to create the sounds.

O'C: Peter Salvato made a home for "Bruce the fish" from this Golden Touch Underwood. The fact that he had to make it hold water and turn it into a living environment was incredible. Salvato built around the inside of the typewriter, leaving everything intact. Betta Bruce also had his own traveling tank and accompanied us by train, plane, bus, and automobile to all of the exhibition venues. He became my daughter's pet at the end of the tour. It was kind of an underwater Underwood!

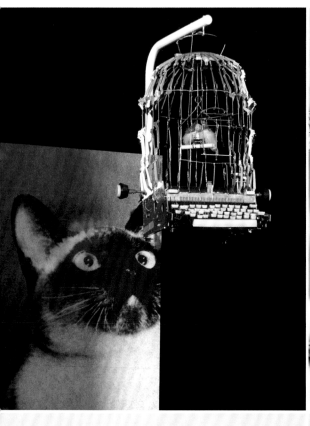

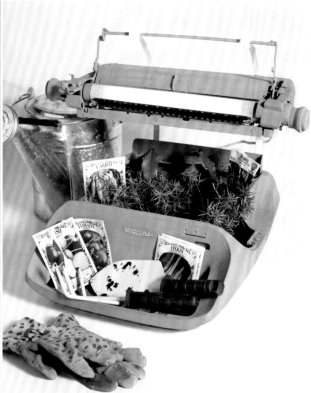

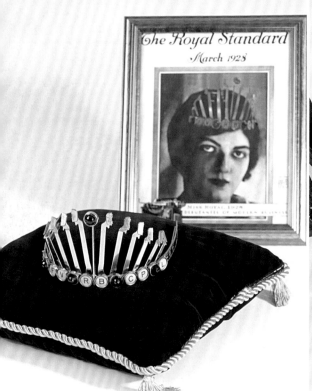

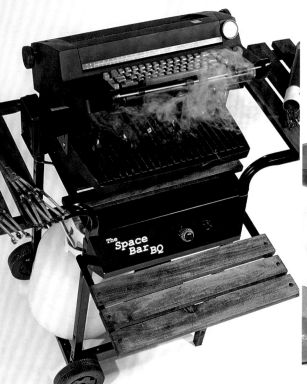

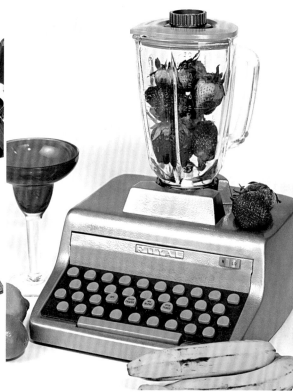

birdcage: *Allegra Raff*

tiara: *Dana Robinson*

planter: *Beth Llewellyn*

barbecue: *Shaun Killman*

paper shredder: *Young Sung Lee*

blender: *Shaun Killman*

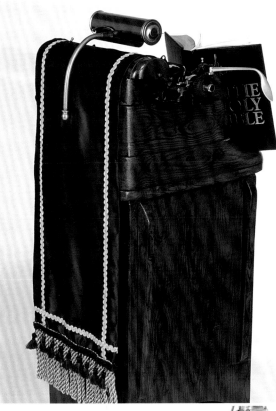

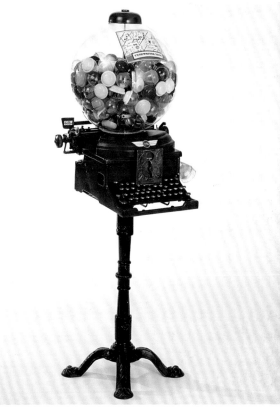

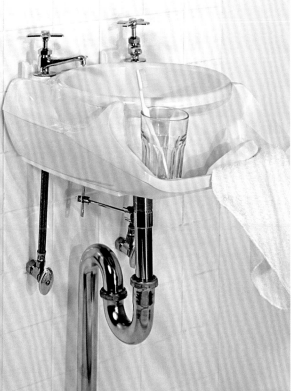

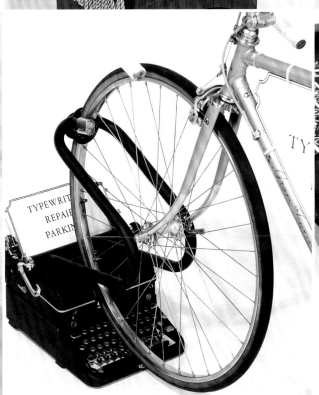

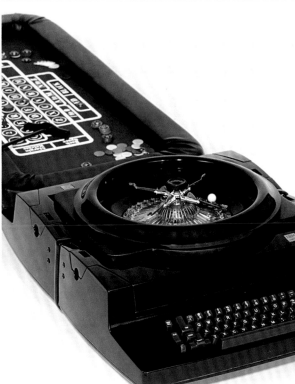

washing machine: *Harlan Silverstein*

sink: *Jae Lee*

podium: *Oscar Gonzalez*

bicycle lock: *Paul Santoro*

bubble gum machine: *Lauren Panepinto*

roulette wheel: *Jose San Juan*

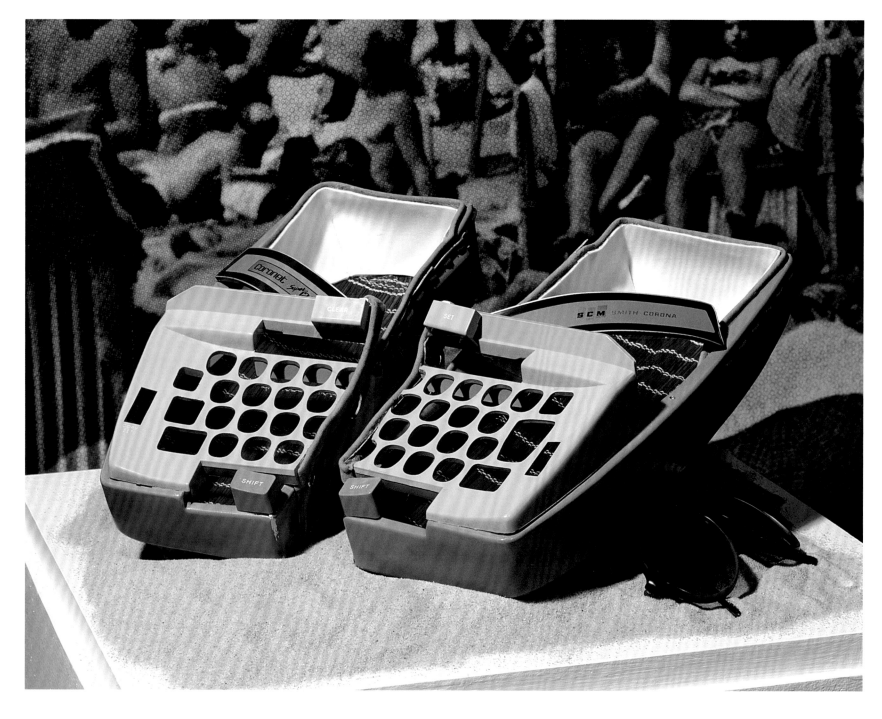

O'C: Allegra Raff used the casing of a typewriter for these mod-looking beach sandals. She loved the brown and beige colors of this 1960s machine.

O'C: Tom Takigayama had been given a typewriter in mint condition. After my initial double take in seeing this pristine, vintage machine covered in rust, I saw the beauty in its conversion.

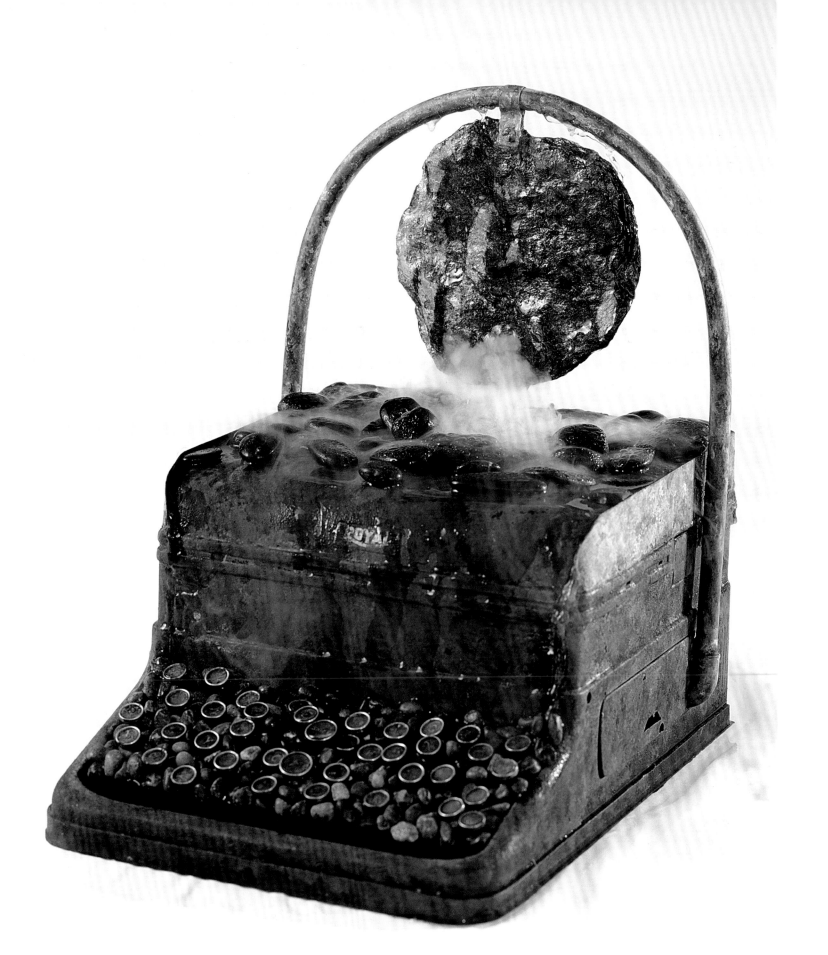

NBC EARTH DAY FRAME

CHALLENGE: TO CELEBRATE EARTH DAY ON *THE TODAY SHOW*, CREATE A PIECE OF ART IN ROCKEFELLER CENTER USING THOUSANDS OF DISCARDED CELL PHONES AND OTHER E-WASTE.

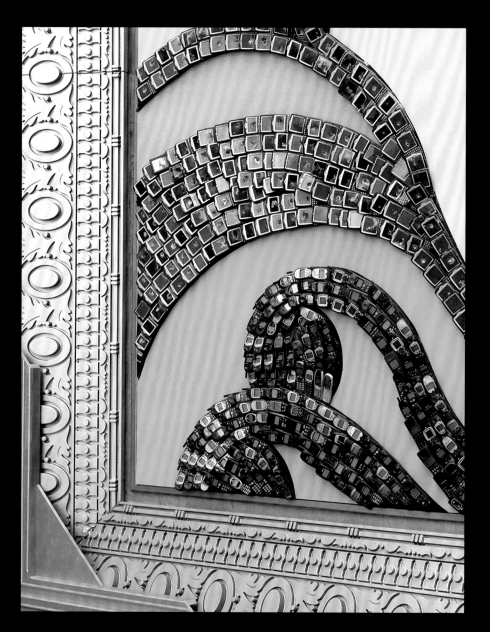

O'C: I was approached by NBC Universal to create a project for Earth Day in Rockefeller Plaza. The idea was to create garbage can tops so that people could throw electronic waste (e-waste) into containers. Their team was thinking of caricatures of the stars where you put your e-waste (cell phones, laptops, and keyboards) into their open mouths on the trash can lids—something along those lines. It had partnered with a company on the West Coast that was going to recycle it. I thought the idea was interesting, but wanted to do something bigger. In this case, it was to use as much Rockefeller Plaza real estate as possible and to create art with the e-waste itself. So I came up with the idea of a giant frame that reached across the plaza. I wanted to do a reveal about the earth and thought a tree was the best statement.

To erect the frame was really an engineering masterpiece. About 150 fifty-gallon drums of water were installed behind the frame to counter its weight and comply with New York City code that required the piece to withstand winds up to 180 miles per hour (though this has never happened here).

The process was broadcast on *The Today Show* for five mornings, and tens of millions of people watched the students create this work. Using individual four-by-four-foot panels that we had pre-painted (a kind of paint-by-number), we then attached the e-waste objects to the panels. The frame was also made from recycled and Earth-friendly materials, and plyboo (bamboo plywood), was used for its filigree. Every detail was eco-compatible. This was done in sections on-site, so every day a few more panels were placed in the frame, giving hints of what the image would be when completed. It turned out that the BlackBerry screens reflected the light in Rockefeller Center and from the end of the plaza they looked like sequins and made it so beautiful.

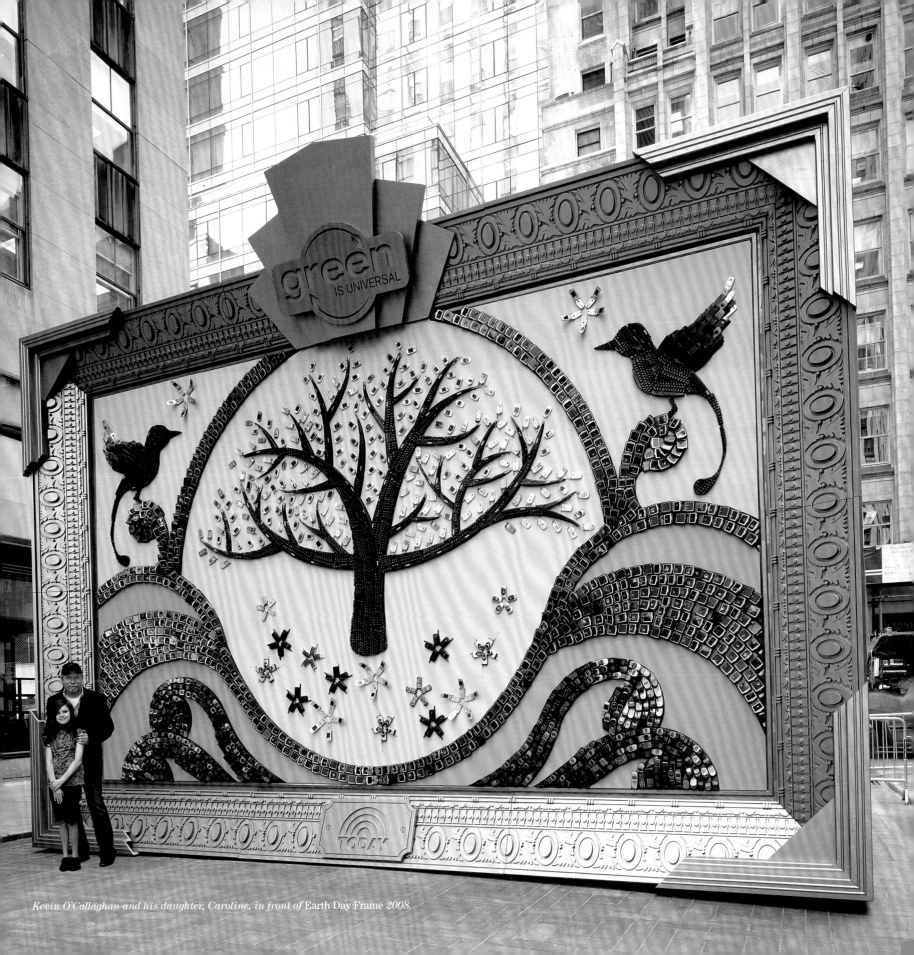

Kevin O'Callaghan and his daughter, Caroline, in front of Earth Day Frame *2008.*

HORSEPOWER

CHALLENGE: IMAGINE THAT THE WORLD HAD RUN OUT OF OIL AND WE FOUND A NEED TO RELY ON OUR PAST. RETROFIT A HORSE-DRAWN VEHICLE OF YESTERYEAR TO FULFILL THE NEEDS OF THE TWENTY-FIRST CENTURY.

STARTING POINT: 16 HORSE-DRAWN VEHICLES
ARTISTS: 16
WEEKS: 3

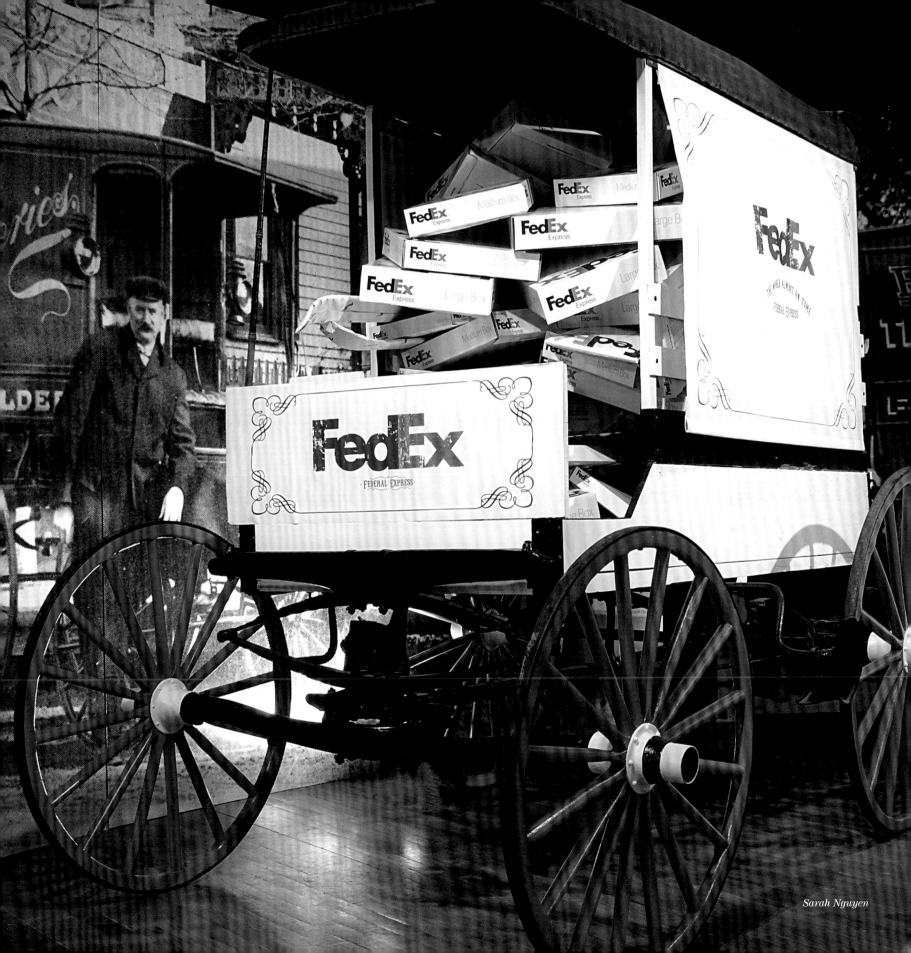

Sarah Nguyen

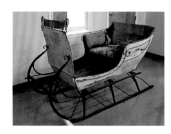

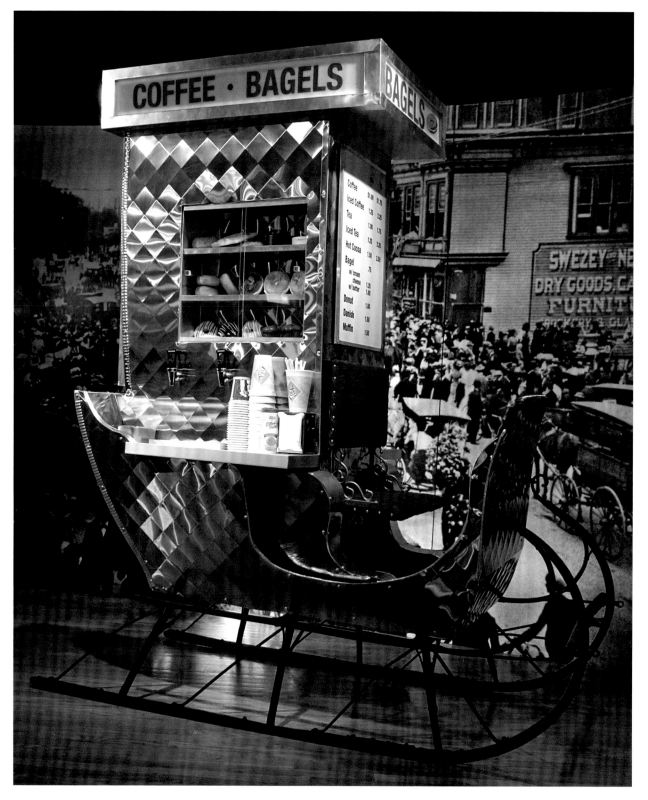

O'C: This sleigh was in terrible condition, with wood rot, missing parts, and a family of mice. Alexis Shields had to basically rebuild it before starting her project. She used stainless steel throughout.

He PLACED it all on some HORSES. The wager WAS A GOOD ONE.

There are more than a million Google entries for horse-drawn carriages, so it's not surprising that someone would venture into the buggy transport business. A fellow whom everyone just called "Roy" had figured out there was a following of carriage lovers scattered in remote locations who could benefit from his service. He bought a fifty-four-foot truck for pickup and delivery of these old-fashioned gems and has traveled the continental United States ever since. Kevin O'Callaghan would draw upon Roy's expertise and livery during his own journey for a stable of carts.

Horse-drawn carriages represent a remarkable design tradition of redefinition and refinement. From the Civil War munitions carriage to the prim surrey with a fringe on top, these vehicles were often crafted with stunning workmanship. Many offered more comfort than their early automotive successors. They were equipped with adjustable beveled-glass windows and lamps for an outing after dusk, and embellished with velveteen upholstery and curtains. Leather seats stretched across many of their interiors, and occasionally patent leather covered the dash and fender. There was even a gentleman's buggy, the Maserati of its Victorian times, intended for its passengers to see and be seen.

The 2007 "Horsepower" exhibition began as a response to skyrocketing gasoline prices and O'Callaghan's love of just about anything on wheels (except his first skateboard that weighed twenty-five pounds, and gas-gulping monster trucks). His thoughts turned to the looming scarcity of fuel and alternate modes of transportation, and he imagined a grassroots embargo on imported black gold that would leave today's vehicles in neutral and call the old-timers out of storage to be modified for modern life.

O'Callaghan's enthusiasm grabbed hold, and he would eventually procure an impressive personal collection of these handsome cabs. Having researched Albany Cutters for a hot-rod Christmas sleigh that he had created for MTV, he knew he could get coaches for next to nothing. Unlike that adventure, O'Callaghan decided that one component of this exhibition's mission would be to respect the integrity of each wagon and keep it intact, although repurposed, to go full circle and accommodate present-day needs. Roy embraced the idea and offered to be the eyes and wheels of the project. He would call from the road saying, "Hey, this is Roy. I'm in Amarillo, and there's a guy selling a stagecoach for two hundred thousand, and he has a doctor's buggy for three hundred dollars." His efforts allowed O'Callaghan to select his convoy from a much larger base than what existed locally, and he helped to avert mounting costs by generously transporting the vehicles at no charge.

O'Callaghan has an original approach to the fiduciary arts. Taking the cash that had been earmarked for delivering the carriages, he placed it all on some horses. The wager was a good one. He contacted Cowpainters LLC, an organization run by women who donate their talents to nonprofit endeavors. Known for their fiberglass bovines that have raised millions for charity and delighted viewers around the world, these public-spirited artists were intrigued by O'Callaghan's intent and agreed to make the horses at a discount.

Horsepower gained a new meaning in Joseph Pastor's Con Edison vehicle. The concept was brilliant and flawlessly crafted. Using found mechanical tanks and gauges that he collaged together, his truck became a perpetual motion machine that maintained its heritage. Su-Hyun Kim's mid-nineteenth-century flatbed carriage had once transported whale oil, an illuminant used in many lamps of that era. During those expeditions, the laden barrels would bounce up and down, carving circles into the carriage's wooden frame. She matched the red of the original wagon and transformed it into a double-decker beauty.

Artworks finished and the exhibition mounted, O'Callaghan and his crew trotted toward the winner's circle.

O'C: Answering the problem of what a Brooklyn, New York, pizza delivery truck would look like, I created *Lucky's Pizza* from an old Rockaway Company carriage. The pepperoni pie on the top spun around as if the golden hand were tossing it in the air. This was a beautiful carriage that we gutted to install imitation heating coils and dried meats. The garlic around the horse's neck was a playful tribute to Italian cuisine. Ironically, the original carriage was made in Rockaway, Queens, New York.

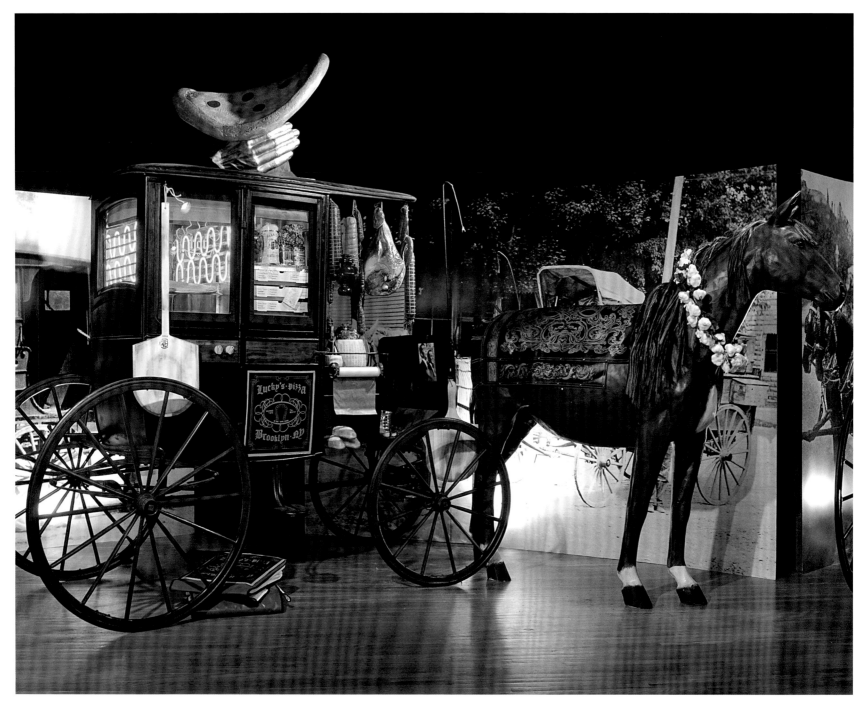

O'C: This horse-drawn cab was a crowd-pleaser. An old sulky trotter carriage used for racing, it was completely open on the sides. Sofia Limpantoudi had to build the entire enclosure. She strapped the meter to the top of the horse's rear. With its horse-powered engine and medallion-yellow paint, her New York City taxi was a stunning success, simple and graphic.

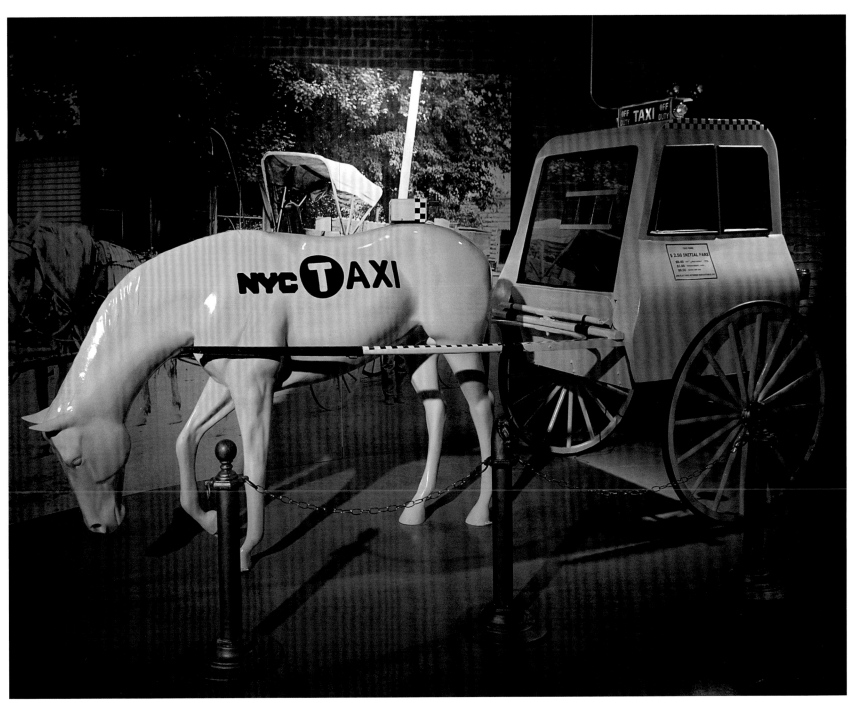

O'C: *Bobbleman's* was a doctor's buggy, a simple two-seater for physicians to make house calls. Christopher Dimino used the awning itself to create the image of a bobbing head, getting the idea from watching the top "bobble" as the carriage rolled. He created a fictitious salesman who sold bobble heads to make a political statement about big oil company executives. The horse also had a bobble head with a big spring on it.

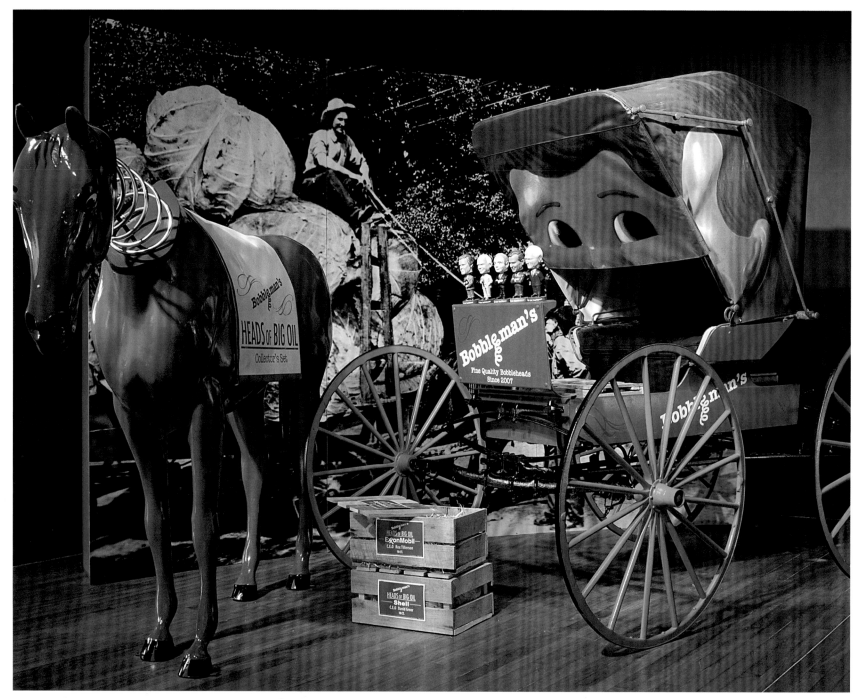

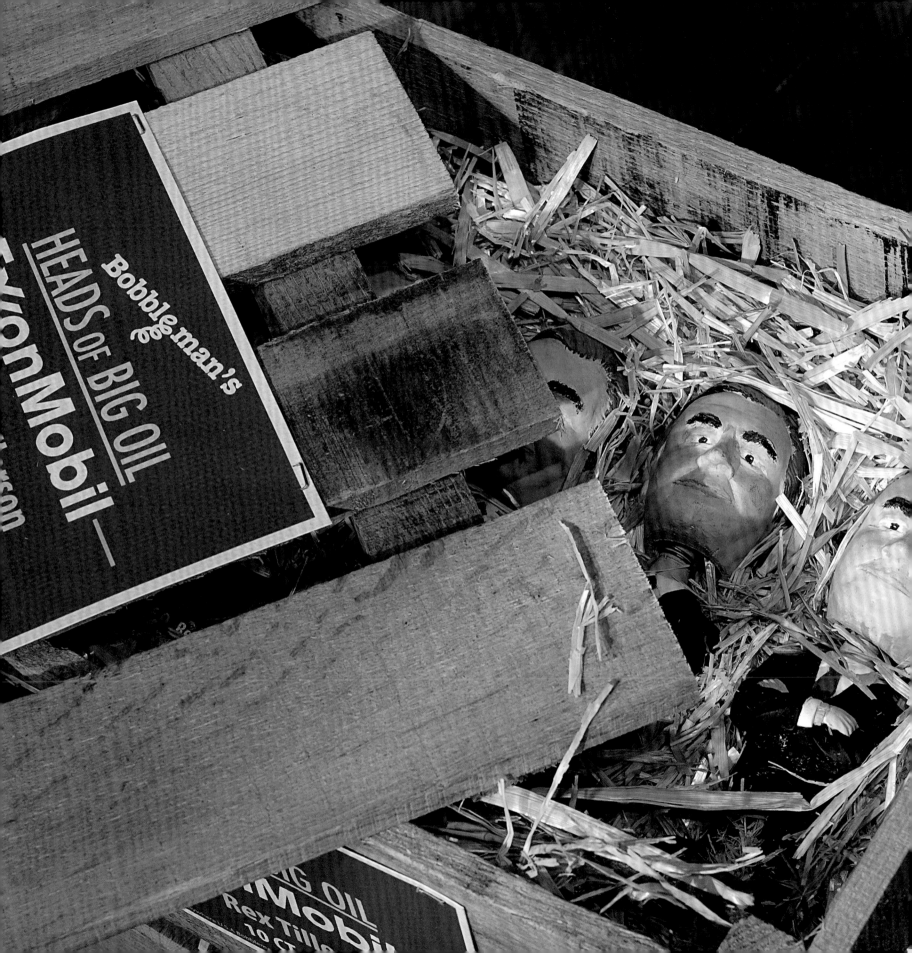

O'C: I found this Victorian sleigh in good condition. Adria Ingegneri saw the "tiki" culture in its shape. She also saw the beautiful wood panels, reminiscent of the old Woodie wagons of the California beach scene, and upholstered the top with material from a beach umbrella supplier.

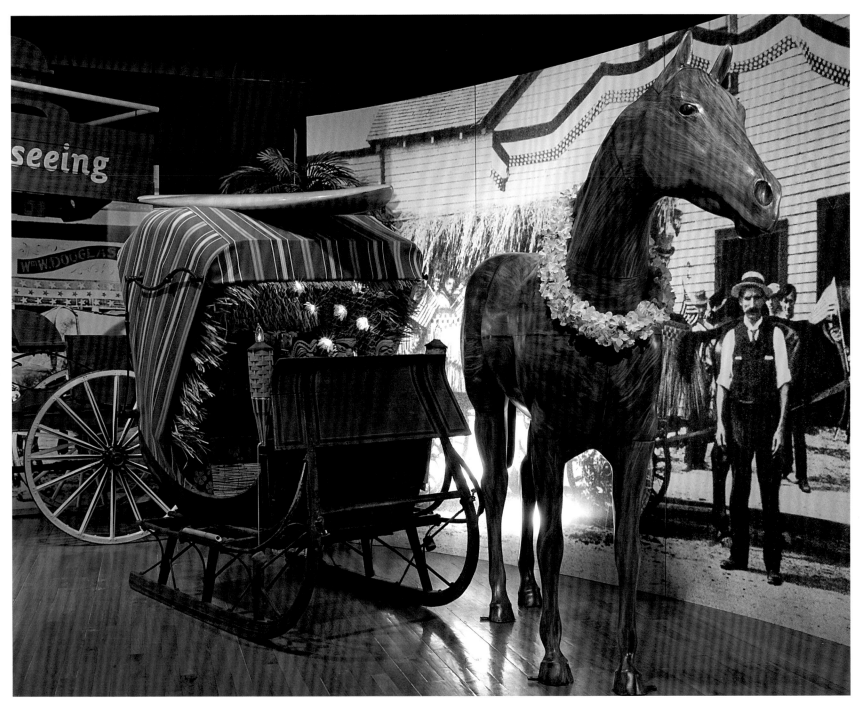

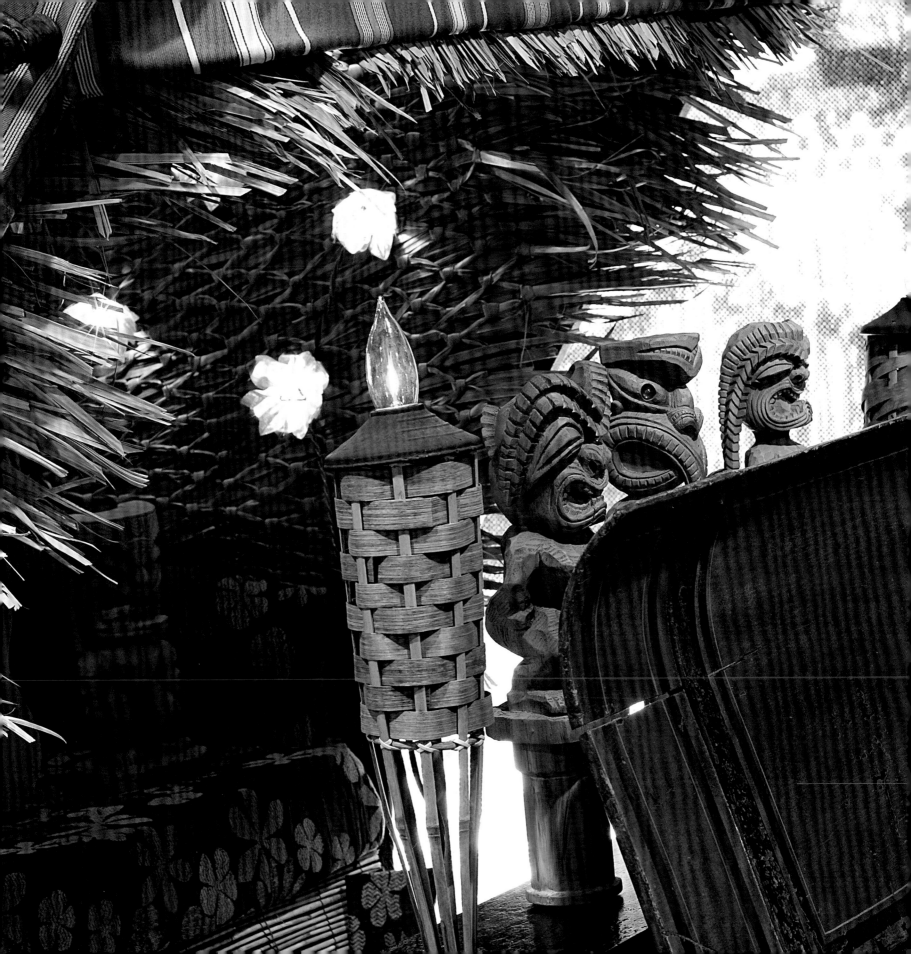

O'C: The Civil War fire wagon turned Con Ed truck was phenomenal. Joseph Pastor revamped it with found objects, including a water heater and discarded fire extinguishers. The horse "ate" hay, and the digested straw cycled its way back into the cart to fuel the vehicle.

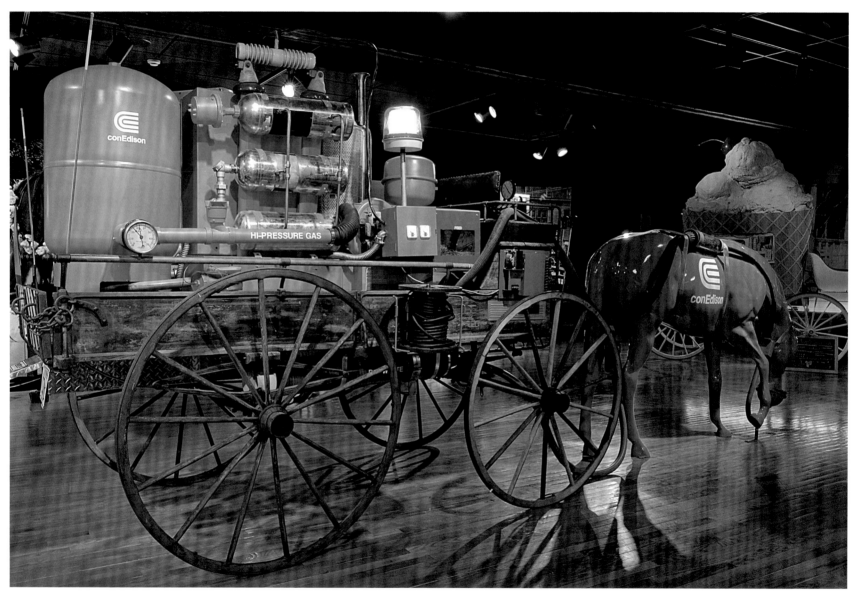

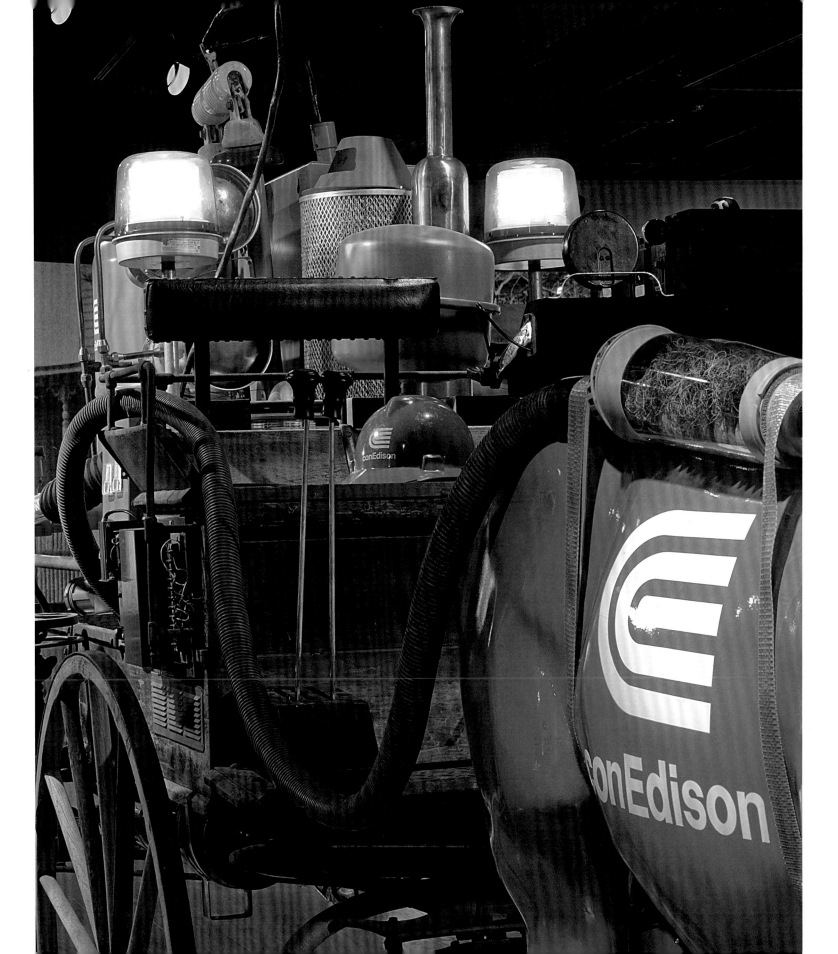

O'C: Su-Hyun Kim's sightseeing wagon was an interesting piece because it was very iconic New York City. When she was done it looked like something that had really existed. This was another Civil War wagon, with a flatbed.

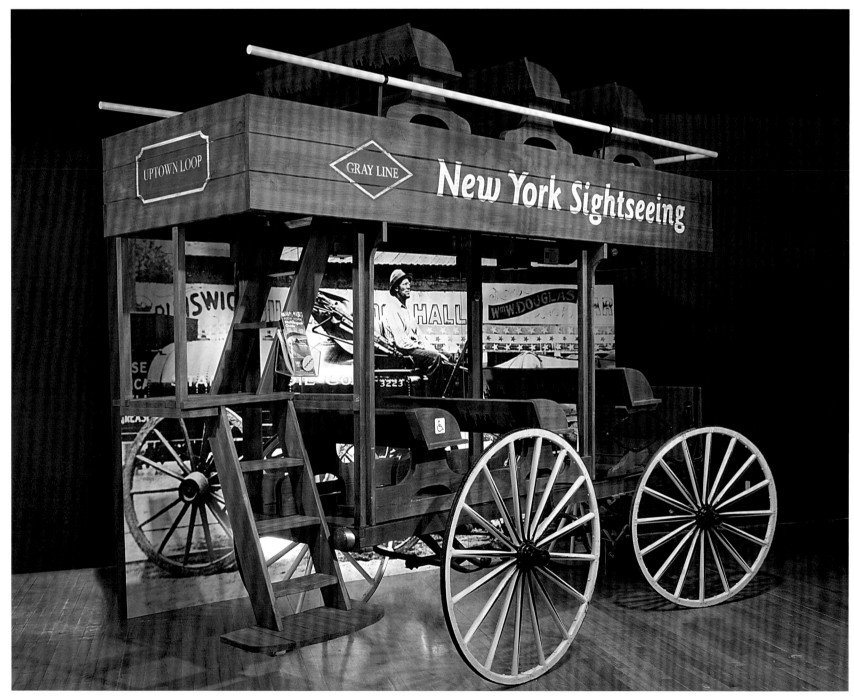

O'C: The ice-cream cart by Kaori Sakai and Rafael Vasquez was originally a small doctor's buggy. They camouflaged the horse into a cow—an advertising idea for the product. At the openings, they served ice cream through the window. To keep the integrity of the carriage, the cone was made from overlapped wood.

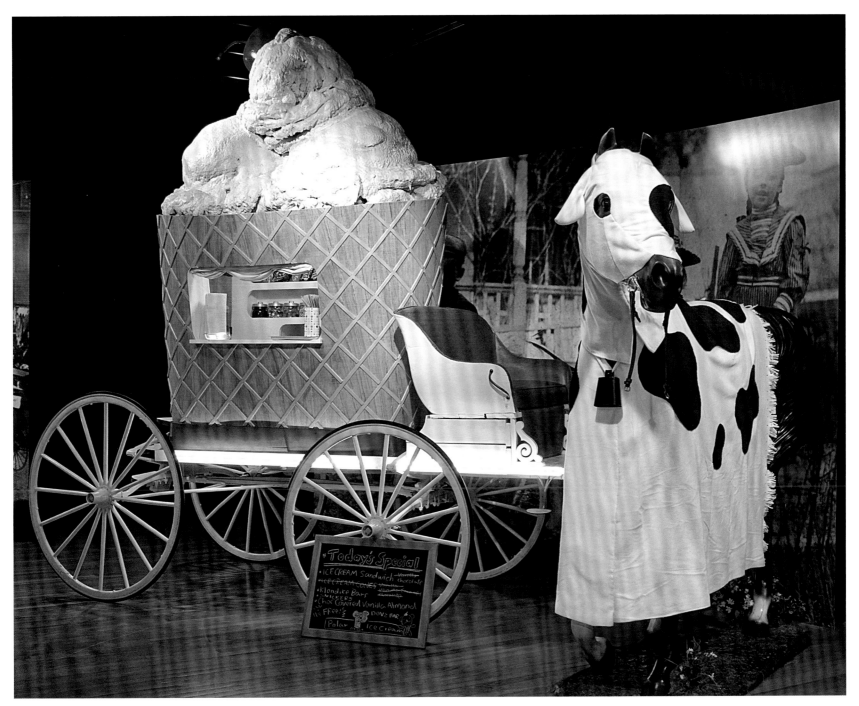

MOONLIGHTING: THE MTV MOONMAN TAKES ON NEW ROLES

CHALLENGE: WHAT CAN THE ICONIC MTV VIDEO MUSIC AWARDS "MOONMAN" TROPHY DO WHEN THE CEREMONIES ARE OVER? REDESIGN THE "MOONMAN" FOR OFF-SEASON EMPLOYMENT.

STARTING POINT: 364 MOONMEN
ARTISTS: 80
WEEKS: 3

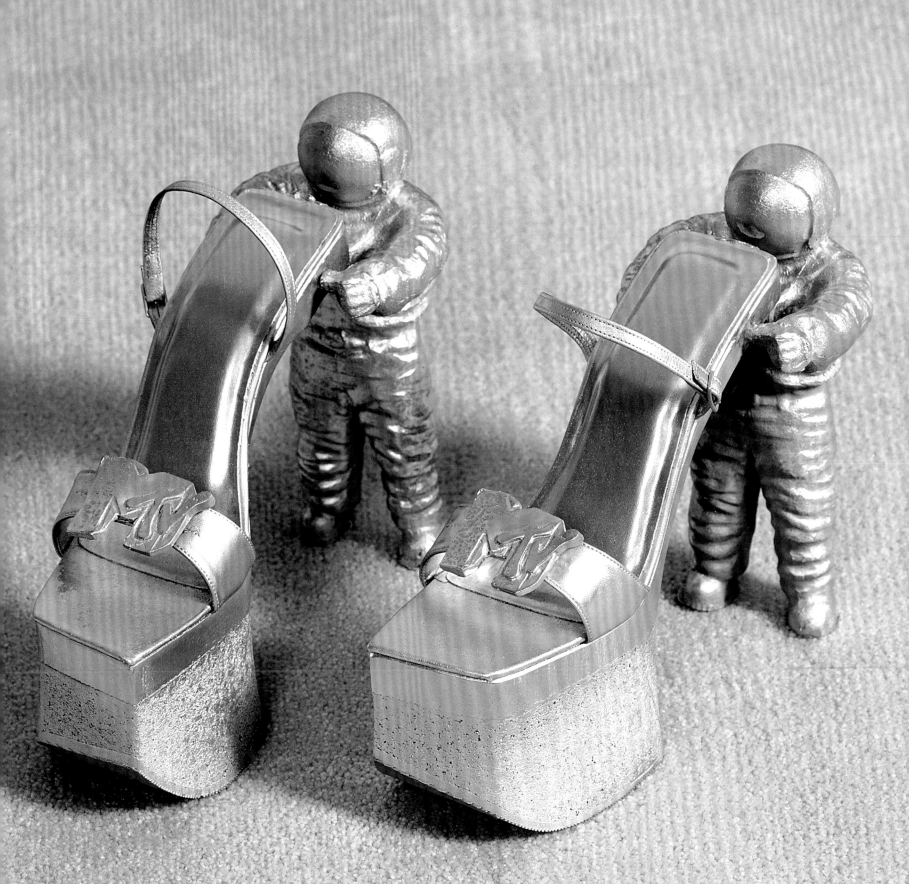

Deborah Adler

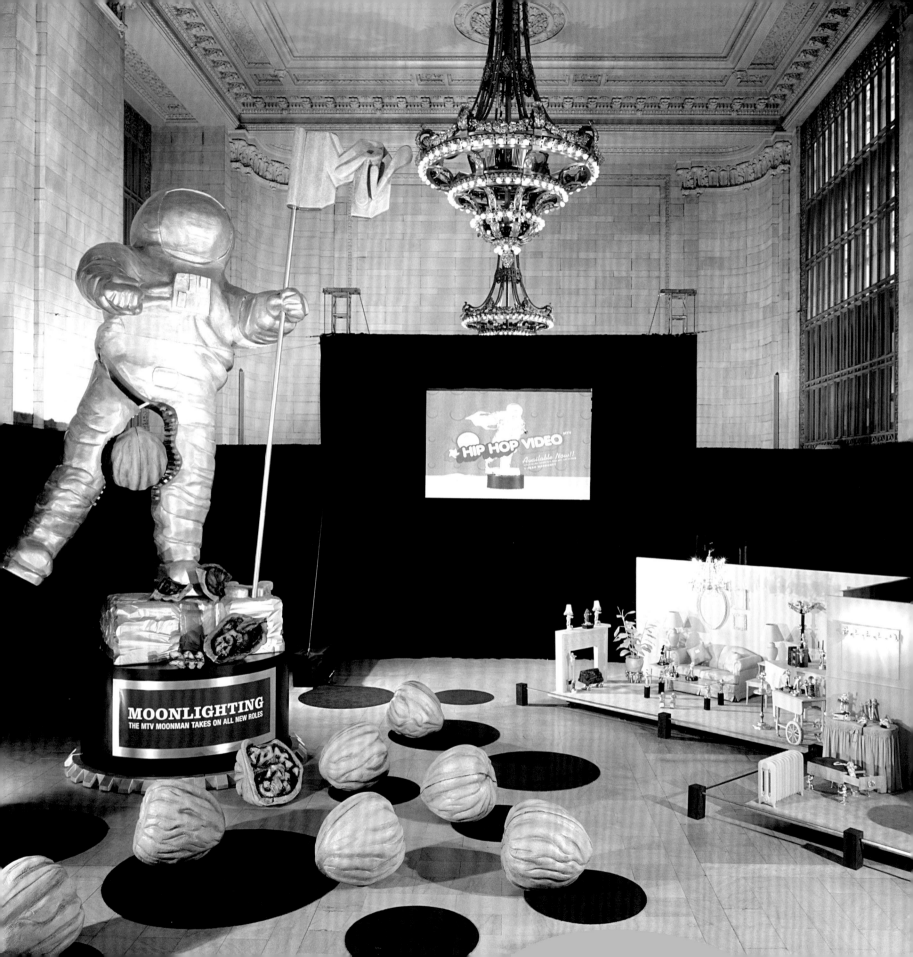

He envisions an exhibition OF MINIATURE space invaders doing EVERYDAY TASKS.

S tranded within the chest cavity of an enormous fiberglass spaceman, Kevin O'Callaghan begins to question his decision to climb inside. A devotee of Raymond Loewy's motto, "Never leave well enough alone," he has ascended to the spaceman's head to undertake a "scootch," the term used by his team when O'Callaghan repositions an artwork in an exhibition. On this occasion, the helmet resting on the shoulders of a gigantic astronaut isn't angled just right; a judgment he reached only after returning the rented scissor lift needed to transport this monumental statue and place it in an upright position. Though generally employed when he wants a large piece moved from one spot to another, "to scootch" can also pertain to an exhibition "tweak" if it includes hiking up a fiberglass creation that is thirty-eight feet high without safety gear, and with no clue of the sculpture's capacity to hold any weight. O'Callaghan is a habitual "scootcher." With the help of a flashlight taped to his baseball cap, and humming Bowie's "Space Oddity," he is mid-performance in his own *Fantastic Voyage*.

O'C: For the MTV Video Music Awards, thirty-second films were made to introduce each award category and were based upon various roles for the iconic MTV moonman to take on. Following the popularity of these video spots, hundreds of hollow statuettes were made for the group show that evolved from the MTV infomercials. The giant walnuts scattered throughout the exhibition space had a diameter of five feet. People used the walnuts to lean against and even sat on them.

Vanderbilt Hall, Grand Central Terminal, New York City

It had all started innocently enough, at a meeting with the folks at MTV about the upcoming Video Music Awards (VMA) gala. O'Callaghan had been invited by Jeffrey Keyton, MTV's senior vice president of Off Air Creative/On Air Design, to discuss strategies for displaying the coveted moonman in new and spectacular ways. O'Callaghan starts thinking about what the little chrome spaceman does when he's not hanging out at the VMA ceremonies. Maybe he helps around the house, lending his unique proportions to hold an ear of corn, mop the kitchen floor, or light the dining room.

Grabbing one of the lunar Lilliputians from the conference table, O'Callaghan and heads home to make a mold and clone some tiny spacemen. A pizza cutter complete with a grated cheese jet pack is next. He's on a roll—a temp agency with a job placement rate at 100 percent. By morning, several devices for various vocations have been added to the spaceman roster: car buffer, thigh exerciser, water sprinkler, and bug zapper.

Although he designed the characters as the central theme for film clips that introduced each category for the VMAs, O'Callaghan is contemplating a room filled with shimmering statuettes; he simply can't help himself. He envisions an exhibition of miniature space invaders doing everyday tasks. Keyton likes the idea and gives it a

name, "Moonlighting." Getting the green light from MTV, O'Callaghan gathers his students to join in the collaboration. A toothbrush holder, basketball hoop, foosball table, and rotisserie join the ranks, ready for their first mission. The moonman mold is handed over to designer Adria Ingegneri, who starts rotocasting plastic replicas, enough for each artist to create multiple objects. With just over three weeks from concept to the VMAs and a simultaneous opening of the exhibition, Ingegneri goes into Mach speed. After making nearly three hundred figures using a twenty-pound mold, her arms are aching and her clothes are covered in Smooth-Cast 320 liquid plastic, but she has entered her mentor's orbit with the rest of the team, and nothing can stop her. Ingegneri's design talent and gregarious spirit led to a job offer from O'Callaghan. Since 2002, she has worked as his assistant and on many of his exhibitions and projects.

THE WOW FACTOR

Successful exhibition design can be as challenging to achieve as the artworks that it will highlight. To curate a two-dimensional show is complex enough; taking the work into the three-dimensional domain requires a score of additional considerations. First and foremost is the overall look of the show from the entrance, what O'Callaghan calls the "wow factor." In public venues such as plazas, train stations, and parks, this is particularly difficult for many reasons, including the possibility of multiple entry points. Pedestrian traffic patterns become an essential facet in the equation, and audience safety, as well as the fragility of the artworks, must be considered in the overall design of the exhibition space. Lighting, backdrops, props, and positioning must be configured and reconfigured until the show tells a story. For an exhibit that travels to different venues, each of these considerations begins anew.

To give a sense of homogeneity, O'Callaghan decided that the chrome color of each moonman could not be altered for the exhibition. He then constructed full-scale rooms for the diminutive sculptures and placed them, by function, in the appropriate environment—living room, kitchen, garage—thus offering additional points of reference to the audience. Because the objects were small, O'Callaghan chose to use a monochromatic palette for each room to offset the chrome of the figures. He included a Triumph Spitfire, complete with green windows, green wheels, and green windshield wipers, in the avocado-green garage.

O'Callaghan created a monumental fiberglass moonman nutcracker as the centerpiece, the very same colossus that had temporarily devoured him, and then constructed giant walnuts that were scattered throughout the exhibition, heightening the surreal aspect of the show's concept.

On the night of the Video Music Awards in Times Square, "Moonlighting" had its opening in Vanderbilt Hall, where the awards ceremony was simulcast on a huge LED screen. Dawn Banket, an events coordinator for Grand Central Terminal and a longtime supporter of O'Callaghan's work, planned the after-party extravaganza on the east side of town with MTV hosting the star-studded event among hundreds of moonmen.

In the weeks following the exhibition, O'Callaghan finds himself reliving his adventure inside the mammoth sculpture of his own creation. With the flashlight still attached securely to his ever-present baseball cap, he reaches the helmet and executes a perfect "scootch." Exiting the nutcracker is next, a maneuver that he hadn't given a thought to before crawling into this Goliath. O'Callaghan wraps himself around the vertical pole at the center of the giant, hoping for the best, and lets gravity take over. The sculpture, secured to the floor by only one leg, begins to shake and then sway, but the sculptor is delivered unharmed onto the marble floor of Vanderbilt Hall. Scootch … whoosh … O'Callaghan. Nuts, anyone?

O'C: The rooms of the house were each painted with a different monochromatic color so that the little chrome figures visually popped out. I was really happy with the color choices, hip colors at the time and very MTV-ish. The round carpets were used to direct people back and forth throughout the exhibition.

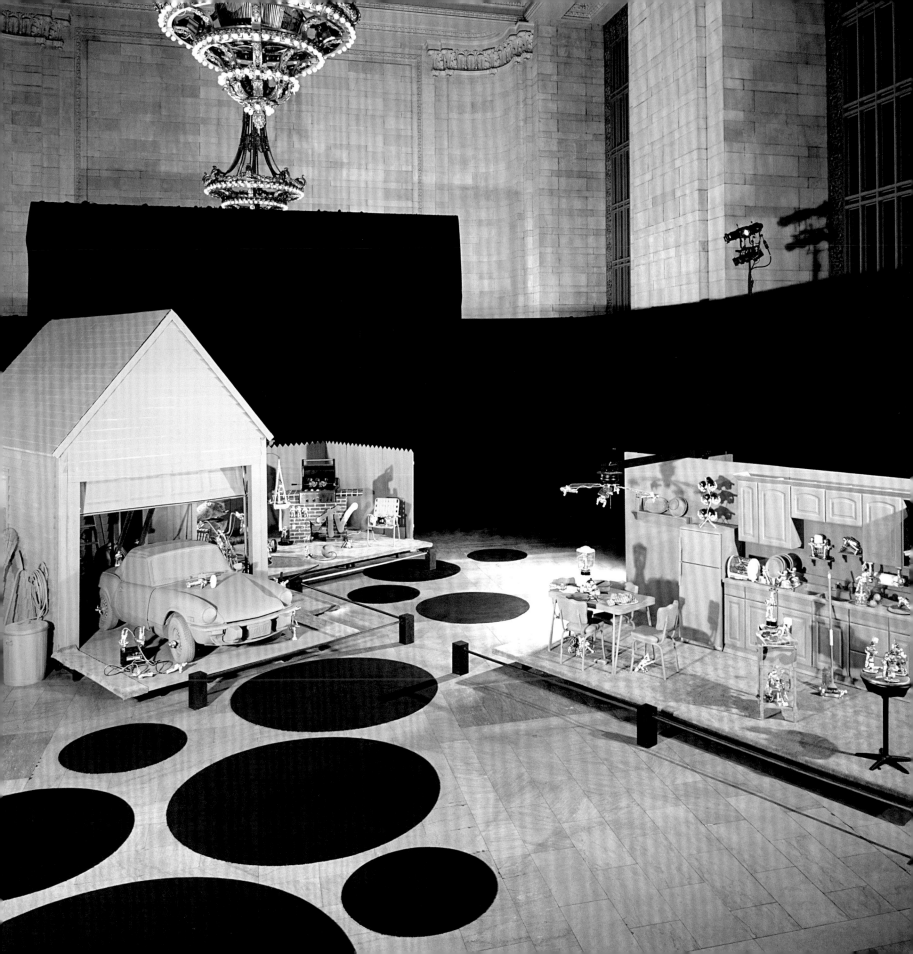

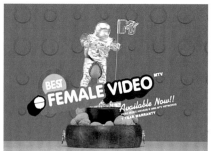
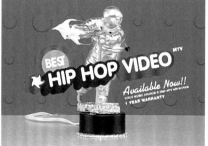
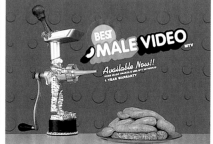
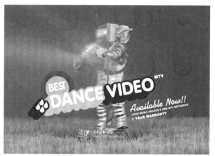

director, producer, art director: Jennifer Roddie; creative director: Jeffrey Keyton; design director: Romy Mann; writer: Laura Murphy; director of photography, editor: Todd Somodavilla; moonman sculptures: Kevin O'Callaghan; assistant, Mark Cadicamo; animator: Luke Choi

O'C: These are still images from the thirty-second promotional videos that announced the award categories for the 2003 MTV Video Music Awards ceremony. The spots won the Art Directors Club Gold Cube Award, beating out notable competitors such as ESPN. The ceremony was broadcast globally, and it was exciting to know that hundreds of millions had seen the clips.

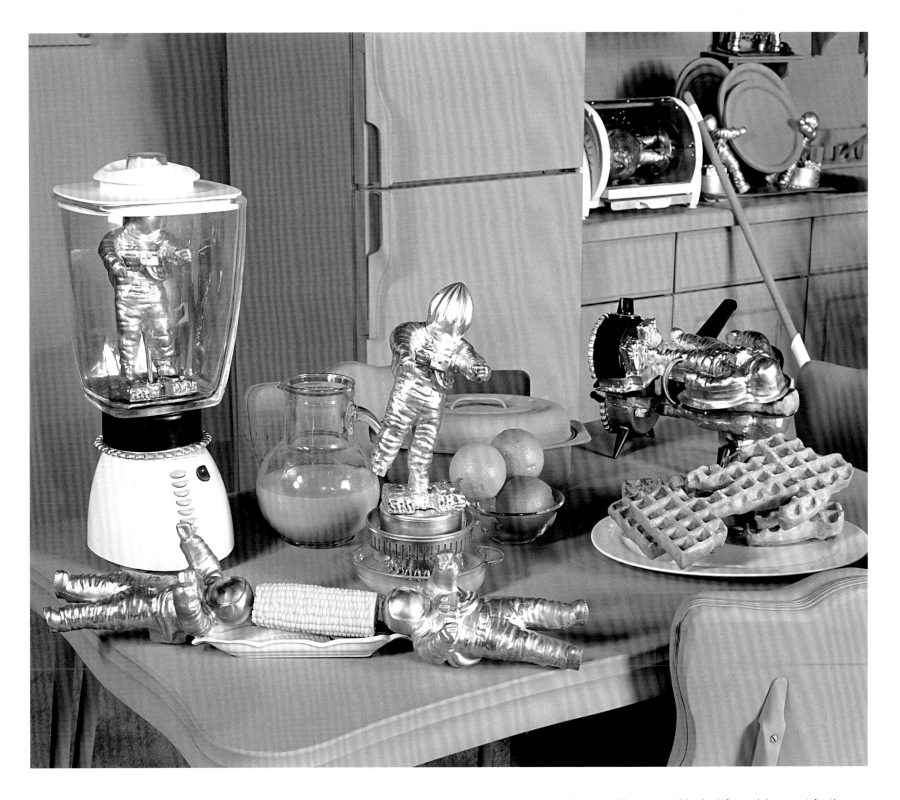

O'C: All of the pieces on the kitchen table were used in the infomercials, except for the corn holders. The infomercial moonmen had to be built over one weekend—all fifteen of them: pizza cutter, nutcracker, sausage maker, cake mixer, lawn sprinkler, blender, juicer, surveillance camera, waffle iron, thigh exerciser, steering-wheel lock, Swiss Army knife, rock'em sock'em robots, bug zapper, and car buffer.

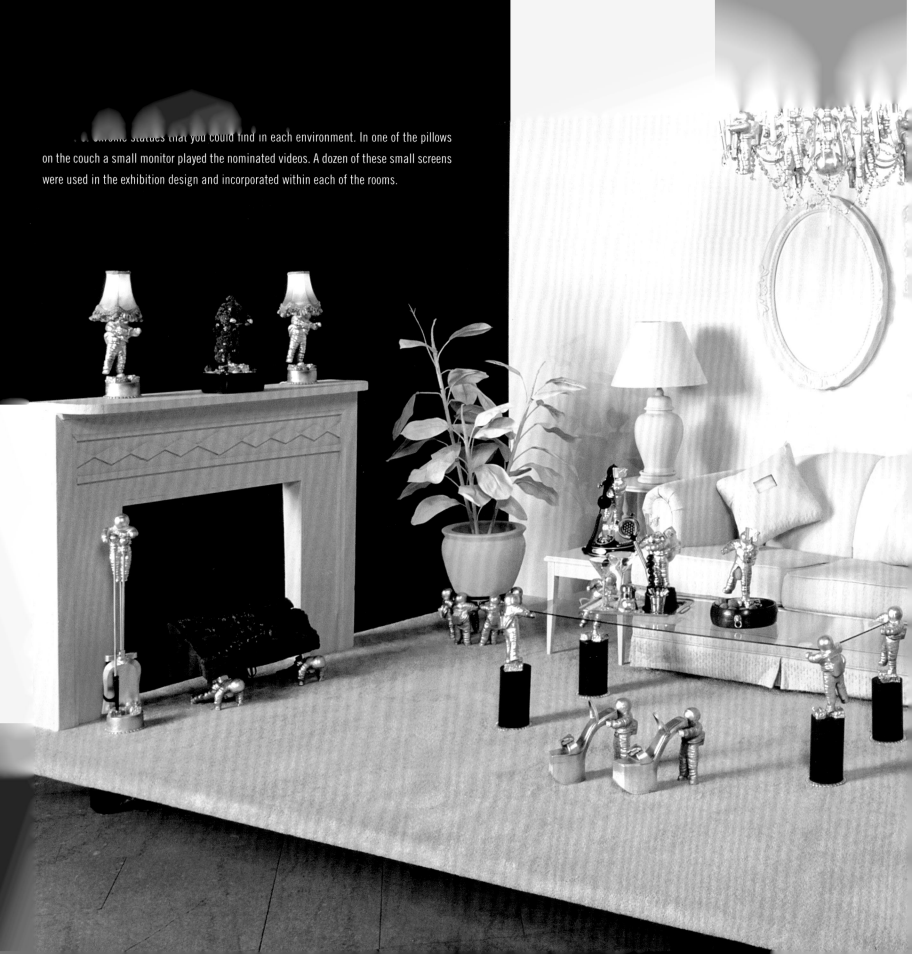

...chrome statues that you could find in each environment. In one of the pillows on the couch a small monitor played the nominated videos. A dozen of these small screens were used in the exhibition design and incorporated within each of the rooms.

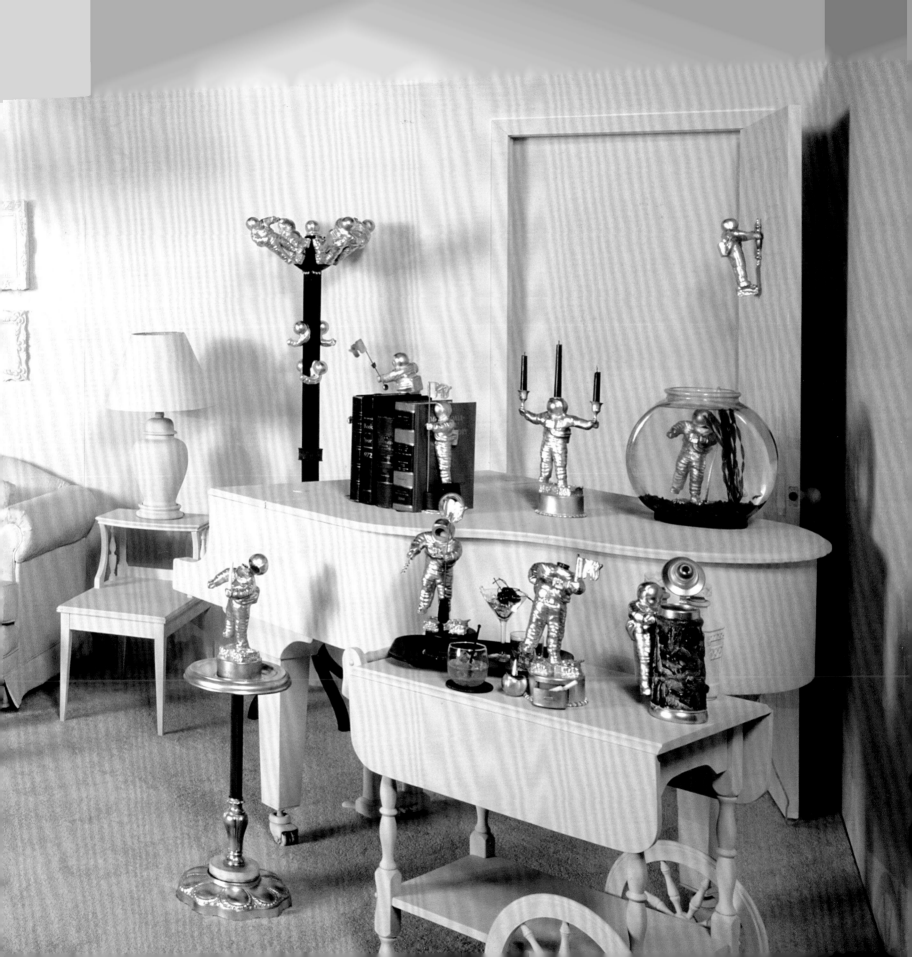

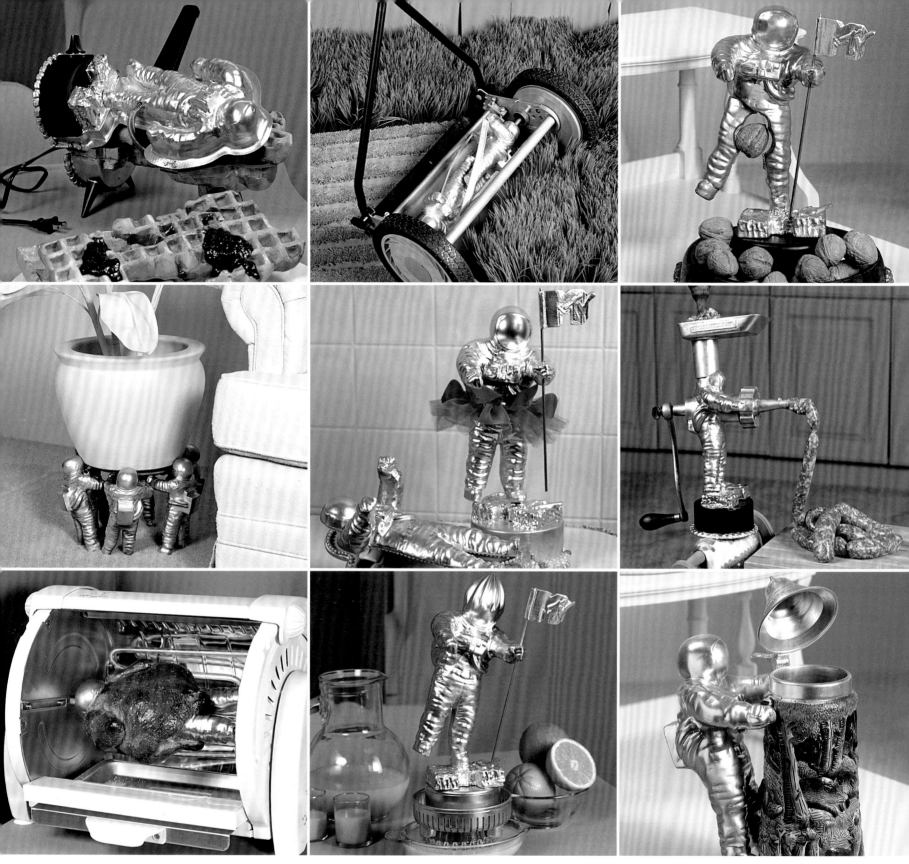

waffle iron: *Christopher Dimino*
plant holder: *Carolyn Mueller*
rotisserie: *Dorothy DiComo*

lawn mower: *Robert Conlon*
music box: *Piotr Wozniak;* compact: *Moon Sun Kim*
juicer: *Mark Cadicamo*

nutcracker: *Kevin O'Callaghan*
sausage maker: *Kevin O'Callaghan*
beer stein: *William Paladino*

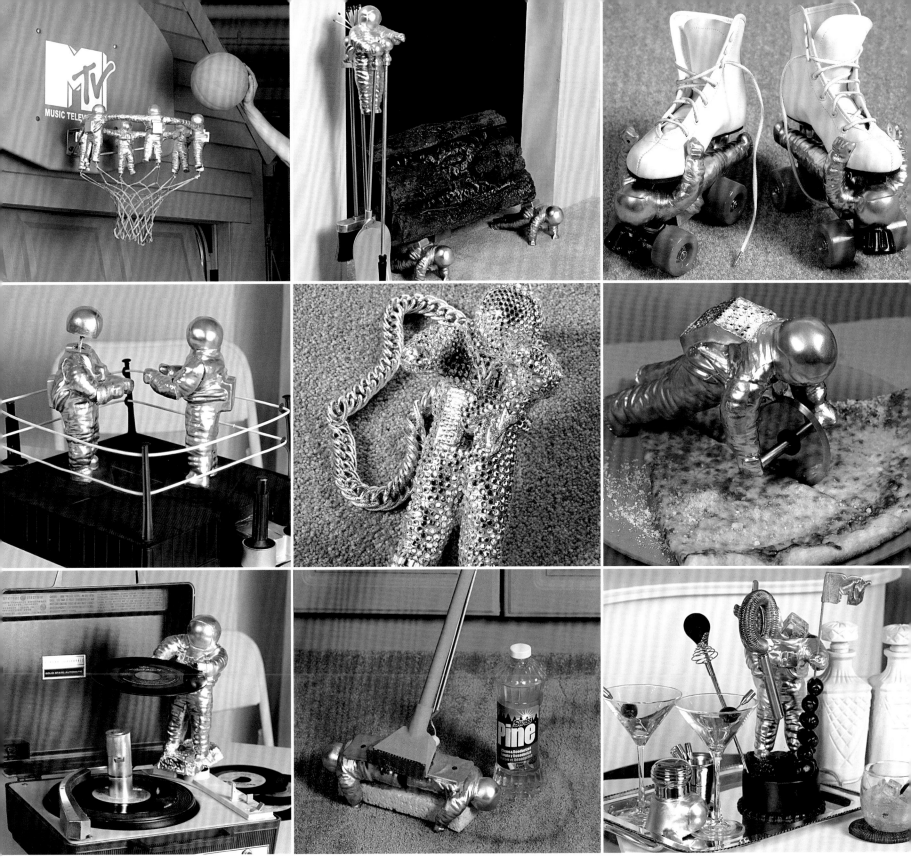

basketball hoop: *Shaun Killman*
rock'em sock'em robots: *Mark Cadicamo*
record player: *Yvette Awad*

fireplace tool set: *Erika Bettencourt*
necklace: *Celia Landegger*
mop: *Jessica Hill*

roller skates: *Christina DeMarco*
pizza cutter: *Kevin O'Callaghan*
martini shaker: *Vincent Keane*

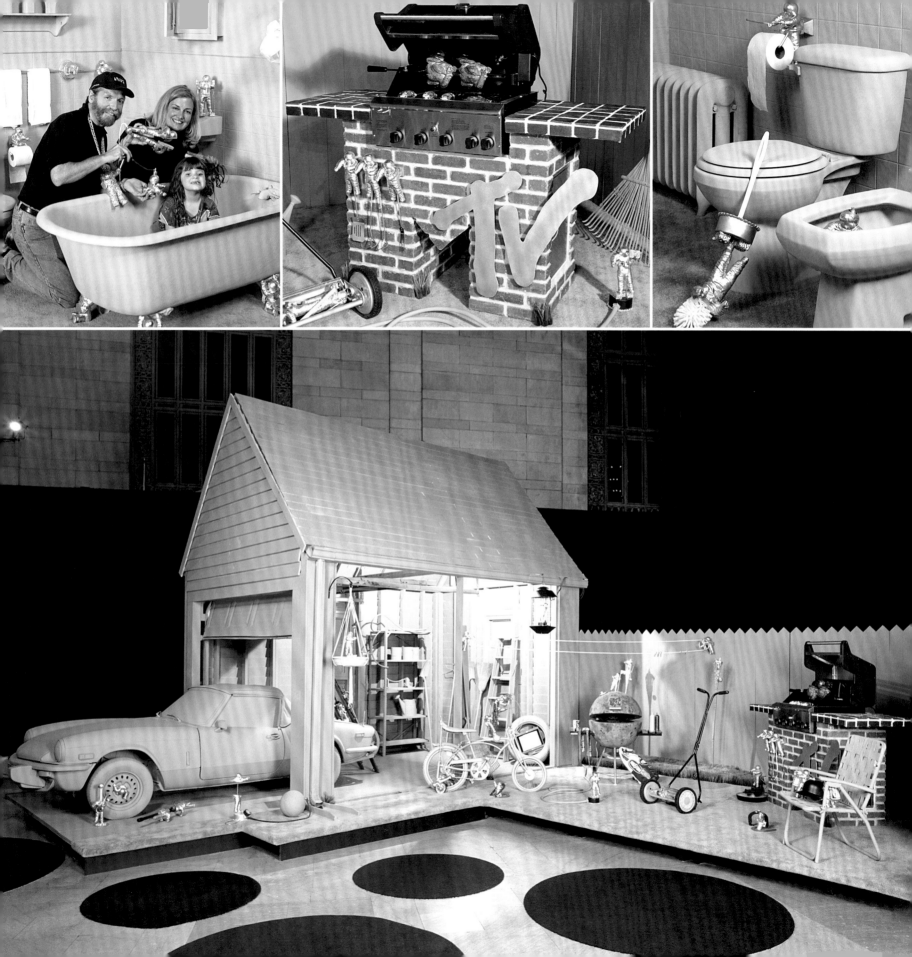

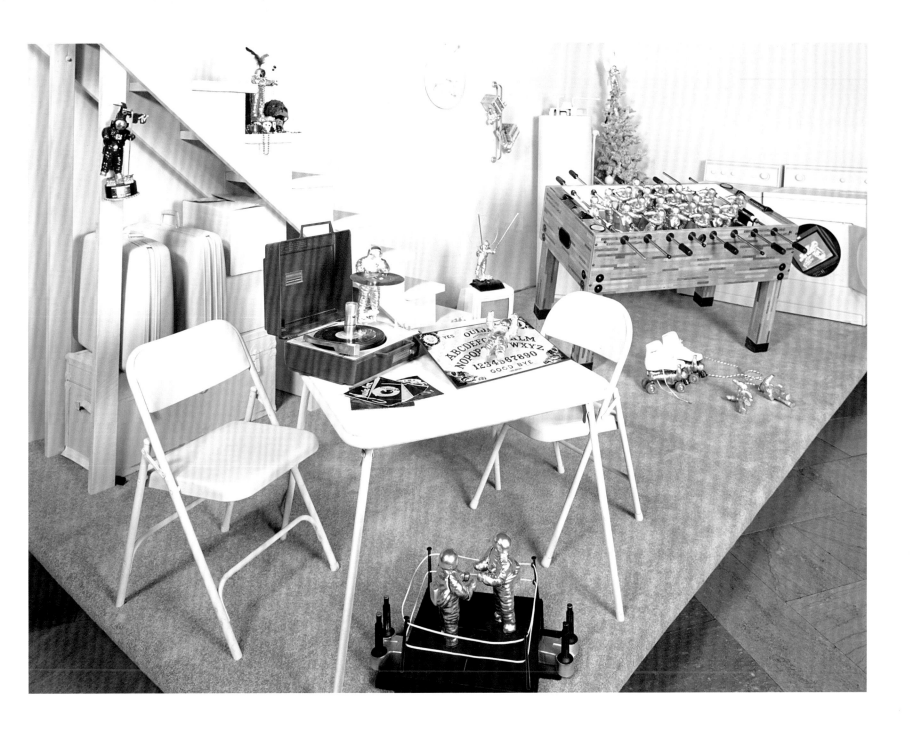

O'C: The image of my wife, my daughter (about six years old), and me is a rare picture of the three of us at an exhibition.

O'C: Lori Casella's brick barbecue was an intricate piece. It was so heavy that it took several people to lift it. Cutting the brick to form the "M" for the MTV logo was quite a feat.

O'C: The bidet was a real crowd pleaser; you can see the head of the moonman that dispersed the water.

O'C: The basement was a lot of fun because the staircase gave it that cellar feeling. This room had the only moonman that I allowed to be painted: a red fire extinguisher.

O'C: My favorite environment in our fictional home was the garage. I didn't have the heart to tell the man who donated the Triumph that I planned to cover it with latex paint, but it needed to be painted to work with the monochromatic theme.

CHALLENGE: CREATE A SPECTACULAR EVENT TO BE THE CENTERPIECE AT ROCKEFELLER CENTER FOR THE 2003 MTV VIDEO MUSIC AWARDS SIDESHOW.

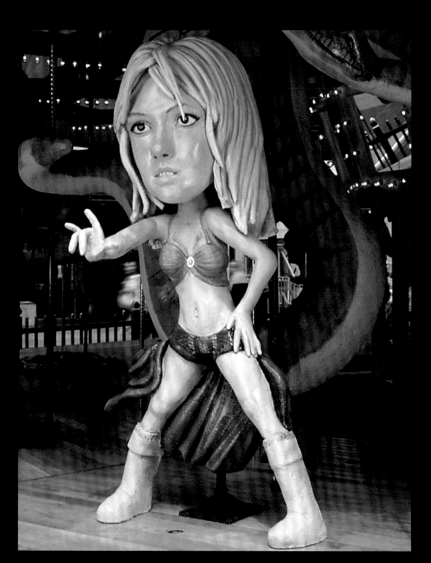

Carousel—concept and design: Kevin O'Callaghan; production assistants: Mark Cadicamo; Adria Ingegneri; Bayard Boudoir, Giovanni Calabrese (caricatures); Christopher Malec (caricature sketches). Posters—creative director: Jeffrey Keyton; design director: Jim DeBarros; art director: Thomas Berger; letterer: Lance Rusoff; photographer: Dewey Nicks

O'C: MTV approached me to create something for their 2003 Sideshow in Rockefeller Center, which included a week of events leading to the MTV Video Music Awards ceremony. Thinking about creating a carnival atmosphere, I walked into the meeting carrying an enormous sculpted head of Madonna under my arm, from the 1997 "Turn of the Century" carousel that I had created. I liked the idea of making another enormous carousel, this time with many of the stars—past and present—of the MTV awards show on it. After presenting the concept to MTV creative team—Jeffrey Keyton, Jim DeBarros, and Thomas Berger—I designed and began creating a carousel with mammoth celebrity heads. The celebrities posed holding their likenesses, and photographed by Dewey Nicks. These beautiful images were used for a series of posters. There were also about twenty sculpted figures, including Justin Timberlake, Beyoncé, Ozzy Osbourne, Missy Elliott, Britney Spears, Gwen Stefani, Marilyn Manson, Chris Rock (awards host), Dr. Dre, Snoop Dogg, Cyndi Lauper, and Kid Rock (See pages 102/103). The carousel was next to the red carpet, and as the celebrities walked by we would spin the carousel to have the corresponding sculpted head up front, and they would walk over and pose next to the head. It became a real hub for that year's presentations.

We worked on creating the celebrity heads in a basement and the day before MTV came to see them, there was a blackout across the Northeast. It was pitch black and we couldn't see anything—the heads, the tools, or our hands. We brought the heads up to the sidewalk and worked all night, using car headlights and sanding by hand. It was mid-August and terribly hot. People began to gather outside, especially since there wasn't much to do until the power came back on. Then they started to critique our work, "Oh, that's not what Britney looks like," and so on. It was hard enough to get these heads to look like famous musicians; we also had to work in the dark in the sweltering summer all night on the street with critics. In the end, it turned into a kind of happening. When it came to the carousel, I had a last-minute thought to "reuse" the giant moonman from the 2002 "Moonlighting" exhibition. I wanted an element to top it off, something a little out of the box. So we placed the colossal MTV moonman in the center of the carousel and had the canopy top collapse around him as if he were crashing through the carousel.

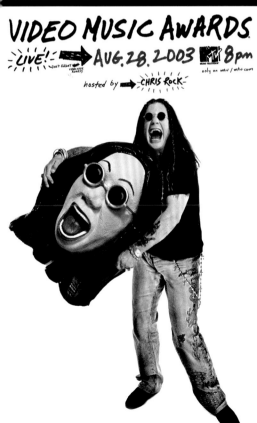

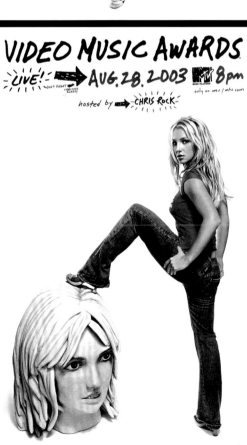

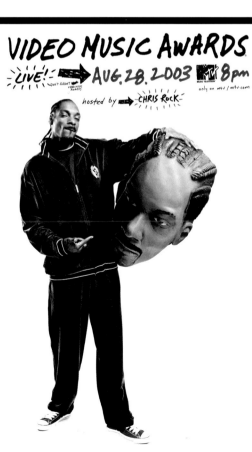

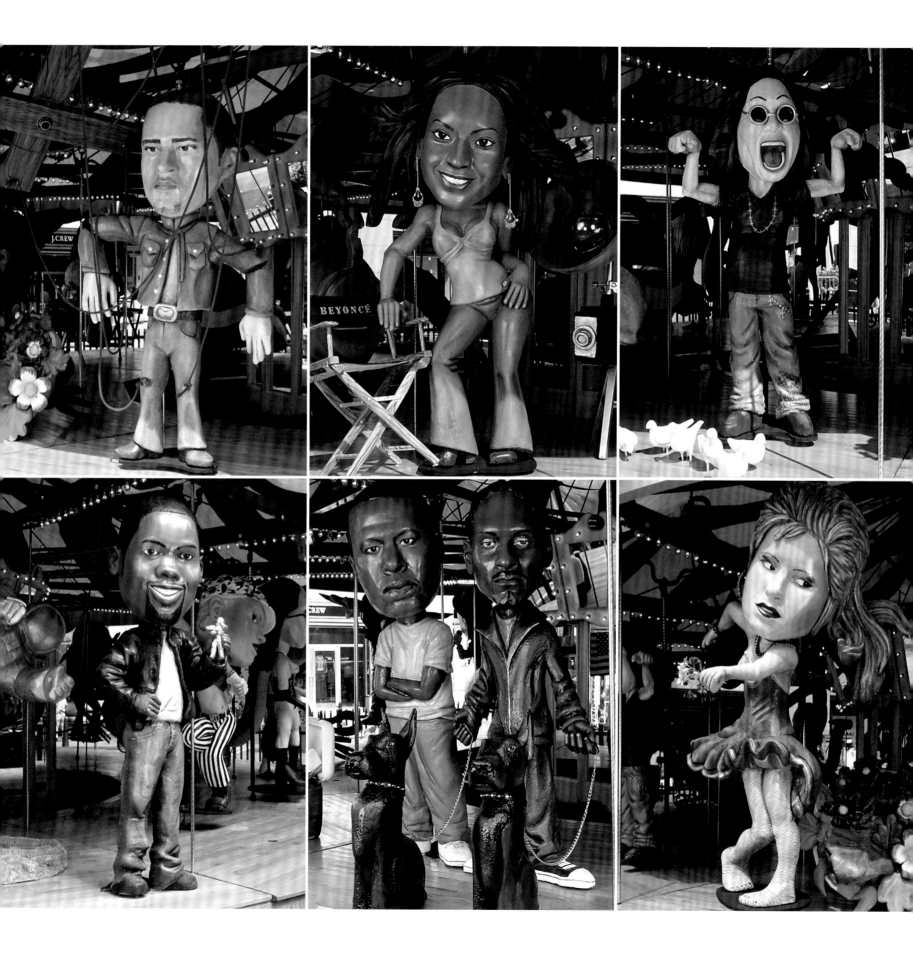

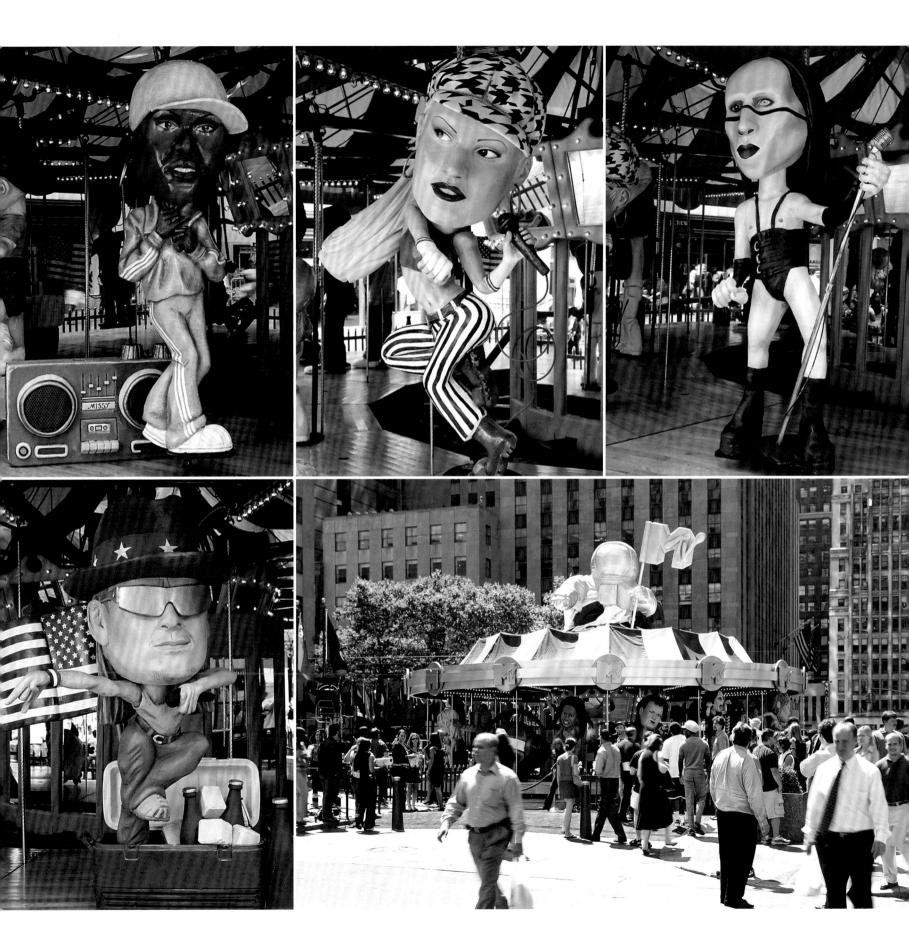

OC: The Popcorn Trophy started out as a satirical thing and ended up becoming a very important award. Some younger people in the industry consider the MTV Movie Awards as important as the traditional movie award shows because of who watches them; it works better for their demographic. In designing the award, it was fun to mix both bronze and paper together. The concept was that the graphics on the paper cup would be redesigned each year to work with that year's branding. I also produced each trophy for the first few years—forty-five of them and all handmade. It became a pop icon that I'm very proud of.

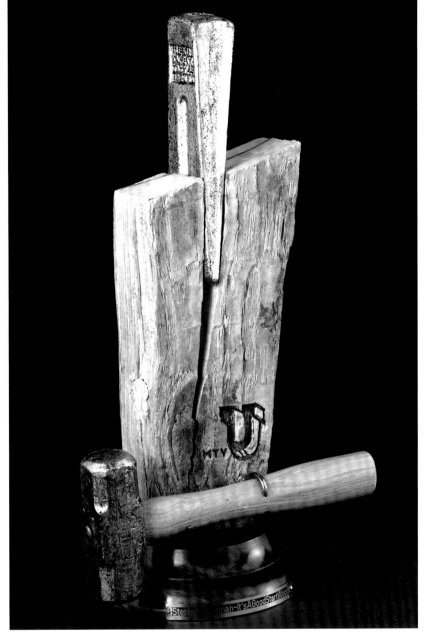

O'C: To my surprise, the Woody Award has also become a serious award to the underground garage bands for the music industry. The Woody is voted on by college students through MTVU, a station that only broadcasts on college campuses. The award is interactive: The winning band can "slam" the gold wedge farther into the wood with the hammer and create the finished trophy onstage.

O'C: For MTV TR3s, the Latin music channel, I created a special People's Choice MTV Latin Music Awards trophy as a classic shrine with a votive candle in it. Very similar in approach to the popcorn movie award where the graphics on the cup holder change each year; here, the graphics on the candle change according to the branding of the event. When the candle is lit, it displays beautifully. It was very labor-intensive to make.

production assistants: Alexis Logothetis, Adria Ingegneri, James Korpai

DISARM

CHALLENGE: ADDRESSING THE CURRENT WORLD CONFLICT, NEUTRALIZE AN M16 ASSAULT RIFLE BY TRANSFORMING IT INTO SOMETHING PRACTICAL OR BENEFICIAL TO A PEACEFUL SOCIETY.

STARTING POINT: 120 MILITARY ASSAULT RIFLES
ARTISTS: 65
WEEKS: 3

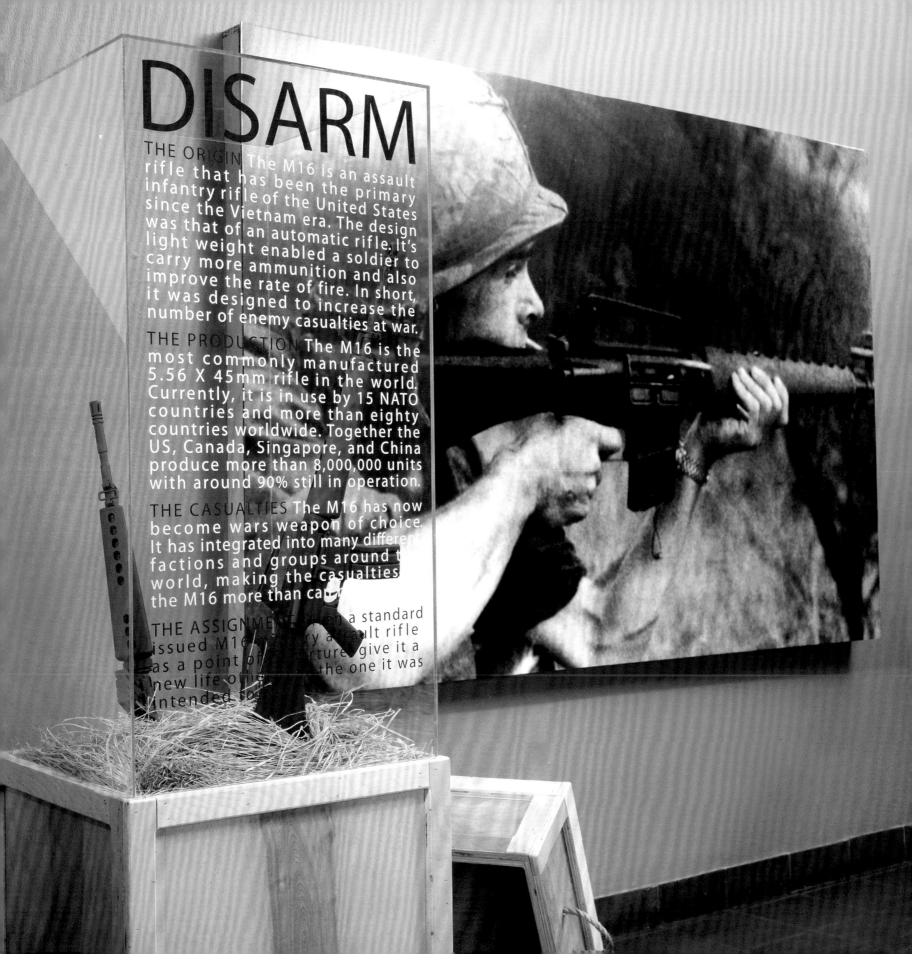

DISARM

THE ORIGIN The M16 is an assault rifle that has been the primary infantry rifle of the United States since the Vietnam era. The design was that of an automatic rifle. It's light weight enabled a soldier to carry more ammunition and also improve the rate of fire. In short, it was designed to increase the number of enemy casualties at war.

THE PRODUCTION The M16 is the most commonly manufactured 5.56 X 45mm rifle in the world. Currently, it is in use by 15 NATO countries and more than eighty countries worldwide. Together the US, Canada, Singapore, and China produce more than 8,000,000 units with around 90% still in operation.

THE CASUALTIES The M16 has now become wars weapon of choice. It has integrated into many different factions and groups around the world, making the casualties the M16 more than can

THE ASSIGNMENT given a standard issued M16 military assault rifle as a point of departure give it a new life other than the one it was intended to

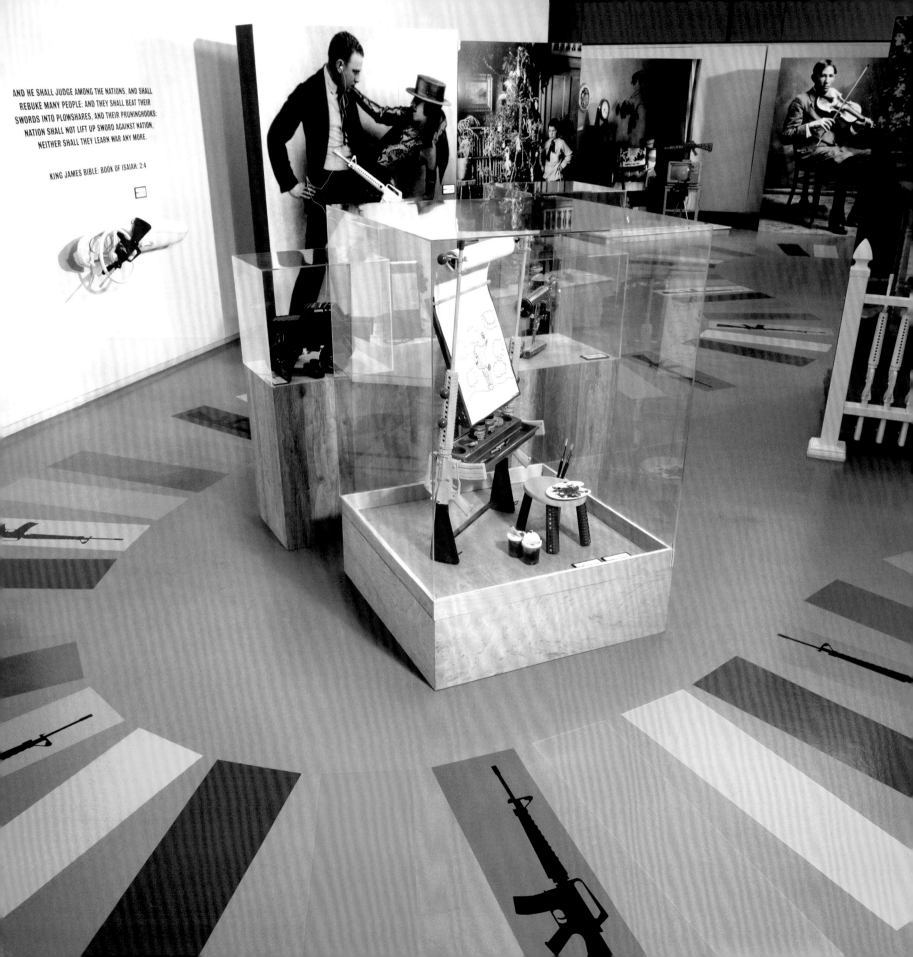

AND HE SHALL JUDGE AMONG THE NATIONS, AND SHALL
REBUKE MANY PEOPLE: AND THEY SHALL BEAT THEIR
SWORDS INTO PLOWSHARES, AND THEIR PRUNINGHOOKS:
NATION SHALL NOT LIFT UP SWORD AGAINST NATION,
NEITHER SHALL THEY LEARN WAR ANY MORE.

KING JAMES BIBLE: BOOK OF ISAIAH: 2:4

A KILLING MACHINE had been TRANSFORMED, if only fleetingly, into a vase.

In 2006, Kevin O'Callaghan's junior undergrads at the School of Visual Arts had already spent their first three years of college study in the shadow of violent conflict. Some had endured the loss of a friend; some were burdened with the death of a family member. Every one of them, United States citizens and students from overseas, was directly affected by the war in Iraq.

O'Callaghan sensed their communal malaise, and he recalled his feelings during the war in Vietnam, which was raging when he was a young art student. He thought about an iconic image of peace from that time, which has stayed with him ever since. It was a graphic and touching photograph of someone placing a flower in the barrel of a military assault rifle. In that moment, a killing machine had been transformed, if only fleetingly, into a vase. The concept for "Disarm" was to create something peaceful with these guns and eliminate their power, real and symbolic. To this end, O'Callaghan added large photographic prints, reminiscent of Norman Rockwell's American families, as exhibition backdrops to the artworks.

A Midwest supplier of assault weapons sold and shipped 120 used army-issue training rifles, firing mechanisms removed, to O'Callaghan. He and his students refused to give the guns power, treating these objects of malice as though they were simply manufactured metal forms to be transformed into artworks, but the strong associations of terror and loss that these weapons retained could not be invalidated through sheer creative will alone. O'Callaghan further rendered the guns passive by insisting that the students take them apart anytime they were not constructing their works.

From his studies with Milton Glaser, O'Callaghan had learned that color was a principal influence in perception. Painting the rifles with a bright and lively palette helped to remove the fear associated with them. Many of the artworks incorporated soft, textured materials that further distanced the intended function of the metal arsenal. The assignment offered these students a way to exorcise their distress as well as an opportunity to change the persona of an object with thoughtful design. The magnificent white picket fence by Adria Ingegneri was an audience favorite, as was designer Michael Pisano's tomato planter, which had been adapted to support the nourishment that sustains life. Artworks from the show were also displayed at the United Nations, and included in "The Missing Peace: Artists Consider the Dalai Lama."

To enter a room filled with artillery that has been neutralized is a very different experience than walking into a commuter train station that is vigilantly monitored by the armed National Guard. The audience for "Disarm" had no sense of danger, although they were milling around more than one hundred rapid assault rifles. O'Callaghan subscribes to the belief that guns don't kill, people do. "Disarm" championed the plea to make art, not war.

The exhibition speaks for itself. We need only to listen.

O'C: At the Art Directors Club in New York, we did the floor treatment like the "Game of Life" game board, and you followed it around in similar fashion. It was a very effective and fun way of moving people through the exhibition.

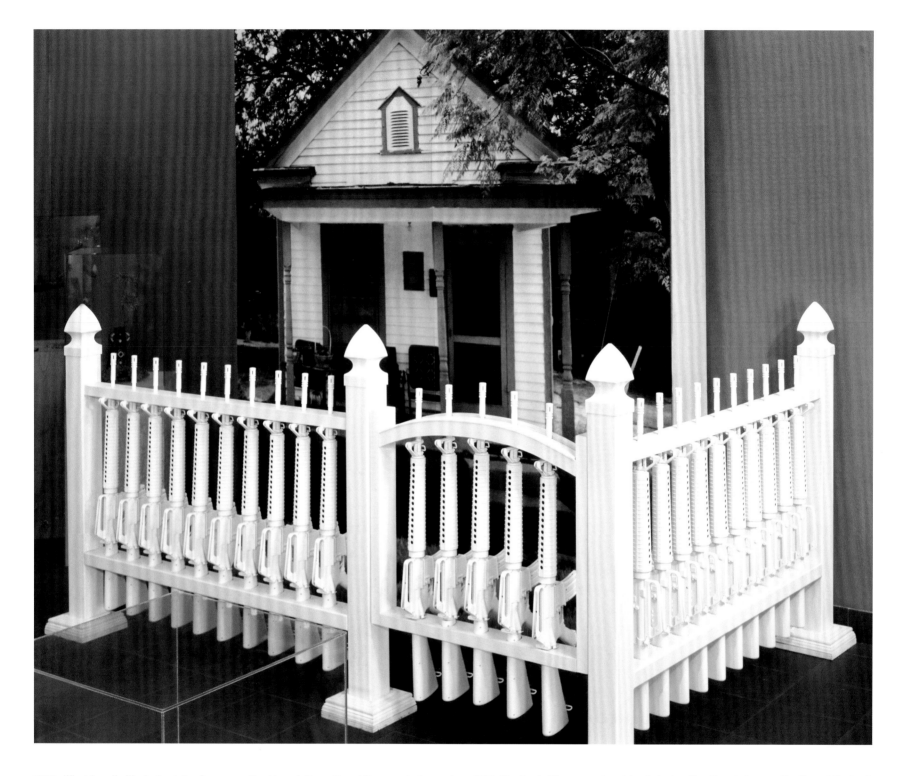

O'C: What I really liked about the fence was the idea of *Home Sweet Home* and also how the guns were painted white, which embellished the filigree detail. Adria Ingegneri transformed these weapons into a peaceful, Victorian-era porch enclosure.

O'C: The mixer was a collaborative piece by Ada Leung and Donald Miller. The color was a perfect choice for transforming this rifle into a kitchen appliance from the 1950s.

O'C: Stephanie Monroe made a tricycle by bending the whole gun. Starting at the back area, it slowly arced and led you to the handlebars; the tip of the gun was in front. By painting it a Radio Flyer red, it became just a tricycle when you looked at it quickly. A second look revealed it had been a lethal weapon. The pedals were made from the ammunition cartridge.

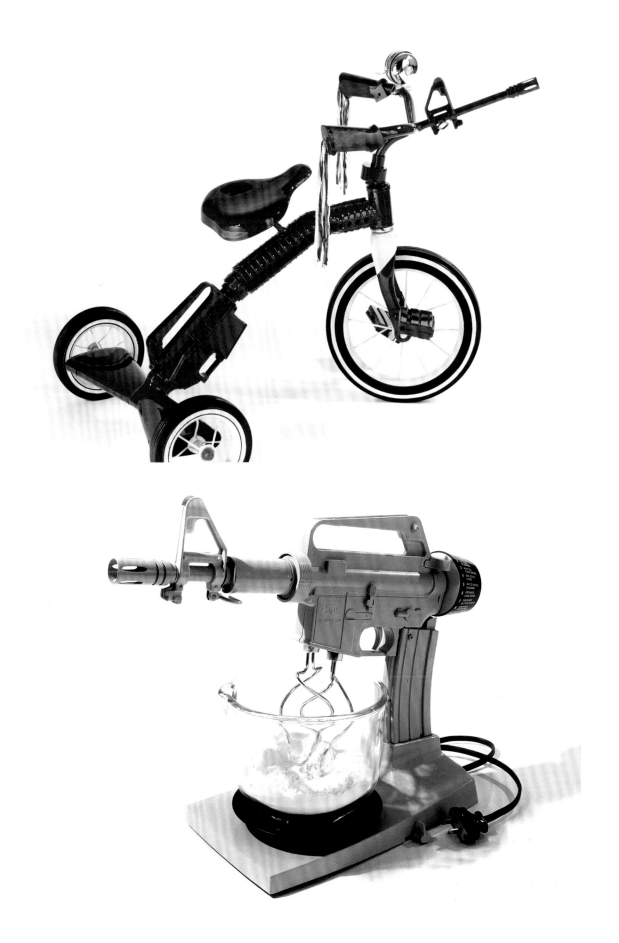

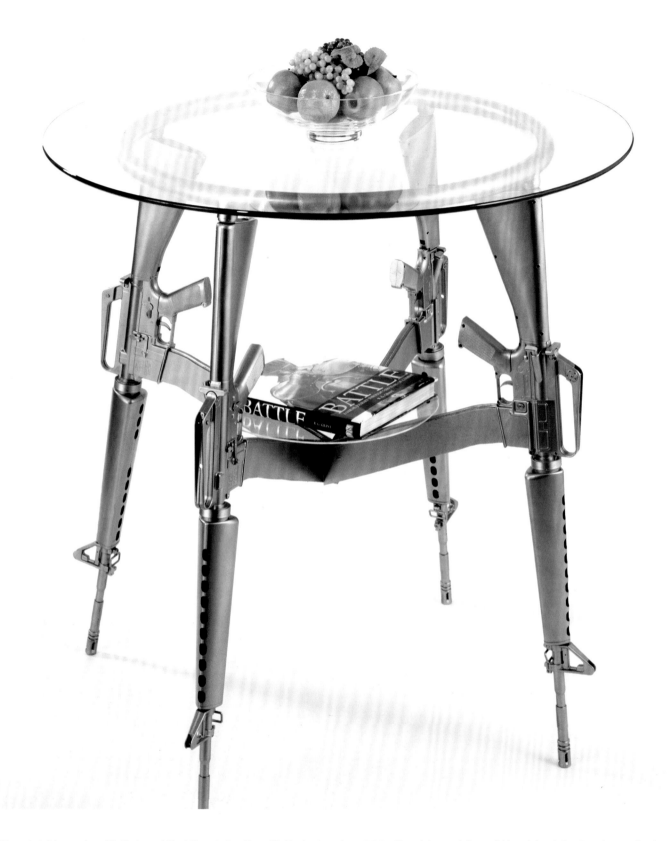

O'C: Myung Ha Chang's table was beautifully done. I liked the art direction with the book on battle in the middle. The silver patina made it so that you hardly noticed the guns.

O'C: The vintage picture of the girls at the beach was the backdrop to this beach scene. Michelle Silverstein made the chair and umbrella, and Gina Marie Maniscalco created the beer keg. These simple elements worked well together for the environment.

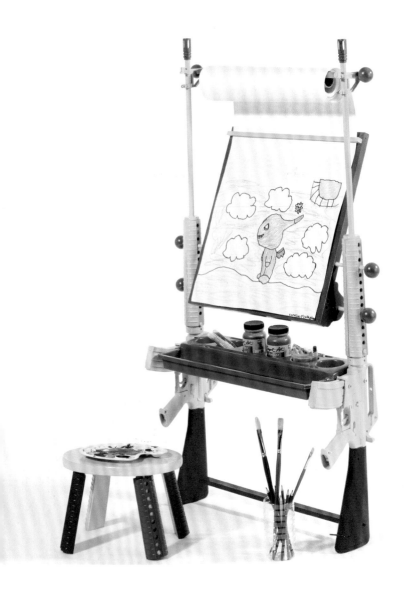

O'C: The children's easel by JungMeen Lee was covered with bold, primary colors and became a creative piece in numerous ways. My daughter, Caroline, drew the picture on the easel when she was eight years old.

O'C: The baby stroller was on display at the United Nations. In addition to Fumiyo Osawa's choice of subject matter, the white and baby blue palette emphasized the juxtaposed elements of the M16s and the infant's carriage.

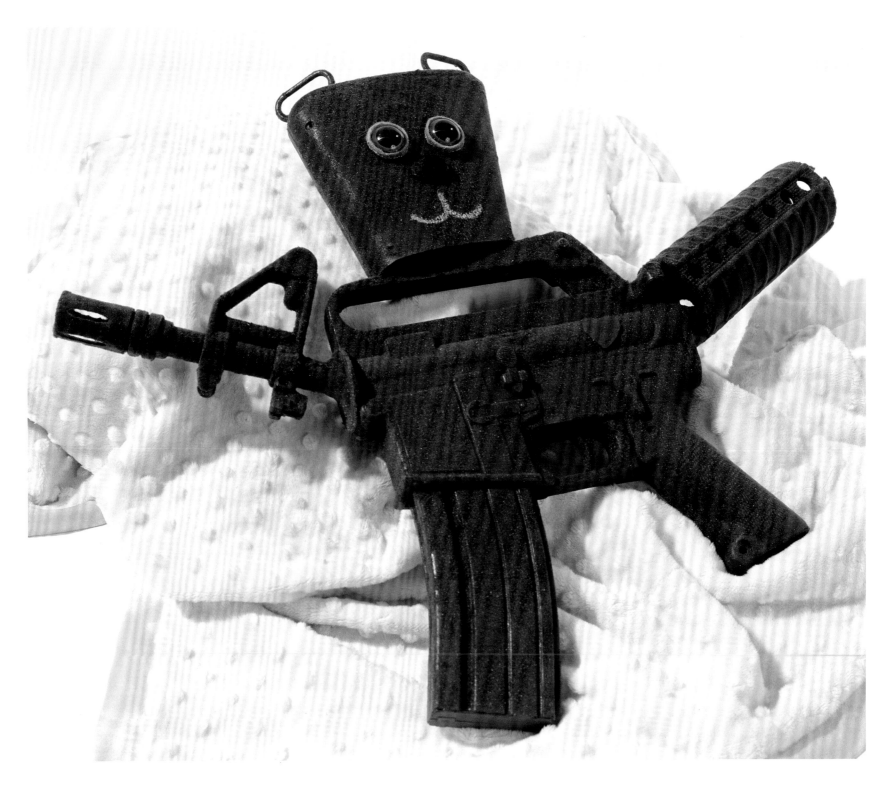

O'C: The teddy bear by Heather Griffin was the ultimate peaceful statement. Simply done, she shaped it and then flocked it (a method of gluing a fuzz-like material to an object), which gave the bear a soft texture.

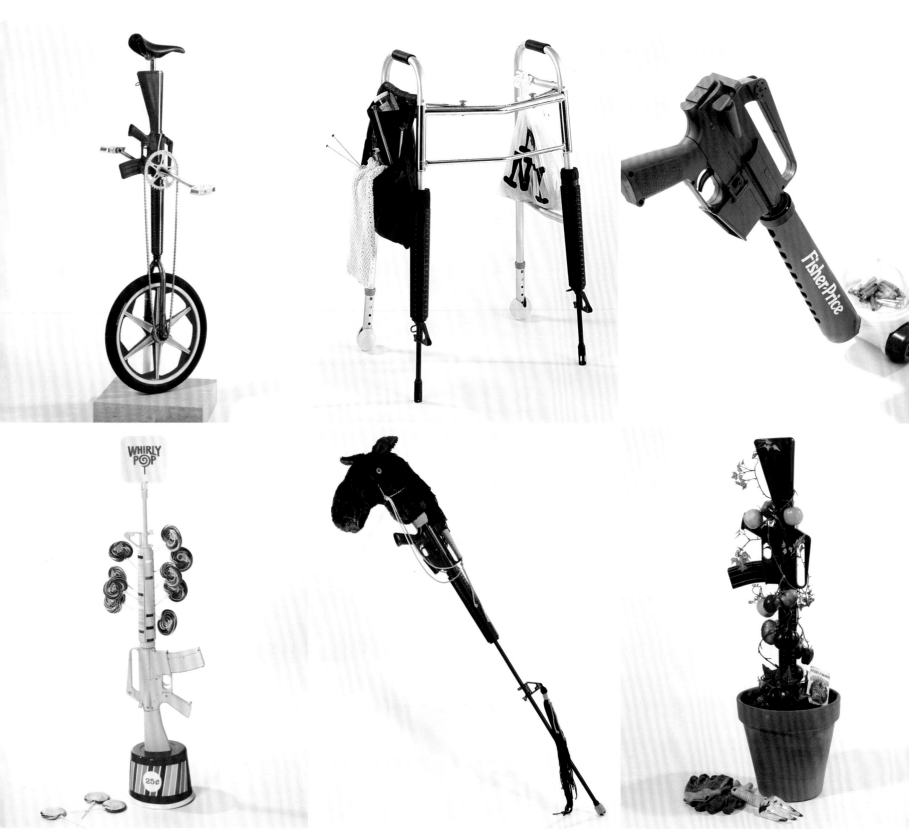

unicycle: *Gregory Westby*
lollipop: *Christopher Brand*

walker: *Michael Pisano*
hobbyhorse: *Wei Lieh Lee*

Fisher-Price toy: *Joaquin Parral*
tomato planter: *Michael Pisano*

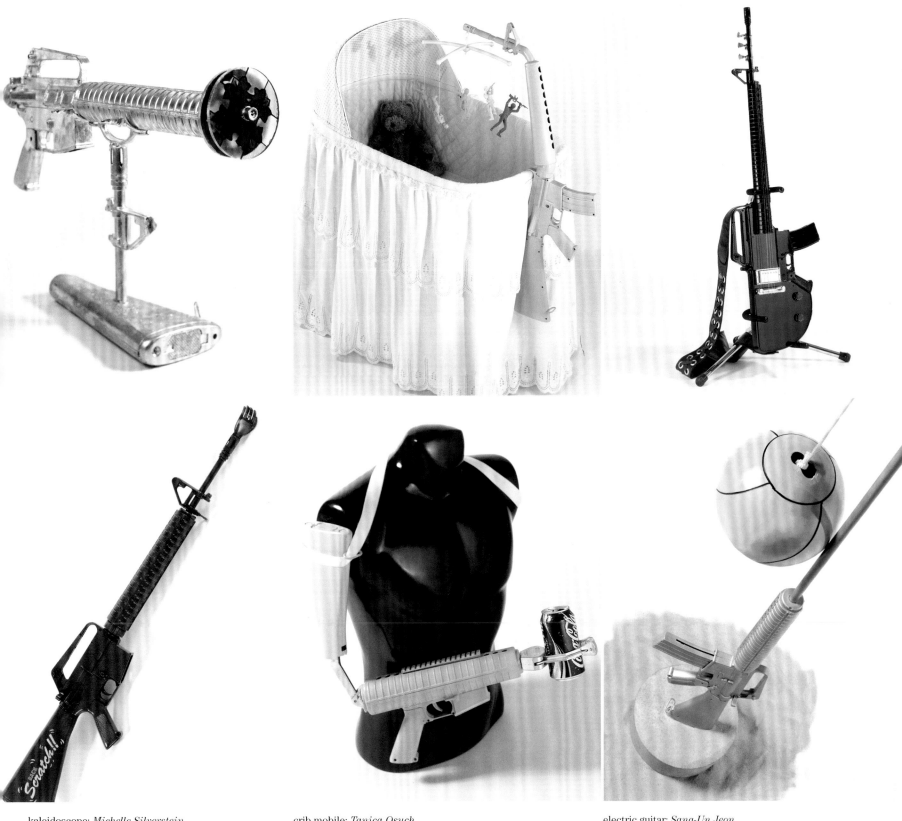

kaleidoscope: *Michelle Silverstein*
back scratcher: *Fumiyo Osawa*

crib mobile: *Tanica Osuch*
prosthetic limb: *André Araujo*

electric guitar: *Sang-Un Jeon*
tetherball: *Omid Sadri*

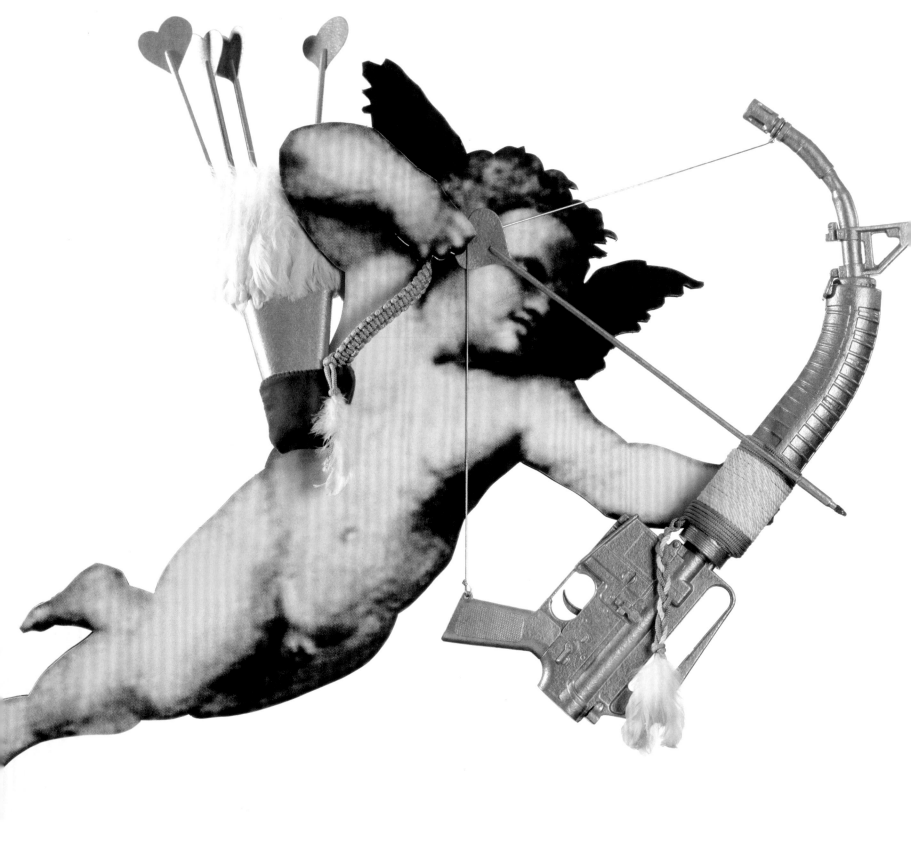

O'C: Answering the assignment in a different way, Wei Lieh Lee made an illustrative statement rather than a product by transforming a weapon into a symbol of love. It was very difficult to bend the gun into that shape.

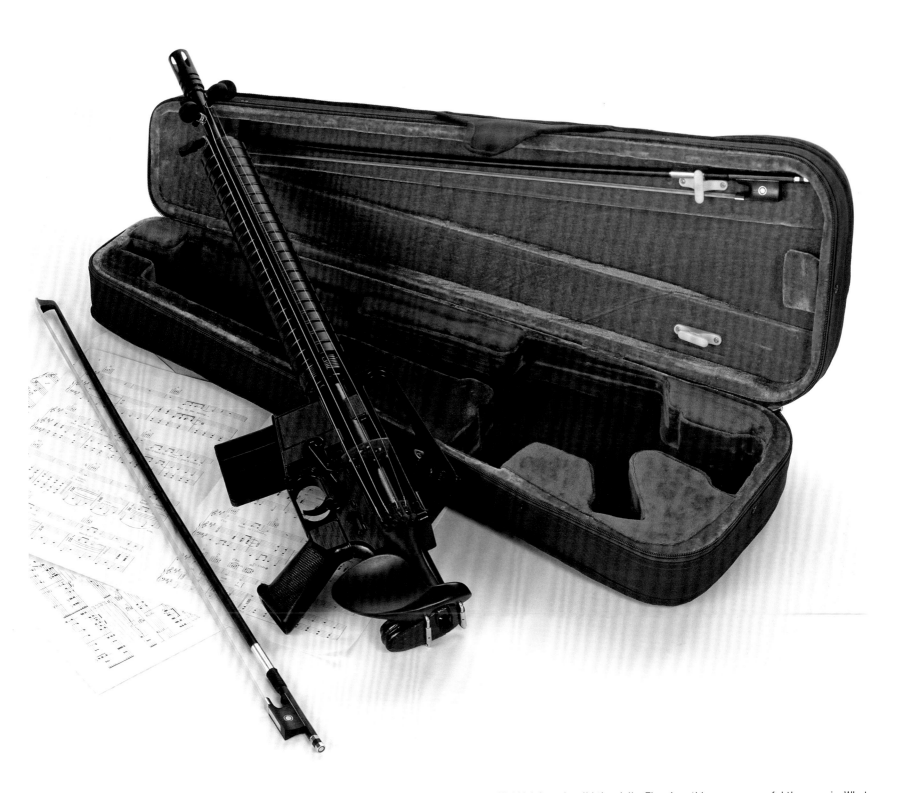

O'C: Wei Lieh Lee also did the violin. There's nothing more peaceful than music. What put this piece over the top was the shape of the gun cut out of the case so that the M16 violin fit perfectly.

URBAN PEDDLERS

CHALLENGE: MAKE A STATEMENT ABOUT LIFE IN NEW YORK CITY USING A SIMPLE BICYCLE AS YOUR VEHICLE OF CREATIVITY.

Danielle Stack

Wearing big plastic salad bowls on their heads, they would PEDAL THE NEIGHBORHOOD on homemade imitations of a RAT FINK HOT ROD.

Bruises, scrapes, and broken bones are occupational hazards for three-dimensional exhibition designers. But none of those injuries compare to the frequent trouncing that O'Callaghan endured from his first Schwinn two-wheeler. Embroidered on his skin, these abrasions form a scrapbook of memories beginning with a Christmas morning long ago in Baldwin, New York, and a shiny new bike poised near the tree.

One of O'Callaghan's novice two-wheel experiences is permanently documented along his back—a memorable slide across a baseball field caked with gravel. In those days, the local emergency room staff referred to him on a first-name basis. Involved in a love affair with speed, movement, and adventure, an adolescent O'Callaghan hit the road often. This was in the 1960s, somewhere between Jack Kerouac's final road trip and Steppenwolf's metamorphosis into a

rock band. *Easy Rider*—a principal catalyst for the mass appeal of custom bicycles to the pre-motorcycle set—was yet to be born, wild or otherwise. O'Callaghan and his cohorts looked to the custom car royalty of the time—Von Dutch, Ed "Big Daddy" Roth, and George Barris—for creative inspiration. Wearing big plastic salad bowls on their heads, they would pedal the neighborhood on homemade imitations of a Rat Fink hot rod. They applied individuality to their generic rides with bold-colored paints and extended the handlebars by cutting the fork of one bike and sticking it onto another.

By the end of the decade, Dennis Hopper was a household name and all sorts of things were being peddled. The teen market was saturated with Kool Lemon, Campus Green, and Flamboyant Red Sting-Ray Krates, complete with prepackaged personalities.

Nostalgia and tradition have always thrived in O'Callaghan's soul, providing equilibrium for his capricious traits. The desire for a less complicated world and the simple pleasures of his youth often influence his artistic initiatives. "Urban Peddlers" is one such example. O'Callaghan had seen a folk-art bike that was embellished with bottle caps, rocks, and costume jewelry. This 1930s marvel brought forth memories of the riding exploits of his youth and generated the idea for the exhibition. It was originally intended

O'C: This bike stereotyped the New York mobster mentality of "swimming with the fishes." You Sik Cho stripped it down to the bare metal, left it outside to rust, and applied a faux finish. The back wheel was encased in cement, and seven people were needed to lift it. Cho wanted some sea grass, which I found on the beach near my home.

O'C: This piece by Danielle Stack (page 121) reflected the urban problem of pigeons making their homes anywhere and everywhere in a city. The imitation pigeon droppings were made with a base varnish of gesso and black powder dust.

as a two-week class assignment: Sketch submissions in one week, finished artwork the next. Each student was given a standard no-frills cruiser that O'Callaghan had acquired with a generous discount from the Huffy Corporation. The goal was to make a statement about New York City and, in so doing, to imbue each bike with unique character. The outcome was an array of original creations.

The chain-link bicycle entertainingly expresses the show's intent. By fastening silver-painted fencing to the bike's frame, designer Gina Marie Maniscalco ensured that it would be camouflaged against a schoolyard fence, securing it from theft. The beggar's bike was crafted using newspaper, cardboard, and butchers' wrapping, virtually without financial outlay. Wei Lieh Lee took pieces of newspaper and wound them tightly until a twine effect was achieved. The rough hand lettering on scraps of brown paper heightens the utilitarian quality. The sanitation cycle, complete with broom and dustpan, called for the O'Callaghan method of collaboration: Rafael Bernstein was rewarded with an authentic bristle roll donated by a sanitation team at a truck-repair facility. The sanitation crew also cut the roller to the appropriate size for the artwork, and removed a coating of slime and debris with a pressure wash.

Others took a more primal approach. The Boston Red Sox bike by Diana Suarez was constructed with care and then covered in cigarette burns and beaten until dented and cracked. Its hopeless frame was then placed in front of an enormous image of Yankee Stadium.

O'Callaghan still rides an old-fashioned two-wheeler, and Christmas mornings continue to yield the latest in cycling accoutrements. With the excitement of a child, he unwraps the bounty: a fresh set of kneepads, a compact first-aid kit, and a shiny new helmet lovingly outfitted with a pocket that holds cab fare to the nearest hospital.

O'C: Basing his work on the tram that takes New Yorkers from Manhattan to Roosevelt Island and back again, Ryo Arita turned his bike upside down and created a great product design. You could sit on it and peddle with your hands to cross part of the East River on a wire.

O'C: The chain-link fence camouflage bike was in response to the frequent theft of bikes in New York City. Gina Marie Maniscalco wanted to make sure that her bike would visually disappear when she left it up against another fence, and it did!

O'C: The Boston Red Sox bike was a playful public notice from Diana Suarez that warned Sox supporters to keep their paraphernalia out of New York. We had it displayed in front of a large image of Yankee Stadium. I thought she could have left the bike outside of the stadium and let Yankee fans go at it, but the show was scheduled during the off-season.

O'C: The beggar's bike by Wei Lieh Lee was made with found objects, and served as a reminder that a masterpiece can be created without cost. He twisted the newspaper to form twine, which he then wrapped around the bike's frame, a painstaking process. The fenders were lined with newspaper clippings, and he added clear plastic around the wheels, inviting people to throw in some money as they went by.

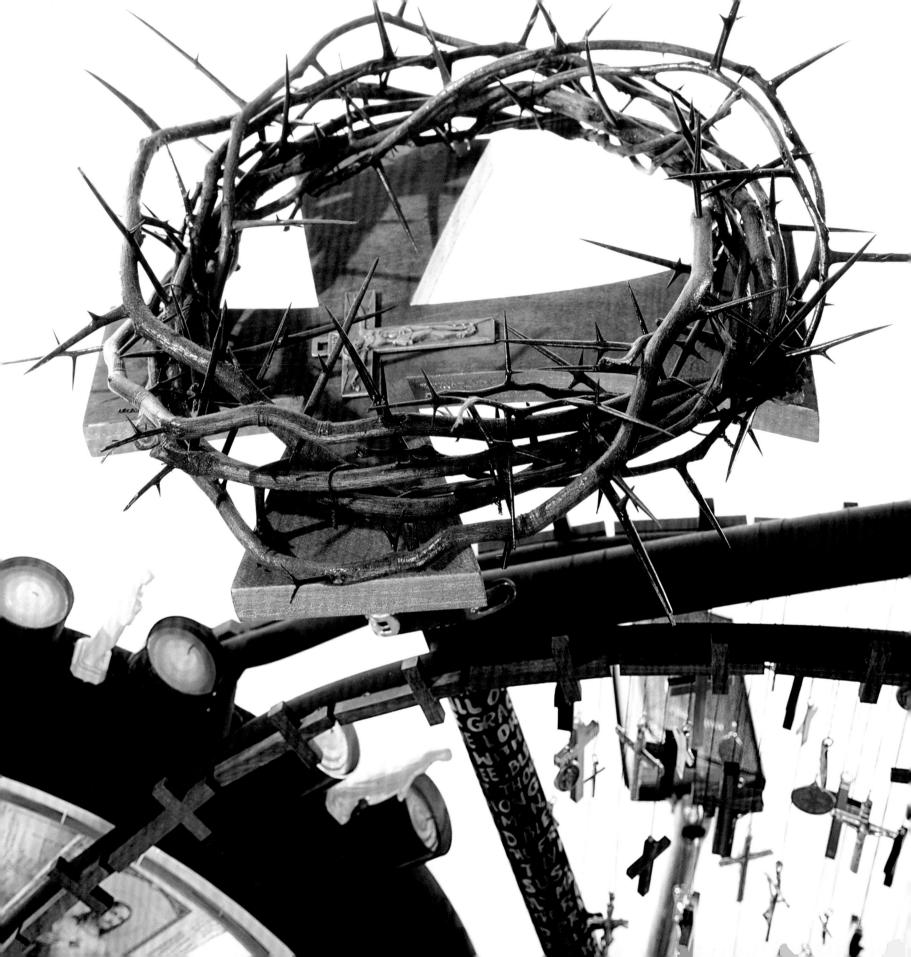

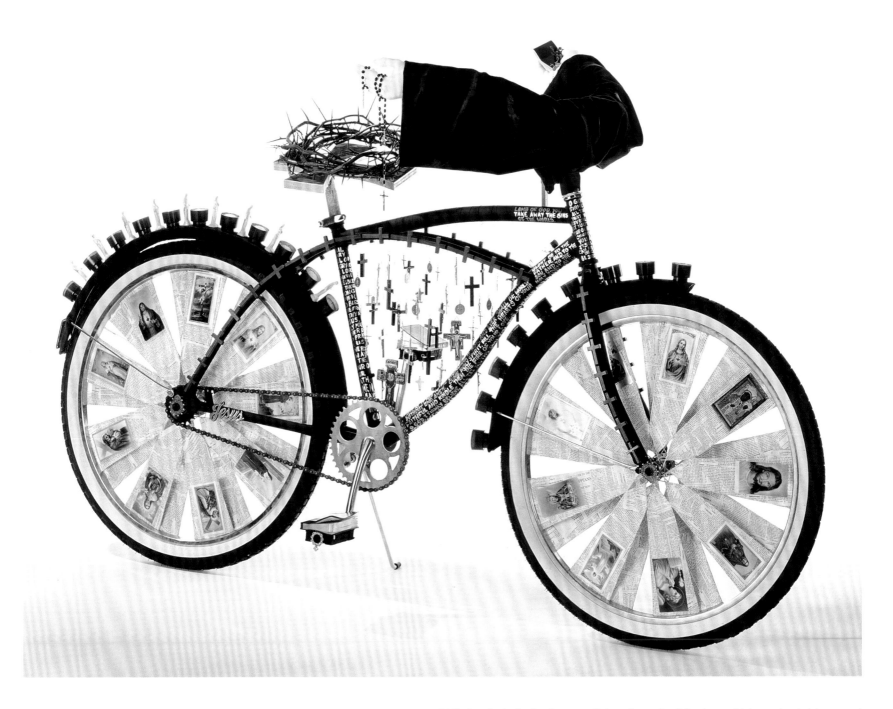

O'C: Anastasia Dudin chose a religious theme for this piece, which was lauded by several people who thought that it was a literal Holy Roller for small bibles and religious cards. It was filled with detail, including a crown of thorns as the seat, and votive candles and statuettes on the wheel frames. The handlebars that reached out in an embrace were a nice touch.

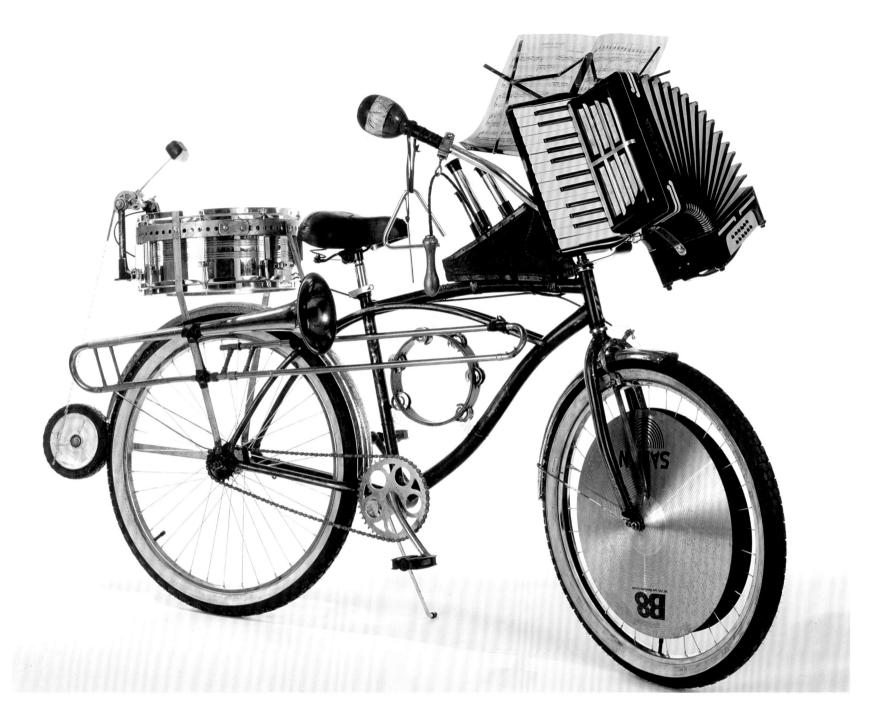

O'C: Erika Bettencourt's rolling band really played. There was a linkage mechanism on the bike, so when the back wheel turned it made the drum bang, and the front wheel controlled the accordion. Of course, the three horns on the crossbar could be pushed at will. It paid homage to New York City street performers.

O'C: Donations from the New York City Department of Sanitation helped to bring Rafael Bernstein's vision to fruition. The huge brush in the front, almost impossible to find, was even power-washed for him by some generous sanitation workers. Everyone likes to help the students.

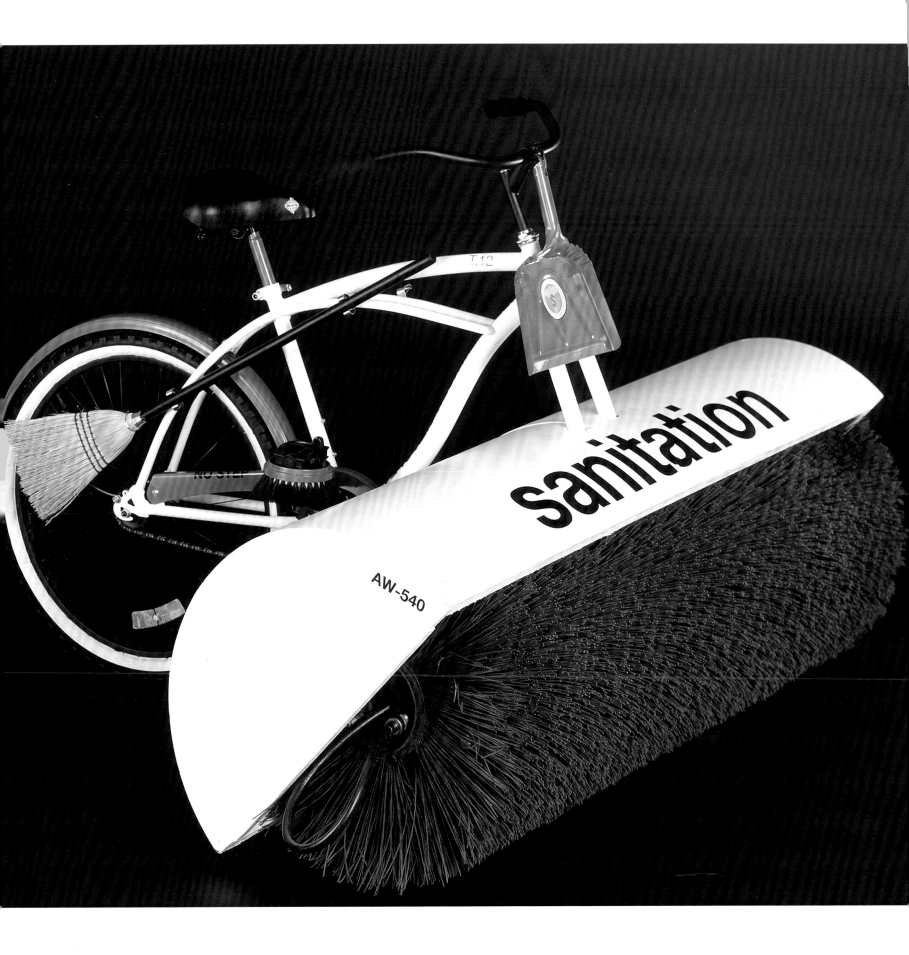

MAY I TAKE YOUR ORDER?

CHALLENGE: DESIGN THE ENVIRONMENT FOR AN UNCONVENTIONAL, THEME-BASED RESTAURANT COMPLETE WITH DINNER SERVICE, FURNITURE, LIGHTING, AND WALL COVERINGS.

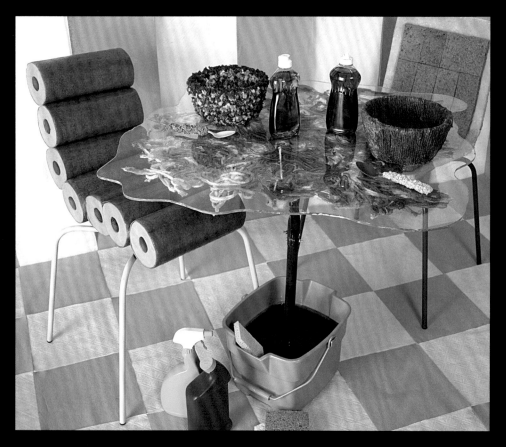

O'C: This 2004 show was a little different from other assignments because I asked my fourth-year undergraduates to create an entire environment. For other exhibitions, I might have asked each student to create one piece for the exhibition: a chair, a table or a lamp. But I thought it would be interesting if they tried to create a complete corner of a theme-based restaurant. The challenge was taking into consideration all of the elements: wall covering, floor treatment, lighting, seating, signage, and even place settings.

I wanted them to think in unconventional ways, and the end result was sixteen theme-driven eateries in four weeks. The outcome was terrific and several were awarded honors from *Graphis*. The concept for the exhibition goes back to my father's professional practice. He was an architect and artist who worked on many nightclubs during the last years of his professional practice. Places like the Stork Club and the renovation of the Cotton Club. I remember as a child visiting some of the clubs, which were theme based and spectacular. One was an underwater environment where the ceiling was made of translucent aqua-colored acrylic with things floating around and the lighting for the club was based on the sun shining through the "water" ceiling. Another club had really interesting walls with two-inch material that looked like dust, a metaphor for a forgotten space.

O'C: *Bacteria Cafeteria* was an exquisitely art-directed environment by David Ben-David. He used cleaning equipment and materials. The wall covering was created with blue and white paper towels that he then patterned to make a checkered floor. The table was an upside-down string mop, formed and solidified with an acrylic resin. I really liked the seats that he created from sponges and paper rolls. The colorful service was made from scouring pads and sponges. One wall held framed photographs of magnified microscopic bacteria, which underscored the paradox of the environment.

O'C: Anastasia Dudin took a minimalist approach to her portrayal of food in its raw state. "Butcher's Corner" was created using an old chicken cage complete with fake fowl and old crating materials to sit on. The walls were covered with burlap and a cow's hide.

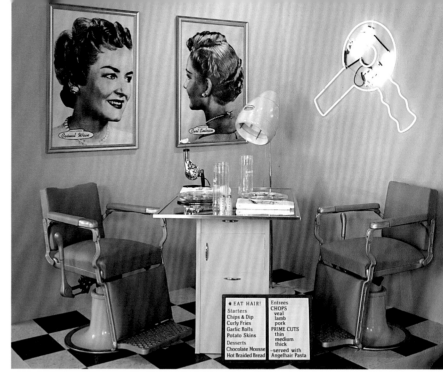

O'C: The *Plastic-Castle Café* reflected a generation that grew up playing with brightly colored plastic toys. Robyn Segal constructed this theme-based environment by creating forms and then casting the pieces. The dining trays were adorned with stickers that showed images of food, reminiscent of dollhouse accessories. The large figure on the table was also a lamp. The environment was beautifully art-directed through color, texture, and composition.

O'C: Jamie Hoyt-Vitale incorporated beauty salon objects to create *Eat Hair*. She stacked transparent plates that held curly locks between them, giving the illusion of eating hair. The beehive hair dryer was a lamp, and she designed the sign on the back wall in neon.

O'C: Ryo Arita took my directive of "unconventional" all the way, inviting you to dine on dog. *Prime Pooch* used chain-link fence for the chairs, and an upside-down doghouse served as a table. The dog bowl was a lamp. Kennel cages with sound effects—barking, yelping, and growling—completed the environment.

PRIME POOCH

I'M SO HUNGRY I COULD EAT A DOG

BEDTIME RITUALS

CHALLENGE: CREATE A BED THAT REPRESENTS YOUR PERSONAL BEDTIME EXPERIENCE—FROM DESIRES TO FEARS, OR SIMPLY YOUR RITUAL TO FALL ASLEEP.

STARTING POINT: 18 BEDS
ARTISTS: 18
WEEKS: 3

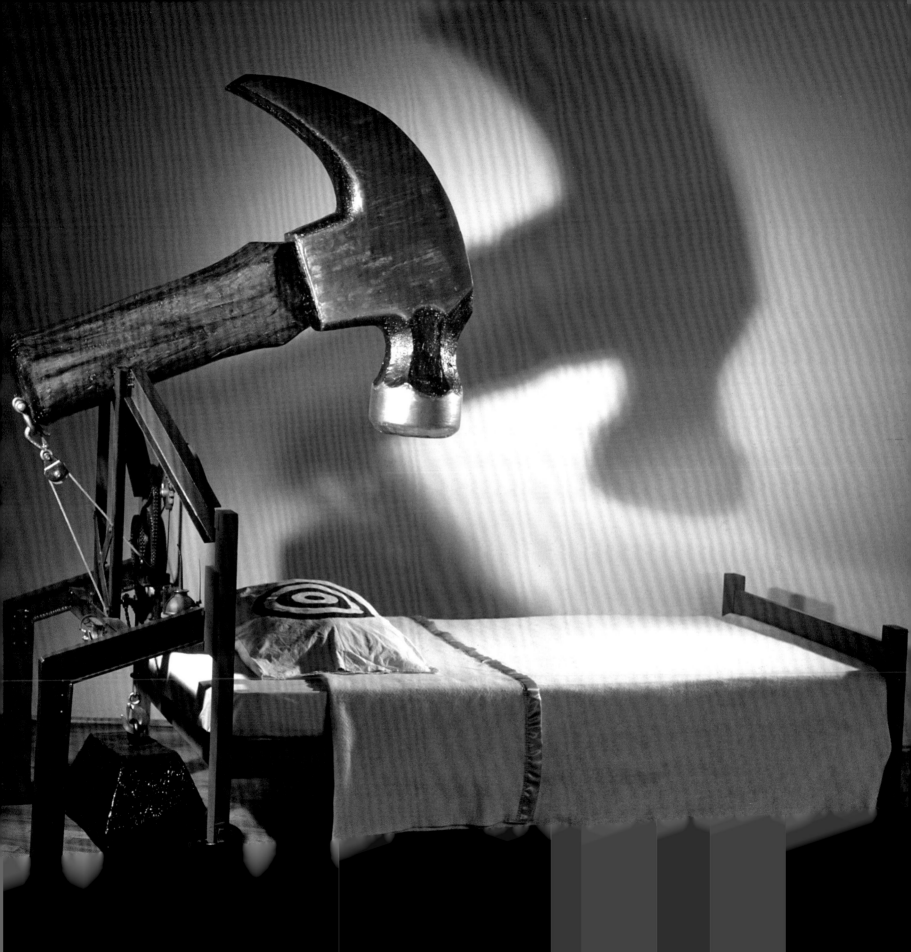

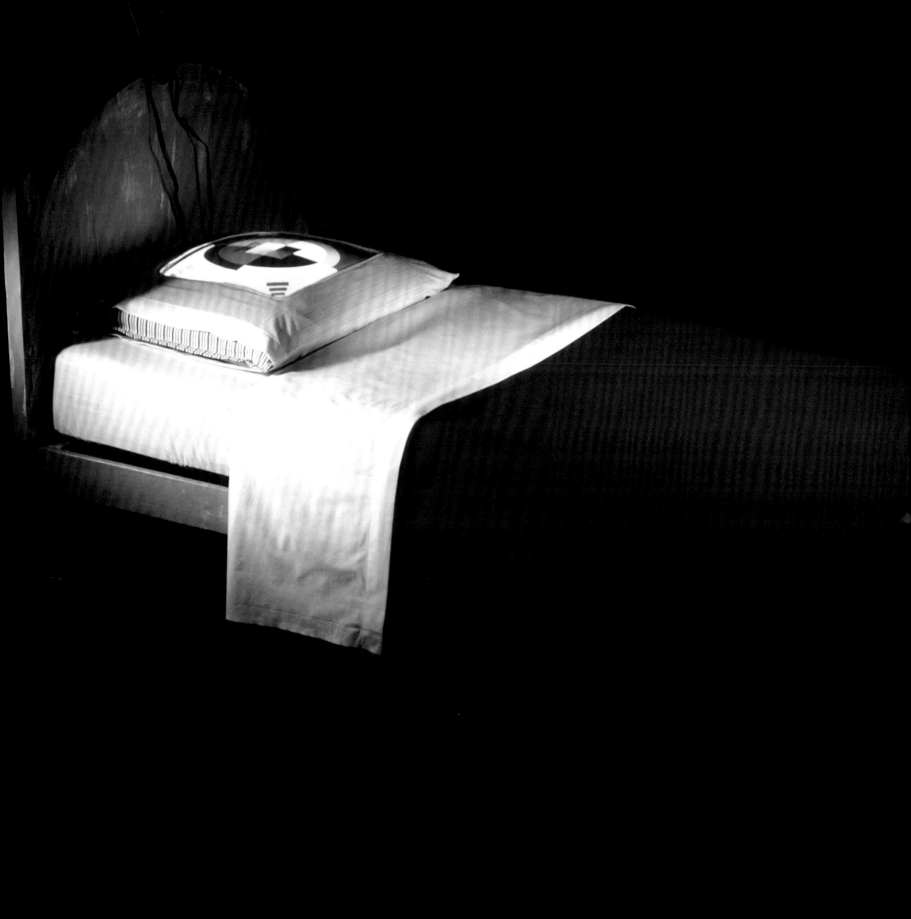

Even as a CHILD, he would begin to worry, long before bedtime, ABOUT FALLING ASLEEP.

When the eighteen-wheeler pulled up to a loading dock on East Twenty-first Street with a truckload of cookies, the building's concierge shook his head and smiled knowingly: The delivery must be for O'Callaghan's workshop. It was, crates and crates of raw material for Cookie Monster's ultimate fantasy: an edible bed of sugar wafers, fig bars, and chocolate rounds sandwiching vanilla cream. Monica Limmer, who created an exquisite sleeper from these ingredients, had originally intended to use a confectionery recipe. Her project's objective was to illustrate snacking before slumber by building a bed that was completely encrusted with candy, topped by a pillow quilted with jewels of colorful rock-hard sweets.

Pricing the candy per square foot, she discovered that it would have cost less to use truffles from the ground. She called O'Callaghan, who asked if she had another favorite bedtime munch. Cookies came to mind, but they were even more expensive than their cavity-inducing counterpart. Suddenly, Limmer remembered that a friend's father was an executive at Nabisco. Two days later, Wafer and Newton headed for college. The resulting masterpiece included a patterned blanket, striped sugar wafer sheets, and a big, fluffy Fig Newton pillow.

One problem ensued: Following the show's opening reception at the New York Art Directors Club, Stuart Little hosted an exclusive after-party for his tailed companions. A delicate leg of bed was served, and the nocturnal gourmands feasted through the night. After that, a sonar device was installed at each exhibition venue to deter any unauthorized snacking.

"Bedtime Rituals" was the first of O'Callaghan's projects that was planned as a group exhibition. Prior to this, some of his class assignments had ended up in galleries, receiving media attention and audience appreciation. This one, however, was not only structured explicitly for a show; it was also the one of the early projects for which O'Callaghan would proffer his now standard starting point. In this case, it took the form of a headboard and footboard for a twin-size bed. O'Callaghan made classic, simple dome-shaped structures from plywood, and the artists had to creatively represent their nighttime routines.

The concept for the exhibition emerged from O'Callaghan's insomnia. Even as a child, he would begin to worry, long before bedtime, about falling asleep. To ward off nighttime anxiety, a youthful O'Callaghan designed methods for going to sleep, generally focusing on the next

O'C: Mercedes Curutchet chose watching TV to fall asleep as her ritual. Embedded in the pillow was a television set with the image of an off-air network test pattern.

ARTISTS TEND TO CHURN around the clock, not knowing how to set their creative ENERGIES TO SNOOZE.

day's activities. He plunged into fantasies about building things, visualizing his descent into the family basement and finding a treasure trove of construction materials.

Not surprisingly, a large percentage of his students also had elaborate rituals to relax them into slumber. Artists tend to churn around the clock, not knowing how to set their creative energies to snooze.

"Bedtime Rituals" was a personal show, and each work told a story about its artist. Before revealing the project's concept, O'Callaghan had given a written assignment on rituals, which included topics such as getting ready for school, preparing dinner, and going to bed. He did this so that the focal points for his students' artworks would remain loyal to their biographies. O'Callaghan did not want to elicit solutions that were visually smart but lacked an emotional element.

The three-week assignment spawned eighteen rituals, as well as several sleeping aids. One result included five pillows on a big wheel that was attached to the headboard. Its designer, Kevin Curran, slept best when he could flip a pillow and rest his head on a cool surface.

"Counting sheep" was humorously illustrated as a satirical 3-D solution. This mechanical marvel counted to one thousand in a slow monotone, sure to lull even the most tightly wound to slumber. Designer Robert Hawse assembled a series of sprockets and chains that moved his New Zealand Suffolk black-and-white lambs up and over, then down and under the bed. Sadly, studies suggest that this adage is but a bedtime story; it actually takes longer to doze off when trying to count sheep—or any thing else for that matter. Current wisdom still invests in the proverbial warm glass of milk, which should be followed by visualization of a tranquil scene, perhaps a bed with a giant hammer hovering above the pillow.

Darren Port's overstuffed bed began with memories of reaching under the bed and pulling out a night's kitchen-sink lineup. Curving the bed frame by steam-bending the wood, he created a beckoning void that was then filled with an eclectic pile of favorite items, from skis and a typewriter to toy trucks and baseball gear … and perhaps a report card or two. Jigsaw pieces scattered around the bed echo the bigger puzzle of objects under the mattress. It's no wonder that this designer had some trouble finding a comfortable position for the night.

The soundtrack for "Bedtime Rituals" was composed of such pop culture classics as "Tossing and Turning," "Mister Sandman," and "Goodnight, Irene." O'Callaghan's Uncle Will owned an impressive collection of sleep-related songs, which he shuffled into a golden stack of oldies. The selection was cleverly assembled, and some who saw the show asked for copies.

As for O'Callaghan, he no longer worries about drifting to sleep; he doesn't have the time for any.

O'C: The overstuffed bed by Darren Port was as exquisitely art-directed underneath the mattress as the design and craft of the bed itself.

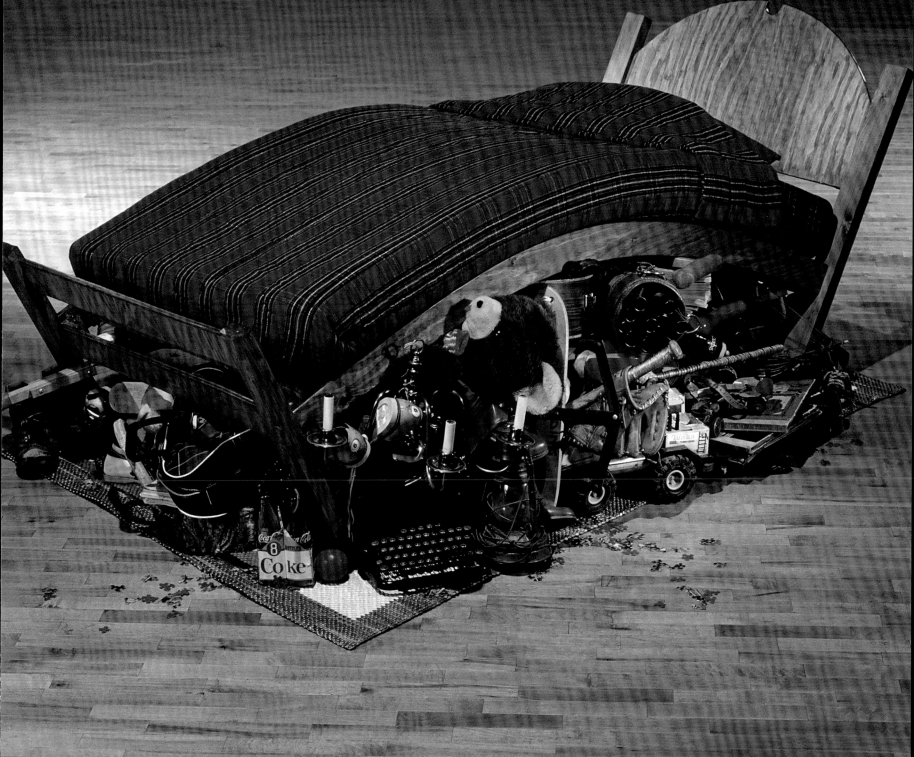

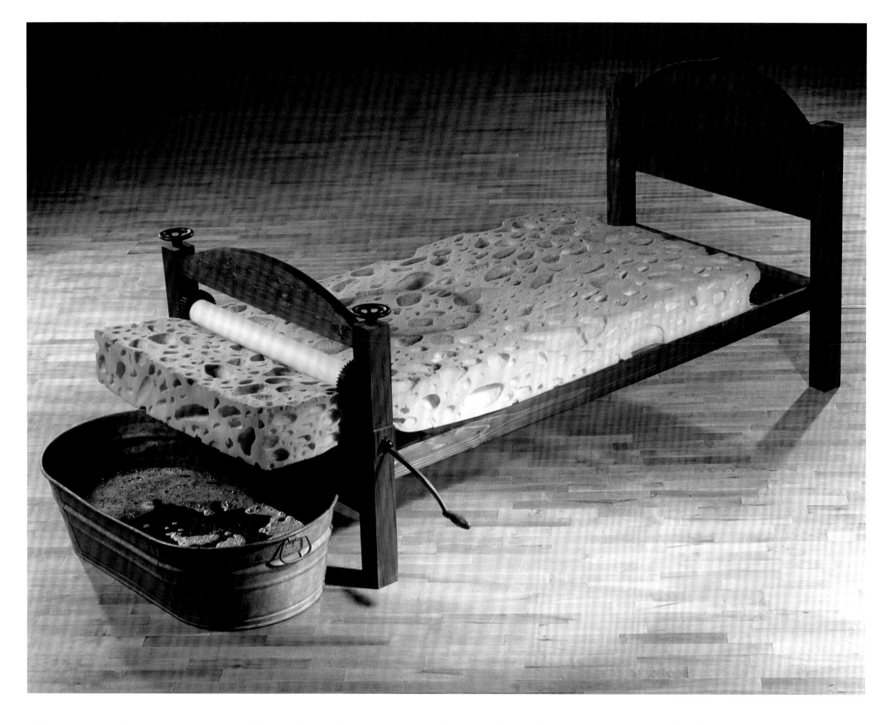

O'C: A perfect solution to bed-wetting, Michael Vassalo ripped out pieces of a foam mattress and transformed it into a giant sponge. The footboard became a huge crank that squeezed the liquid out of the mattress. It had a pump that circulated colored water through the end of the mattress.

O'C: Charles Stinson's illustrative piece reflected the expression "getting up on the wrong side of the bed," and portrayed the stark differences in how a day might begin depending on the previous night's sleep.

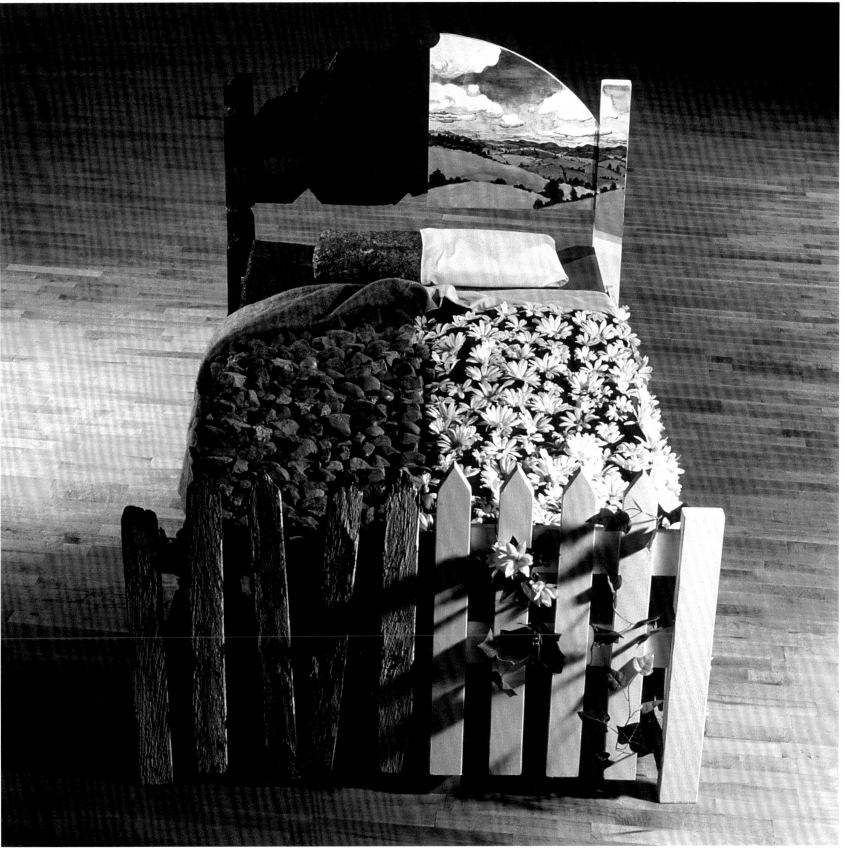

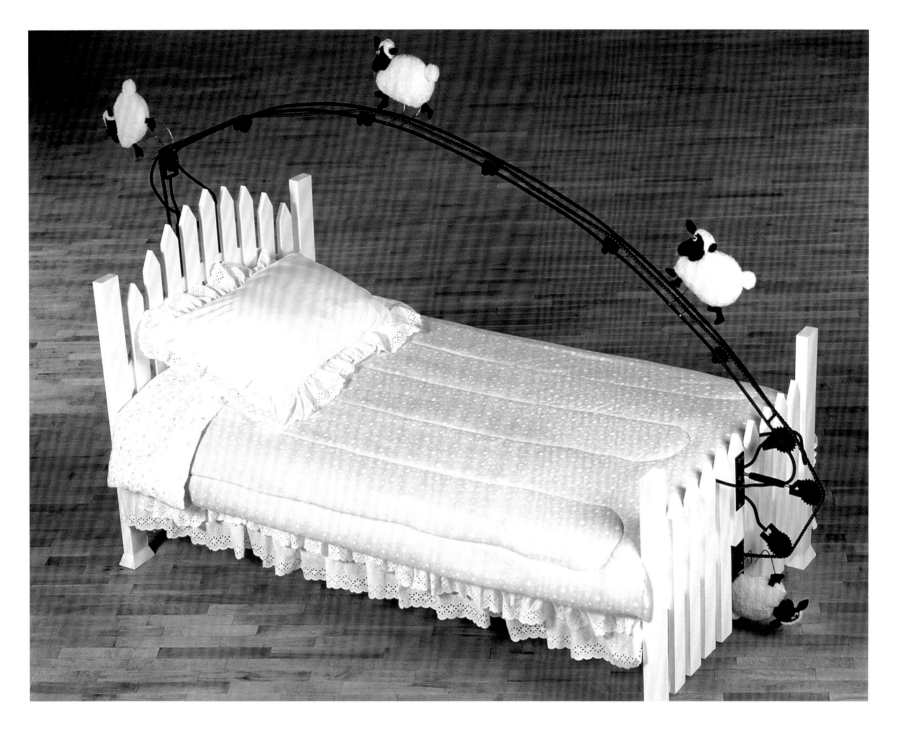

O'C: Counting sheep was Robert Hawse's solution to falling asleep. It was the first student project for my class that ventured into using an intricate mechanical component. The sheep revolved overhead as you counted to slumber. It had a tape recording of Hawse counting slowly to one thousand, which was timed with the passing of each little lamb over the pillow.

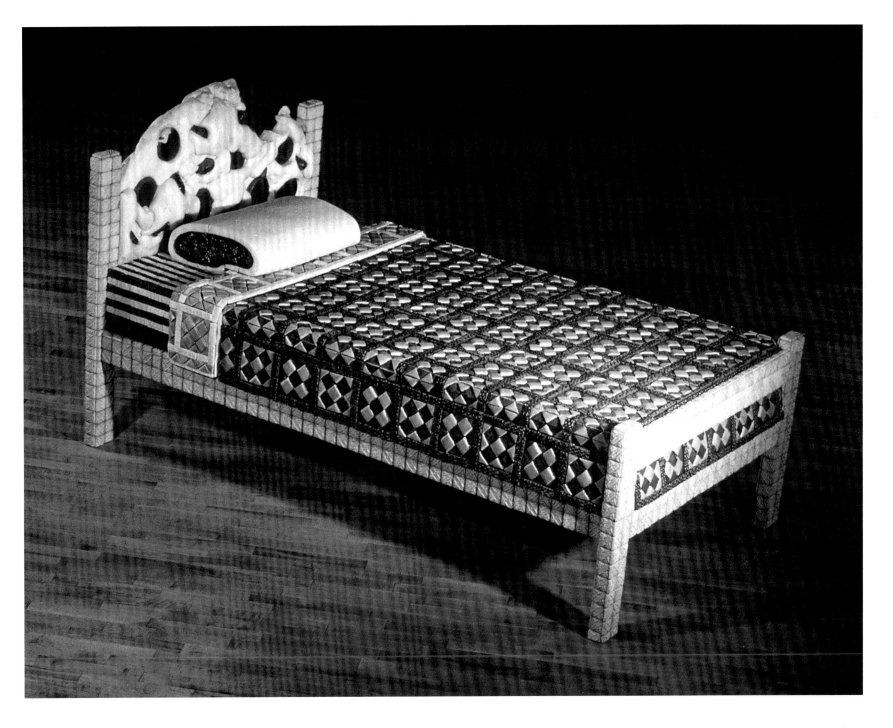

O'C: The morning after the exhibition opened, we came back to see that several inches from each leg of Monica Limmer's cookie bed had been munched on by rodents; we knew we were in trouble. Years later, I asked Monica what had happened to the cookie bed, and I was shocked to hear it was still in perfect shape. That says a lot about artificial preservatives.

OFF-ROADING: THE REINVENTION OF THE AMERICAN GAS-GUZZLER

CHALLENGE: WITH THE IDEA OF REMOVING ONE "GAS-GUZZLING" VEHICLE OFF THE PLANET, SYSTEMATICALLY TAKE APART A 300,000-MILE "MONSTER" TRUCK TO CREATE HOUSEHOLD FURNISHINGS THAT WORK AS A COLLABORATIVE ENVIRONMENT AND HEIGHTEN CONSCIOUSNESS ABOUT CONSUMPTION AND WASTE.

STARTING POINT: 1 TRUCK
ARTISTS: 22
WEEKS: 2

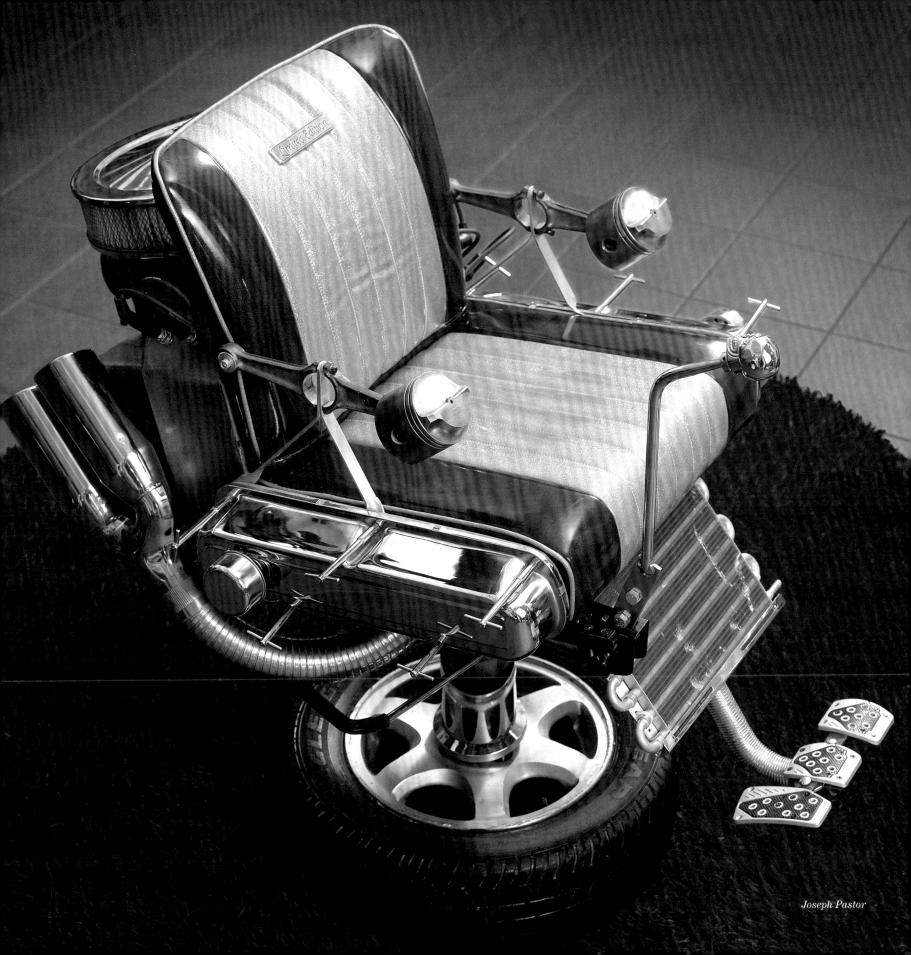

Joseph Pastor

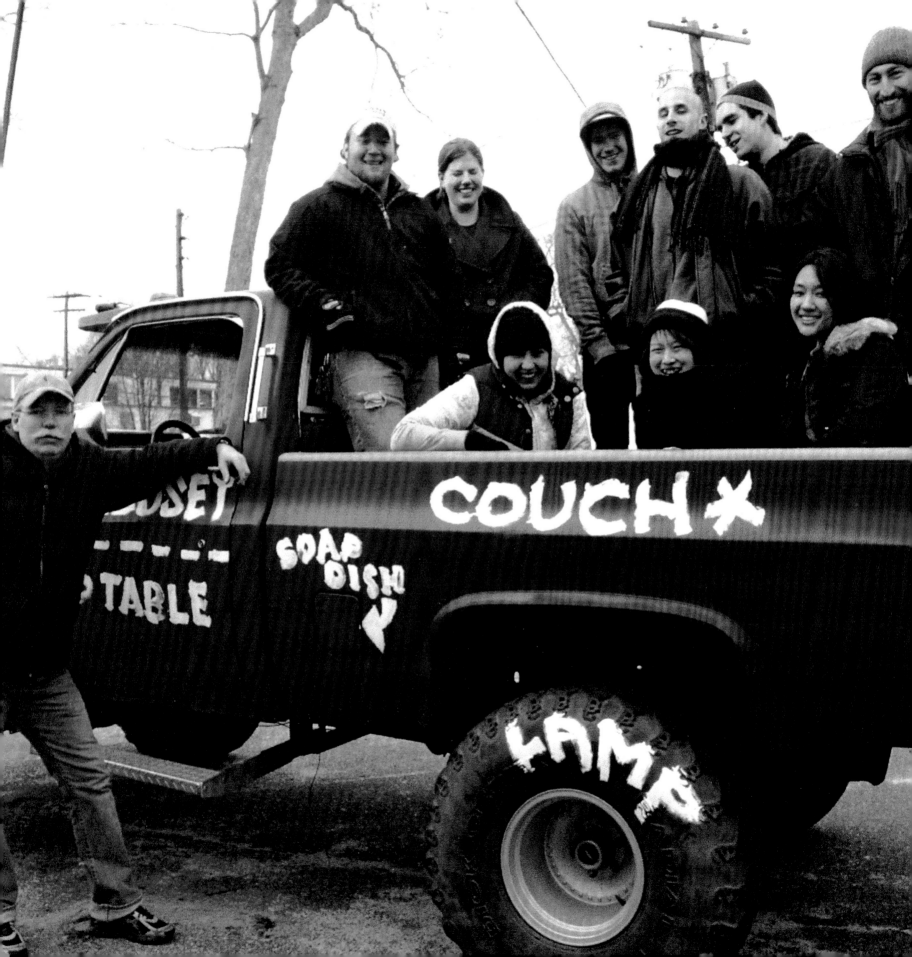

Kevin O'Callaghan summoned his MERRY BAND OF ARTISTS, and TOGETHER they lifted a fuel-swigging BEAST from the road.

Invisible monsters are all around us. They lurk in overstuffed closets and linger under beds. Others lounge on the proverbial couch with hopes of transmutation. There are also the dangerous, self-branded global demons that leave their imaginary counterparts in the dust: Monster Trucks. Ecologically dubious when spanking new, these trucks often continue to travel the highway well past their prime, emitting noxious smoke and leaking oil.

In 2009, during yet another oil crisis, Kevin O'Callaghan summoned his merry band of artists, and together they lifted a fuel-swigging beast from the road. Purchased for the asking price of 500 dollars, this dilapidated specimen had already logged more than a quarter of a million miles and was still barreling at full spew. O'Callaghan is an automotive junkie, but even he is offended by these decrepit trucks that burn fuel as though they were in training for an aircraft jettison.

Within exhibition walls, there are a variety of ways to address environmental problems. O'Callaghan chose to tackle the issue by taking one small stride toward global cleanup. And in a spectacular way, he and his students at the School of Visual Arts had saved a little piece of our planet. The goal of the "Off-Roading" group exhibition was to transform an oil-drinking fiend into innocuous household furnishings. For O'Callaghan, the choices were unimportant. He didn't care if the truck became ten chairs and no tables. As it turned out, his young collaborators created a range of interior décor to outfit an apartment—complete with couch, chairs, tables, lamps, and a fireplace.

On a table made from the truck's windshield, a set of chess pieces waited to be moved; its kings and queens, along with the knights, bishops, rooks, and pawns, had been crafted from the springs of the engine valve, and were ready for play. The truck's cab was reconfigured to become a working washing machine and dryer. The 1980 Chevy pickup that had fouled the earth for more than two decades at a rate of nine miles per gallon had been transformed into some of the objects it may have once transported.

Producing "Off-Roading" offered a challenge to an environmentalist. Finding the right vehicle within a predetermined budget took only a few keystrokes on Craigslist. The artists' submissions covered a broad range of items, and to O'Callaghan's delight, each design solution could be attained using a different part of the monster truck. He received four ideas that each required a tire (and the truck had no spare).

Projects approved, O'Callaghan's students convened at his Long Island workshop and within a handful of hours were headed back to their studios, each with the things he or she would need. They had dissected the mechanical ogre with surgical precision so that no parts were wasted or damaged; O'Callaghan's concern about how to dispose of unwanted parts was put to rest by the truck's total deconstruction.

What O'Callaghan thought would be the simplest part of the monster's dismantling became the most challenging: the steel-belted radials. They were relatively new, with rubber that was inches thick and reinforced by a network of steel cords. Ironically called the "carcass," this mesh

of armored wire had enough elasticity that it could not be cut with a saw: It would simply stretch and contract with the tool's motion. It's like trying to quarter the string of a cello by drawing a bow across its base. O'Callaghan grasped a set of ten-inch grinding wheels and nullified the steely opposition.

Since childhood, O'Callaghan has been distressed by waste, and he emphasizes the distinction between recycling materials and repurposing discarded items to become objects of value. "Off-Roading" was as much an event tasked with awakening awareness about consumption and waste as it was an art show. The exhibit never lost a light touch, though, demonstrating fanciful and creative ways through which new uses can be found for purpose-built objects.

In the end, O'Callaghan's crusaders left nothing save the dipstick, which they curved into the shape of a tombstone and stuck in the ground.

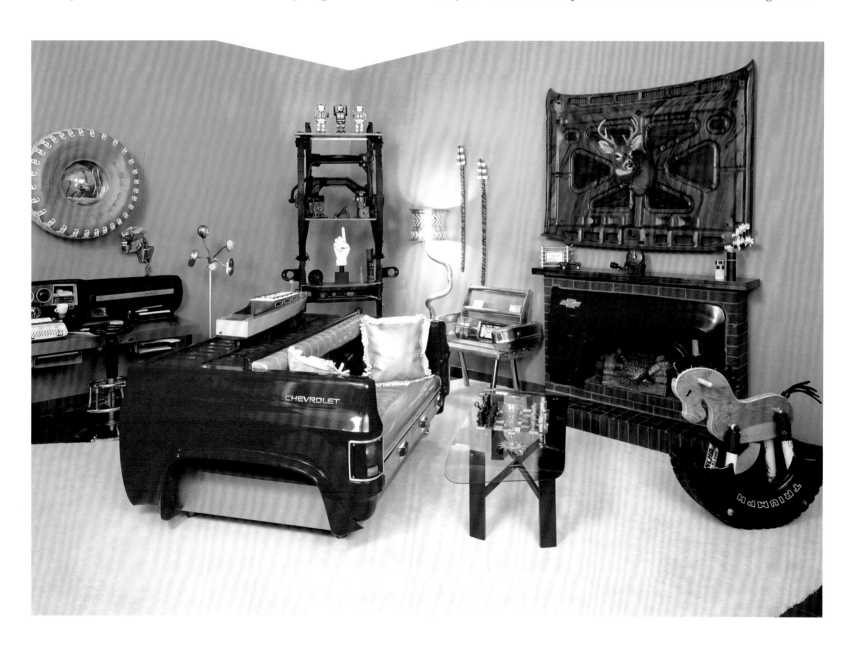

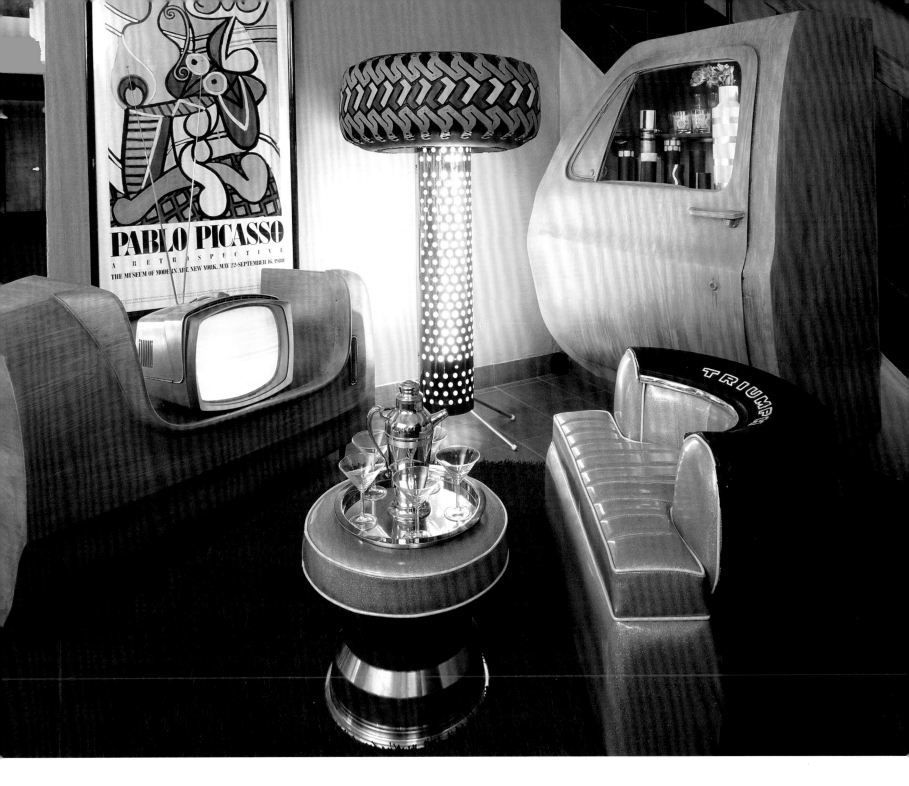

O'C: The fender, turned upside down, became a TV stand. What I loved about the stand were the little peg legs that Benjamin Taylor put under the fender to give it a sixties Danish-contemporary look.

O'C: The body of the lamp was made from the heat shield that had covered the exhaust of the truck. By just painting the trends of the tire at the top, Kaori Sakai created a great modern pattern around the shade.

O'C: Shaun Killman used the side of the truck for the liquor cabinet. The door swung open, and the window rolled up and down to allow access to the bottles.

O'C: Sarah Nguyen took a tire and cut it in half to make this little club chair. The rim of the tire was upholstered on top and became a small cocktail table.

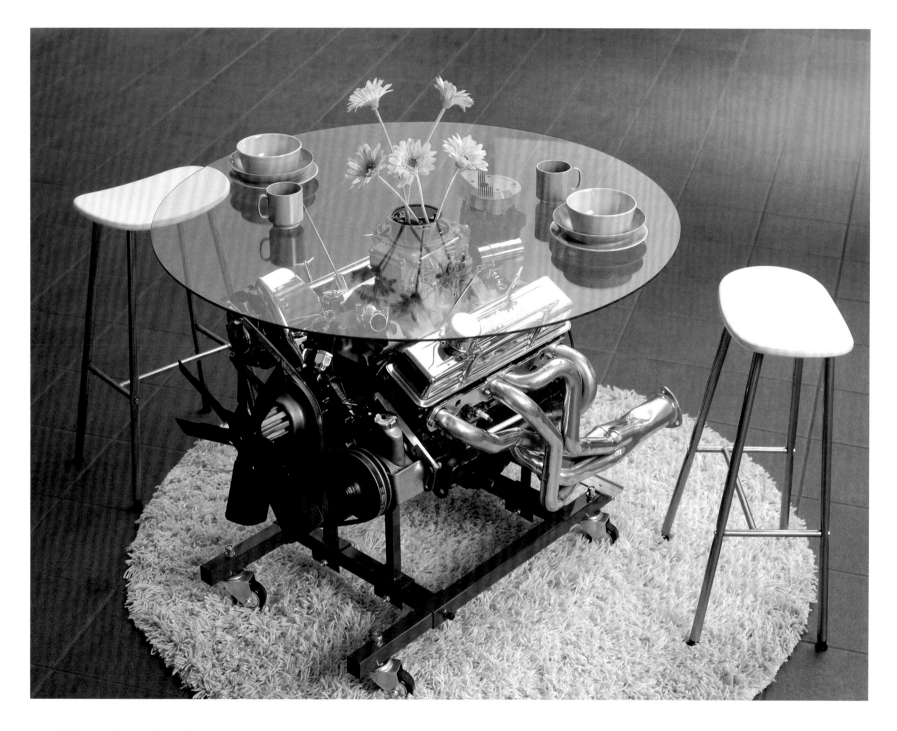

O'C: I felt strongly that the engine should not be taken apart, though one student used some of its internal parts. The outside of the engine stayed intact, and I made it into a table. I love how the flowers went into the carburetor, which became a vase.

O'C: I love the pedestal sink because John O'Callaghan simply sat the transmission on its end and it became this great pedestal-shaped thing that he transformed into a sink with a stainless steel patina. Behind the sink, Kathleen Ugurlu used the entire back of the truck: She made the rear window a medicine cabinet and then took the details of the embossed panels and highlighted them with tiles.

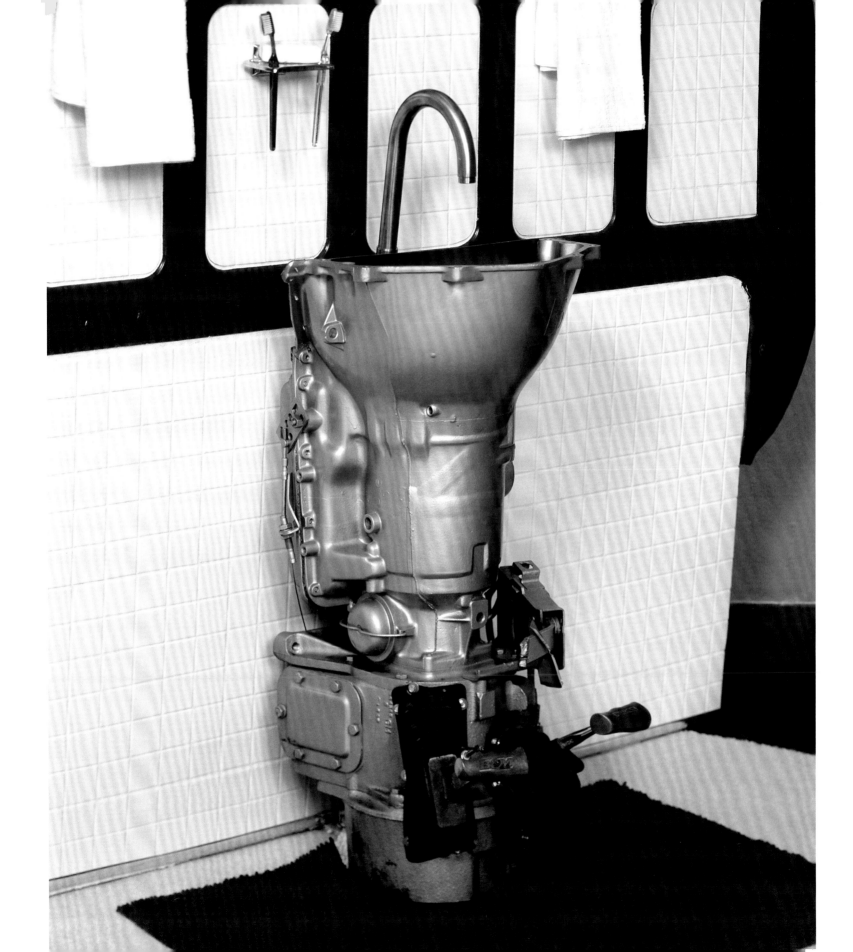

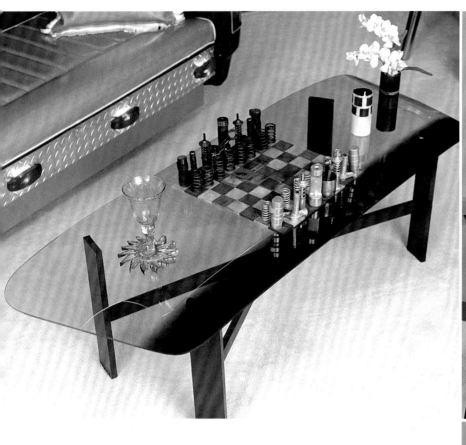

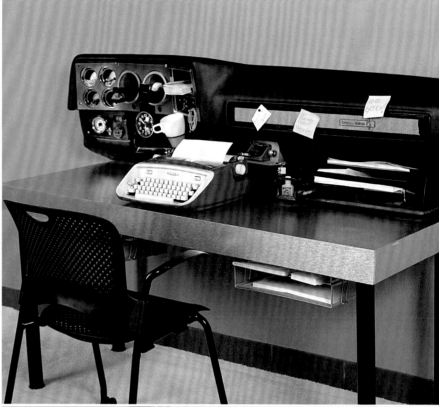

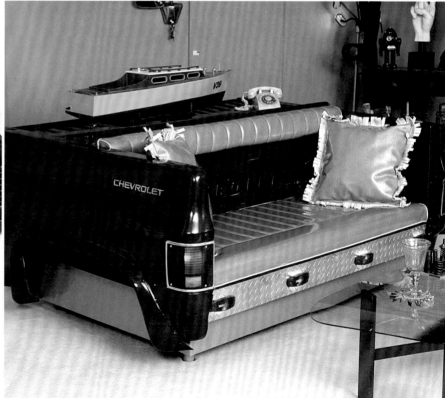

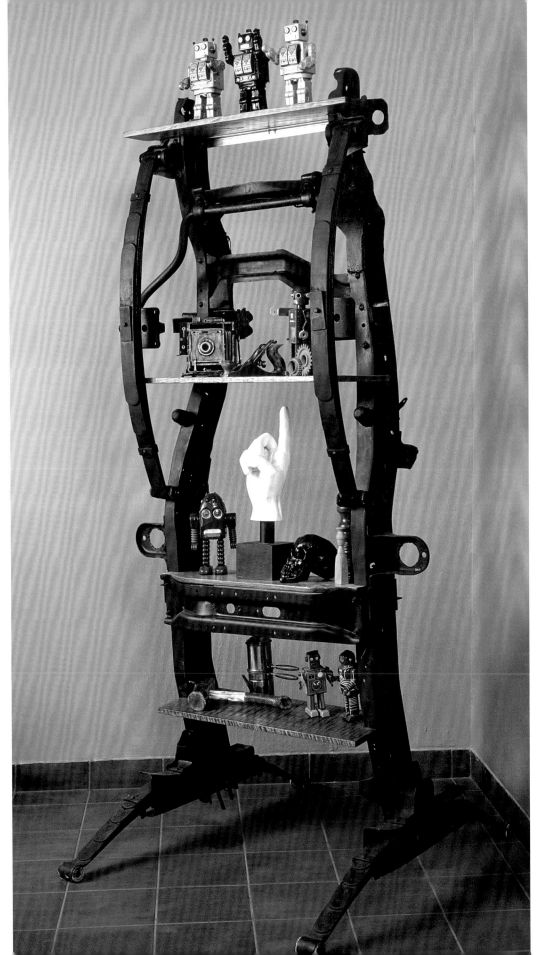

Opposite page, clockwise from top left

O'C: Turning the windshield into a table seems obvious, but it took Kaori Sakai to think of it. The chess pieces by John O'Callaghan were made with springs and valves from inside the engine, and he cut discarded pieces of metal to make the chess board. Alexandra Alcantara used rusty pipes from the muffler system to make the vases, and incorporated the rust color as a design element. The only part of the truck left over after the students had made their pieces was a cooling fan blade from the truck's generator, which I brought home for my young daughter, Caroline. I thought she would put it on her wall as a decoration, but she immediately put it on a table with a glass and turned it into a coaster. I'm so proud!

O'C: The dashboard was turned into a desk, a great idea by Nicole Penna. By removing the gauges and ashtray, and opening up the glove box, there were lots of little cubbies for paper clips and pencils. It was complemented by a stainless-steel desktop. I like how she put the cork across the strip that said the name of the truck and put Post-its in there.

O'C: The biggest piece of the show was the pickup bed that John O'Callaghan turned into a couch. Again, it seemed like an obvious solution, since people sit in the back of a pickup, but it was exquisitely art-directed with the upholstery choice of automotive vinyl, including the pillows. Shelves were built into the wheel wells. One thing that I stressed with the project was to keep as much of the red as possible to emphasize that these furnishings had come from one truck.

O'C: Robert Paternostro's radiator welcome mat also seems a simple solution yet made complete sense. You wiped your shoes on the venting of the radiator, and the dirt and water ran through. The word *welcome* wasn't painted, it was pounded in. If you look at the back of an air conditioner that someone has scraped against, it becomes kind of silver because the fins get pointed in another direction. That's how the *welcome* was done.

This page

O'C: Dave Waelder took the chassis of the truck, weighing about 1,500 pounds, and dragged it from Long Island back to New York City. He took the springs of the truck and made feet for the shelving unit, beautifully done. Cleaning off the dirt and grime was quite a job.

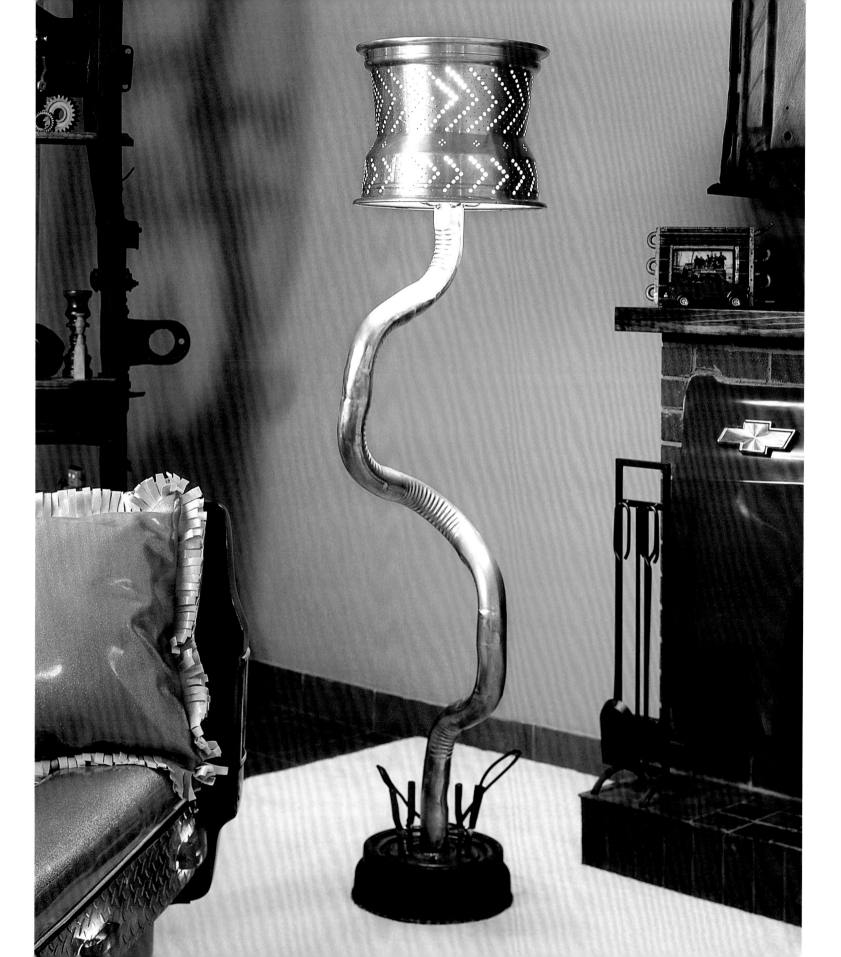

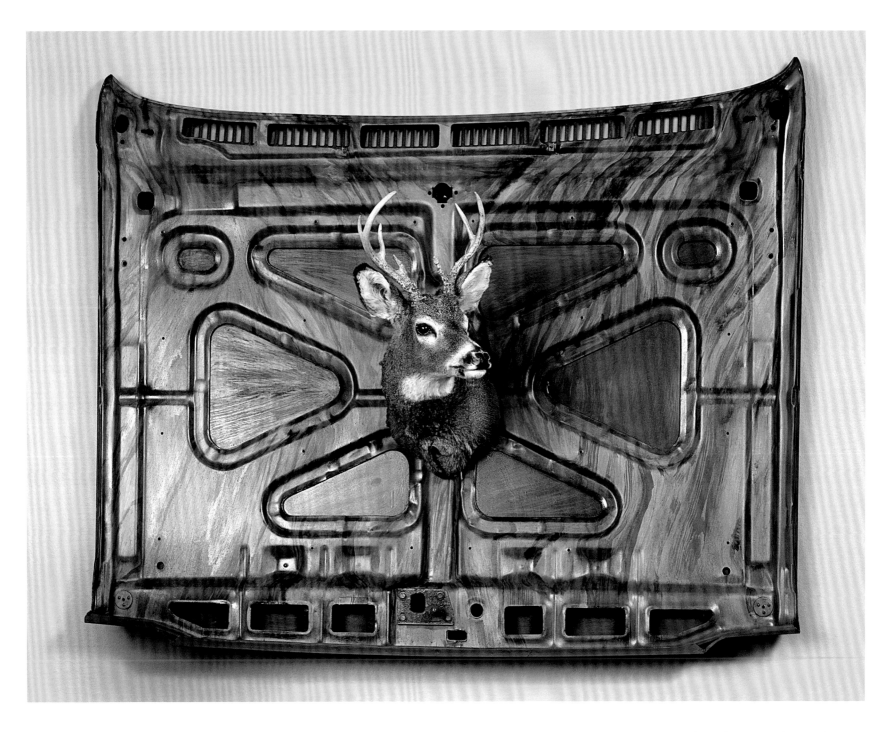

O'C: A fun piece was the floor lamp created from the bent pipes of the exhaust system. Alexej Steinhardt made the base of the lamp from a wheel drum. The shade was amazing: The aluminum rim of the truck was drilled with hundreds of holes that formed a pattern when the light came through. He broke countless drill bits, but it was well worth it.

O'C: The hood of the truck was a part that could have been turned into a table or cut in half as two end tables, or made into the front of an Armoire. Ann Marie Mattioli decided to use the underside and paint it with a faux finish wood grain. It became this beautiful panel, like a raised panel in an old library. The imitation deer mount gave an old-world touch to the exhibition.

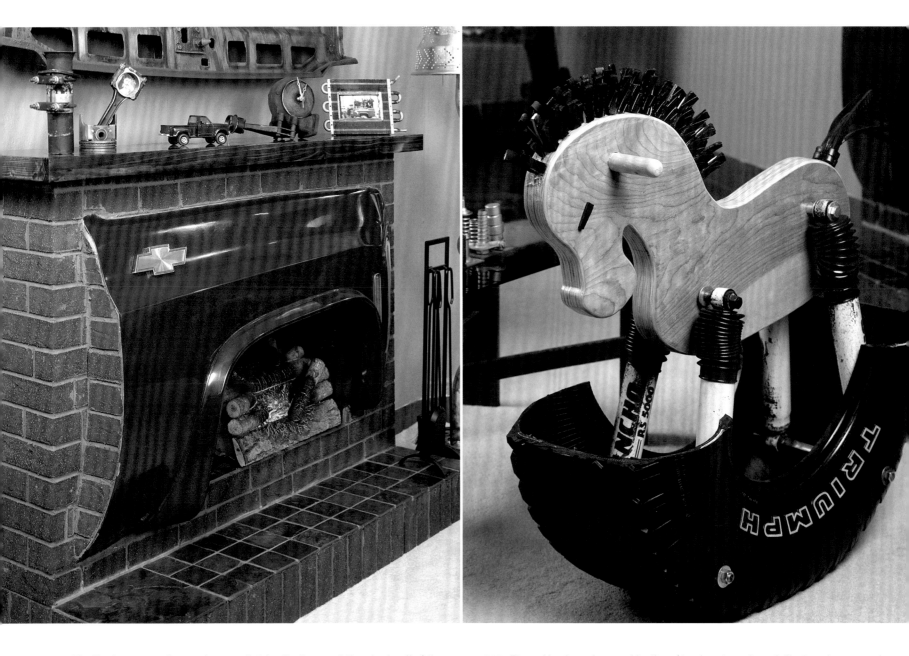

O'C: The fireplace was a fun one because Katelyn Hughes used the wheel well of the fender as the opening, surrounded by thin slices of brick. I really love what was done with the mantle: pieces of the truck turned into little tchotchkes (as we call them on Long Island) that included a cylinder into a mantle clock and pistons into bookends. She also constructed a little model of the truck itself. Cesar de la Vega used a small cooling element from the air-conditioning system for the picture frame.

O'C: The rocking horse is a combination of truck parts and wood. The horse's mane and tail are from cut pieces of tire, and half of the tire became the rocking part. Sabina Ciari used shock absorbers for the legs of the horse.

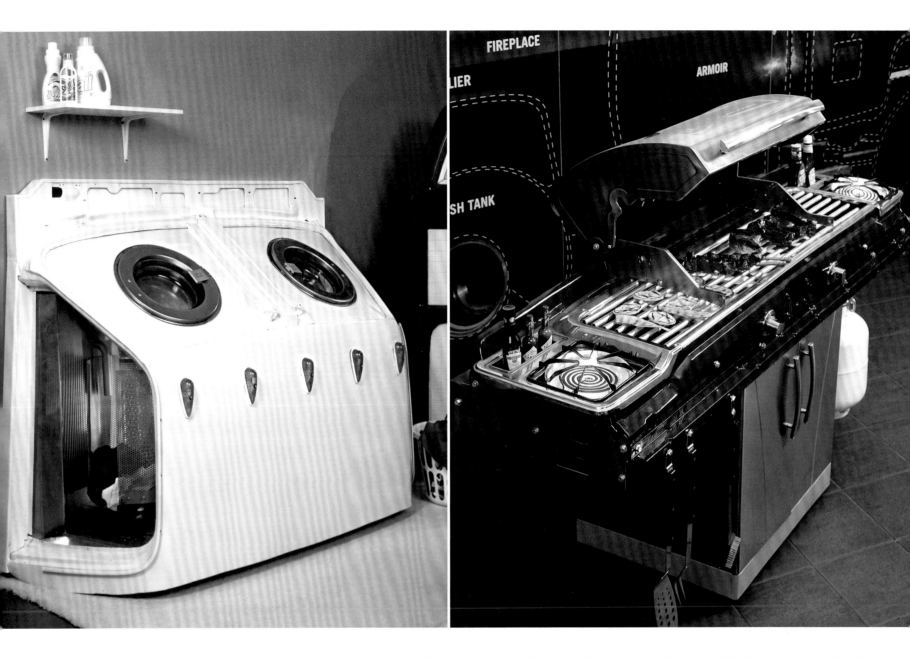

O'C: The roof of the truck was turned on its end and made into a functional washer/dryer by Joseph Pastor. It was a giant effort to take this piece off the truck. He left the glass on the side so you could see the mechanics of the appliances.

O'C: I thought it was cool that Stephen Park took the grill of the truck to create the grill of a barbecue. Heating elements were placed where the headlights had been. His parents didn't know that he had used their barbecue as a base until they came to the show, but he had done such a beautiful job that I think they forgave him.

A TWISTED CHRISTMAS: ON BROADWAY

CHALLENGE: USING ONLY FOUND OBJECTS, CREATE AN OUTRAGEOUS CHRISTMAS STAGE SET FOR THE HEAVY METAL BAND TWISTED SISTER.

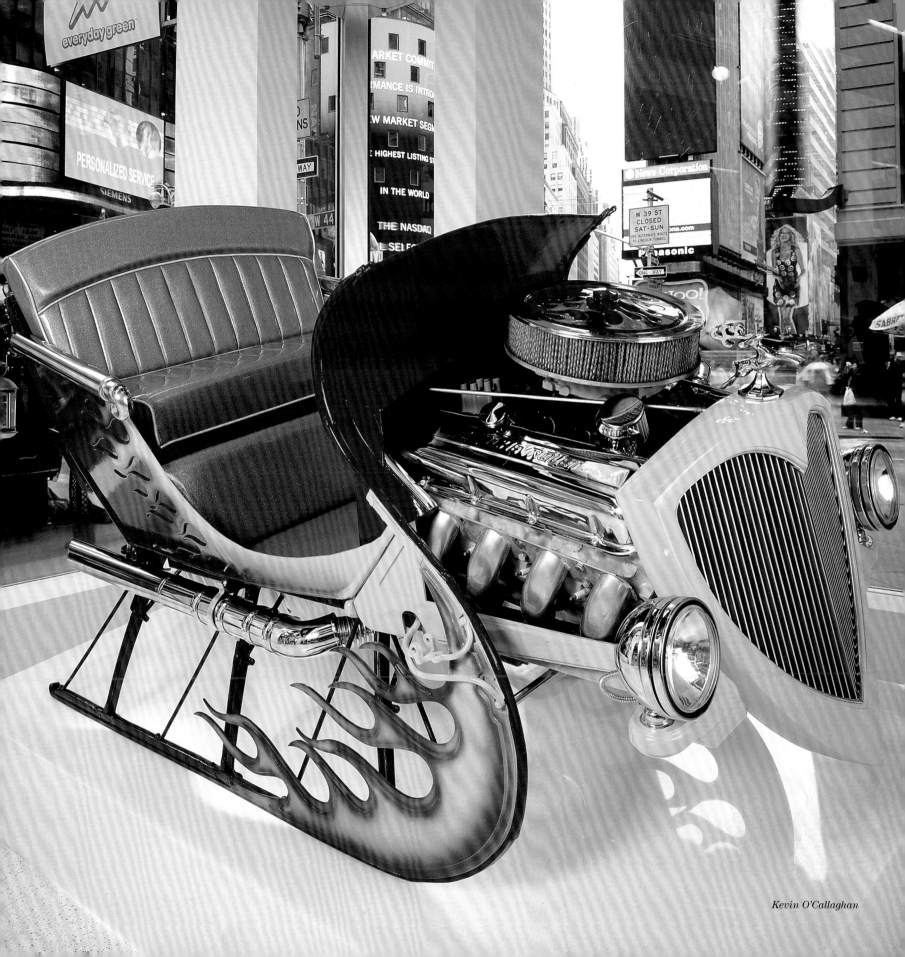

Kevin O'Callaghan

Scavenging through an archaeological dig of cornices and turrets, O'CALLAGHAN WAS IN HIS ELEMENT.

K evin O'Callaghan has a hole in his head. It was revealed by the CAT scan he needed after he fell off the back of a truck that was loaded with a stage set for a concert that night. Though some would be disconcerted by such news, O'Callaghan relishes the thought that microscopic black-hole jumpers, Bowie's starmen, may be circling in his cerebrum on an Einstein ring. There are no dangerous consequences to this particular type of void in the brain, and many of his friends and collaborators found comfort in its discovery. Some credit this physiological anomaly as the root of O'Callaghan's idiosyncrasies. Others are relieved that his dense creative matter can expand when necessary, previously fearful that another big idea might just cause his head to explode.

Waiting for the hospital to discharge him, O'Callaghan decides on a last-minute change to the set he designed for that night's show at the Nokia Theatre. O'Callaghan is known for fidgeting with details until the final minutes before an event. He once added a prop he found on the way to an opening, considering it essential for the show. Amid a roomful of guests, he placed it seamlessly in the exhibition space and headed for the hors d'oeuvres.

Organizing a set change can be a bit more complicated from a gurney in the ER, though. The concert only hours away, a rather disturbing conversation could be heard between O'Callaghan and his assistant.

"I want Ozzy's body."

"We don't have time to get it. You already have his head."

"I want his body, too."

A mildly concussed O'Callaghan had made up his mind, and one of his crew turned back toward Long Island to get Osbourne's stiff body out of the shed. Ozzy's head had been a no-brainer; it was a perfect companion to that night's heavy metal extravaganza and was already at the Nokia. Only after he fell off the tail lift did O'Callaghan conclude that the body would also be a nice design touch.

Not long before O'Callaghan's misstep, his childhood friend and heavy metal icon Dee Snider, of the band Twisted Sister, had been telling him about the band's upcoming holiday concert. O'Callaghan was reminded of the dynamite Santa sleigh he had created for an MTV window display. Thinking it could be used as set decoration, he emailed some pictures to his friend. Snider took one look at the images of the ice glider and deemed it to be *A Twisted Christmas* defined. He asked O'Callaghan to design and construct the stage sets for Twisted Sister's 2008 holiday spectacular.

The Ozzy Osbourne sculpture that O'Callaghan now wanted in its entirety was from another project for MTV that featured over-size celebrity heads. The opportunity for O'Callaghan to add his hot-rod sleigh and a bobble-headed bloke to the *Twisted Christmas* set brought him great joy. He simply cannot endure putting his favorite things in storage. And he has lots and lots of cherished possessions.

O'C: (Page 161) I originally created the sleigh for the MTV holiday window in Times Square. It's a late 1890s Albany Cutter that I found it on eBay. A New Jersey man had kept it in his den for forty years—an heirloom.

Kevin O'Callaghan with discarded molds at Seal Reinforced Fiberglass, Inc.

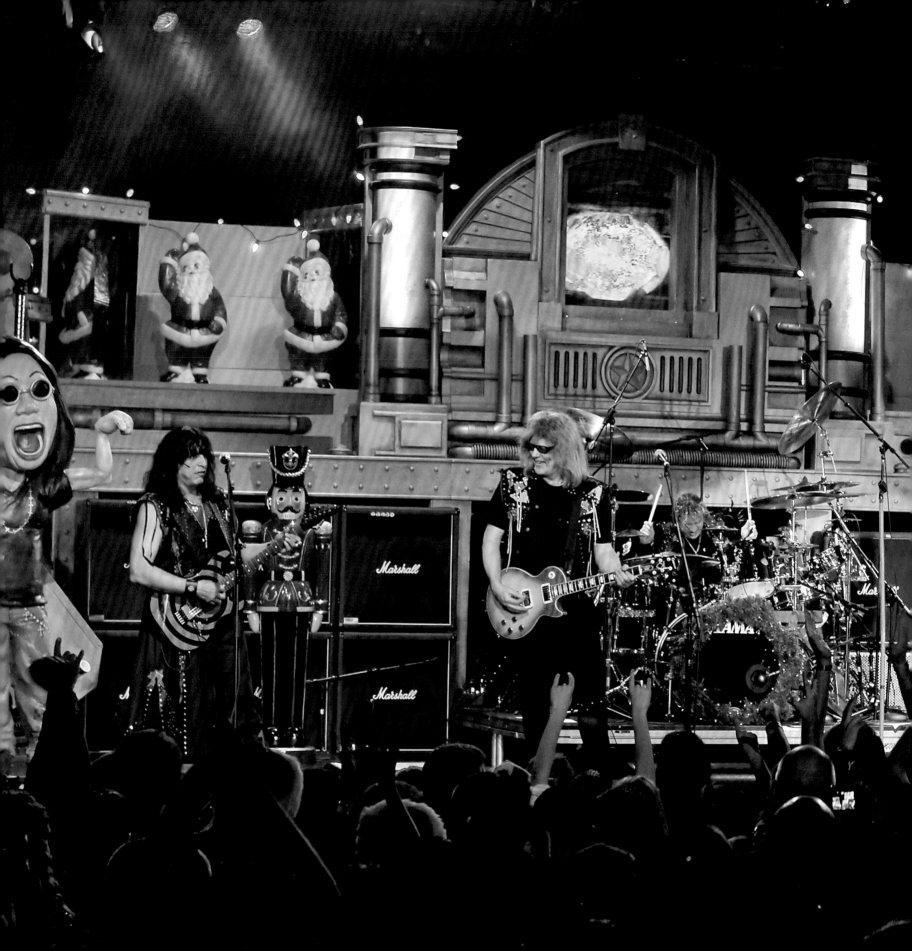

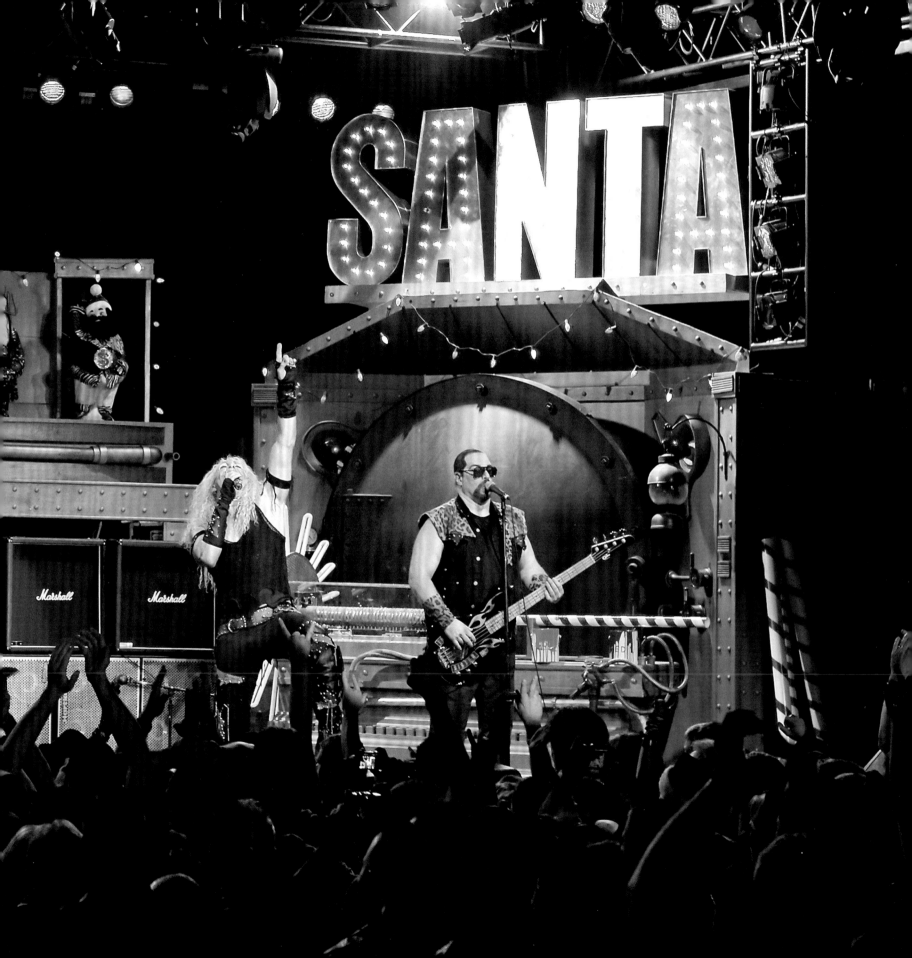

Designing the sleigh was one of O'Callaghan's most beloved projects. The overall concept was inspired by *Pimp My Ride*, the MTV series featuring distinguished professionals who customize automobiles based on the likes and interests of the show's guests. O'Callaghan purchased an Albany Cutter sleigh from the 1890s that had been immaculately restored. For authenticity, he wanted to create an open-engine hot-rod sleigh with a 427 Chevy motor (he's a serious car freak). Weighing nearly half a ton, this big-block horsepower leviathan could never be supported by the sleigh's frame. O'Callaghan searched for a foam-cast display engine, which tops out at around thirty pounds. Used only for hot-rod design when the motor has to be removed and inserted numerous times for fittings, these models are very rare. But this was the season of elves and holiday angels, and O'Callaghan found exactly what he needed. Just off the trade show circuit, this stand-in engine came fully dressed and ready for a new home.

O'Callaghan built a stand for the sleigh out of white frosted Plexiglas. Instead of peeling off both sides of the blue paper protecting the acrylic sheet, O'Callaghan removed it from only one side. Illuminated from below, the stand took on a translucent glow that gave it the appearance of ice. To add a finishing touch, O'Callaghan brandished his X-Acto right there in the MTV window. *Pimp My Sleigh* glided right into place on two thin lines cut in the blue paper.

For Twisted Sister's Broadway gig, O'Callaghan decided on an industrial look, akin to the steel-gray sets of Fritz Lang's *Metropolis*. Here was the perfect background for heavy metal musicians. The judicious application of bold reds, yellows, and greens heightened the dramatic effect. With a limited budget and more limited time, he turned to found objects to construct Santa's massive workshop, which stretched the length of the theater's stage. It was a very narrow space, so with no room to build wide, O'Callaghan had to compensate by designing high and tight.

A Twisted Christmas stage set (pages 164-65)—design and concept: Kevin O'Callaghan; production assistants: James Korpai, Adria Ingegneri, Shaun Killman, Joseph Pastor, André Araujo, Kaori Sakai

When O'Callaghan speaks about his professional work, *reuse* and *repurpose* are two principal words in his lexicon. In seeking objects that he would later bolt together, he turned to Patrick Kaler of Seal Reinforced Fiberglass, Inc., a firm specializing in architectural restoration and replication. Seal has mounds of molds in a wide range of sizes and motifs. The firm keeps these custom-made fiberglass forms for a period of time, and then puts them in massive disposal containers, waiting for pickup. When O'Callaghan arrived to look over items earmarked for the junkyard, he was met by a half-dozen overfilled Dumpsters of plastic goodies hoping for adoption. Scavenging through an archaeological dig of cornices and turrets, O'Callaghan was in his element. When Snider first saw some of the unfinished junkyard remnants that had been earmarked for the set, he concluded that a certain degree of trust in his friend's vision and creativity was required. This leap of faith is a prerequisite for collaborating with O'Callaghan, because it is nearly impossible to comprehend the ways in which he can visualize the potential of any given mound of trash.

Having never worked with found objects of such large dimension, O'Callaghan took pictures of individual pieces and then collaged them into a sixty-five-foot workshop for the Clauses. Motors were added, and a conveyor belt of plastic Santas revolved on the set. A sixty-inch flat screen was converted into a furnace, and a spinning candy-cane machine caused vertigo if watched too long. O'Callaghan didn't build any reindeer. Cover band Mini Kiss escorted Snider onto the stage.

The set had to be installed at the Nokia Theatre during the morning hours before the show. There would be no time to fix a damaged piece. All of the parts had to join flawlessly, as each section was dependent on its neighboring elements. With this in mind, O'Callaghan had taken extra care to assure that the set's components were all placed correctly in the transport trucks. He was so focused on their welfare that he forgot about his own, reaching back to get a final look and landing in the hospital. But the show went on, his creative cabal joining together for their mentor and friend.

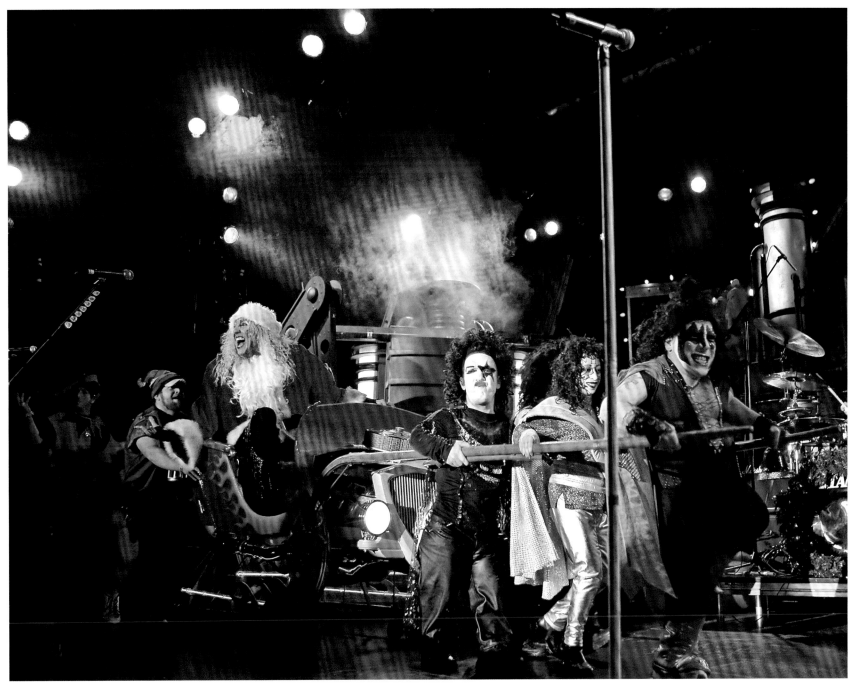

"Santa" Dee Snider in the hot-rod sleigh is pulled across the stage by Mini Kiss, Nokia Theatre, 2008.

BED, BATH, AND BOMB SHELTER

THE INCREASE OF WORLDWIDE TERRORISM HAS CREATED AN AMERICAN MARKET FOR GAS MASKS.
KEEPING IT FUNCTIONAL, DESIGN A GAS MASK THAT APPEALS TO THE AMERICAN AESTHETIC.

45 GASMASKS
36
3

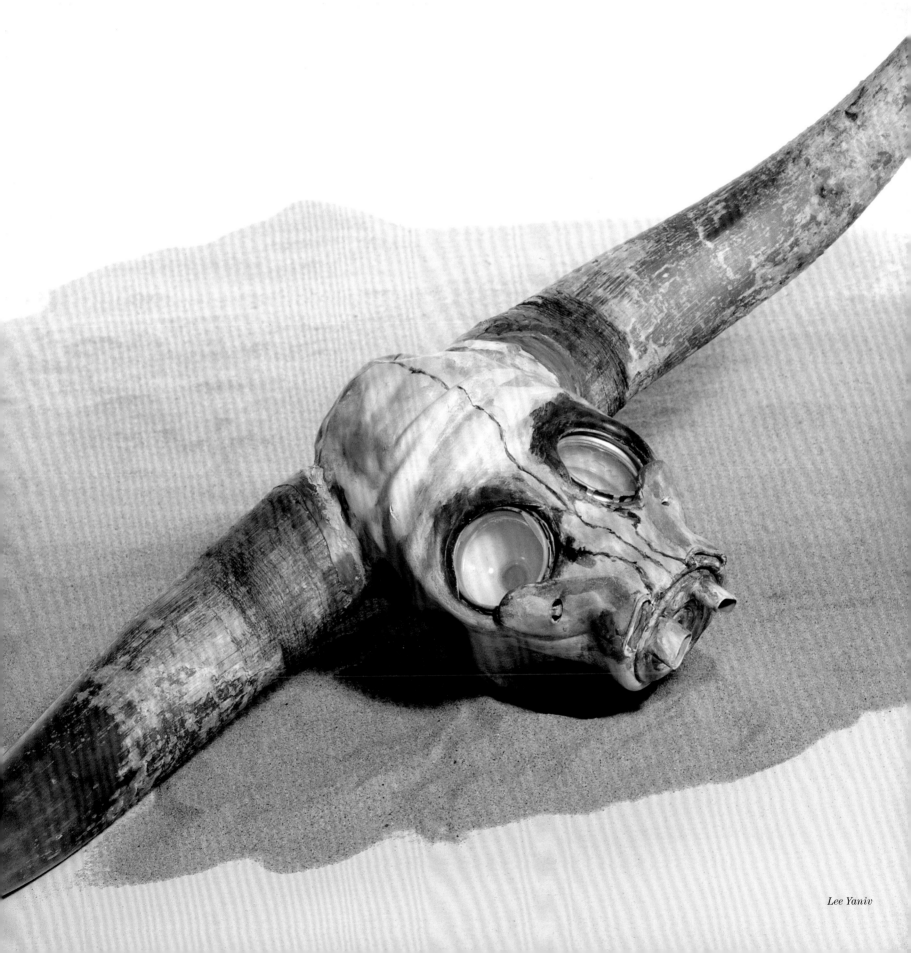

Lee Yaniv

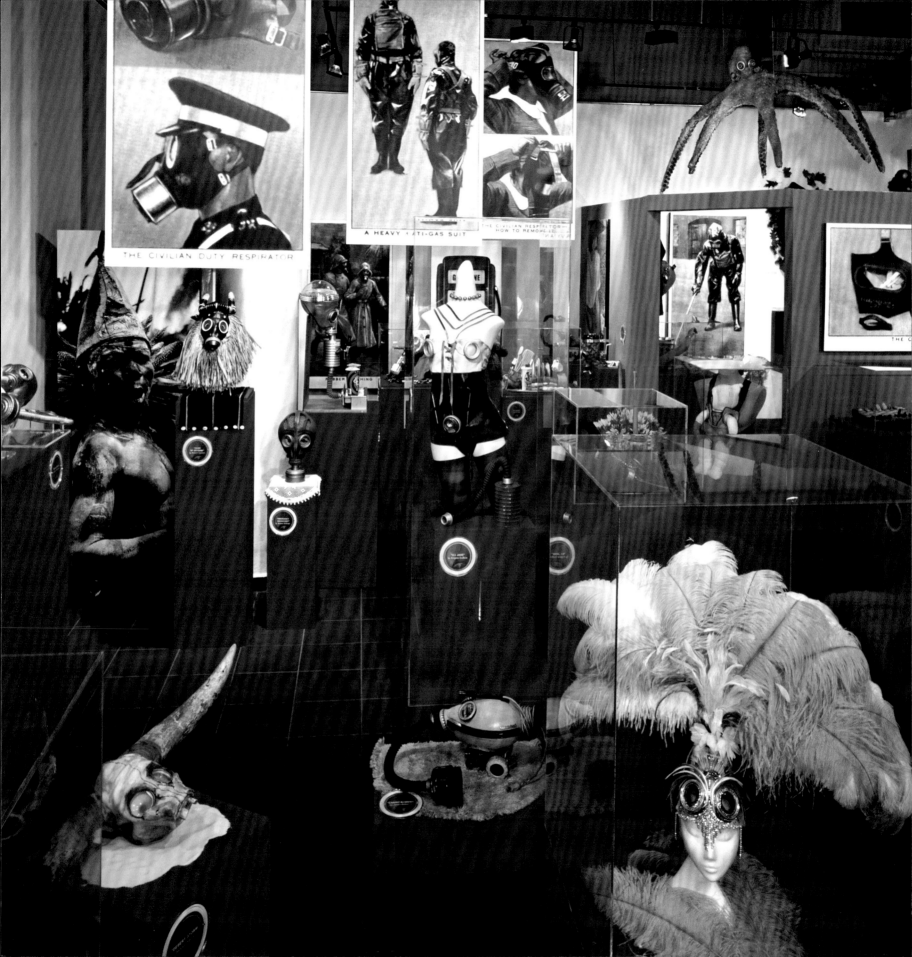

THE CIVILIAN DUTY RESPIRATOR

A HEAVY ANTI-GAS SUIT

THE CIVILIAN RESPIRATOR—
HOW TO REMOVE IT

Americans were unfamiliar with the GAS MASK aesthetic and found them both FRIGHTENING and highly unattractive.

For many people in the world, life's reality is fraught with the knowledge that their homes, places of worship, schools, and neighborhoods might be overcome by bombings or toxic gas. Unable or unwilling to relocate to avoid being in harm's way, people try to protect themselves through whatever means can be found. In these communities, it is commonplace to find a den filled with the paraphernalia of defense: gas masks and survival kits.

Following the dawn of this millennium, out of fear of terrorist attacks and envelopes laced with anthrax, people across the United States began to behave in a similar fashion. O'Callaghan read an article about a supplier in the rural northeast that sold army-issue gas masks at the rate of a few per month. The destruction of the Twin Towers, the synchronized attack on the Pentagon, and the airplane disaster in Pennsylvania caused gas mask sales for this supplier to exceed two thousand to exceed two thousand within the equivalent time period. The newspaper article went on to explain that unlike communities that have incorporated gas masks into daily life for far too long, Americans were unfamiliar with the gas mask aesthetic and found them both frightening and highly unattractive.

O'Callaghan's mind raced with ideas. Why not accessorize gas masks to fit into the fashion trends of American culture? Make them out of denim, wear them to the office, or decorate the den with them. He gave his students a three-week assignment to create a gas mask that was both aesthetically charming and usable. Unlike other projects that addressed the transformation of objects by giving them new roles, this time the artworks were to retain the masks' original purpose and be functional at a moment's notice.

A stunning example that addressed the design problem was the feathered gas mask by designer Laurie Mosco. It looked like a headdress that might be worn by a Las Vegas showgirl, but one strong tug would make the device cover the face instantly, ready for action. Allegra Raff went from the shoulders up with an imitation mink-stole gas mask that could be demurely fastened over the nose in a flash. Bittersweet was the gas mask–baby carrier by Katarzyna McCarthy.

Home interior décor was also on offer. Three gold gas masks gave added dimension to a dining-room chandelier. Perfect for the single-child household, this work by Dorothy DiComo could be slipped off the chandelier and quickly attached between courses.

The exhibition design included vintage illustrations of gas masks from a British set of cigarette cards, which O'Callaghan had enlarged to poster size. Issued as a series with one card per cigarette pack, the cards reinforced the packaging and bolstered brand loyalty for tobacco companies. Popular from the mid-nineteenth century to the early decades of the twentieth, the miniature card sets were beautifully illustrated and sported a vast range of subjects, from world monuments to sports figures to … well, the latest in gas mask couture.

O'C: This was a small two-room gallery exhibition that was prompted by the terrorist attacks of 2001. It addressed various ways to camouflage the unappealing look of a gas mask while assuring that it was within reach and ready to use.

Mounted on the exhibition walls, the oppressive palette of these prints accentuated the mood of the show. In addition, the images demonstrated the unappealing and menacing appearance of an unadorned gas mask.

Kevin O'Callaghan dreams of a time when the associations evoked by a mask are limited to formal masquerades, baseball catchers, and Halloween nights.

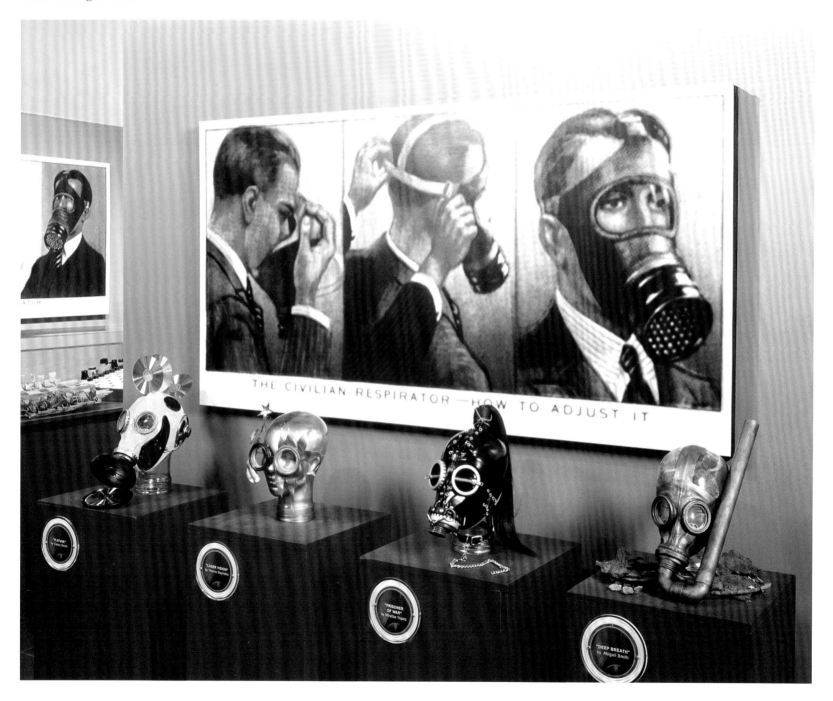

CD player by Casey Smith; designer glasses by Yelena Deyneko; dominatrix mask by Miralba Yepez; scuba gear by Abigail Smith

O'C: Laurie Mosco's solution was brilliant, beautiful, and humorous. Perfect for Mardi Gras in New Orleans or for a Las Vegas showgirl.

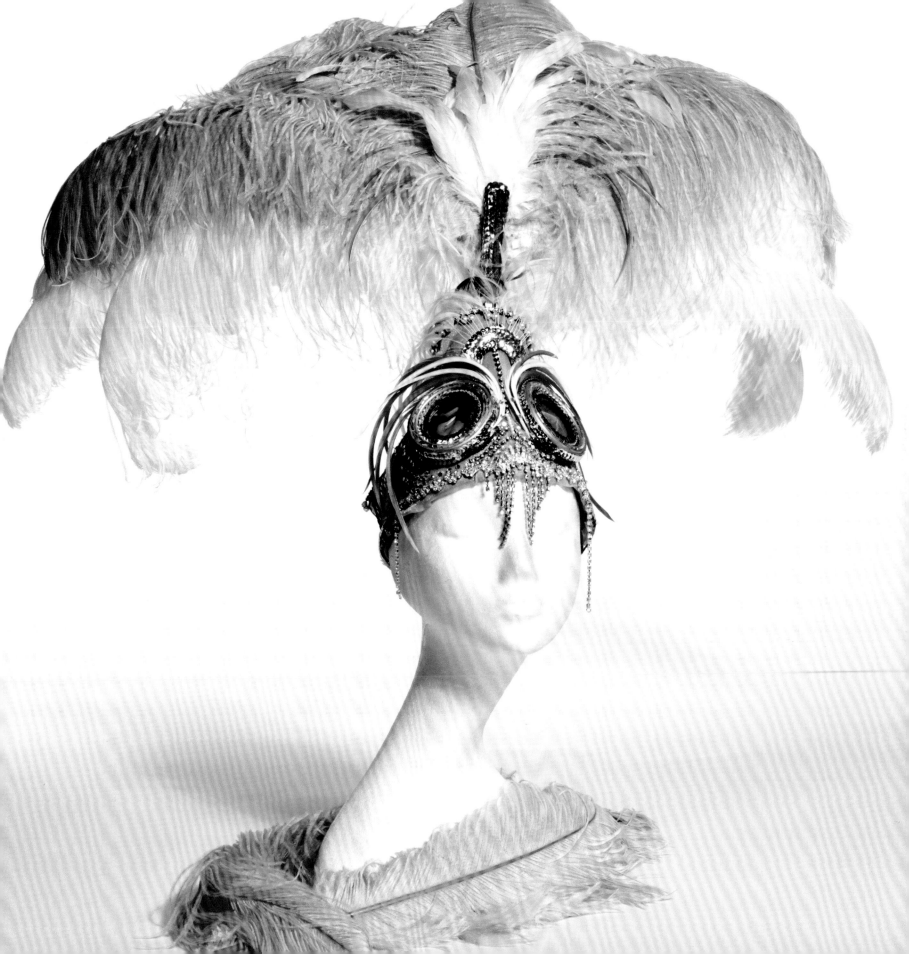

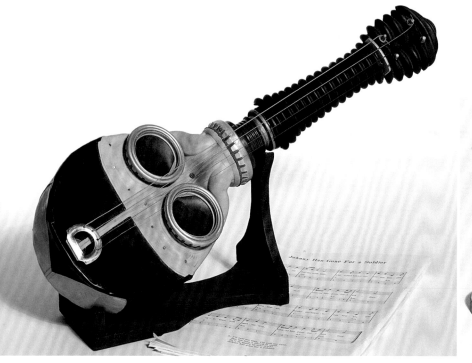

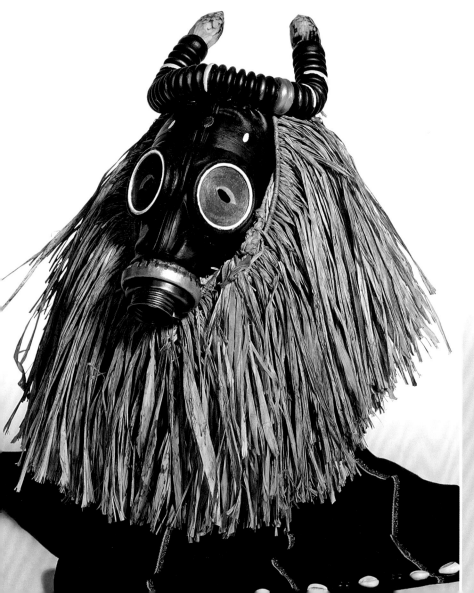

O'C: The rubber hose on the mandolin by Vincent Perrella gave it an interesting sound. Vincent enjoyed playing the guitar; I encourage my students to create something that interests them.

O'C: The African mask by Robert Conlon was another great solution. Created as a decorative table piece for a modern-style home, it used natural fibers and made a wonderful statement because its intended function was not "masked" within the sculpture.

O'C: Allegra Raff's cosmetics kit was had many components. The eyepiece of the gas mask flipped open to reveal a compact with a mirror. The hairbrush was inserted through the front of the mask's hose, which became the brush handle. She also created the faux stole, ready to be used at a moment's notice. The filter was hidden inside and easily connected to the hose. I loved the little diamond-like jewels that surrounded the goggles—very fashionable.

O'C: The dish rack was beautifully art-directed by Jessica Hill. The muted-green color was very reminiscent of the 1950s fallout shelters. The illustrations on the plates were weapons, tanks, and gas masks that echoed the homey, decorative style. The dishwashing liquid container was found in a thrift store and is from the mid-twentieth century, with the addition of expandable foam. I like the feeling it gave of a very fifties, atomic-era look.

O'C: Dorothy DiComo used gold patina on the chandelier to give it a formal and elegant look. This piece accommodated a family of three if the situation warranted. She also created the planter on the opposite page, which sustained life outside of its intended function. Nice idea!

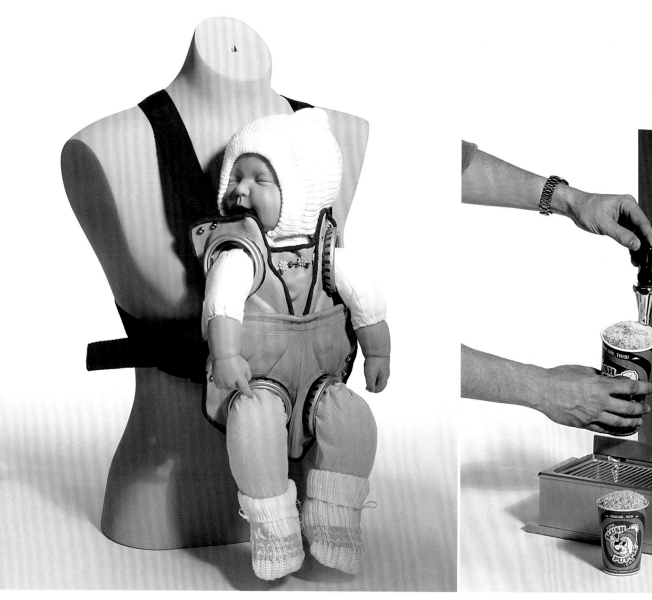

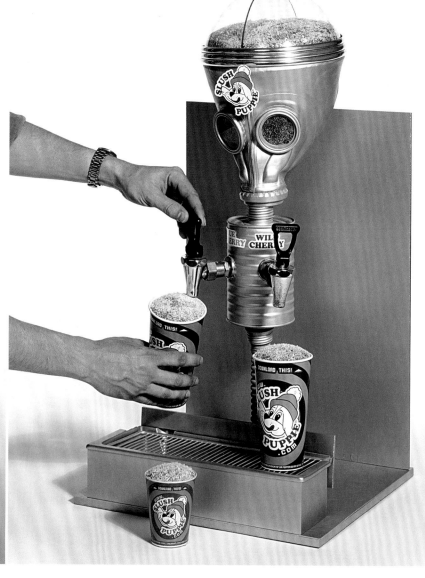

O'C: Maternal instinct was the catalyst for this baby carrier. Katarzyna McCarthy conceptualized this piece when she was in the hospital after giving birth.

O'C: This slush puppie machine brought back happy childhood memories for Adria Ingegneri who took this gas mask and divided it to make two frozen treats.

O'C: The water fountain by Oscar Gonzalez was created using real copper pigment for the finish. The pigment was chemically oxidized to create a realistic look.

O'C: Angela Dubois chose to make a fashion statement by turning a gas mask into a corset. Later this piece was actually included in a major fashion runway show!

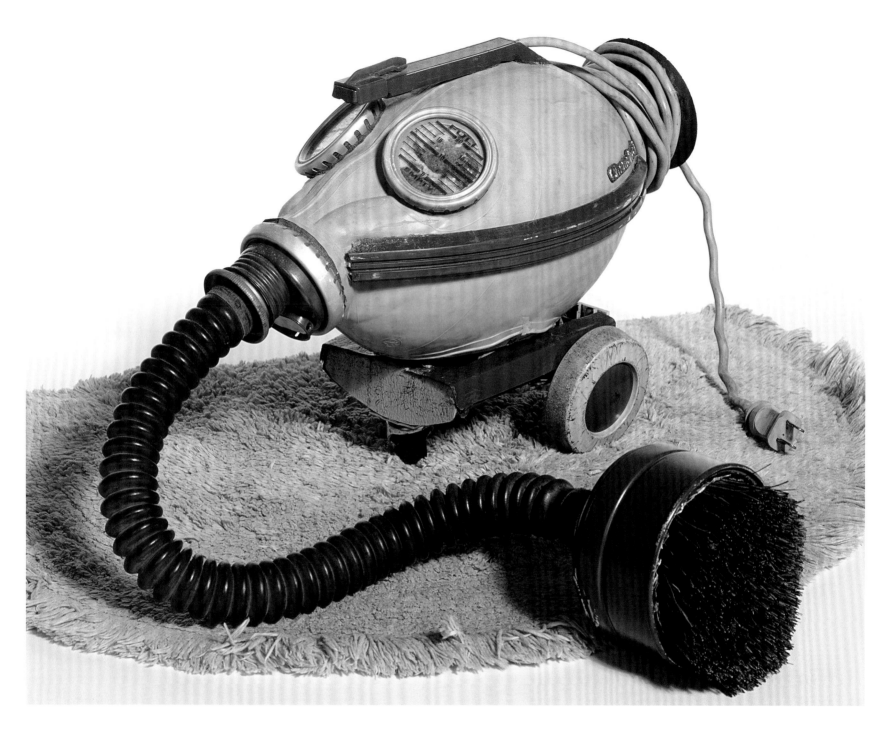

O'C: The dual-function mini vacuum cleaner by Jason Robbins offered a paradoxical filtration system.

O'C: Shaun Killman reached back to the American homes of the Depression-era when he created this cathedral-style tabletop radio. The little details were beautifully art-directed.

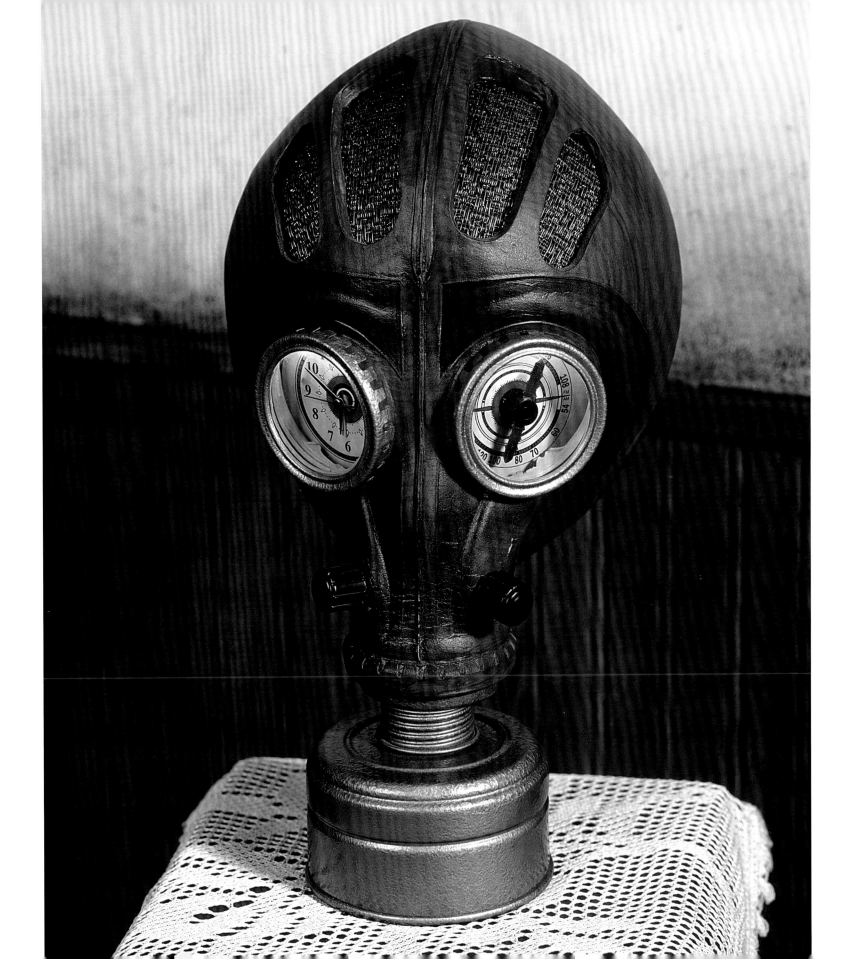

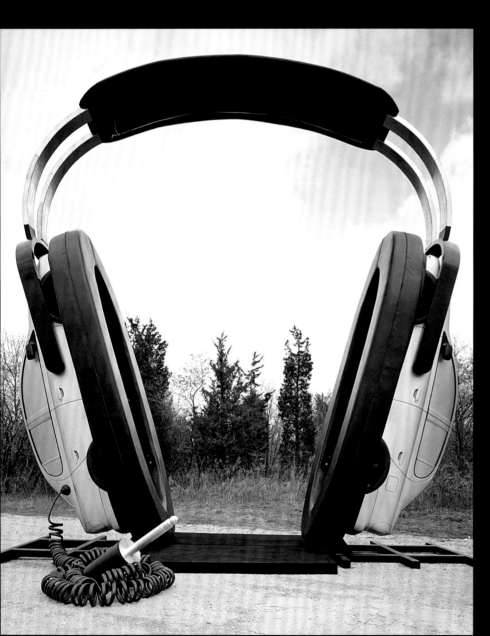

O'C: This was a project that originated with a phone call from a Toyota representative who was looking for the person "who did 'Yugo Next.' " Toyota wanted something to promote its soon-to-be-released Echo car to a techno music audience, referring to the genre of electronic music that originated in Detroit. I thought it was a bit strange for Toyota to approach the guy who took a bunch of lemons and turned them into artworks, when Toyota really wanted to sell their Echo cars.

Coupled with my love of automobiles, I was intrigued with the challenge and decided to take on the project. The goal was to create a promotional headset from two new Echo cars and found objects. My students Brian Brindisi and Shelly Federman worked as part of the design team, along with my project assistant Mark Cadicamo.

The headset was gigantic, and it was one of the few times that I couldn't install it by myself. We needed cranes to stand the cars up. The bases were welded to the back of the cars, and then the Echo cars were rolled into place, lifted, and left standing there. When the cars were put back down on their wheels, the iron bases stayed attached. Each padded earphone was the size of a huge raft. I used a refrigerator hose for the cord and its rubber component was a black plunger. A beautiful stainless-steel headband connected the two Toyotas.

We installed the headphones in Irving Place, where they blocked traffic for about twelve hours and blasted music, to the delight of many New Yorkers.

construction assistants: Nigel Buxton, Al Braunreuther, Rob Tringali

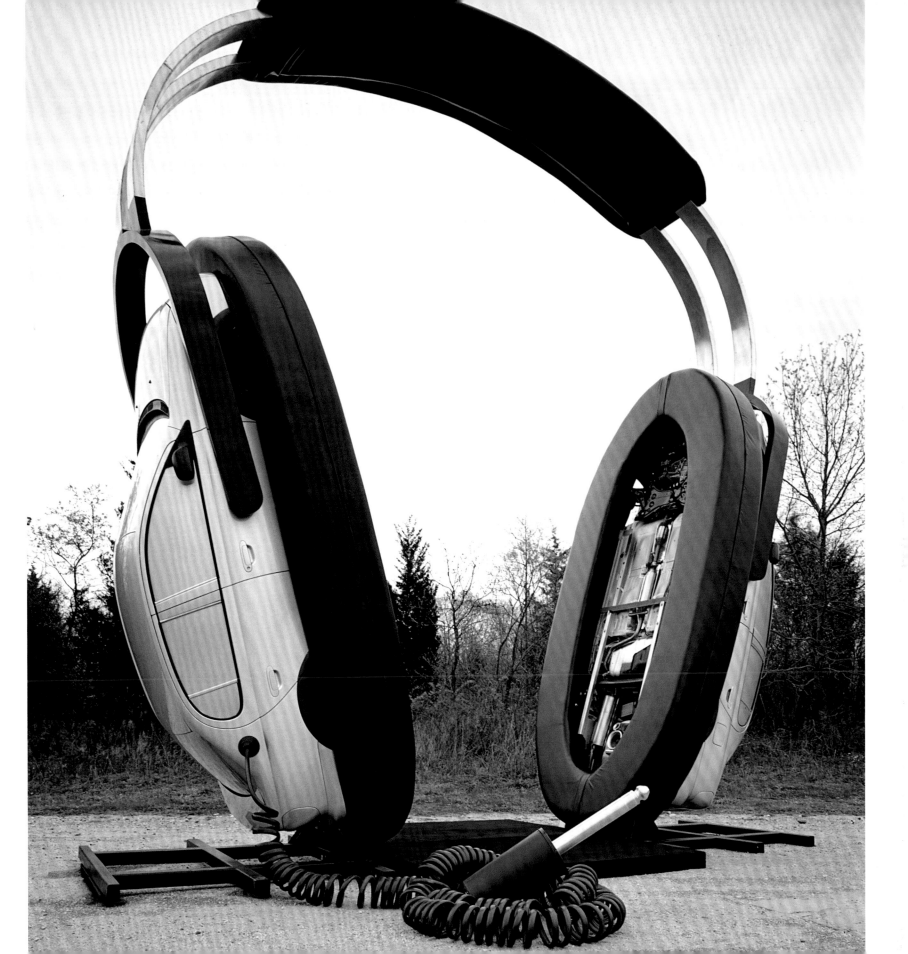

DISCONNECTED

CHALLENGE: CELL PHONE USE HAS PROMPTED THE MASS REMOVAL OF CITY PAY PHONE ENCLOSURES. TAKE A PHONE BOOTH AND GIVE IT A PRACTICAL SERVICE SO THAT IT DOES NOT HAVE TO BE MOVED FROM ITS VALUABLE CORNER REAL ESTATE.

STARTING POINT: 35 PHONE BOOTHS
ARTISTS: 28
WEEKS: 3

Wei Leih Lee

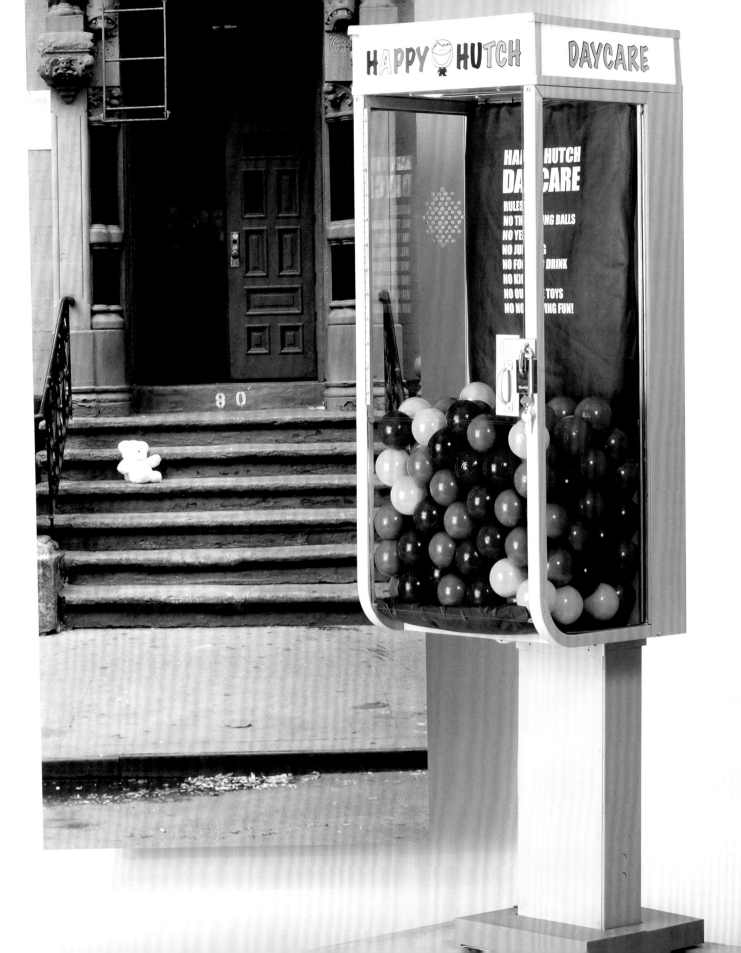

By the time O'Callaghan got his bill FOR AN OVERPRICED CAESAR without the chicken, the phone booth had provided assistance in a HALF-DOZEN services, NONE related to its designated intent.

The farmlands of Pennsylvania provide peace and quiet for Kevin O'Callaghan's creative thinking. With few distractions and the sanctity of leisure time, he grazes through the daily newspaper, consuming editorials of interest and cataloging the information for subsequent artistic feeds. During an earlier forage, a brief article about a typewriter repairman had resulted in the enormously popular exhibition, "The Next Best … *Ding!*" This time, a story on the obsolescence of public telephone booths took seed in O'Callaghan's gray matter, and it began to germinate.

Returning to New York, further study led O'Callaghan to discover that the pay phone booths in New York City were being dismantled at an alarming rate. It was time for some field research. Taking a front-row seat in a diner on Third and Twenty-sixth, O'Callaghan settled in, enjoying an unobstructed view of the avenue. A hive of pedestrian activity surrounded the phone booth outside the restaurant. As O'Callaghan watched, a woman with an infant entered the booth and inconspicuously checked the baby's diaper. Someone took shelter from the wind to light a cigarette. A man scooted in, placed his

O'C: Michelle Silverstein created a satirical, makeshift day care center where parents could drop their children on the way to work. You put money in a slot, unlocked the opening, and locked your child in the booth. The center's rules, including how long you could leave your kid, were posted on the back wall, which was safety-padded. It underscored the lack of appropriate day care for working parents.

go-cup on the phone's casing, and rearranged the folders in his briefcase. The most injurious blow to the phone booth's intended function came from a preoccupied shopper who had temporarily converted it into a sound shelter for her cell-phone conversation.

By the time O'Callaghan got his bill for an overpriced Caesar without the chicken, the phone booth had provided assistance in a half-dozen services, none related to its designated intent.

Prior to their removal, these booths had become worse than useless due to the cell-phone boom. Many were filthy and decrepit, like an abandoned house the day after a squatters' shindig. Few callers in need of a public phone would venture to touch the receiver without surgical gloves, if a working pay phone could even be found. A substantial number of kiosks had been stripped of their receivers. Phones that remained intact often ate enough change to pay the orthodontist bill, without offering a functional dial tone in return. Still, O'Callaghan wondered about the costs involved in removing these phone booths, disposing of them, and patching the cement that once held them in place. He thought it would be far more worthwhile to redirect their function and offer various services to urbanites. The 2007 "Disconnected" exhibition illustrated some potential solutions through creative and humorous artworks.

Securing the material was the first obstacle. Following an educational lecture on Alexander Graham Bell and the phone company that

bore his name, O'Callaghan's team of young artists grabbed their cells and joined the hunt for the phantom booths. None of the civic offices seemed to know where they had been sent. Internet searches revealed a wealth of phone parts, but no booths. Trailing the dismembered components, the team found a fellow in Idaho who had cornered the market on discarded pay phone shelters, which he bought and sold to developing nations. He had thirty-five booths in the desired style and shipped them to O'Callaghan's workshop at the School of Visual Arts.

They were hideous: rusted, bent, slimy, and tagged with mediocre graffiti. And they arrived with personal escorts: A colony of giant spiders indigenous to the Pacific Northwest crawled out of the debris. O'Callaghan had given his students three weeks for this project, and it seemed that it would take at least that much time just to clean and disinfect the starting point.

The final results were magnificent products and services for people on the go. At the New York Art Directors Club, O'Callaghan lined up the booths like a sidewalk show. To accentuate a neighborhood feeling, large images offering a street-level perspective were installed as backdrops and complemented the artworks. An audio mix played topical tunes that included Stevie Ray Vaughan's "Telephone Song" and Jim Croce's "Operator."

Some of the pieces were viable products for a busy metropolis. Gregory Westby, a 3-D designer, constructed a foot spa where passersby could stop and soak en route to their pied-à-terre. Those who prefer a more active form of relieving stress could try the punching booth by product designer Wei Lieh Lee, complete with boxing gloves and a padded shelter. Others were whimsical. Using three phone shelters, graphic designer André Araujo created a fantasy apartment for rent. It promised lots of sunlight and great views. A mattress lay across the top of the conjoined booths, a true New York loft.

The success of "Disconnected" was quickly transmitted throughout the region, with O'Callaghan's cell ringing off the hook.

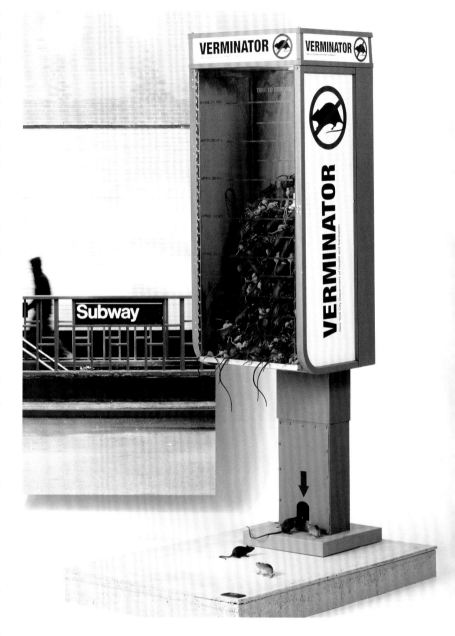

O'C: Michael Pisano designed *The Verminator* to include a little one-way opening at the bottom that tempted the rats to go inside, but they couldn't get back out. This pest control prison was a graphic solution for any city with an unwanted rodent population.

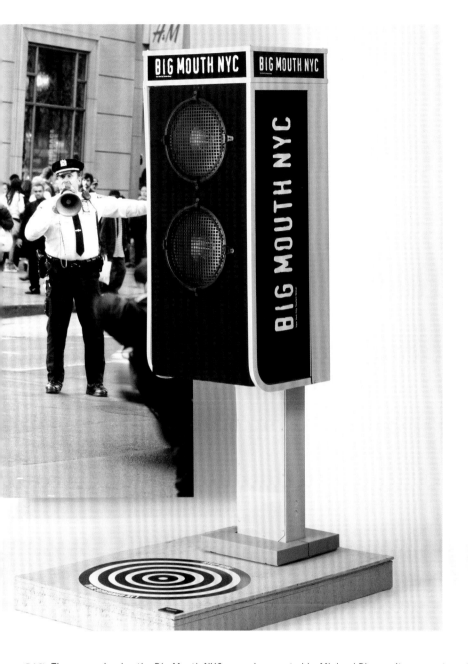

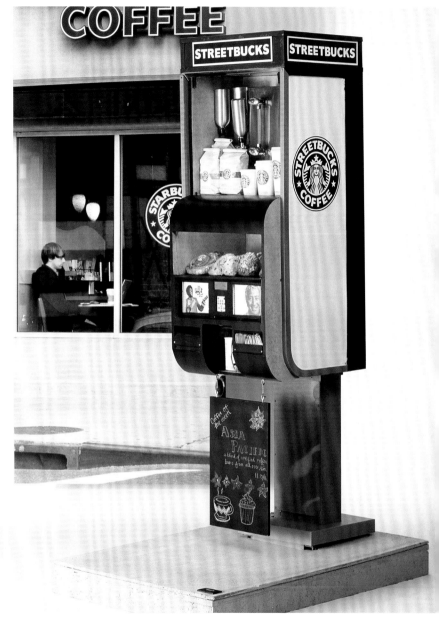

O'C: The screaming booth, *Big Mouth NYC*, was also created by Michael Pisano. It was a funny narrative about New Yorkers, who are used to being yelled at as they walk down the street. It was built exclusively to provide your daily session.

O'C: Joseph Pastor created a viable idea with his *Streetbucks*, and also commented on the proliferation of Starbucks throughout the city. If these phone booths were repurposed and installed, maybe Starbucks would consider this idea.

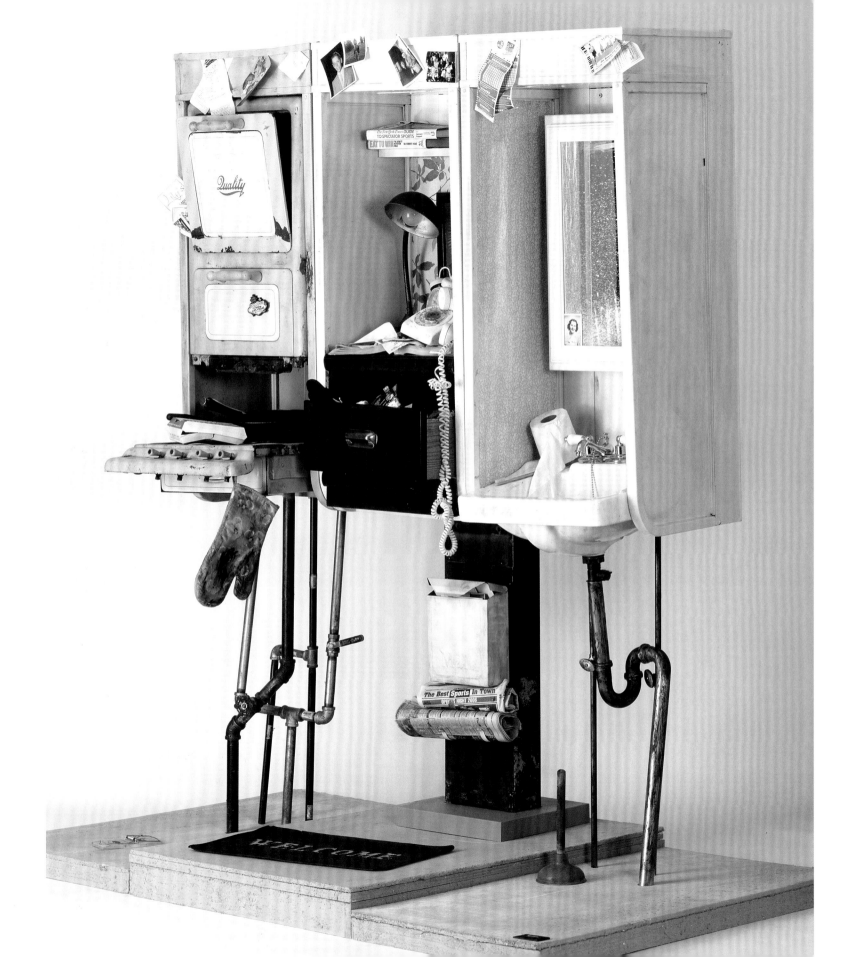

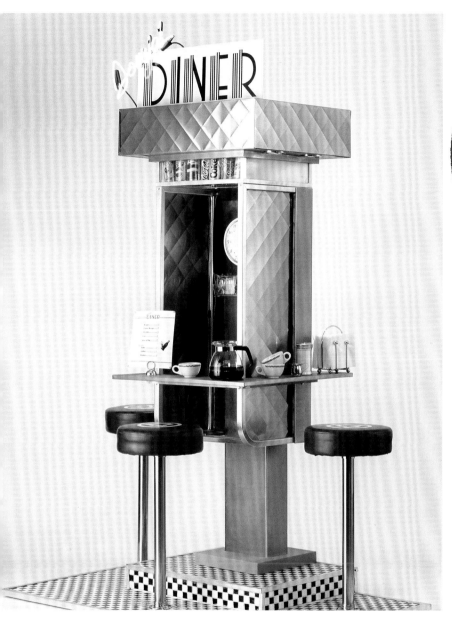

O'C: The phony diner by Donald Miller made use of valuable street corner real estate, and gave new meaning to "fast food."

O'C: The three-booth apartment by André Araujo reflected the size of living quarters in New York City. We had a blown-up ad that would be in a newspaper, listing things like "great view," "lots of sunlight," "loft area"—all the hype that rental agencies use to sell, and at, of course, at an outrageous price. For the exhibitions, he placed a mattress across the top.

O'C: The bike rack by Erin Scally was another concept that could benefit any city. She added bars on all four sides of the booth and painted it a park-colored green.

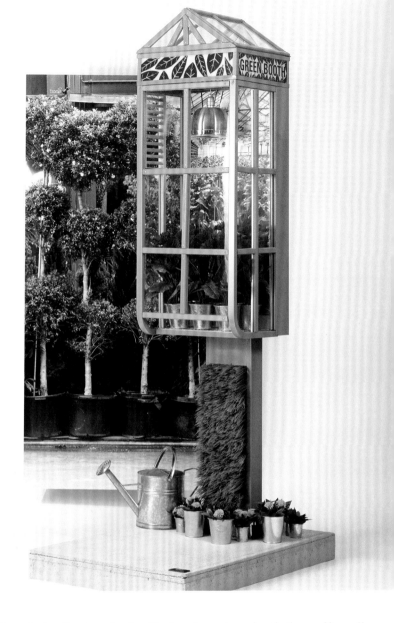

O'C: For the peep show, Marcelo Alves installed a video monitor inside the enclosure with a young woman speaking to you—on a working phone! The palette and typographic choices made this a beautifully art-directed work.

O'C: By enclosing the phone booth with glass to create a plant hothouse, Myung Ha Chang brought a little green to the concrete street corners of New York.

O'C: Gregory Westby's foot massage booth re-created Dr. Scholl's blue and yellow branding. It was a good idea for a city where people do a lot of walking. I liked how he turned the booth upside down. This was a good example of "thinking outside the box," which I encourage my students to do.

O'C: The Greek Orthodox church by Sofia Limpantoudi was intricately detailed. I really liked the gold dome and stained glass. Sofia would call her parents in Greece to confirm some of the details on her piece.

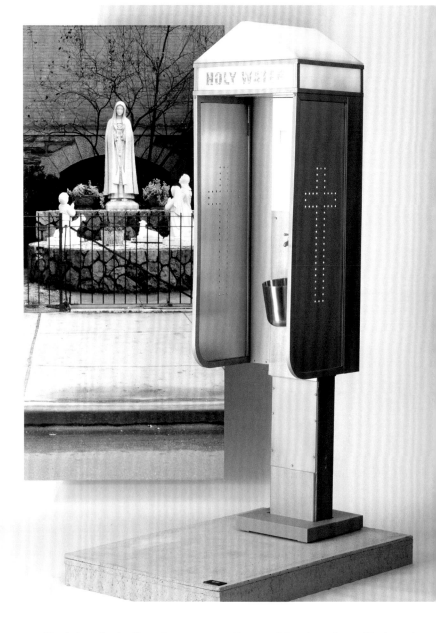

O'C: Christopher Hawthorne's fallout shelter was a statement about terrorism and the fear that many still live with. The booth provided a total enclosure. The institutional green reinforced the concept. Once inside the shelter you found everything needed to survive an attack, including a ventilation system on top. It was a little frightening.

O'C: The holy water booth enclosure was another exquisite piece. Devon Kinch used stainless steel and other phone booth materials. Even the roof that was pitched like a church was made from white plastic similar to the walls inside a phone shelter. The crosses were punched out of the sides in the same manner that the word Bell had been. You stopped in, dipped your fingers in the water, and went about your activities.

O'C: Donald Miller's Chinatown market, complete with a pagoda roof, had fake ice in it and sold bizarre-looking fish. It's all about the details!

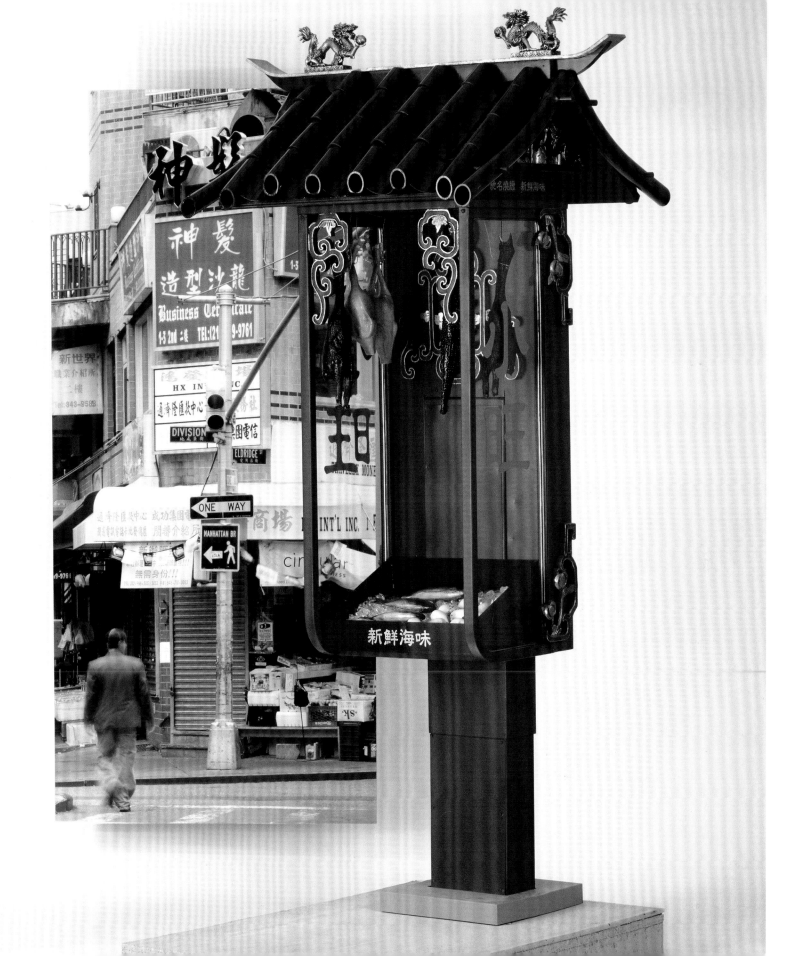

EXHIBITION DESIGN: RETROSPECTIVES

CHALLENGE: DESIGN A RETROSPECTIVE EXHIBITION THAT HONORS THE LIFETIME ACHIEVEMENTS OF AN OUTSTANDING PRACTITIONER IN VISUAL COMMUNICATION.

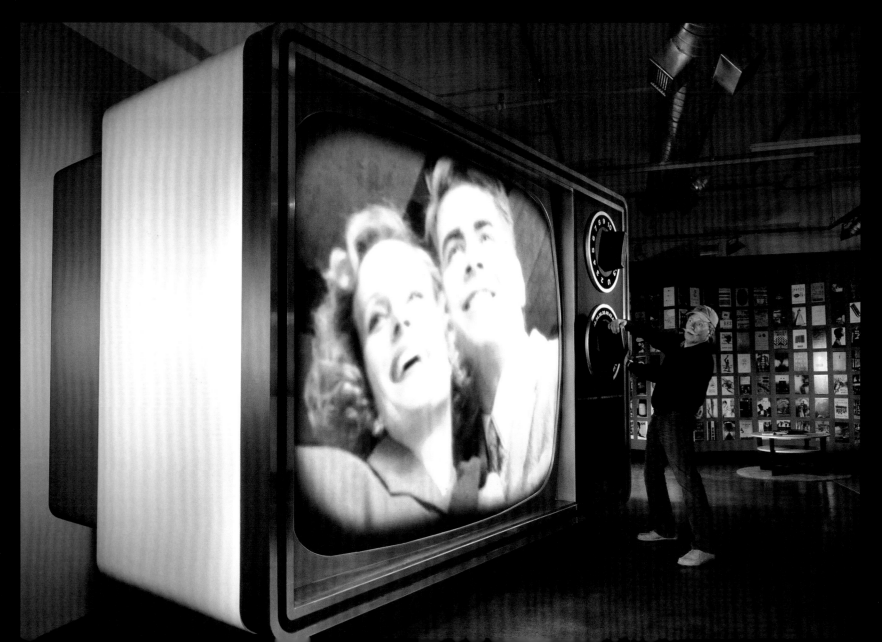

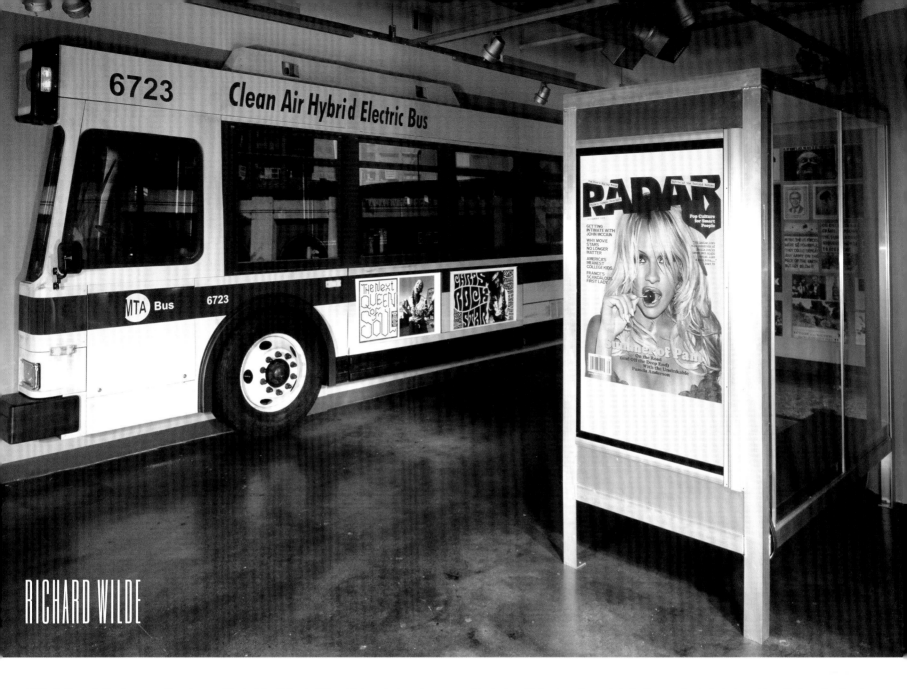

RICHARD WILDE

O'C: Anthony P. Rhodes, executive vice president of the School of Visual Arts, asked me to design a retrospective exhibition for my mentor and friend, Richard Wilde, to commemorated four decades of alumni from Richard's programs at SVA. I had collaborated with Anthony on several projects, and was thrilled to participate in honoring Richard. The show included more than one hundred alumni, each of whom have impacted contemporary culture through an array of media. Richard Wilde is a Hall of fame laureate of the Art Directors Club, and has more than two hundred professional awards, including gold medals from the American institute of Graphic Arts, *Creativity*, The One Show, and the Society of Illustrators, as well as ANDY and CLIO awards. As chair of SVA's undergraduate programs in advertising and graphic design, Richard continues to help thousands of students achieve their professional aspirations, in large part because of his abilities and kindness. The 2009 exhibition represented about two dozen disciplines, from broadcast to print to package and editorial design, video, motion graphics, and so on. One of the biggest hurdles was in trying to present a balanced and cohesive exhibition with so many disparate works. The exhibition included an undulating curved wall for added square footage to mount the two-dimensional pieces, as well as a full-scale public bus in low-relief, along with a three-dimensional bus shelter. On these I installed three 60-inch flat-screen monitors, which appeared like posters but changed over and over again and incorporated one hundred extra pieces that couldn't fit on walls. The giant TV was used to showcase some of the most iconic ads in the history of broadcasting. Many said the exhibition design was beyond their "wildest dreams."

exhibition design: Kevin O'Callaghan; exhibition construction: Scott Lesiak (tv),
James Korpai (bus), Shaun Killman, Joseph Pastor, André Araujo, Adria Ingegneri

STEVEN HELLER

exhibition design: Kevin O'Callaghan; construction assistants: James Korpai, Shaun Killman, Adria Ingegneri

O'C: I always felt a connection with Steven Heller because of the way he produces massive amounts of work in short amounts of time. Steve worked as an art director at the *New York Times* for more than thirty years and still writes the "Visuals" column for the *Times Book Review*. He is cochair of the MFA Designer as Author program at the School of Visual Arts (with Lita Talarico), and has authored, co-authored, and edited more than one hundred and thirty books on design and popular culture. Among many tributes, Steve has received a Lifetime Achievement Medal from the American Institute of Graphic Arts, the Hall of Fame Special Educators Award from the Art Directors Club, the Herschel Levitt Award from Pratt Institute, and the Richard Gangel Award for Art Direction from the Society of Illustrators.

Steve told me he had three wishes: The first was for me to do the show, the second was that there be something monumental about the show, and the last was to have a newsstand that represented what he loves in life: magazines and the like. A big challenge was putting together a show about someone who is such a Renaissance man and is credited by so many people for their success, even though he may not have created the design or the artwork. For the newsstand, we added a three-hour tape of a newsstand worker on the job. To achieve a replica of part of Steve's sanctorum, photographed by Laura Yeffeth, we systematically moved the camera and tripod in increments and took eighteen shots of one wall. I added a couch in front so you felt like you were looking at Steve's inspiration from his vantage point. Happily, we were able to fulfill all three of his wishes.

AMC: TVs FOR MOVIE PEOPLE

CHALLENGE: USING A TELEVISION SET, CREATE A SHRINE TO YOUR FAVORITE MOVIE MOMENT THAT CAPTURES ITS ESSENCE.

STARTING POINT: 382 TELEVISION SETS
ARTISTS: 80
WEEKS: 4

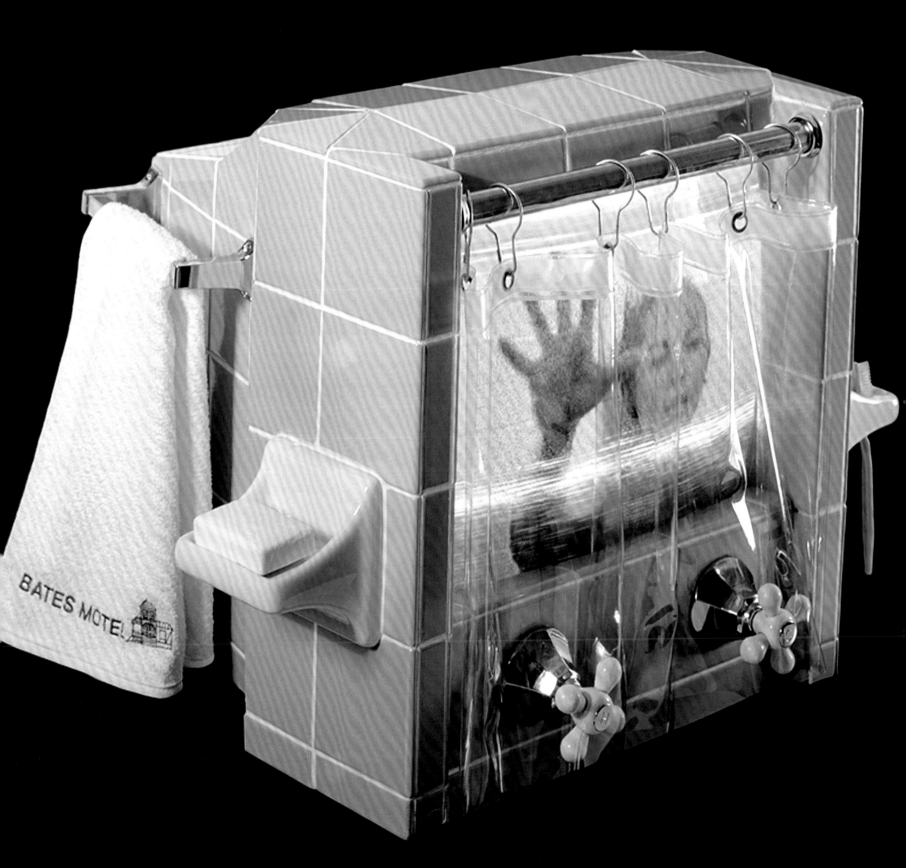

BATES MOTEL

Kevin O'Callaghan

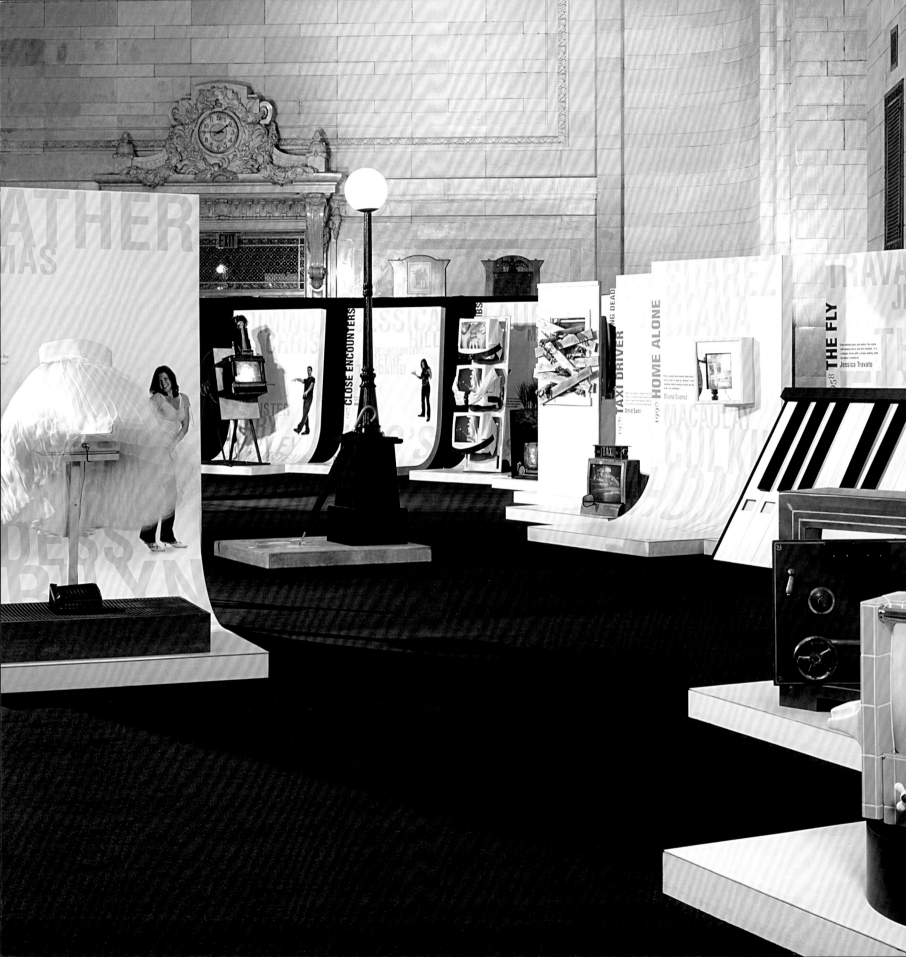

He was told that the channel WASN'T in the ART SHOW BUSINESS. THE GUARD escorted him out.

In the 1989 film *Field of Dreams*, a disembodied voice persuades Kevin Costner to raze his cornfield and replace it with a baseball diamond, convincing him that "if you build it ..." Kevin O'Callaghan has subscribed to this way of working since he constructed a monumental portfolio hoping to land a job. That time, *People* did come, and its article helped to launch his career. But it doesn't always work out that easily, even for O'Callaghan—at least not at the first pitch. He would need to go extra innings to convince the American Movie Classics channel about an idea that would eventually become the blockbuster AMC exhibition "TVs for Movie People."

Late-night television has been a mainstay throughout O'Callaghan's life. The sleepless nights of his childhood were frequently spent watching TV into the early morning hours. His mother, a devotee of pop culture and all things theatrical, would often join him and share her amassed wealth of biographical details about the actors they were watching. Films from the 1930s and 1940s and Johnny Carson topped their late-night entertainment, and O'Callaghan was among the few sixth graders who could name Elizabeth Taylor's then-current husband. One sleep-deprived night in 2003, O'Callaghan switched on his set to the 1940 version of *Waterloo Bridge*. Familiar with the film, his thoughts jumped to fast-forward in anticipation of an upcoming scene. As he waited, a concept was ignited: TV sets repurposed as shrines that incorporated cherished moments of lens-based masterpieces through the medium of sculpture. The exhibition would eventually grow to include seventy artworks that tugged at heartstrings, wrenched guts, and made hair stand on end.

A poster child for art therapy, O'Callaghan has learned to embrace his obsessions and use them to jump-start his creative energies. Concept complete, he immediately began to construct a shrine to Alfred Hitchcock's *Psycho*. The final offering was a television set encased in turquoise bathroom tiles, adorned with porcelain toothbrush and soap dish holders, and an embroidered hand towel that read "Bates Motel." The volume was regulated by turning the hot and cold water taps. Behind a transparent shower curtain played the infamous scene that has terrified the multitudes, skyrocketed the sale of bathroom door bolts, and driven motor inns to bankruptcy. It was perfect.

Now he just needed to get past the security desk at AMC.

O'Callaghan is seldom ruffled by an initial strikeout. Adhering to the motto, "The world is run by those who show up," he rolled Anthony Perkins into the lobby of AMC's Manhattan offices. He was told that the channel wasn't in the art-show business. The guard escorted him out.

This happened several times.

O'C: Large, two-dimensional vignettes accompanied the movie shrines and featured the artists and their chosen movie scenes.

Persistence paid off, and O'Callaghan would pitch the idea to AMC's Catherine Moran, who understood its potential and helped bring it to the attention of AMC's promotions department.

Among O'Callaghan's favorite films are *The Wizard of Oz*, *Close Encounters of the Third Kind*, and *The Great Escape*. Each personifies a different facet of his inner life. The Emerald City makeovers speak to his reverence for reinvention. Citing nonfiction characters who have successfully and repeatedly altered their image, his admiration extends to an eclectic ensemble that includes Alexander Calder, Red Grooms, Elton John, and Madonna. O'Callaghan may hold the attendance record for Elton John's Yellow Brick Road tour.

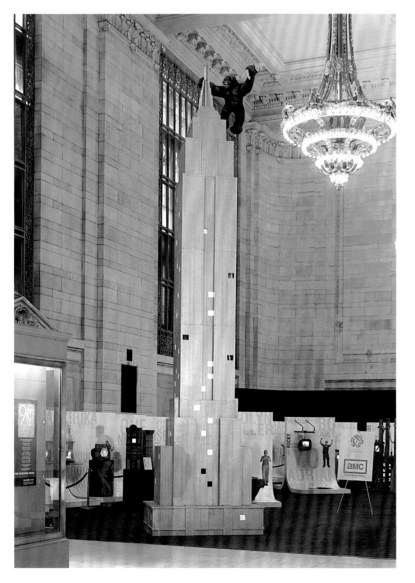

As illustrated through the collective building of Devil's Tower, *Close Encounters* epitomizes O'Callaghan's belief in the enigmatic connections between strangers. "TVs for Movie People" offers another archetypal example of the universal emotions that bind us. Its cinematic shrines unearthed wide-ranging memories that left viewers deeply moved. *The Great Escape* completes the triad, and represents a core principle in O'Callaghan's educational philosophy and lifestyle: triumph through collaborative effort. At the top of his list, *Citizen Kane* reigns supreme, but that's mostly because O'Callaghan loves to tinker with sleighs.

Boasting the largest attendance for any art exhibition at Grand Central Terminal, "TVs for Movie People" was an undertaking of epic proportion. More than three hundred televisions were needed for the shrines, not counting the eighty-five that designer Shaun Killman placed in the Empire State Building model he constructed for *King Kong*. Eight miles of electrical cord had to be snaked through Vanderbilt Hall. O'Callaghan became concerned about people tripping on the wires and decided to carpet the entire 12,000-square-foot floor, though this was unprecedented. He wanted theatrical red carpeting no less, to complement the theme.

With seventy-two hours left, O'Callaghan's team spread out to hunt down a wholesaler who could achieve the unthinkable. With images of the shrines in hand, they pleaded their case throughout the five boroughs. A swarm of O'Callaghan angels flew in to perform a quick miracle on Forty-second Street. A local supplier had just what they needed: an immense quantity of red carpet that had been paid for in full by a previous customer but never picked up. Even better, the carpeting was delivered and installed free of charge, gifts from a group of exceptionally generous motion-picture enthusiasts.

From deep in left field, another O'Callaghan vision was on the scoreboard.

O'C: I like the pieces that were simply done, such as this one. For *The Shining*, Ben Kim used a door that he found in the garbage and retrofitted it to the TV. He cut deep ax marks in the door to reflect the scene with Jack Nicholson playing inside.

O'C: *King Kong* by Shaun Killman rose above the chandeliers at Grand Central Terminal.

Oscar Gonzalez

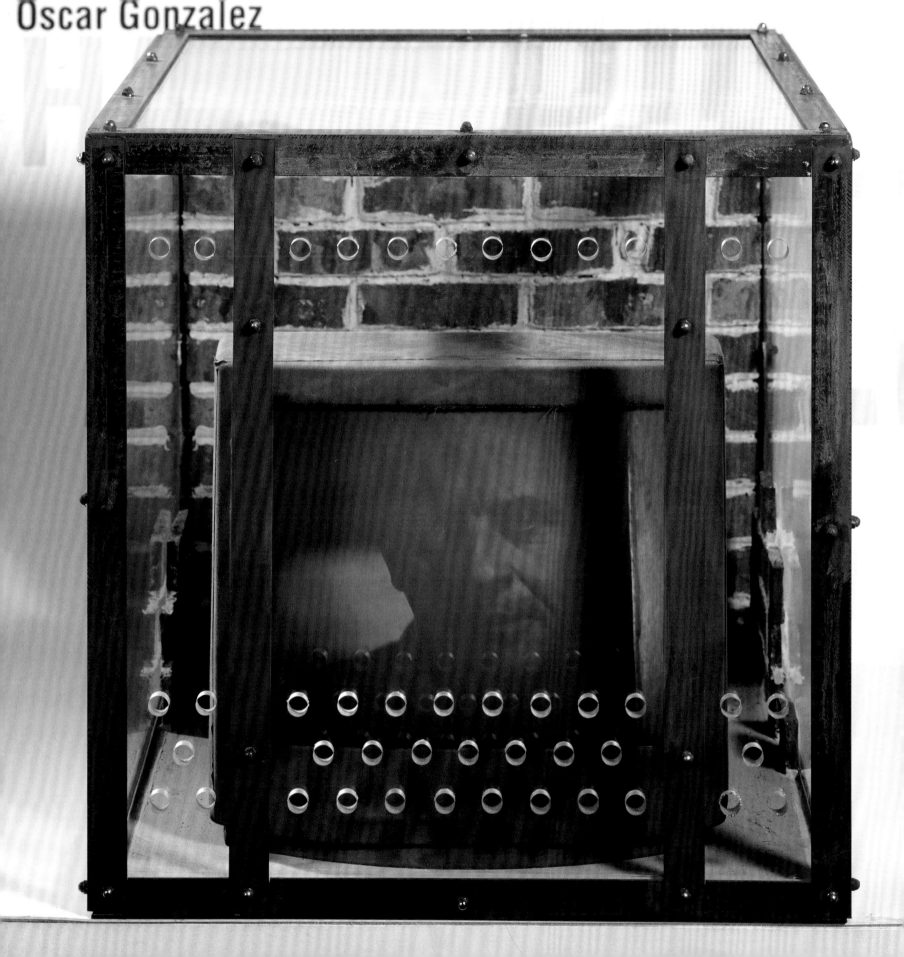

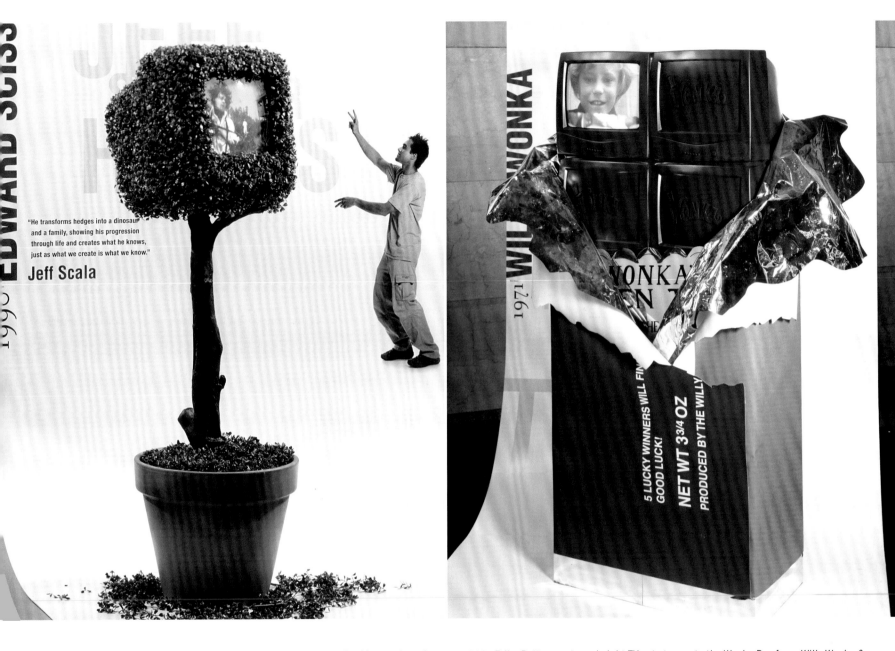

O'C: Jeff Scala sculpted a simple topiary to hold the TV screen for his version of *Edward Scissorhands*.

O'C: Oscar Gonzalez came up with a great solution for *Silence of the Lambs* by putting the TV into a glass case like solitary confinement. The Plexiglas used was a half-inch thick so it really gave the feeling of being encased.

O'C: Erika Bettencourt used eight TV sets to create the Wonka Bar from *Willy Wonka & the Chocolate Factory*. Seven of the screens were painted with a "chocolate" patina, and one was left uncovered to reveal the scene. The golden ticket was hidden in the chocolate bar.

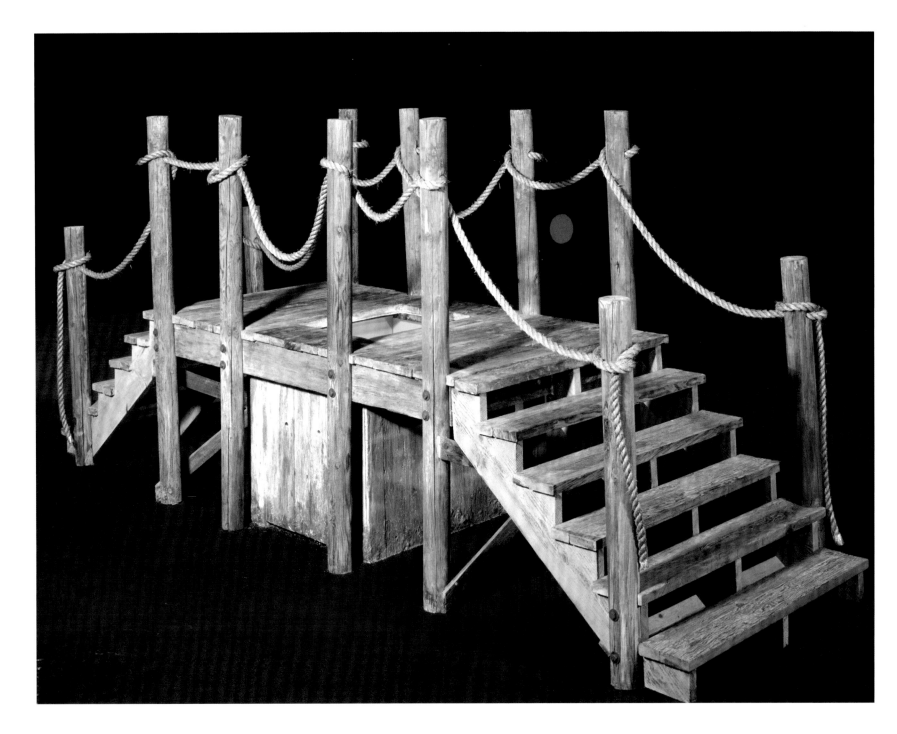

O'C: Starting with authentic dock components, Christina DeMarco added a faux finish to give the wood a more weathered appearance. What made the *Jaws* shrine magic was that the TV set seemed to be in the water. It was an illusion that she created with a tank of water installed above the TV screen. You looked through the glass bottom of the water tank to watch the scene. She even had a sound system built into the pier, which vibrated from the thumping noise on the soundtrack when the shark came toward you.

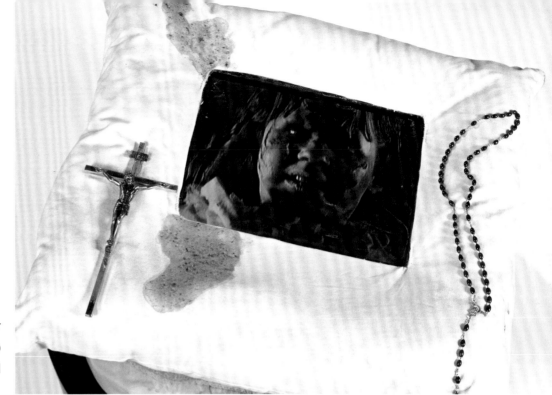

O'C: For *The Exorcist*, Lauren Panepinto installed a paint mixer machine from a hardware store so the pillow would shake violently up and down as though it was really possessed. She masterfully solved how to conceal a wide and bulky TV set in the pillow.

O'C: *To Kill a Mockingbird* was beautifully done. Carolyn Mueller covered the TV set with bark and painted tree rings onto the screen. Using a computer, she isolated the scene on the thirty-two-inch screen to appear as if Scout's keepsakes were in the cigar box.

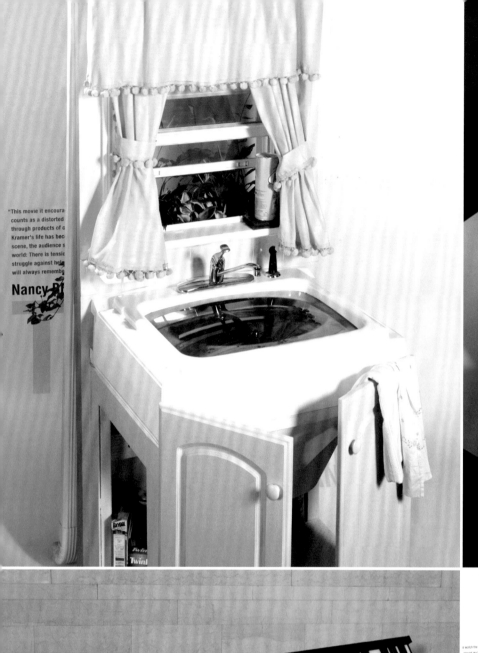

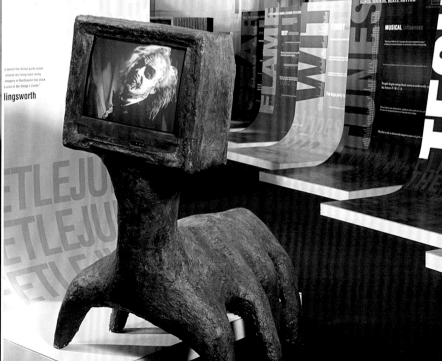

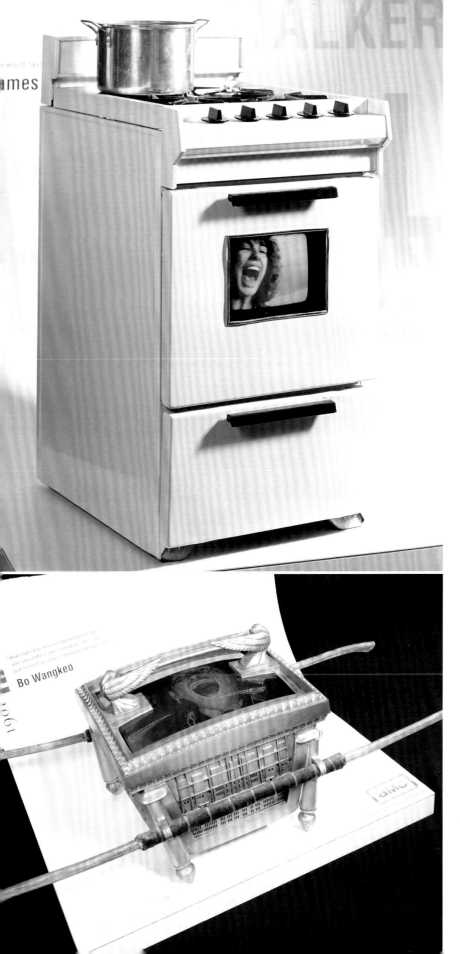

O'C: *The Incredible Shrinking Woman* was a very innovative piece. Nancy Blumberg didn't do anything to the actual TV set except to paint it a white porcelain color and then put the set on its back. It was amazing how closely it resembled a sink. The woman is going down the drain in the movie was the selected scene, and the piece made it look like she was on her way down the drain.

O'C: For *Butch Cassidy and the Sundance Kid*, Christopher Dimino did not alter the TV set. By putting the safe door on the front of the set, the environment was immediately transformed.

O'C: The shrine to *Fatal Attraction* by James O'Brien went one step farther: in the large pan on the stovetop he had a video clip of a rabbit in the "boiling" water.

O'C: Adria Ingegneri's *Big* was involved. The piece had twenty-five small TVs, and each had its own DVD player. They were synchronized so that when the piano scene from the movie played "Heart and Soul," the corresponding note lit up on the piano and showed that movie moment. The timed sequence was not computer-generated; it was achieved mechanically by starting the DVD players simultaneously.

O'C: For *Beetlejuice*, David Hollingsworth took one of the monsters from the film to house the scene. It felt as if the monster always had a TV head.

O'C: Boworndej Wangkeo took an old thirty-two-inch TV and placed it on its back for *Raiders of the Lost Ark*. With gold leaf applied to the existing molded plastic structure on the set, the shrine became decorative and magical, like the lost vessel.

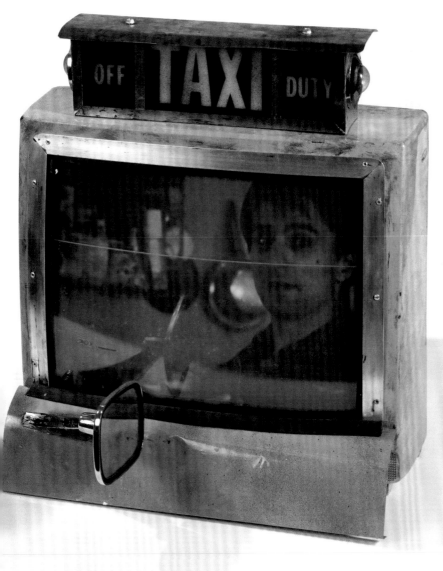

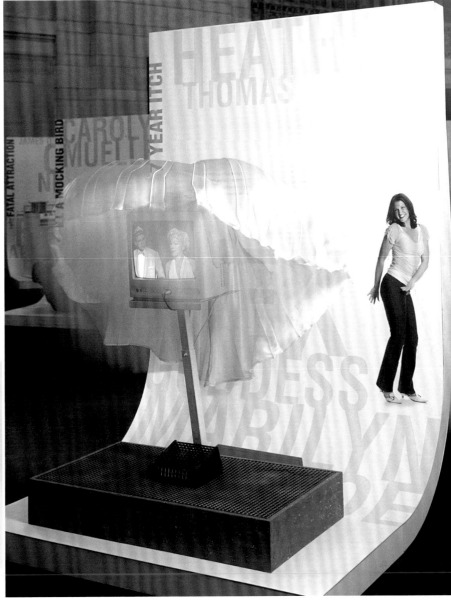

O'C: Omid Sadri's *Taxi Driver* was a simple, clean solution. He made it look like the side of a cab with Robert De Niro in it. Denting the cab was a nice touch.

O'C: Shannie Cohen used a one-inch viewing monitor from a pre-digital video camera for her shrine to *Breakfast at Tiffany's*. It was the exhibition's most diminutive jewel.

O'C: Heather Thomas placed a fan under the fake sidewalk grating that held the TV set, and it was timed to generate a gust of wind for the length of the scene from *The Seven Year Itch*. The fan turned off when the scene ended and Marilyn Monroe's dress covered the screen. Even knowing what they were going to see, the audience would wait for the dress to blow up and reveal the screen.

THE TURN OF THE CENTURY: A CAROUSEL

CHALLENGE: CREATE A TIME CAPSULE OF THE PEOPLE AND EVENTS FROM THE TWENTIETH CENTURY IN THE FORM OF A HISTORIC CAROUSEL.

STARTING POINT: 1 CAROUSEL
ARTISTS: 53
WEEKS: 22

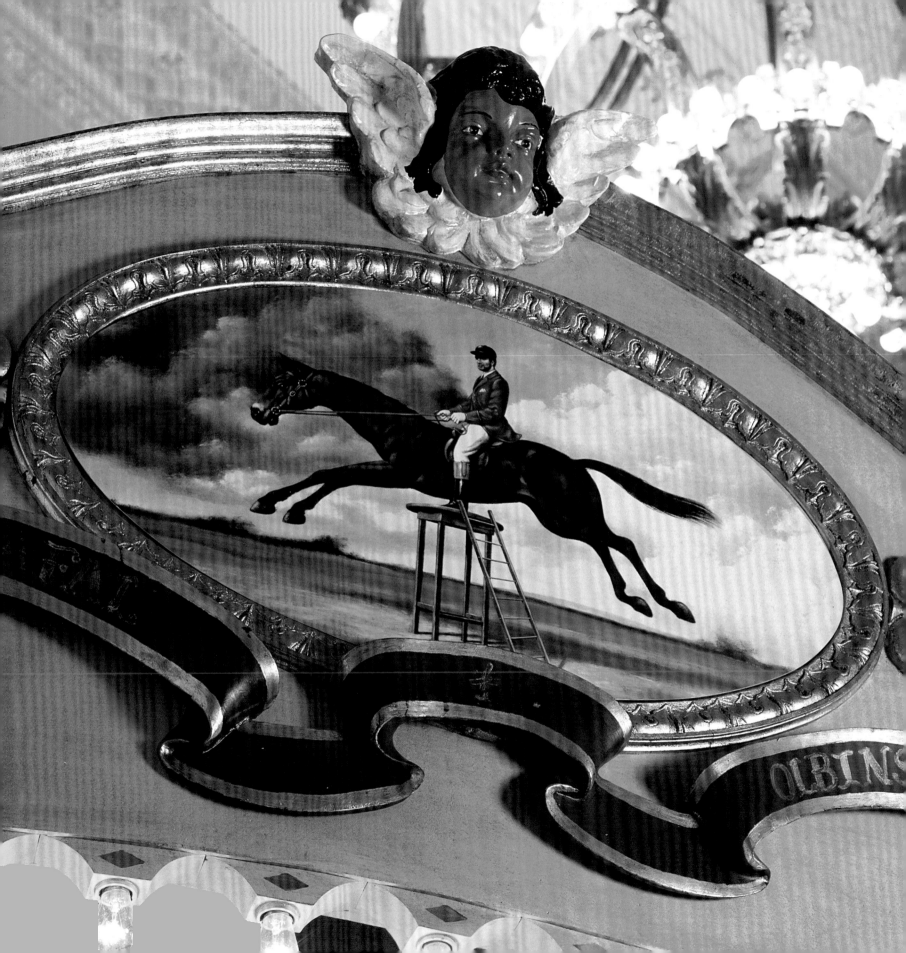

The carousel was a MAGNIFICENT TRIBUTE to the "ups and downs" of the past ONE HUNDRED YEARS, and highlighted ICONIC IMAGES OF THE TWENTIETH CENTURY.

Perched on the balcony of the 69th Regiment Armory in New York City, Kevin O'Callaghan overlooks the tanks parked on the ground floor. Within the vast expanse, the camouflaged cruisers remind him of the palm-size Matchbox cars of his youth, and he begins to feel light-headed. The diagnosis is butterflies in the stomach, enormous ones and lots of them, a malady that stems from accepting an assignment without certain vital statistics, such as how many cubic feet are inside a building that spans almost a full city block north, south, east, and west. The project had sounded simple enough. The chairman of the School of Visual Arts, Silas H. Rhodes, wanted to hold a masquerade ball—a really, really big one—in celebration of the college's golden anniversary. So he had summoned O'Callaghan and said, "I want you to fill a space with the greatest centerpiece in the world."

Looking down at the olive-green tanks, O'Callaghan surveyed a space measuring more than 200-by-168 feet. With a capacity for five thousand people, this building had hosted the celebrated Armory Show of 1913 that brought the works of Van Gogh, Cézanne, and Matisse to America. To honor the artists who had taught at SVA during the last fifty years, Rhodes wanted an event of equal magnitude.

O'Callaghan recalled a documentary he had seen on the plight of abandoned carousels that had been stripped of their treasures and left for dead, victims of collectors' carnage. The bounty was in the exquisitely hand-carved horses that had adorned them. The switch to producing carousel horses in aluminum and then fiberglass in the 1970s had forced the wooden steeds into retirement. While these folk-art carvings found shelter in auction houses and private collections, their forsaken carousels were rendered useless. But O'Callaghan saw beauty in the intricate mechanics of these discarded remains, which embodied the enduring memories of their riders: the smells of popcorn and freshly twirled cotton candy; the music; the lights; the cold, bronze poles that set brightly colored horses in motion—all summoning fantasies at a gallop. For O'Callaghan, the dream was to create a beautiful, massive kinetic sculpture, suggestive in feeling, if not in size, of Calder's *Circus* that had many years earlier awakened his own creative spirit.

O'Callaghan envisioned his centerpiece as an antique carousel with a new kind of ride. A frozen TV dinner, Dolly the cloned sheep, and Howard Stern's tongue were among the icons chosen by the young artists to create a three-dimensional centennial time capsule of pivotal twentieth-century images. In the end, it would have but one horse, crafted in homage to Picasso's *Guernica*.

Getting the go-ahead from Rhodes, O'Callaghan began what would be an arduous journey to find a carousel and then refurbish it. Carousels come in standard sizes: the smallest is the merry-go-round; the largest, the grand carousel, spans a minimum of thirty-six feet and is site specific, built to remain in one place. O'Callaghan went big, eventually transforming a thirty-six-footer into a portable grand carousel, fifty feet in diameter, the first of its kind.

O'C: I'm standing on the foam that was donated and delivered by Dow Chemical Company. When it arrived, I knew I had what was needed to make the carousel. It was one of the happiest days of my life.

The Internet was in its infancy, and locating a carousel carcass was an adventure unto itself. O'Callaghan discovered that there was a local subculture of carousel lovers, and he joined its ranks. Research led him to the world's premier carousel restorer, Todd Goings, who he contacted to discuss a metal-frame model. Goings advised against using the metal skeleton. Asked why, he replied, "I do this for a reason. There is nothing more beautiful to me than the sound of the wood creaking when the carousel turns." O'Callaghan immediately knew he had found a kindred spirit whom he could turn to for advice.

Now he just needed a carousel.

Through newsletters and club members, he unearthed three potential fatalities of the looting that had left intact fewer than two hundred wooden carousels. He tracked one down to a barn in Kentucky, amid hay and debris. The carousel was in shambles and O'Callaghan left it behind. He went to Indiana and inspected one by flashlight in the middle of the night, the vestiges of an amusement park foreclosure.

O'C: I took this picture of the farmer in Spokane, Washington, as he showed me pieces of the carousel that were covered in dirt and debris. The carousel had been under the tarp in his field since 1927.

Finally, on a lead from his carousel-club newsletter, he traveled to Spokane, Washington, with a picture of a Victorian beauty that had originally been built by the C.W. Parker Company in the early 1900s. When O'Callaghan arrived, he found a bunch of junk under a tarp in a farmer's field. Frustrated and concerned about wasting more time, he bought it for 3,500 dollars. It was delivered to New York, complete with wildflowers, bugs, and gravel.

Todd Goings estimated it would take years to turn the pile of rubble into, well, anything. They had five months. But he agreed to the monumental challenge, later recalling that he saw in O'Callaghan a "large thinker who pulls you in with his enthusiasm. When you can put something together and have an experience—that's the goal." Goings is a die-hard carousel traditionalist, but he was lured by the collective nature of the project and intrigued with the concept of larger-than-life animations created in three dimensions.

Unable to contain his ideas within a standard range, O'Callaghan had decided to create not only the world's biggest portable carousel, but also the tallest. So he brought in an engineering team, and they raised it thirty-eight feet into the air. Then there was the matter of getting a top. Iowa's Waterloo Tent & Tarp Company joined the collaboration. They stock all standard sizes and shapes, furnishing the likes of Barnum & Bailey. At first, Waterloo tried to tell O'Callaghan that there was no such thing as extending a carousel top as he had spec'd, but the firm finally acquiesced to the O'Callaghan passion and custom-crafted the canvas roof.

O'Callaghan was receiving an education in the back rooms of Coney Island, where he beseeched the carnival community to assist in his search for missing but necessary carousel parts. There was a lot to learn. He realized that to make the carousel creations sturdy enough to ride would require the addition of a special cantilever, which attached horizontally through the midsection of the piece to reinforce the weight that it would bear. This precaution came to mind only after the artists had started sculpting, and forced the temporary dismemberment of Elvis, among others.

O'Callaghan also learned that the gold leaf on the carousel's crown would short-circuit the traditional carnival bulbs when it flaked with

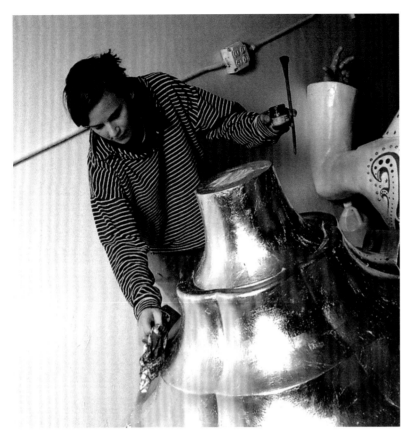

applying gold leaf to carousel detail

weights of the artworks. Time constraints added to the challenge. The first opportunity to place and then adjust all of the sculptural works came on the morning of SVA's half-century celebration. Prior to that, securing a facility large enough to hold the carousel fully assembled was not possible.

Nothing is easy in the O'Callaghan universe, but there is always magic. The carousel's debut was golden in years and good fortune. With the flip of a switch, the carousel was glowing, but hesitated in its appointed rounds. That queasy feeling O'Callaghan had experienced his first time in the armory began to creep back. The carousel started and stopped, creaked and moaned, and then stalwartly took its inaugural revolution.

The ability to achieve an undertaking of such magnitude relies, in part, on the generosity of many. The foam needed by the artists to carve their sculptures was donated by the Dow Chemical Company. Thousands of dollars worth of gold leaf was also gifted. People from all walks of life gave of their expertise and talent. The artists who sculpted their visions invested all they had in the project.

To give the carousel visual unity, O'Callaghan specified a palette of thirteen colors (those used to decorate the carousels of the early twentieth century) for the individual pieces. This was of particular importance, because the subject choices were left entirely to the discretion of their creators. The carousel was a direct representation of what these young artists deemed culturally significant to the final one hundred years of the second millennium.

The intricate details created for the carousel's crown are remarkable. Traditionally, the crown is constructed with rounding boards inlayed with mirrors to reflect the lights or decorated with landscape murals that underscore the feeling of riding through the countryside. Designed by O'Callaghan, the rounding boards were based on elements from various carousels that he had encountered along the way. He carved the ribbon banner from the Dow foam, which was then rendered in fiberglass. Unique to this carousel is rounding-board art painted by Milton Glaser, Marshall Arisman, and Seymour Chwast. These artists and others each painted a scene that represents the twentieth century.

the turning of the monumental artwork. Because the carousel was a self-contained art gallery, a tremendous number of miniature lights were necessary, and O'Callaghan would not consider alternatives to the authenticity of their glow. The disruption of electrical circuits around the nation seemed a minor concession.

There were massive logistical considerations in moving a carousel that's not supposed to leave town. It weighed about ten tons. When the carousel traveled, a semitrailer truck was dedicated to relocating just the platform. Erecting the carousel and its tent at each site took eight skilled men and a lot of muscle.

O'Callaghan and his team could only address the placement of the rides after the carousel's platform and big top had been assembled. Through inventive rigging and pulley systems, these artworks were designed with a variety of movements. The sculptures would need to be reconfigured, repeatedly, until there was no possibility of a collision. Placement changes were also needed to balance the varying

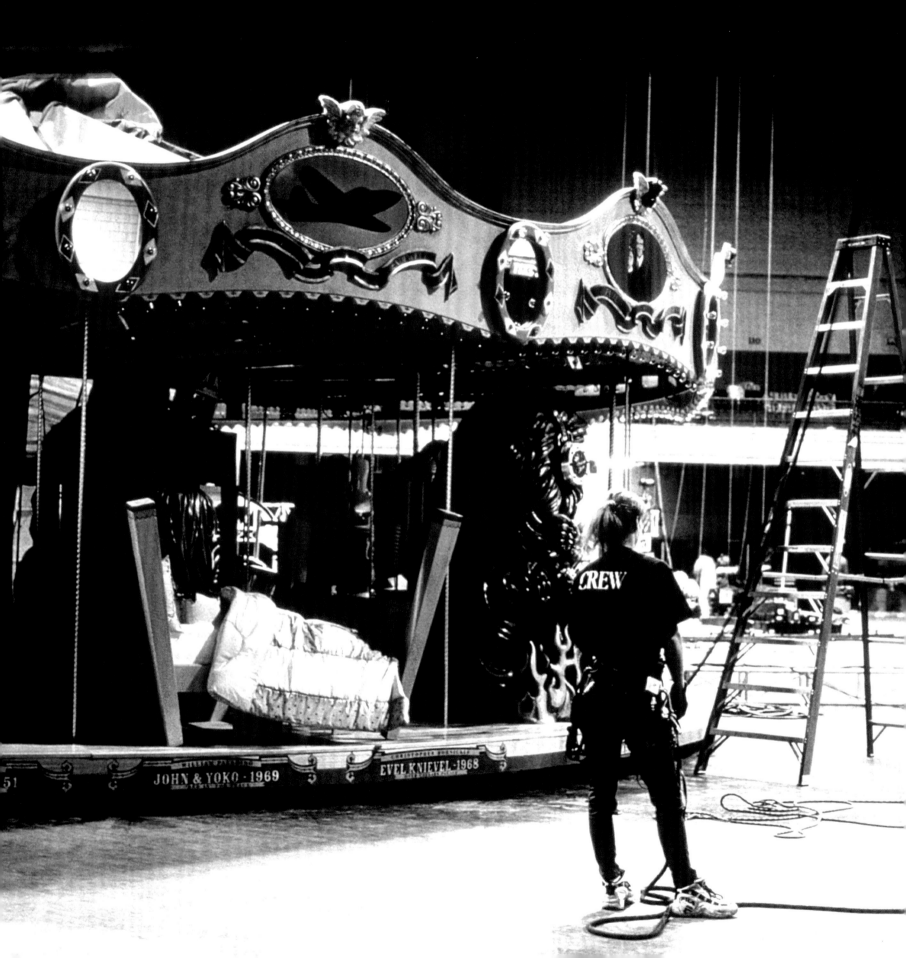

As with most O'Callaghan projects, not everything went smoothly on tour. When the carousel went on the road, so did Todd Goings, ready to reassemble her at each new venue. The reconstruction at the Los Angeles Convention Center proved to be particularly challenging because the location allocated only a few yards of workspace beyond the carousel's diameter. In the haste of installation, the crew knocked into a nearby portable wall, which then came crashing down, accompanied by an elephant's ear. A new addition to the carousel's roster, and carved expressly for the LA show, Jumbo the Elephant had suffered a disfiguring blow. Pandemonium among the crew ensued, leaving Goings with the short straw: to find and inform O'Callaghan of the disaster. With the pachyderm's earlobe in hand, he walked to the other side of the carousel, hesitating somewhere between Picasso and Einstein. O'Callaghan had a cow. Three hours to showtime. He ran frantically to the other exhibition booths, hoping to find something that could be used to reattach the mammoth ear. And then he saw it—a huge bowl of giant gumballs. While his team watched in disbelief, O'Callaghan chewed the confection into a wad of masticated super gum. With an hour to spare, Jumbo the Elephant was looking very together, a freshly painted ear shining in the spotlight.

The "Turn of the Century" carousel spun its way across the United States from 1997 through 2000. Its journey ended in the grand hall of Union Station, Washington, D.C. As the carousel began to slow, the signature rasp of Louis Armstrong singing "What a Wonderful World" filled the room. All eyes were on the carousel that glistened with everything O'Callaghan: creative genius, passion and compassion, and an unbridled love of life.

poster by Rafal Olbinski

O'C: The carousel traveled from the armory to Grand Central Station, where the CEO of A&E Networks saw it and booked it for a nationwide tour. In addition to being featured on The History Channel, the carousel received first prize in New Orleans at the Western Show, a premier cable networks convention.

O'C: Assembling the carousel on the morning of the School of Visual Arts' fiftieth anniversary event held at the 69th Regiment Armory in New York City.

SVA student assistants: Genevieve Gorder, Basia Grotholski, Olga Krigman

O'C: The gold leaf on the carousel's rounding boards (detail page 215) was beautifully applied by master faux-finish painter Eva Glaser. Each of the twelve frames on the board contained an illustration by a faculty member at SVA; the images they chose were their personal contributions to this twentieth-century time capsule.

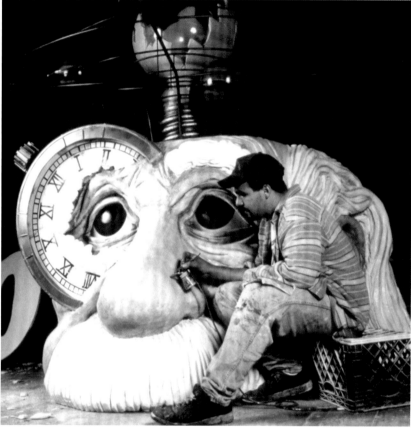

O'C: These images show James Korpai examining the white expandable foam and working on the details for his piece. The expandable foam covered the blue foam that was donated. In the image on the left, you can still see a little of the blue foam that was sculpted for the eyes. After the sculptures were completed, the students then coated the artworks with a resin material to give them additional durability. The process is similar to the way surfboards are manufactured.

O'C: The complete Einstein head was a gondola ride that you sat in as the little planets revolved around you. In Einstein's head was a beautifully upholstered curved seat. It was hypnotic to sit there and watch the universe go around. A real masterpiece.

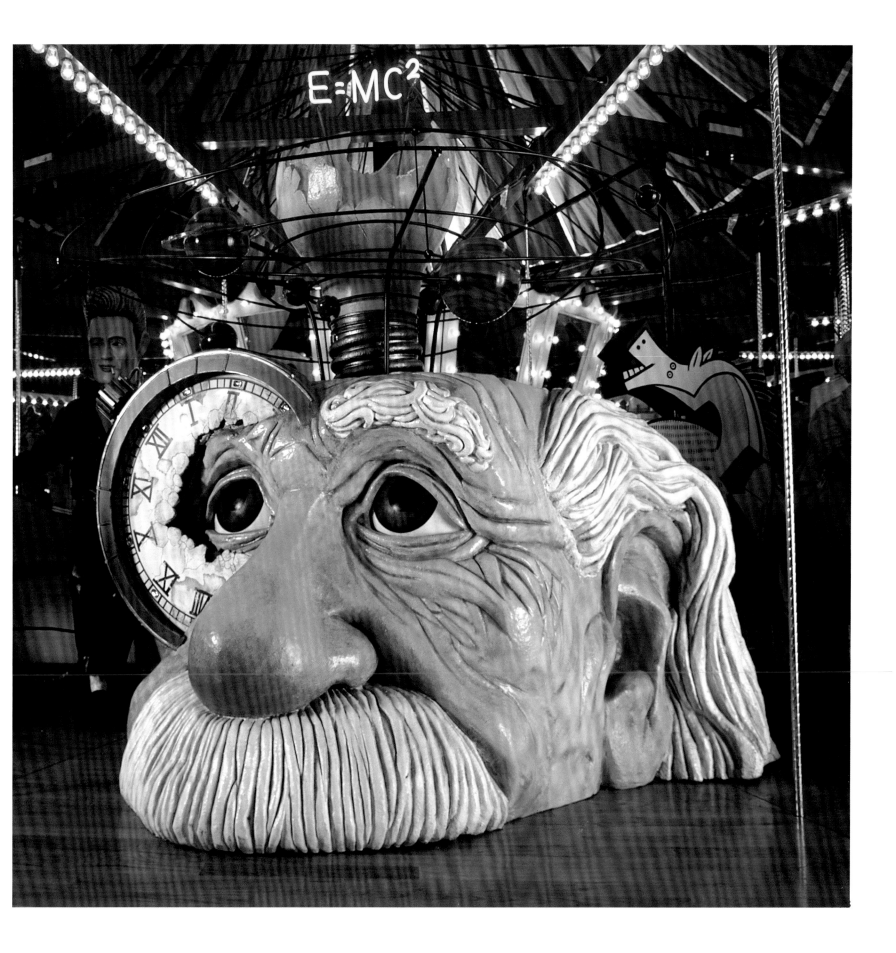

ANNETTE & FRANKIE · 1962 ANDY WARHOL · 1964 ELVIS PRESLEY · 1976

School of
VISUAL ARTS

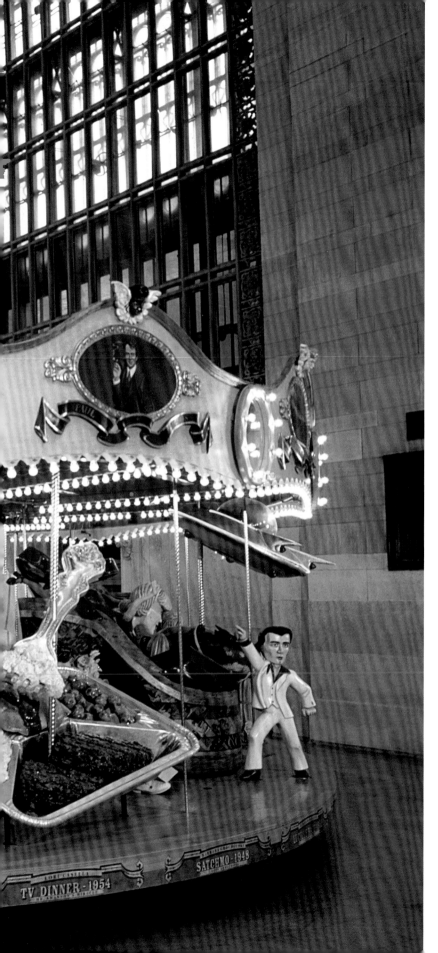

Union Station, Washington, D.C.

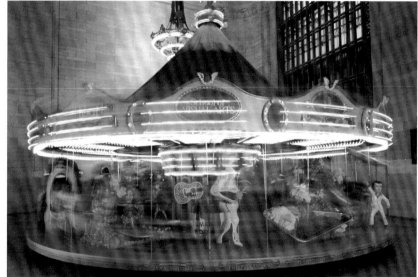

Vanderbilt Hall Grand Central Terminal, New York City

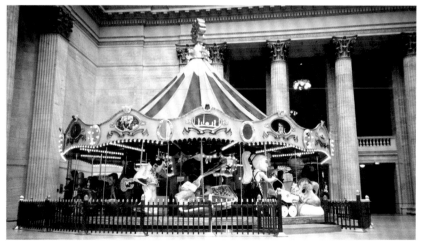

Union Station, Chicago

O'C: The carousel was a magnificent tribute to the "ups and downs" of the past one hundred years, and highlighted iconic images of the twentieth century.

O'C: William Paladino chose the introduction of television as representative of the twentieth century, and Lucille Ball was certainly the queen of television. This piece was very involved: The carousel seat was the CBS camera, and you could watch the famous Vitameatavegamin scene from *I Love Lucy* through its monitor. The Lucy sculpture is from the same scene. When the camera went up and down, Lucy spun toward the camera. The carousel pieces not only went up and down, they also moved in other directions.

O'C: The Chuck Berry piece was my favorite to ride, in part because I love early rock and roll, and also because Joseph Vitale's craft on this piece was outstanding. You rode up and down on the guitar, while Chuck's bent leg stayed in position. Bending at the knee, it looked like he was doing his famous duckwalk across the floor.

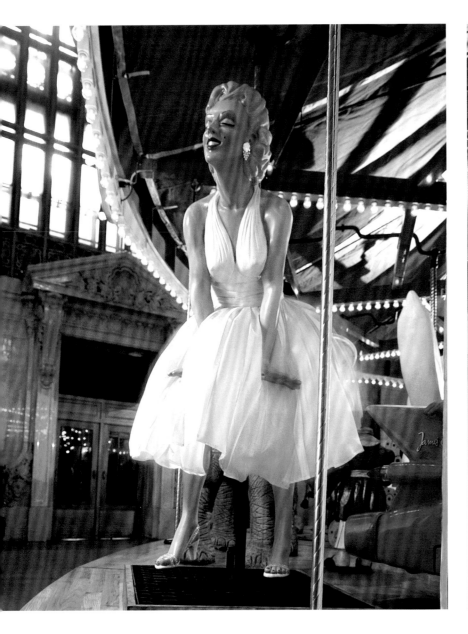

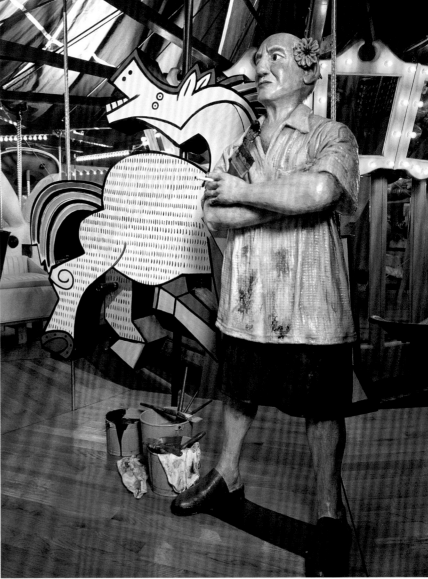

O'C: Harlan Silverstein was inspired by the white dress Marilyn Monroe wore in *The Seven Year Itch*, the movie scene that was also chosen for the later exhibition "TVs for Movie People." On the carousel ride, the seat was Marilyn's back, and you put your feet on her hands. As the ride went down the dress went up.

O'C: The Picasso piece had the only horse on the carousel, which was created in the cubist style of *Guernica* and about ten inches thick. Lael Porcelli's sculpture of Pablo Picasso remained stationary, and you rode on the horse.

O'C: David Polanski's Madonna piece showed the Material Girl with her cone-shaped bustiere and ponytail, her chosen style at that time. He felt Madonna's decision to become a mother was an important moment of the twentieth century. What made this piece great was that the carriage rocked as you sat in it. Madonna's arms were hinged and animated to rock you back and forth.

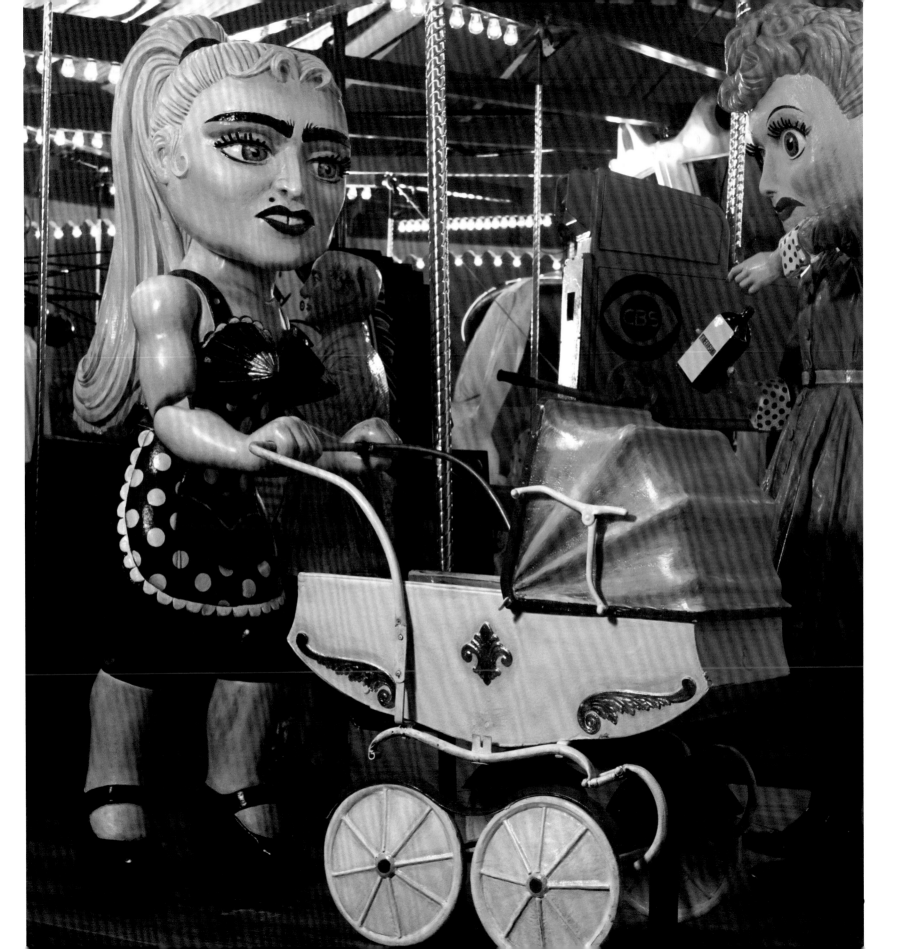

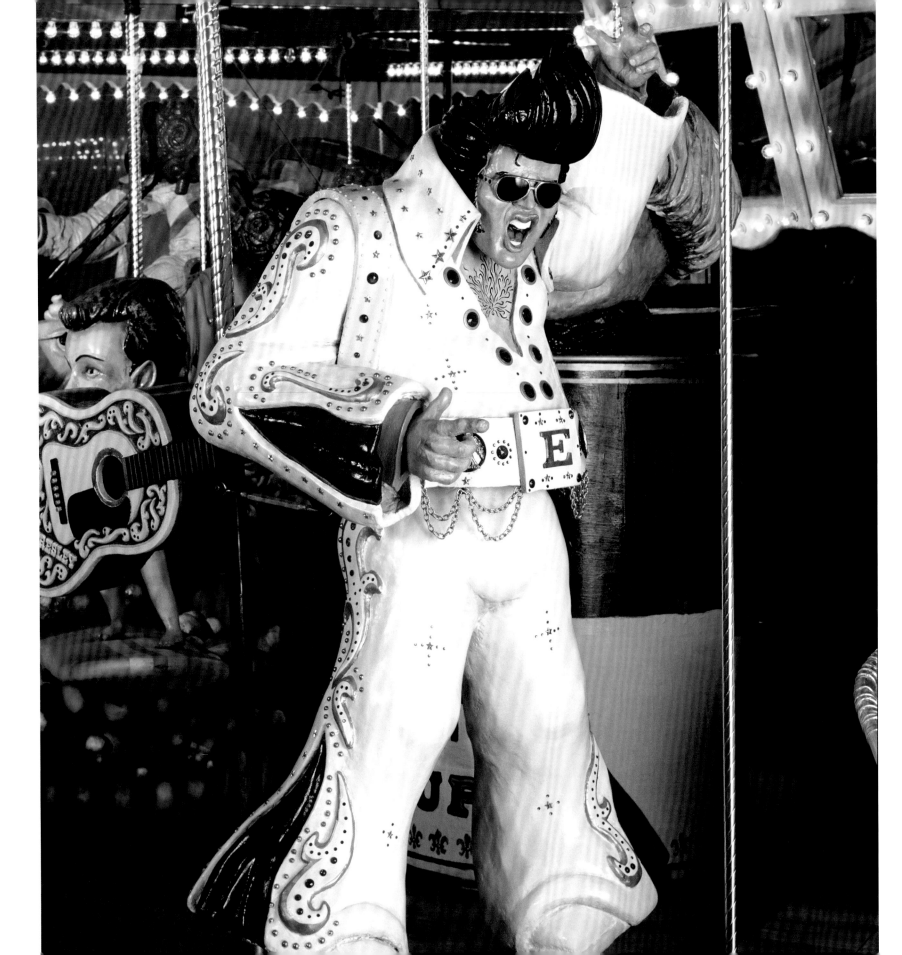

O'C: Steven Ellis created the Elvis Presley piece. The body remained stationary, except for his hips, which gyrated back and forth. His guitar was the seat. What also made this work superior was that Ellis saw the form of a carousel horse in Elvis's persona. He placed carousel jewels down the side of the suit, as on a carousel horse, and the mouth formed a horse-like jowl. The hair was styled like a mane, and the guitar had carvings like those on a saddle.

O'C: The TV dinner was a gorgeous piece, eight feet by four feet and very realistic looking. Riders sat on mashed potatoes on a fork that went down into the Salisbury steak. All of the details were incredible. Lori Casella made the steak with a foam material, so it was kind of soft.

O'C: At the end of the twentieth century, Howard Stern became a huge media personality, known for his provocative perspectives. Scott Lesiak sculpted a Stern caricature, detailed with carvings of Stern as a devil and an angel on the side of his head. His tongue was the seat, complete with little taste buds made from carousel jewels.

O'C: Matthew Targon used more than two thousand blue carousel jewels for this Cookie Monster. You rode on the cookie and went up and down in the glass of milk, which was filled with a resin material. To get to the seat, you climbed up the cookie stairs. I really liked the illustration he painted on the side of the glass. It looked like an iconic 1970s plastic cup for kids.

O'C: The Forrest Gump piece was beautifully done by Christopher Klimasz. You sat on the bench, and as the carousel went around, the arm extended to offer a chocolate. The bench was created in the style of an old carousel.

O'C: Andy Warhol and the pop art movement certainly belonged on the carousel since our carousel itself was a piece of pop art. This was one of the few pieces that made a statement about an art movement. Warhol's shoulders were the seat, which went up and down above the iconic soup can. Olga Krigman designed the camera in Warhol's hand to flash as his head popped up.

O'C: Joseph Vitale was involved in surf culture and loved the "beach blanket" movies of the early 1960s. This piece was enormous, about eight feet by eight feet and seven feet tall. You stood on the surfboard, and the heads on Annette Funicello and Frankie Avalon bobbed back and forth. The sides of the waves spun as if the waves were crashing. Joe went on to design amusement rides at Universal Studios in Orlando.

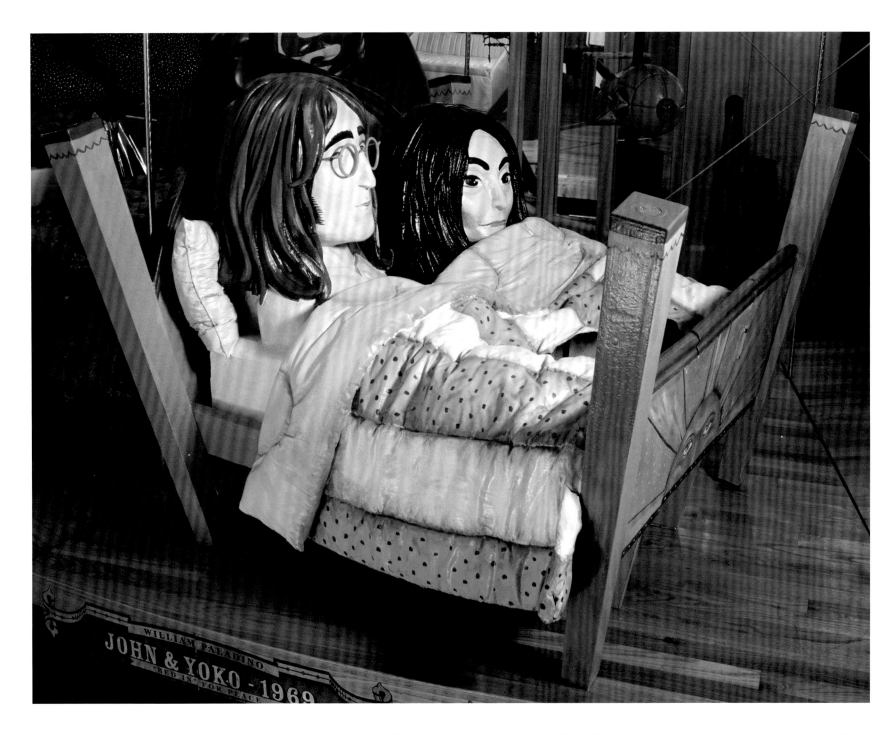

WILLIAM PALADINO

JOHN & YOKO - 1969
BED IN FOR PEACE

O'C: From more than two hundred sketched ideas for the Beatles that I got, this one represented a well-known happening: the 1969 bed-in for peace. William Paladino created a gondola piece, and you rode under the covers with John and Yoko. Beautifully done, and painted in a psychedelic style using the palette of thirteen colors that I gave the students to work with.

O'C: The hand by Shane Nearman was a mechanical marvel. It was about eight feet in height, and two fingers went up and down giving the universal peace sign as the carousel revolved. It worked flawlessly until the *CBS Early Show* ran a live interview. As I was speaking on camera with the carousel turning behind me, the index finger stopped working, and it looked like the ride was giving thirty million people the finger. And of course the screen caption read, "Kevin O'Callaghan, School of Visual Arts." My students were hysterical. To this day, I think they rigged it to do that.

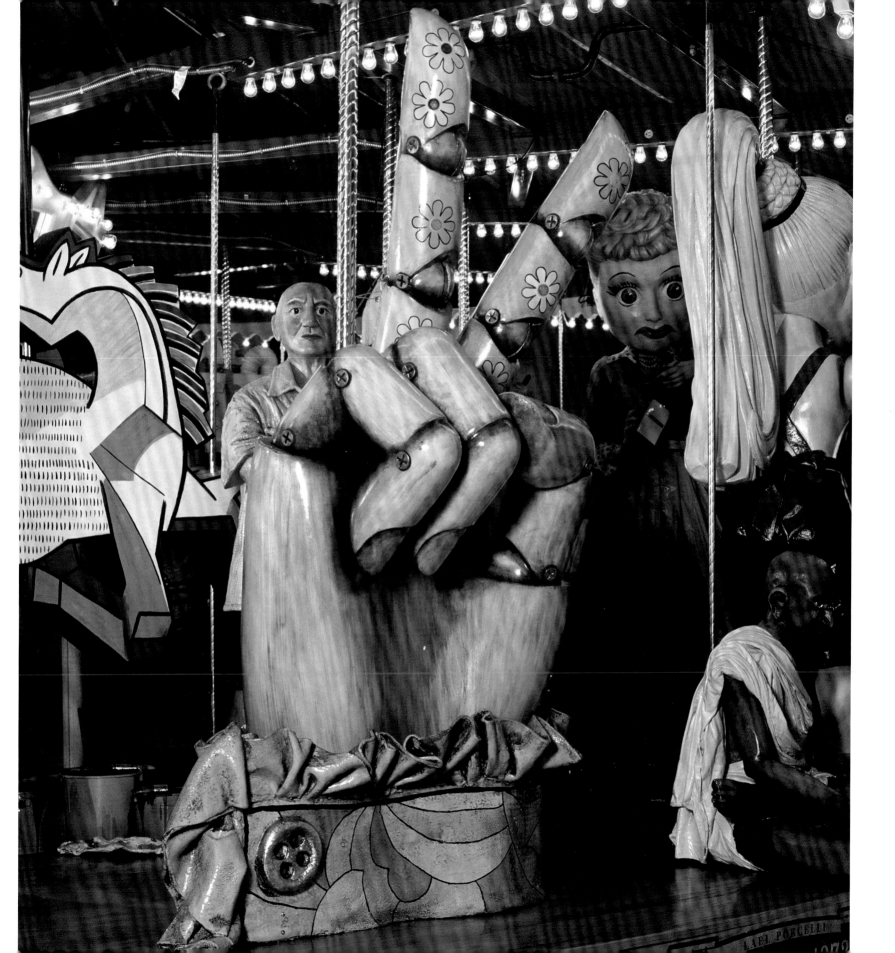

INDEX

All page numbers in italics refer to illustrations.

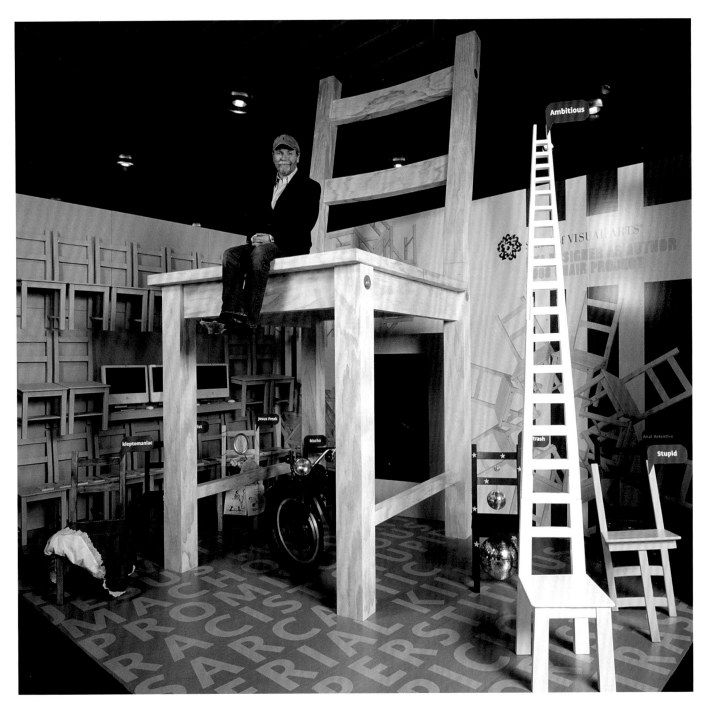

Kevin O'Callaghan sitting on Big Chair *at the 2008 ICFF (International Contemporary Furniture Fair).
The artworks were created by O'Callaghan's graduate students in the MFA Designer as Author program
at the School of Visual Arts, and won the ICFF Best Booth Award. It beat out more than four hundred other
entries, including the work of some of the most applauded designers. The students created chairs that
illustrated a particular personality type. Design and concept: Kevin O'Callaghan; chair: Shaun Killman;
student assistants, graphics: Nigel Sielegar, Gustavo Garcia*